PREHISTORIC ROCK ART
OF NEVADA AND
EASTERN CALIFORNIA

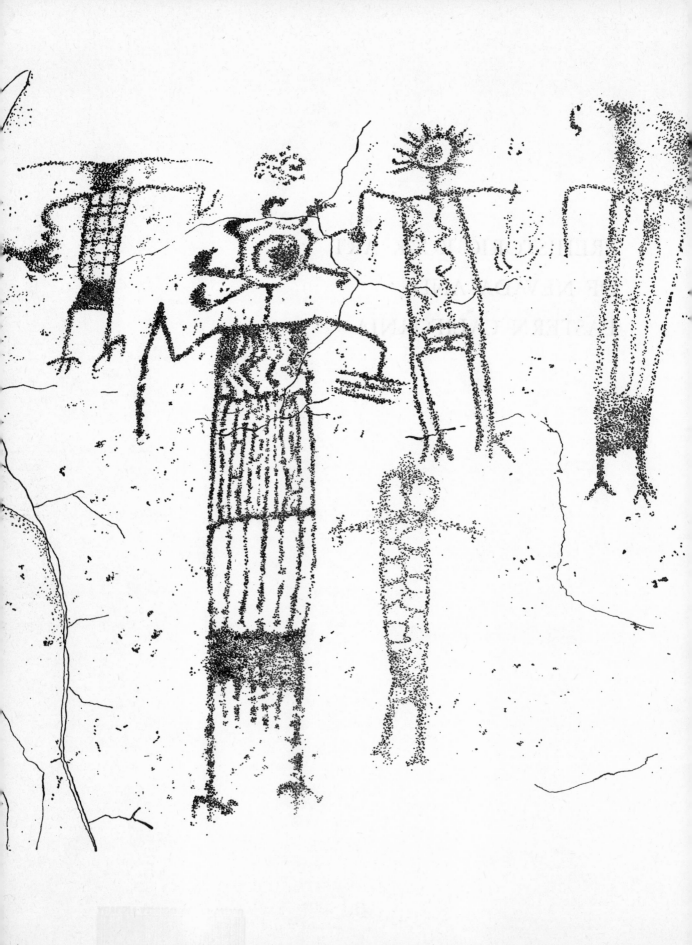

PREHISTORIC ROCK ART OF NEVADA AND EASTERN CALIFORNIA

ROBERT F. HEIZER AND MARTIN A. BAUMHOFF

1962

UNIVERSITY OF CALIFORNIA PRESS

Berkeley and Los Angeles

UNIVERSITY OF CALIFORNIA PRESS

BERKELEY AND LOS ANGELES, CALIFORNIA

CAMBRIDGE UNIVERSITY PRESS

LONDON, ENGLAND

©1962 BY THE REGENTS OF THE UNIVERSITY OF CALIFORNIA

LIBRARY OF CONGRESS CATALOG CARD NUMBER: 62-13074

PRINTED IN THE UNITED STATES OF AMERICA

FRONTISPIECE: PECKED PETROGLYPHS, SITE INY-281

DEDICATED

TO THE MEMORY OF

ALFRED LOUIS KROEBER

1876-1960

Acknowledgments

The study presented here is a report on some of the findings resulting from a three-year program of research on the prehistoric Indian occupation of the western part of the Great Basin area. This research program has been supported by the National Science Foundation[1] and the Committees on Research of the University of California, Berkeley and Davis campuses.

The facts presented here have been derived from a variety of sources. Numerous individuals and organizations have volunteered information on location of petroglyph sites. While we here offer our appreciation to all those who have helped us in our work of accumulating information, we wish specifically to acknowledge the help of the following: Mr. J. Calhoun, Director of the Nevada State Museum; Mr. M. R. Harrington and Dr. Charles Rozaire of the Southwest Museum, Los Angeles; Dr. Dale W. Ritter, Chico, California; Dr. Donald Scott, Peabody Museum, Harvard University; Mr. Albert B. Elsasser of the University of California Lowie Museum of Anthropology, Berkeley; and Mr. Eugene R. Prince, Mrs. Edna Flood, and Mrs. Anne Brower, Berkeley, California.

Contents

Illustrations

APPENDIX FIGURES

List of Tables

Introduction

In the field of the history of art, the last century has seen a whole new dimension added with the discovery of the great galleries of Paleolithic cave paintings in France and Spain (for example, at Lascaux and Altamira). Paintings made by man twenty or thirty thousand years ago are common in western Europe. From more recent times and of a much simpler order (but not less interesting as art) are the painted and engraved rocks of North American prehistoric peoples. The present work is an attempt to make available to the interested public the known facts of the petroglyphic art of the prehistoric occupants of one part of the arid interior plateau of western North America.

For the reader's general interest we review briefly the wider occurrence of petroglyphic and pictographic art in the rest of the world.

The first serious attempt to determine the nature and occurrence of petroglyphs in North America was made by Mallery (1886, pp. 19-33), who cited evidence from the New England states, Pennsylvania, Ohio, West Virginia, Georgia, Iowa, Minnesota, Wyoming, Idaho, Nevada, Oregon, Washington, Utah, Colorado, New Mexico, Arizona, and California. Rock paintings or pictographs are mentioned by Mallery (*op. cit.,* pp. 33-37, *passim*) from Virginia, Tennessee, New Mexico, Illinois, Minnesota, Iowa, Colorado, California, Utah, Idaho, and Arizona.

Steward (1937) briefly surveyed the occurrence and styles of petroglyphs in the United States, and Tatum (1946) published a valuable, though brief, summary of the occurrence of petroglyphs, with a list of reported localities by state. The total number of sites listed by him is in excess of 2,200, but it is certain that this is only a rough or minimal estimate, since the archaeology of no single state is sufficiently well recorded to guarantee an accurate figure. Thus Tatum (*op. cit.,* p. 124) lists over 130 petroglyph sites for California, and yet fourteen years later records and locations of 600 petroglyph sites in the state can be noted in the manuscript files of the University of California Archaeological Survey at Berkeley, and we estimate that half again as many sites are recorded in the files of other California institutions and organizations, and further, that these 900 sites are probably not more than two-thirds of the total number of such sites in the state. Thus for California alone there may be about 1400 petroglyph sites. Tatum's list was derived from published sources, and his record of nine states

from which no petroglyph sites had been reported as of 1946 may be somewhat
reduced in the future. The states without reported petroglyph sites in 1946 were
Alabama, Connecticut, Delaware, Florida, Indiana, Louisiana, Mississippi, New
Hampshire, and South Carolina.

In North America more attention has been devoted to petroglyphs in the Far
West than to those in other regions. Petroglyphs are rare in the area occupied
by the Eskimos, except for Kodiak Island (Heizer, 1947). They are common
on the Northwest coast (southeast Alaska and British Columbia coast), where
they have been studied by Newcombe (1907), Emmons (1908), H. I. Smith
(1927), Keithahn (1940), and Gjessing (1952, 1958). Surveys of petroglyphs
and pictographs in the state of Washington have been carried out by M. W.
Smith (1946) and Cain (1950), in Idaho by Erwin (1930), in Oregon by
Cressman (1937), and in Texas by Jackson (1938). For a report on an initial
attempt to survey the data for California, Nevada, Utah, and Arizona, see
Steward (1929). Lower (Baja) California has been little studied, and useful
works are limited to those of Diguet (1894), Engerrand (1912), Dahlgren and
Romero (1951), and Aschmann (1959, pp. 43-44). Northern Mexico has been
discussed by Orellana (1953) and Pompa y Pompa (1956). In spite of the pro-
digious amount of archaeology carried out in the Southwest (Arizona and New
Mexico), there is to date no published general review of sites and petroglyph
designs from any part of the area, although nearly every archaeological report
dealing with the Southwest contains some information on petroglyphs. Partial
surveys for the South Dakota, Wyoming, Colorado, and New Mexico areas have
been published by Renaud (1933, 1936, 1938), Tanner and Connolly (1938),
and Gebhard (1951). Kirkland (1937a, 1938, 1939) has contributed an im-
portant corpus of data on Texas pictographs. The remarkable shield-carrying hu-
man figures in Colorado and Montana pictographs have been discussed by
Wormington (1955) and Secrist (1960). Dr. Donald Scott of the Peabody
Museum, Harvard University, has accumulated the largest single file of data for
North American petroglyphs, but this has not yet been published.

Caribbean petroglyphs are known to occur, but little systematic recording and
no general survey have been done (cf. Fewkes, 1903; Huckerby, 1914; Frasetto,
1960). Central and South American occurrences are listed by Mallery (1886)
from Venezuela, Nicaragua, British Guiana, Brazil, and Peru. Rouse (1949) pro-
vides a general South American survey, and other contributions are by Koch-
Grünberg (1907), Quirogà (1931), Cruxent (1946-1947), Hissink (1955),
Schuster (1955), and Tavera-Acosta (1956).

Outside the New World, the Australian continent is known to hold many
hundreds of localities where painted pictographs and pecked petroglyphs occur
(see, for example, Davidson, 1936; Elkin, 1949). Africa has abundant petro-
glyph sites north of the Sahara (Flamand, 1921; Frobenius and Obermaier, 1925;
Kühn, 1927; Obermaier, 1931; Reygasse, 1935; Frobenius, 1937; Chasseloup-
Laubat, 1938; Vaufrey, 1939; Wulsin, 1941; Graziozi, 1942; Bosch-Gimpera,
1950; Lhote, 1952, 1953a, 1953b, 1957; Rhotert, 1952). In the Kalahari region

of southwest Africa are the famous Bushmen-Hottentot rock paintings (Burkitt, 1928; Stow and Bleek, 1930; Wilman, 1933; Nelson, 1937; Van der Riet and Bleek, 1940; Craig, 1947; Battiss, 1948; Goodwin, 1953; Van Riet Lowe, 1956; J. D. Clark, 1959; Cooke, n.d.). Northern Europe is another center of petroglyph art; here the inscriptions often are representative and illustrate aspects of religion or economics which are useful to prehistorians in attempting to interpret the way of life in the Bronze and Iron Ages (Brøgger, 1931; G. Clark, 1937; Hallström 1938, 1960; Althin, 1945). Petroglyphs are widely distributed through the island world of the Pacific, but here again we lack any review of their occurrence and styles (cf. Linton, 1925, on the Marquesas; and Métraux, 1940, and Lavachery, 1939, on Easter Island). In Asia petroglyphs are not well known, but mention is made of their occurrence on the lower Amur River in Mongolia and Siberia (Laufer, 1899; Tallgren, 1933; Nelson, 1937; Maenchen-Helfen, 1951).

The most ancient evidence of painting or inscribing designs on rock surfaces dates from the Upper Paleolithic period in western Europe. The oldest of these (from the culture called Aurignacian) may be around 50,000 years old. The best known cave paintings date from the Magdalenian period with an antiquity of 15,000 to 20,000 years, and to this period belong most of the famous caves of the Dordogne and of Spain, such as Lascaux and Altamira (Breuil, Burkitt, and Pollock, 1929; Breuil and Obermaier, 1935; Windels, 1949; Breuil, 1952). Most students of Paleolithic cave art believe that its main purpose was magical compulsion directed to success in the chase and for the purpose of increasing game (cf. Bégouen, 1929; Almgren, 1934; Sauter, 1954; Maringer, 1960). General surveys of European Paleolithic cave art have been published by Osborn (1916, pp. 392-429), MacCurdy (1924), Bandi and Maringer (1952), Kühn (1952, 1955), and Zervos (1959). The outstanding northern Italy petroglyph locality at Camonica is discussed by Süss (1954) and Anati (1960a). A comparison of African and European rock paintings has been presented by Frobenius and Fox (1937).

From our overabbreviated survey of painted and pecked rock art we may conclude that this means of artistic expression, which served also as an aid to man's spiritual and food-getting activities, is an old practice.[1] Whether there is a historical unity or connection among all the manifestations of this world-wide practice cannot be categorically affirmed or denied. To conclude that there is a "genetic" connection between African-European-Asiatic and North and South American rock art would first require a critical intercontinental comparison of designs, design complexes, techniques of manufacture, age, and the like, and this has not yet been done. As with many anthropological problems, we are still in the initial stages, which involve the collection of data that may then serve for analysis. One worker who is actively working on the larger problem of the possible unity of pecked and painted rock designs is Dr. Gutorm Gjessing in Oslo, but his findings are still to appear in print. Brief comparisons between New World pictographs and petroglyphs and Paleolithic painted cave art have been made (Renaud, 1936, pp. 7-8, and figure following p. 8; Kirkland, 1937b).

The writers variously attributed similar designs to what Goldenweiser called the "principle of limited possibilities," to the same psychology (that is, "psychic unity"), or to relatively similar degrees of skill.

I

The Problem

Although North American petroglyphs[1] have been studied for more than a century, the study has remained on a curiously simple level. Beginning with Garrick Mallery's monumental North American survey, published by the Smithsonian Institution (Mallery, 1886, 1893), the study still remains in the initial (that is, descriptive and classificatory) stage of development, and interpretive or explanatory analysis has been tentative, speculative, or subsidiary. Steward (1929, p. 224) says, "The meaning and purpose of petroglyphs and pictographs can only be ascertained through careful study of art and symbolism of present Indian groups and a comparison of these with petrographic elements." This approach may not be fruitful, however, since it implies that there is a historical continuity as well as an artistic connection between prehistoric petroglyph-pictograph designs and such artistic pursuits as the geometric designs woven in basketry. Although this may be true, it would first have to be demonstrated. Some general similarities in form of design elements do exist between those pecked on rocks and those plaited in baskets in the Great Basin area, but a proven direct connection between the two would have to rest upon more than the demonstration that zigzags, triangles, rectangles, and the like are represented in both arts, since these are simple elements of much wider distribution.

Mallery was responsible for what is perhaps the most serious attempt at interpretation. He regarded petroglyphs as "picture-writing," precursors of later "sound-writing," and felt that in order to understand the evolutionary process involved in the development of writing researchers should direct their efforts toward understanding the "picture-writing" stage. To this end he gathered interpretations of petroglyphs from all possible sources and made a special effort to obtain translations of "rock-writing" found in the native territories of Indian informants. Mallery admitted that he was unable to develop a key or generalized clue to the interpretation of his great corpus of material. He found that in a few instances translations were available, but even then no sure ground was pro-

vided for interpretation. Thus, one informant gave a legendary explanation of turkey-foot marks found on a rock, the legend purporting to explain the marks as commemorating a historic incident. Mallery comments (1893, p. 769), "This tale may be true, but it surely does not account for the turkey-foot marks which are so common in the northeastern Algonquian region, extending from Dighton rock to Ohio, that they form a typical characteristic of its pictographs." His general conclusions are (*op. cit.*, p. 768) that "no attempt should be made at symbolic interpretation unless the symbolic nature of the particular characters under examination is known or can be logically inferred from independent facts."

Later workers in the field (for example, Steward, 1929; Erwin, 1930; Cressman, 1937; Cain, 1950; Gjessing, 1952) have been less ambitious and daring than Mallery, usually going no further than to make limited culture-historical inferences based on geographical distribution studies. The caution of these scholars is given typical expression by Cain (*op. cit.*, p. 54) when he says, "it is felt that additional detailed information should be collected from 'blank areas' before the complex problem of interpretation is attempted." One has the feeling that these later studies were undertaken not so much because of a burning interest on the part of the scholars but rather because the petroglyphs themselves, by sheer quantity, forced their way into the consciousness of archaeologists, whose duty it is to study prehistoric cultural remains.

From the beginning of the present project, we felt that the study of petroglyphs should be approached from two directions. The first approach would involve inspection, full recording, and collation of data from as many Nevada petroglyph sites as possible, with the aim of isolating significant stylistic distinctions. The various styles so defined would then be placed in a relative time sequence so far as possible. Next would come the distribution of elements and styles, from which historical inferences could be extracted. This historiographic phase of the program, then, would not differ materially from the several studies which have been done since Mallery's time.

The second phase of analysis, we felt, should be aimed at determining the purpose of the petroglyphs, that is, the meaning or significance they may have had to their makers. This in turn led us to the question of the meaning or significance associated with the symbols. One obvious possibility, already suggested by Mallery, was that they made up a kind of writing, a graphic representation of words or ideas made by one person and meant to be understood by another person. This possibility is one that has intrigued many people for many years and has often led to the wildest sort of speculation. A careful study of our material has led us to conclude that Nevada petroglyphs are not a form of writing and are not communicative in intent.[2] Our reasoning on this point is as follows: Any system of communication, be it written or oral or other, must be composed of a limited series of precise elements with specific meanings. In order to be understood, each repetition of an element must have some formal characteristic which remains invariant, or sufficiently invariant, so that it will not be confused with elements of similar form but distinct meaning. In our present

treatment of Nevada petroglyphs we have, in fact, assigned each recorded speci-
men to one or another of the classificatory groups which we term "elements."
In a few instances, for example that of "mountain sheep," we find that all, or
nearly all, known renderings are specifically similar and conform so well to a
pattern that they could indeed fit our specifications as a communicative element.
In most elements, however, we find that similarity among examples is usually
only of the most general kind, with no specific characteristic being consistently
repetitive. It is not possible, of course, to assert categorically that specific repeti-
tive characteristics are not present in the corpus of our material. Such charac-
teristics may be there and may have been largely undiscovered by us in the course
of our analysis. But we feel that most of the named elements do not represent
standardized elements of communication; one need only observe the amorphous
character of many of the designs (the variable curvilinear meander, for example)
to conclude that there was no attempt at communication by means of symbols
with exact meanings. One of the essential features of communication, after all,
is its built-in regulatory mechanism, which maintains a specific conformity to con-
vention; in the absence of this conformity the auditor or viewer (the person
communicated with) fails to apprehend the intended meaning, and hence the
message fails to communicate. Although it is merely a matter of judgment, it
seems quite clear to us that the necessary conformity was lacking in the Nevada
petroglyphs.

As the problem stood, then, the question was reduced to the following form:
If the Nevada petroglyphs were not to be regarded as writing, then what other
possible areas of meaning could be investigated? We felt that the essential clue
to interpretation must probably come from some connection with the subsistence
habits of the prehistoric inhabitants of the area. Our reasoning here is derived
from Steward's classic work, *Basin-Plateau Aboriginal Sociopolitical Groups*
(1938). Steward has shown conclusively, it seems to us, that the harshness of
the Great Basin environment imposed restrictions so severe that, to live there at
all (with a hunting-gathering economy), the Indians were forced into a rather
narrowly prescribed set of subsistence and social customs. Aggregation of popu-
lation, form of social unit, annual migration patterns, and many other features
of life were not merely delimited by the environment but often actually specified.
The food quest, for example, provided that for a great part of the year social
groups remained at no more than nuclear (that is, biological) family size, since
the seed plots which were exploited usually could not maintain a larger group.
Again, the reliance on piñon nuts as a staple winter food — a virtual necessity
throughout much of the Great Basin — prevented development of stable social
groups larger than the nuclear family; the uncertainty of the pine nut crop in
a given area often prevented families from regularly occupying the same winter
village. Hence, the constitution of the village populations was shifting and un-
stable, and corporate social groups were unable to attain permanent status.

Considering these facts in the light of the number and size of petroglyph sites
to be found in Nevada, we come to an obvious conclusion. We know of more

than one hundred petroglyph sites in Nevada, and there must be at least twice that many sites as yet unrecorded, since our actual field work has covered only parts of the northern half of the state and present knowledge indicates that petroglyph sites are even more numerous in the southern part. But if the number of sites is considered large, then the size and extent of some sites is immense. For example, at the moderately large Lagomarsino site (St-1)[3] we recorded a total of 439 separate elements pecked on the rocks, and even this coverage was not complete. This means that there must be a grand aggregate of many thousands of elements within the state. Since even the simplest element required a certain amount of time to execute, and some of the more complex ones may have taken as much as several days, there is evidently represented here an enormous total amount of time devoted to the making of petroglyphs. While it might be argued that the total time spent could have been distributed over many centuries or even millenia, it is also true that each petroglyph element of any size and complexity must have required many hours or even days of a man's time. Since free time is at a premium in an environment like the Great Basin, and since nearly unremitting attention to securing food is required for mere survival, we reason that petroglyphs must be connected directly in some fashion with the securing of food.

Two qualifications of this thesis are worth bringing up here. One of them concerns the question of the antiquity of present environmental conditions. Even if our contentions regarding the association of petroglyphs with subsistence activities are correct for the historic period, what assurance have we that past environmental conditions were sufficiently similar to bring about the same effect? Briefly, we hold with the view that climatic conditions in the Great Basin have been very similar over the past 7,000 years (cf. Antevs, 1948) and, therefore, that ecological conditions would not have been appreciably more favorable during that length of earlier time than they were at the opening of the historic period. Indeed, the Desert Culture as defined by Jennings and Norbeck (1955) and by Jennings (1957), although exhibiting minor stylistic variations, is conceived as an essentially unchanging culture-environment adaptation and is thought to have begun at least 8,000 years ago. If the Nevada petroglyphs were made within that period, and we believe that most of them were, then essentially the same conditions would have prevailed and the same postulates would hold.

The second qualification refers to the possibility that a different technology might have become available to the inhabitants at some time during the prehistoric period and thus altered the conditions of existence in such a way as to change the assumptions presented above. We know, of course, that just such a change did occur in southeastern Nevada during the Christian era when Puebloan agriculture was introduced from the east and caused a radical alteration of the subsistence patterns (cf. M. R. Harrington, 1928). We shall see that there is a Puebloan rock art in southeastern Nevada, here pictographic, which is quite distinct from anything else in Nevada and is to be related to similar manifestations found in the Southwest. We shall not presume to interpret these Puebloan

pictographs in the same terms as the bulk of the Nevada petroglyphs. We feel, however, that Nevada archaeology is sufficiently well known so that we can say that this Puebloan intrusion was a unique occurrence and that, with this exception, the technology was sufficiently uniform to uphold our postulates.

We had reached approximately this state of reasoning when we went into the field in the summer of 1959. A variety of alternative subsistence activities with which petroglyphs might have been associated had by then occurred to us. It had been suggested, for example, that they might have been associated with increase rites for certain seed products (cf. Baumhoff, Heizer, and Elsasser, 1958, p. 5). Again there was the possibility that some might have been associated with fishing as, for example, at pictograph site Mi-3 on Walker Lake, where there is a possible representation of a fish swimming upstream. Finally, the petroglyphs might have been associated with game taking, for we know that the mountain sheep is a favorite motif in the petroglyphs of southern Nevada and neighboring California. Our field work was directed to a search for some definite evidence that would show which forms of subsistence might be associated with petroglyphs. Up to this point our argument had been purely, albeit loosely, deductive and was therefore subject to the usual frailties of that form of reasoning, that is, untrue assumptions and faulty logic. In short, we had now to test the hypotheses. To this end we spent six weeks in the summer of 1958 driving and walking throughout northern Nevada, spending a large part of our time either looking for petroglyph sites or reinvestigating those already known to us. During this survey we inspected, either at close range or from a short distance away by means of binoculars, literally hundreds of potential petroglyph sites. Whenever possible we inspected any cliff or boulder outcrop which seemed at all suitable as a petroglyph location, regardless of the possible subsistence potential of the particular locality. At all petroglyph sites we studied the local landscape for possible clues to what economic exploitation might have been practiced there.

In the course of our field work we soon came to see that if we were to discover a pattern in the location of the petroglyph sites (fig. 1), it would not be in relation either to seed-gathering or to fishing localities. We felt that the only seed crop which had sufficient quantity and regularity to merit consideration by the prehistoric inhabitants, and which was, at the same time, sufficiently localized to be associated with the petroglyphs, would be the pine nut. Upon inspection of the sites we found that, although a very few were located in or near piñon groves, most were not; hence, even if petroglyphs were made in connection with the pine nut crop, the locations were such that the association could not be proved. The same reasoning eliminated fishing from consideration. Although two examples of probable fish figures are known from Nevada petroglyphs and some large sites are found on fishing streams, by far the greatest number of sites are in dry and barren washes and on mountain passes where no fish could be caught.

When, however, we turned to the possibility that the petroglyph sites might be associated with hunting, we found a quite different situation. We observed

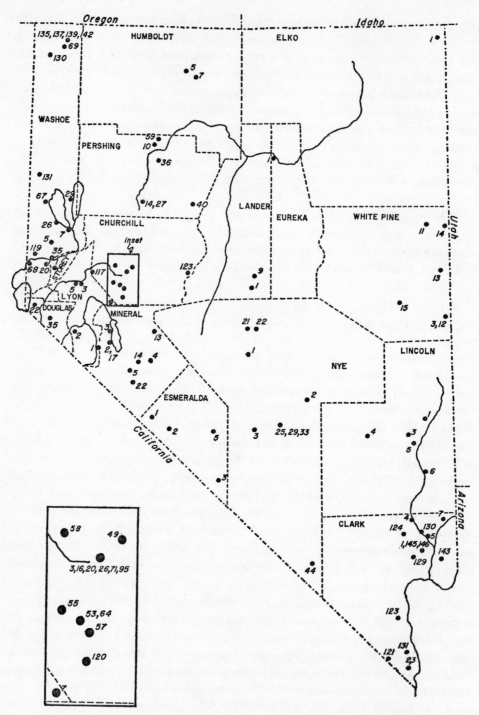

FIG. 1. Key map showing location of Nevada petroglyph sites.

that most petroglyph sites could quite reasonably have been associated with good hunting spots or game ambush sites. For some sites we had direct evidence,

from hunters or wildlife service field officers, of present-day game migration routes, and we found that frequently the migration route did indeed pass directly by or through one or more of the known petroglyph sites. At other sites our theory was supported by the presence of structural remains, indicating that formerly there had been drift fences directing the movement of the animals, and by stone circles, which can be interpreted as the remains of hunting blinds from which concealed archers could shoot arrows at passing game. Our findings are summarized in an earlier preliminary report (Heizer and Baumhoff, 1959):

At certain points, especially at the mouths or along the courses of washes or canyons through which the deer travel, are locations which are ideal for hunting from ambush. Thus, where a wash has cut through a rock reef and the canyon narrows to form a chute or gate, or where a canyon is narrow with a boulder-strewn bench perched above the defile, or in a saddle or pass [for example, pl. 7b], the moving animals (particularly if driven from the rear) could be forced to run past concealed archers. Preferred hunters' positions appear to have been at those spots where the animals could be shot from above at very close range. It is at such locations that one finds petroglyphs in western and central Nevada and a long migration trail which crosses a series of valley floors and low mountain ranges has such hunting sites (and petroglyphs) scattered along it at appropriate points.

Thus we feel that many or most petroglyph sites in Nevada can be shown to have been associated with hunting,[4] although much work still remains to be done in tracing out known or probable game trails and determining their association or nonassociation with petroglyph sites.

Our conclusion here refers to petroglyphs and not to pictographs, many of which will require explanation in terms other than those proposed here. Also, one of the less prevalent petroglyph styles defined herein (the Pit-and-Groove style) does not fit the pattern as defined in the quotation given above. These problems will be considered in detail in later sections of the present work.

The burden of our argument is that most Nevada petroglyphs have "meaning" in terms of one of the hunting patterns of the prehistoric inhabitants of the state. What more specific meaning may be attributed to them is less certain and less subject to proof. The most reasonable assumption, we feel, is that the glyphs themselves, or the act of making them, were of magico-religious significance, most probably a ritual device to insure the success of the hunt. The recent Great Basin tribes did not use petroglyphs as hunting magic and, in fact, deny having made them for any reason. At the same time, shamanistic rituals connected with the hunting of deer, antelope, or mountain sheep are widely practiced throughout the Great Basin. Since the petroglyphs are evidently connected with hunting, and since they had no real influence on the game (although they may have had psychological influence on the hunters), it is most likely that they were of ritualistic importance. Presumably, then, the making of petroglyphs once formed an aspect of the hunting ritual of the Great Basin peoples, and our evidence is that this practice disappeared in the not too distant past; the fresh appearance of some of the glyphs indicates comparatively recent execution.

Whatever the magico-religious significance of petroglyphs, it seems clear, in some instances at least, that this rock art was religious in the Durkheimian sense, in that it evidently signified or somehow expressed the solidarity of a social group. That this is so is made quite clear by the evidence of organized hunts preserved at several of the sites. Consider, for example, the Whisky Flat site (Mi-5) south of Walker Lake. Here we find that a fence about a half-mile long, consisting of a low rock wall with juniper posts set upright at fairly close intervals (and possibly other, unpreserved elements) was built to divert and direct the game animals to convenient kill locations. In addition there are a dozen or more circular rock blinds in which archers were probably concealed. The building of these structures must have required the concerted efforts of a considerable group, and for the hunt itself the blinds would have had to be manned by a dozen or more archers and perhaps as many beaters would have been needed behind the herd. These organized activities involved the coöperative activities of a social group. If the petroglyphs in association with these structures were made in connection with these activities, as they presumably were, then they are an expression of the goals of the social group, and hence an expression of its solidarity. Although the Whisky Flat site is perhaps the most notable example we can point to in this connection, it is by no means an isolated example. The Grimes site (Ch-3), the East Walker River site (Ly-1), and the Allen Springs site (Ch-57) each surely required concerted group action in both construction and operation. Other sites were probably used in similar fashion, but physical evidence, aside from the petroglyphs themselves, has not been preserved. In any case, group activity is attested to at some sites, and we may presume that such occurrences are not merely the result of isolated examples of group action but are more likely to have been associated with a characteristic widespread Basin socio-economic organization, especially since none of our evidence controverts such a presumption.

If the petroglyph sites, or at least some of them, represent social action, then what sort of social group may we suppose was involved? On this question we are quite unable to produce any physical evidence, but, if we return to our original premise regarding the relationship between the Great Basin environment and the social organizations of its inhabitants, we may suppose that the social groups in question were similar in organization and composition to the temporary specialized groups of the Western Shoshone. Steward's statement (1938, p. 247) of such groups follows:

Organization superseding the village was only temporary among Western Shoshoni. It involved specific communal endeavors of limited duration and specialized leadership which pertained only to such endeavors. Several of these activities were economic. Rabbit drives brought the members of several adjoining villages to a certain place where they drove under the direction of a skilled rabbit hunter. Antelope drives similarly entailed joint effort, but the leader acquired authority by the accident of having received a vision for the power of antelope shamanism. Festivals, held either at places of abundant foods or at prominent villages, usually required the leadership of a dance specialist. During such communal affairs the headmen of the villages participating

usually lent their influence to that of the special director by "talking" from time to time. These talks were harangues, exhorting the people to behave, have a good time, prepare food for feasts, etc. In some instances a village headman was also antelope shaman, dance director, or rabbit-drive leader. But his special authority was restricted to the communal activity and ceased at its conclusion.

If similar circumstances can be assumed to have prevailed in earlier times, then the larger petroglyph sites represent places where a relatively large group (perhaps fifty people or more) gathered under the direction of a hunt shaman who made petroglyphs and performed other necessary rituals. The ritual may have been adapted to specifically local conditions and thus would have depended on the knowledge of one, or at most a few, shamans. The petroglyphs themselves, however, suggest that the ritual knowledge was not confined to single individuals; otherwise, more local peculiarities and fewer widespread stylistic similarities would be present. The composition of the local group would vary from year to year in response to variable seed crops or other local conditions of food supply, and hence the social group formed around the hunting ritual would not become fixed and stable, as, for example, along kinship lines; thus its functions would remain restricted to hunting, and it would not form the core of a more complex social group. Presumably the hunting group camped somewhere in the vicinity of the petroglyph site during the hunt, but the evidence is clear that they did not live precisely at the site since there are only two or three exceptions to the rule that habitation refuse occurs separately from petroglyph sites. We have not investigated petroglyph sites specifically for over-all settlement patterns, although careful investigation along this line might reveal the relationship of petroglyph sites and habitation sites. The difficulty of such an inquiry derives from the scarcity of habitation sites in Nevada and the sparse cultural leavings at such sites.

Many petroglyph sites show long-continued use, as though a few designs were added from time to time. Whether these increments were annual, we have no way of knowing, but if one man or a few men from one group used the spot each year for hunting, we might expect that one or more designs would have been inscribed during each season of use. The use of hunt shamans, for example in securing antelope (Steward, 1938; Park, 1938), may provide some lead toward suggesting who made the petroglyphs. If hunt shamans functioned at the ambush sites, the shamans may have been the individuals who actually pecked the designs on the rocks. Since hunt shamans in the ethnographic period were much in demand, they might be hired by a neighboring group some distance away to supervise their hunt. If such events occurred in prehistoric times among petroglyph-making shamans, we would then have a partial explanation for the diffusion of design elements. Hunters themselves in the recent Northern Paiute and Western Shoshone bands did not always remain permanently attached to a territory, but might affiliate (with their families, of course) with different bands at different times. Such shifts of habitat might also partly explain the diffusion of design elements over space, provided only that we assume that the hunters themselves made petroglyphs. While we cannot prove any of these possibilities,

it should be emphasized that the general nature of Shoshonean culture in the petroglyph area treated in this work allows such speculation a certain measure of credibility.

We noted above that recent Indians of the Great Basin deny knowledge of the meaning or authorship of petroglyphs,[5] and concluded from this that the prehistoric inhabitants made petroglyphs up to fairly recent times and then, for some reason, discontinued the practice. We suggest now that the explanation of this cultural loss may be found in the recent culture history of the Great Basin. Analysis of Shoshonean dialects of the Great Basin indicates that the ancestral home of the Numic speakers of Nevada (Northern Paiute, Southern Paiute, Western Shoshone) is in southeastern California, possibly in the vicinity of Death Valley (Lamb, 1958; Kroeber, 1959).[6] The linguistic evidence further suggests that the Numic peoples migrated from that point northward along the eastern flank of the Sierra Nevada and eastward until they occupied the Great Basin and Colorado Plateau. Throughout the Great Basin, the Numic speakers are presumed to have replaced an indigenous population of unknown linguistic affiliation. The linguistic evidence for such a reconstruction is at least partially borne out by the archaeology of Nevada. Specifically we refer to the materials recovered from Humboldt Cave near Lovelock, Nevada (Heizer and Krieger, 1956). At that site a sequence of cultures was discovered which reveals, in its earlier phases, manifestations which can only be considered as belonging to the Lovelock Culture, a culture known to have existed from about 2000 B.C. to sometime later than A.D. 1000. In the later phase the Humboldt Cave artifacts are nearly indistinguishable from the material culture of the historic Northern Paiute. The differences between the later Lovelock Culture and the culture of the ethnographic Northern Paiute are not substantial nor generic, but rather are specific typological differences (Grosscup, 1960). Most noticeable is the disappearance in late prehistoric times of the distinctive Lovelock wicker basketry, a basketry type common in Lovelock Culture sites but lacking among the recent Northern Paiute and in the uppermost levels of Humboldt Cave. While such differences do not indicate a change of basic economic or social organization, they do lend some support to the idea of a population change. Thus the archaeological data seem to agree generally, if not conclusively, with the linguistic hypothesis.

Let us then accept as a probable fact a Numic migration from southeastern California throughout the Great Basin and the replacement of an earlier population by Numic speakers. The dating of this migration is not finally settled, but it may at least be placed within probable limits. Lamb (1958, p. 99) believes that "dialect differences are so slight that one can only with the greatest difficulty imagine that they [the present tribes] could have occupied the vast areas in which we find them for more than a very few centuries." Although this opinion is not, and was not meant to be, conclusive or precise as to date, it finds further substantial support in the archaeological evidence recovered from Humboldt Cave. The date of the possible population replacement at that site is not certain,

but in terms of the probable duration of Lovelock Culture a date of A.D. 1400 would not seem to be out of line (cf. Baumhoff and Heizer, 1958, p. 53). Available evidence suggests, then, that the Numic migration took place sometime between A.D. 1200 and A.D. 1800; by the latter date the Numic speakers are known to have been in full possession of their present territories. Whatever the specific date of these events, it is quite clear that the migrations occurred in the very recent past and that linguists and archaeologists are in agreement on this point. The migration, having been so recent, must also have been rapid; if such tremendous areas were filled in a few centuries the migratory movement must have been swift and continuous.

The point of this argument in the present connection is that a migrating population is constantly moving into new and unfamiliar country where it will not immediately know the game migration trails and hence will be unable to locate readily the best hunting spots. Let us suppose that the Numic speakers did use petroglyphs as an element of hunting ritual in their ancestral home. As they expanded into new country, driving out and replacing their predecessors, they might continue to apply this hunt magic but now they would have less knowledge of game movements, and hence their ritual would lose its effectiveness. A shaman might make a few petroglyphs in what seemed to him a likely spot, but if no animals actually came by that spot then faith would be lost in the efficacy of petroglyph magic and its use would be discontinued. Although magic need not, in general, be abandoned simply because it has no apparent effectiveness, it seems likely that Great Basin peoples, in particular, would not spend a great deal of time on any hunting ritual which was demonstrably unsuccessful; if they had wasted too much of their efforts in such a manner they would very likely have starved to death. Once the Numic speakers had lived for a time in their new territories and had familiarized themselves with game movements there, they could have resumed the ritual use of petroglyphs. By this time, however, they might have lost faith in or even knowledge of this magical device.

An alternative possibility is that the original Numic speakers did not make petroglyphs in their ancestral territory at the time their eastward and northward spread began. In either case, though, the fact that petroglyphs in the Great Basin did not continue to be made up to the historic period could be explained by the recent Numic migrations.

II
Nevada
Petroglyph
Sites

A total of 99 Nevada petroglyph sites is recorded in the present work. All but one of the sixteen counties have at least one site, although sites are more common in the western and southern counties than in the northeast. The possible significance of this concentration will be considered in the discussion of styles and their distribution.

Table 1 is a list of sites, by county, as they are designated in the files of the University of California Archaeological Survey. In addition we indicate other names for the sites, where these are known, and the numbers assigned by Steward (1929) to some of the sites. The location of the sites is indicated in figure 1. After table 1 we give individual descriptions of the sites.

TABLE 1
NEVADA PETROGLYPH SITES

Site	Site name	Steward (1929) number
Churchill County		
Ch-3	Grimes Petroglyph Area	207
Ch-16	Hidden Cave	—
Ch-20	Fish Cave	—
Ch-26	Burnt Cave	—
Ch-49	Dynamite Cave	—
Ch-53	Flat Top Cave	—
Ch-55	Salt Cave	—
Ch-57	Allen Springs	—
Ch-58	Lone Butte, Rattlesnake Hill	210
Ch-64	Flat Top No. 2	—
Ch-71	—	—
Ch-95	—	—
Ch-117	Lahontan Reservoir	—
Ch-120	Rawhide Flats	—
Ch-123	Drumm Ranch	—

Site	Site name	Steward (1929) number
Clark County		
Cl-1	Valley of Fire, Atlatl Rock	—
Cl-2	Grapevine Canyon	227
Cl-3	Hiko Springs	228
Cl-4	Cane Springs	225
Cl-5	Lost City, Pueblo Grande de Nevada	218, 226
Cl-7	—	291
Cl-9	—	229
Cl-121	Lewis Holes	—
Cl-123	Keyhole Canyon	—
Cl-124	Arrowhead Canyon	—
Cl-129	Crystal Springs	—
Cl-130	—	—
Cl-131	Christmas Tree Pass	—
Cl-143	—	—
Cl-145	Mouse's Tank	—
Cl-146	—	—
Douglas County		
Do-22	Genoa	—
Do-35	—	—
Elko County*		
El-1	—	—
Esmeralda County		
Es-1	—	222
Es-2	—	223
Es-3	—	224
Es-5	—	221
Eureka County		
Eu-1	Dunphy	—
Humboldt County		
Hu-5	—	—
Hu-7	—	—
Lander County		
La-1	Potts Cave	—
La-9	Hickison Summit	—
Lincoln County		
Li-1	—	217
Li-3	—	—
Li-4	Hiko Springs	—
Li-5	—	—
Li-6	—	—
Lyon County		
Ly-1	East Walker River	202, 212
Ly-2	Smith Valley	211
Ly-3	Prayer Cave	—
Ly-5	—	209
Ly-7	Simpson Pass	—
Mineral County		
Mi-2	Cottonwood Canyon	—
Mi-3	—	—
Mi-4	Garfield Flat	—
Mi-5	Whisky Flat	—
Mi-13	Redrock Canyon	—
Mi-14	Rattlesnake Well	—
Mi-17	Dutch Creek	—
Mi-22	Huntoon Valley	—
Nye County		
Ny-1	—	215
Ny-2	—	219
Ny-3	—	220
Ny-21	—	213
Ny-22	—	214
Ny-25	Big George Cave	—
Ny-29	Ammonia Tanks	—
Ny-33	—	—
Ny-44	—	—

*For an additional Elko County site, see Appendix E.

Site	Site name	Steward (1929) number
Pershing County		
Pe-10	Pole Canyon	—
Pe-14	Leonard Rock Shelter	—
Pe-27	Medicine Rock	—
Pe-36	Star Canyon	200
Pe-40	Painted Cave	—
Pe-59	—	—
Storey County		
St-1	Lagomarsino	208
Washoe County		
Wa-5	Spanish Springs Valley	205, 208
Wa-7	—	203
Wa-20	Smokey Flat	—
Wa-26	Paul Bunyan's Corral	—
Wa-29	—	—
Wa-35	Court of Antiquity	204
Wa-67	—	—
Wa-68	Verdi	—
Wa-69	Massacre Lake	—
Wa-119	—	—
Wa-130	—	—
Wa-131	Pipe Spring	—
Wa-135	—	—
Wa-137	—	—
Wa-139	—	—
Wa-142	—	
White Pine County		
Wh-3	—	216
Wh-11	Tunnel Canyon	—
Wh-12	—	—
Wh-13	Katchina Rock Shelter	—
Wh-14	Chokecherry Creek	—
Wh-15	Mosier Canyon	—

CHURCHILL COUNTY

Ch-3 — Grimes Petroglyph Area, Steward 207
(figs. 33-40; pls. 1, 2, and 3c)[1]

The Carson River rises in the Sierra Nevada south of Lake Tahoe, and from there flows northeasterly about 80 miles to its sink in the Carson Desert, where it forms the marsh and playa lake area known as Carson Sink. Carson Sink is bounded on the east by the Stillwater Range, a substantial mountain chain rising 3,000 to 4,000 feet above the Sink level, with piñon-juniper vegetation at the higher elevations. At the southern end of the Stillwater Range a rocky peninsula (Grimes Point) strikes westward into Carson Sink, sloping off rather suddenly a mile or less from the old marsh (fig. 2). On the end of this rocky spur is found a profusion of large black basalt boulders covered with petroglyphs. Most of the petroglyphs are found on the extreme western point of the spur, but they also occur on the boulders of its southern margin for about a quarter of a mile as it swings back to the east. Altogether there are 150 or more boulders with petroglyphs in this locality. The upper margin of the petroglyph area has been disturbed by bulldozing for terrace gravels, and for about ten years the area has been used as a trash dump for the town of Fallon, which lies about a dozen miles to the northwest.

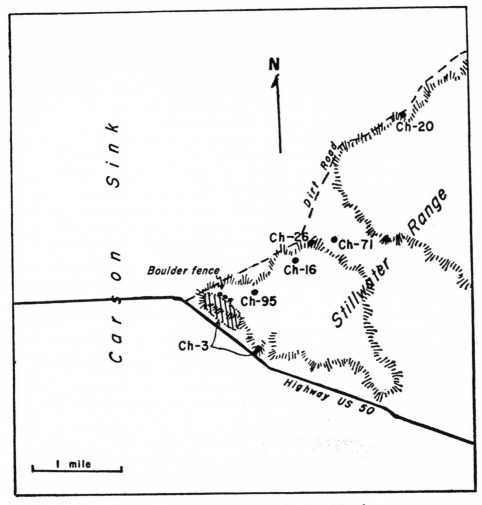

FIG. 2. Petroglyph sites east of Fallon, Nevada.

The petroglyphs from the Grimes site are shown in figures 33-40 and plates 1, 2, and 3c. We believe that most of the glyphs from the site are recorded here, but there are also some without record. A number of designs are too dim to record, and there are probably others on boulders which have been overturned by gravel-quarrying operations.

The glyphs here are made in two very different styles: (1) the usual style found in this part of the Great Basin, consisting of pecked figures in the form of circles, snakes, wavy lines, and so on, and (2) an entirely different style consisting of conical pits pecked into the surfaces of boulders with an occasional groove connecting several pits. Observation of these glyphs leaves no doubt that the second, or Pit-and-Groove, style is very much the older. Since the pits and grooves were originally pecked into the boulders, chemical alteration has taken place on the surface of the elements until now they show a smooth, glassy patina exactly like the original surface of the boulders. Petroglyphs in the ordinary

Great Basin style here do not show this heavy patination — they contrast definitely, though not markedly, with the boulder surfaces. It might be conjectured that the pits trap water or in some other way have the effect of hastening patination, but there are reasons for believing that this is not so. For example, both styles are sometimes found on the same rock surface, to the same depth and evidently with equal chance of weathering, yet in every one of these instances the Pit-and-Groove style shows the greater patination. Vertical surfaces which bear pits and grooves are as heavily patinated as are horizontally lying surfaces exposed to the sun and rain.

We can only conclude, then, that the Pit-and-Groove style is much the older of the two styles found at the Grimes site. The same Pit-and-Groove style has been observed at other sites in Nevada as well as at a number of California localities. We believe that this petroglyph style is the oldest in the Great Basin, and a large part of the evidence which we adduce in support of this idea is the relatively heavy patination found on such petroglyphs at the Grimes site.

About a mile southeast of the main portion of the Grimes site is another point jutting out to the southwest. The smaller point is covered with boulders identical to those on the main point, but careful search revealed only two of them with pecked petroglyphs. About a half-dozen boulders on the smaller point have rubbed surfaces which seem definitely to have been man-made. The surfaces are small, 6 to 8 inches square, but the rubbing has been intensive enough to cause definite indentation (pl. 3c). The rubbed surfaces would look as though they had been used as metates were not some of them on vertical surfaces; they may somehow be related to the petroglyphs here, but we cannot determine this with certainty, for they occur only rarely at Nevada petroglyph sites.

One other point is worth mentioning here. On the hill of Grimes Point, above the petroglyphs, there is evidence of an aboriginal fence running east and west along the ridge. There are piles of stones 25 feet apart which seem to have been used to hold up posts — they are circular piles with hollow centers like those at Whisky Flat (site Mi-5), which held up juniper posts. The existence of such a fence is important to the proposal we advance in the discussion of sites Ch-57 and Ch-71 below. Briefly, the hypothesis is that the natural game trail up the east side of Carson Lake would lead either alongside Grimes Point or to the east up the draw past site Ch-71, and that one or both of these spots would be natural locations for the ambush of moving herds. If a game trap were placed at Grimes Point, then a fence on the ridge would have been necessary to keep the animals from escaping over the ridge and to force them around the edge of the point where the hunters would have had their best opportunity to shoot the animals.

Ch-16 — Hidden Cave (fig. 42a-f)

Hidden Cave is one of the large cache and habitation caves found commonly in western Nevada. This cave was partly excavated by Wheeler and Wheeler

(1944) in 1940 and more fully by Grosscup and Roust in 1951 (Grosscup, 1956). The excavations revealed a long cultural sequence beginning perhaps as early as Anathermal times and culminating in the Medithermal, with cultural materials exhibiting great similarity to those of the Lovelock Culture.

Hidden Cave is in the same spur of the Stillwater Range that contains the Grimes petroglyph site (Ch-3) and, in fact, lies only a little more than a mile northeast of that locality (fig. 2). The cave is in a shallow draw which is littered with a profusion of black basalt boulders. Six of the boulders near the mouth of the cave have been decorated with pecked petroglyphs in a style very much like the later of the two petroglyph styles at the Grimes site (see above under Ch-3).

Ch-20 — Fish Cave (fig. 42g-i)

Fish Cave is in the same range of hills as the Grimes site (Ch-3) and Hidden Cave (Ch-16), about 2 miles northeast of the latter (fig. 2). The cave formerly had some culture-bearing deposits which were excavated by Wheeler and Wheeler (1944) in 1940, and which evidently were very similar to the upper levels of Hidden Cave. This cave, too, has many boulders scattered around its entrance, and six of them display pecked petroglyphs. Like the glyphs at Hidden Cave, those at Fish Cave resemble the later of the two Grimes petroglyph styles.

Ch-26 — Burnt Cave (fig. 42j)

Burnt Cave (fig. 2) is a small shelter only a quarter of a mile or so north of Hidden Cave (Ch-16). Whatever cultural deposit it may have is covered with rockfall. One of the walls of the shelter is decorated with red painted designs.

Ch-49 — Dynamite Cave (figs. 41a, 42k-o)

Dynamite Cave is in the Stillwater Range on the edge of Carson Sink, about 14 miles northeast of the Grimes locality (Ch-3) and 4 miles east of the town of Stillwater. In the tufa-covered cliffs here there are two crevices: a higher one, from 20 to 30 feet into the cliff, and a lower one, about 10 feet into the cliff. A child's skeleton is said to have been found in the higher, deeper crevice, and here also was found some matting as well as a mano covered with red paint. The smaller crevice below is painted with pictographs in red paint, presumably the same pigment found on the mano.

Ch-53 — Flat Top Cave

The old road and natural trail from Walker Lake to Carson Sink leaves the valley of the Walker River at Schurz and continues northeast through a low pass in the Desert Mountains to Allen Springs, about 5 miles south of Carson Lake

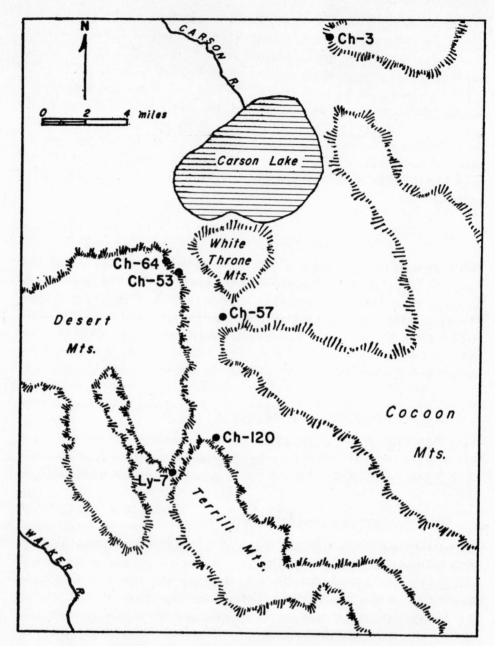

FIG. 3. Petroglyph sites in the Walker River-Carson Sink area, Nevada.

(fig. 3). Here the road forks, one branch going around the east side of the sink toward the Grimes petroglyph area (Ch-3) and the other going through Russell Pass to the west side of the Sink. About 150 feet above the floor of the pass is the small cave with a rectangular mouth, called Flat Top Cave. There are red pictographs painted on the walls, but no photographs or drawings of them are available. We did not visit the site in the summer of 1958.

Ch-55 — Salt Cave (fig. 41b-r)

Salt Cave is in the mountains bordering Carson Sink on the west, about 10 miles west of Carson Lake. The walls of this small cave are covered with Lahontan tufa, and red pictographs have been painted on the tufa. There is evidently a midden deposit here, but nothing is known of the cultural materials which may have been recovered in the cave. The culture-bearing deposit has been disturbed, presumably by relic hunters.

Ch-57 — Allen Springs (fig. 41s-x)

The natural passage from Walker River into Carson Sink follows through the mountain gaps shown in figure 3. The trail goes through the gap between the Desert Mountains and Terrill Mountains called Simpson Pass, where there is a rather large petroglyph site (Ly-7), and thence north to Allen Springs at the base of a large butte called White Throne Mountains. From Allen Springs there are two natural passages into the Sink: one, to the left of the White Throne Mountains, leads to the west side of the Sink; the other, around the right side of the White Throne Mountains, leads to the east side of the Sink and past the Grimes petroglyph site (Ch-3) on the point of a spur of the Stillwater Range. It is the eastern fork of this trail that would have been taken by migratory animals going north out of the Walker River Valley into summer range, since the east fork leads ultimately to the high elevation of the Stillwater Range whereas the west fork leads to the low, arid, desert mountains.

The petroglyphs at Allen Springs are situated as shown in figure 4. They are in an east-west saddle, which is relatively flat for 200 to 300 yards of its width before the mountains rise to the north and south of it. The northern flank of the saddle has a cold spring (Allen Springs), and the center of the saddle has a hot spring. Just east of the hot spring is a small butte from 20 to 30 feet high, and north of the butte are scattered tufa-covered boulders or stacks, six of which have petroglyphs pecked into them. One of the boulders also has traces of red paint over its petroglyphs.

One of the tufa-covered boulders is of especial interest because it seems to be the remains of a structure, either a temporary dwelling or a hunting blind. The main boulder here has cracked so that it is in one large piece together with smaller pieces, grouped so that they form an almost complete enclosure about 10 feet in diameter. Large gaps remain between the boulder fragments, but these have been filled by piles of smaller rocks. That the enclosed area has been subject to human occupation is apparent from a heavy concentration of charcoal to a depth of a foot or more.

There is also evidence of human occupancy elsewhere in the saddle. Around Allen Springs proper, on the northern edge of the saddle, is a scattering of chipping debris and artifacts characteristic of the open camp sites in this part of Nevada. Artifacts collected here by others include a perforated sandstone disc

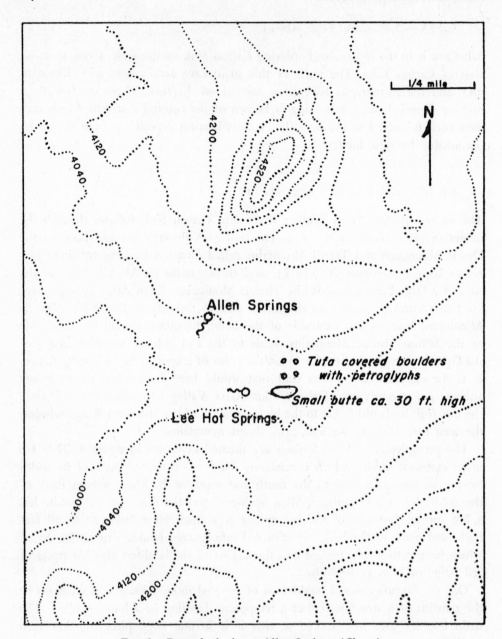

FIG. 4. Petroglyph site at Allen Springs (Ch-57).

(possible drill weight), shell beads (of unknown type), and a small, stemmed obsidian arrow point of a type probably in use within the last millenium. Although the arrow point indicates fairly recent occupation, it is believed that the area around the spring was probably used as a temporary camp as long as man has lived in this region.

Ch-58 — Lone Butte, Rattlesnake Hill, Steward 210

Mallery (1893, p. 92) says of this site, "Petroglyphs also occur in considerable numbers on the western slope of Lone Butte, in the Carson desert. All of these appear to have been produced on the faces of boulders and rocks by pecking and scratching with some hard mineral material like quartz." The Lone Butte mentioned here is evidently that shown by Russell (1885, pl. VII) and now known as Rattlesnake Hill, situated a mile northeast of the city of Fallon. Petroglyphs are known to have existed on Rattlesnake Hill, but they are reported to have been destroyed by blasting.

Ch-64 — Flat Top No. 2

This is a small cave northwest of Flat Top Cave (Ch-53; fig. 3). Petroglyphs (or pictographs) are said to be on the walls of the cave, but no details concerning them are available. It is not known whether there are cultural deposits in the cave.

Ch-71 (figs. 43, 44, 60a-d; pls. 23, 24)

As noted above in the discussion of the Allen Springs site (Ch-57), the natural trail from Walker River to the Stillwater Range turns east at Allen Springs and from there passes around the east side of Carson Sink (fig. 3). Northeast of Carson Lake the trail forks again, the west fork going north around the point of the land where the Grimes site (Ch-3) is found, the other fork turning eastward. The east fork of the trail leads out into a desolate sand flat along present-day U. S. Highway 50, an area holding no attractions for migratory animals, but if one travels along this route about 2 miles it is possible to turn north again to pass through a low saddle and again get on the western slope of the Stillwater Range. Thus there are two natural trails here, one through a gap in the spur and another at its western base.

The trail at the base of the point is flanked by the Grimes site (Ch-3), and the trail through the saddle is marked by another petroglyph site, Ch-71 (see fig. 2). Site Ch-71 is very much like the Grimes site, with pecked petroglyphs on scattered black basalt boulders, but the older pit-and-groove style does not occur. (Site Ch-71 is discussed in detail in Appendix E.)

Ch-95 (fig. 60e)

Site Ch-95 is a small cave near the Grimes petroglyph site (see fig. 2). There were cultural deposits in the cave at one time, but these have been badly disturbed. Traces of matting were observed in the debris. Red pictographs were painted on the ceiling of the cave.

Ch-117 — Lahontan Reservoir

According to information in the files of the Nevada State Museum, there is a petroglyph site on the end of a long point extending into the east (south?) side of Lahontan Reservoir just below the place where the Carson River makes a horseshoe bend. This information was recorded by S. M. Wheeler, formerly employed by the Nevada State Park Commission, who had not himself seen the site. Wheeler thought the site might be below the high-water level of Lahontan Reservoir. We searched the accessible south shore rather thoroughly in the summer of 1958 for a distance of several miles but were unable to find the site. It may be covered by normal high water of Lahontan Reservoir.

Ch-120 — Rawhide Flats (pl. 3b)

About 10 miles south of Carson Lake and just east of the Walker River–Carson Sink road is an alkali flat 7 miles long and 2 miles wide known as Rawhide Flats. The flat is now quite barren, but it may have held a small lake at a time of greater rainfall. The mountains bordering Rawhide Flats are dissected by numerous canyons which carry water during storms but which usually are simply dry washes. Near the northwest end of the flat such a wash emerges from the hills; it is bordered on the south by the Terrill Mountains and on the north by a low gravel ridge (figs. 3, 5). At the base of the alluvial fan associated with the wash are two large rhyolite boulders, 4 feet high and 8 feet long, decorated with pits. One of the boulders has grooves as well. The more easterly boulder has been moved within the past few years, evidently by a bulldozer during a nearby road-building operation. The other boulder is buried in sand to a depth of 3 feet or more. The sand around and beneath the north edge of the west boulder was excavated on the chance that something had been cached there, but nothing was found.

The pits which have been pecked into these boulders are of various sizes. On the west boulder nearly all of one face is covered by about twenty pits ranging down in size from a large one 8 inches in diameter, and in depth from one-half to 10 inches (pl. 3b). On the east boulder two faces are decorated. One face is very much like the west boulder; there is one large pit, 10 inches deep and nearly a foot in diameter, surrounded by about ten smaller pits of varying size. The other face of the east boulder is decorated in different fashion; it has two small pits, 4 inches in diameter and 1 inch deep, each of which is surrounded ring-fashion by a shallow groove. Below the ringed pits are irregular grooves evidently intended to represent snakes.

The petroglyphs on these rocks are very much like the pit-and-groove style petroglyphs found at the Grimes site (Ch-3). Like the Grimes pit-and-groove petroglyphs, those at Rawhide Flats give every appearance of antiquity in that the petroglyphs are heavily weathered and patinated to exactly the same extent

as the remainder of the rock surfaces. One cannot be sure of the antiquity of the glyphs at Rawhide Flats because there are no recent ones with which to compare them, but it is believed that they are quite probably as ancient as the oldest examples at Grimes.

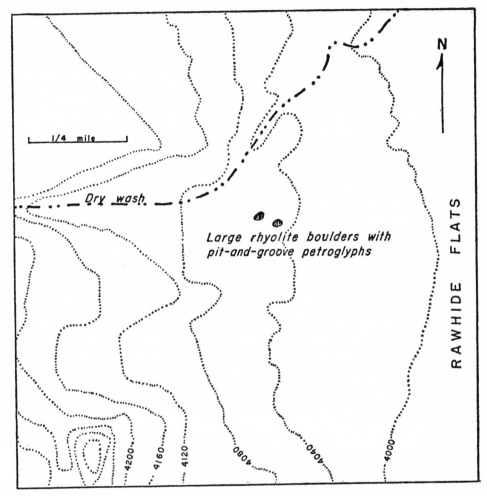

FIG. 5. Petroglyph site at Rawhide Flats (Ch-120).

Ch-123 — Drumm Ranch

There are said to be petroglyphs on the Drumm Ranch in easternmost Churchill County, 15 miles north of Eastgate. This ranch is shown as the Whitaker Ranch on Nevada General Highway Map, Churchill County, No. 2. The site is said to be 2½ miles above the ranch house on the south side of Edwards Creek. The locality was not accessible to us in the summer of 1958.

CLARK COUNTY

Cl-1 — Valley of Fire, Atlatl Rock (figs. 45-59; pl. 4)

At the western end of the Valley of Fire State Park near Overton there is a group of large rounded boulders, one standing over 100 feet high, with many pecked petroglyphs on them. Steward's "Lost City" is actually this site (Steward, 1929, pl. 72; cf. discussion under site Cl-4 below). A photograph of it is also shown in the November, 1957, issue of *Sunset Magazine* (p. 31), and a drawing of some of the elements has been published (Henley, 1929, p. 26).

In June, 1958, the entire site was photographed for the University of California Archaeological Survey by Jay von Werlhof and William J. Maund, Jr. The designs shown in figures 45-59 are taken from these photographs.

We have not visited this site, but from its description as an isolated group of boulders at some distance from other rocks it would seem ill suited as a game ambush or trap. There is a possibility, though, that it was a watering place for game; on the south edge of one of the rocks is a natural basin with a rock dam on one side which is said to be large enough to hold about a thousand gallons of water. If this tank were filled by a rainstorm the game would very likely water there in succeeding days. Our information does not make clear whether the dam is aboriginal, but if it is an ancient construction the early inhabitants of the area may have ambushed mountain sheep or antelope at this spot and the petroglyphs may have been associated with this practice.

Cl-2 — Grapevine Canyon, Steward 227 (figs. 132, 133)

This site is in the extreme southern corner of Nevada, about 7 miles west of Davis Dam. The site has petroglyphs pecked into the cliffs. They have been described by Professor Blackwelder of Stanford University (Steward, 1929, p. 150) as follows:

The carvings are made on a hard granite porphyry and have been cut through a patina of hydrous iron and manganese oxides. Subsequent to the cutting of some of the figures, however, this "desert varnish" has reformed in different degrees, causing some figures to be scarcely noticeable. These seem to be the older and are probably very ancient for the formation of desert varnish is a very slow process. Another point favoring the great antiquity of these petroglyphs is that granite surfaces with carvings have exfoliated. . . . A more incisive piece of evidence in favor of antiquity is that the rock cliff containing the petroglyphs is buried by a deposit of twenty-two or more feet of gravel. The terrace was excavated by Captain LeBaron and the petroglyphs found to extend to a depth of at least twenty feet. . . . This terrace is but part of a large alluvial fan formed by a small intermittent stream. A gradual rather than a torrential accumulation of the deposit is indicated by the mixture of sand and fine gravel and the stratification into thin, even beds . . . but none were encountered. Since forming the fan, the stream has cut it down, leaving the twenty-two-foot terrace which now covers the petroglyphs. . . . That this occurred long ago is shown by the presence in the bottom of the wash of willow trees with 150 annual growth-rings. It is also to be noted that precipitation in this region at present is very slight (average

annual rainfall, about two and one-half inches). The water-worn pebbles making up the granite are somewhat cemented together and show a high degree of decay, which again points toward considerable antiquity. The presence of desert varnish, not forming at present, suggests a more moist climate and hence also indicates antiquity.

Even an approximate date for these petroglyphs is out of the question. We may be safe, however, in placing their age at a minimum of several hundred years and we may have to multiply this many times in the light of further evidence.

Steward (1929, fig. 73, pls. 73-78) has illustrated the petroglyphs at this site profusely. The designs shown in figures 132 and 133 are from that source.

As Steward points out, there is dating evidence here in the differential patination and also from the burial of glyphs by the gravels. Unfortunately, one cannot tell from the photographs which glyphs have evidence of greatest antiquity. This is particularly regrettable because elements belonging to several styles are found at the site.

Professor Blackwelder's statement and one of Steward's photographs (1929, pl. 78d) indicate that the site is on the edge of an alluvial fan at the mouth of a very narrow, vertical-walled canyon. It appears that it would have been an excellent ambush spot for hunting mountain sheep traveling up the wash.

Cl-3 — Hiko Springs, Steward 228 (figs. 60f-u, 61a)

The Hiko Springs site (this spring should not be confused with the Hiko Springs in Lincoln County) seems to have essentially the same designs as the site in Grapevine Canyon (Cl-2) located 4 miles to the north. Here too the petroglyphs are pecked into vertical cliffs of granitic rock. Steward (1929, pl. 79) illustrates some of the petroglyphs at the site, but since publication of Steward's paper additional information on the site has been gathered by Miss Arda Haenszel of San Bernardino, California. The design elements shown in figures 60f-u and 61a are adapted from photographs by Miss Haenszel.

We also have some ethnographic information on this site. Kroeber (1959, pp. 285-296) gives us the following data: "Mukewiune, the oldest of the Van Valkenburgh-Farmer informants, born well north of Mohave Valley, not west or south of it, said that she was living at Beaver Lake (opposite Fort Mohave) and near-by Hico ('White man's') Springs while the Fort was being built in 1858." There is no eyewitness evidence on the exact situation of this site, but it is clear from the map (U.S.G.S. Davis Dam Quadrangle, 1950) that the site is near a live spring and at the mouth of a narrow canyon. Again the situation indicates a good place for a mountain-sheep ambush.

Cl-4 — Cane Springs, Steward 225 (figs. 61b-f, 62; pl. 5a)

This may be the site referred to by Mallery (1893, p. 95), who quotes R. L. Fulton: "Eighty miles farther south [90 miles south of Pioche], near Kane's Spring, the most numerous and perfect specimens of this prehistoric art are found.

Men on horseback engaged in the pursuit of animals are among the most numerous, best preserved, and carefully executed."

The Donald Scott collection at Peabody Museum, Harvard University, contains two groups of photographs marked "Kane Springs, Clark County." One group consists of six pictures marked "Source: unknown." These represent Katchina figures appearing as shown in figure 62b-e.

The second group of photographs, showing mountain sheep and riders, is marked as having been provided by Louis Schellbach. Since the elements depicted by the two groups of photographs are so unlike, they probably come from two different sites, both being located, perhaps, near Cane Spring which is itself located on the Meadow Valley Wash road about 8 miles north of Glendale, Clark County.[2]

The Schellbach photographs help to clear up some uncertainty concerning some of Steward's photographs. The rather complicated situation may be summarized as follows. When Steward was gathering information for his *Petroglyphs of California and Adjoining States,* he acquired six 8 x 10 inch negatives from the magazine *Touring Topics* (now called *Westways*). These six negatives were said to have been taken at "Lost City" or Pueblo Grande de Nevada, and accordingly they were subsumed by Steward under a single site number (site 226) and were shown by him as plates 70-72.

The Schellbach photographs in the Scott collection at Harvard University consist of ten 8 x 10 inch positives. Four of the Schellbach prints were made from negatives which Steward had acquired from *Touring Topics.* From the notations on the Schellbach photographs it is evident that Schellbach was himself the photographer (perhaps Schellbach was writing an article for *Touring Topics* or perhaps the magazine obtained the negatives by other means).

The upshot of this discussion is that the notations on the Schellbach photographs enable us to separate the plates illustrating Steward's site 226 and to assign them to three distinct sites as follows:

Plate 70. The photographs are evidently of Cl-4 (Cane Springs). Plates 70a and 70c are among the Schellbach photographs, and pl. 70b shows men on horseback characteristic of the site.

Plate 71. These photos have been assigned to site Cl-5, said by Schellbach to be located in the Red Hills north of the Valley of Fire.

Plate 72. This photograph is of Atlatl Rock (Cl-1) in the Valley of Fire.

Figures 61b-f, 62, and 63a in the present text illustrate the petroglyphs and pictographs here grouped under the designation Cl-4. Data on them are presented herewith.

Figure 62b-d. These show the Katchina figures marked "Kane Springs, Clark County, Source: unknown" in the Scott collection at Harvard University. These are evidently painted pictographs, but what colors were used is not known.

Figure 61*b*. This is Steward's plate 70*c*. The Schellbach data in the Scott collection says of it "No. 44. A close up view of part of the petroglyphs shown on the right in Photo No. 43. Note man with gun on shoulder holding horse. This set may commemorate the event of the coming of the Spaniards."

Figure 62*g*. The Schellbach notation says "No. 48. A close up view of writings appearing in upper part of Photo No. 46, and just above the big picture rock in the foreground. Kane Springs, Nevada, group of writings."

Figure 61*d*. This is Steward's pl. 70*a*. Schellbach says of it "No. 49. Kane Springs on the bluffs of the railroad grade."

Other illustrations from the Scott collection are shown on figures 62*f* and 63*a*. Figures 61*c*, *e*, *f*, and 62*a* are from the University of California Archaeological Survey.

Cl-5 — *Lost City, Pueblo Grande de Nevada, Steward 218, 226* (figs. 63*b-k*, 64)

According to Steward (1929, p. 147) this site is "located on the east bank of the Muddy river, one mile north of St. Thomas and twenty miles south of the Arrowhead trail. The 'city' occupies an area approximately two miles wide and six miles long stretching along the Muddy and extending back upon the ridges that run out from a range of hills that parallels the river. Petroglyphs are numerous in the vicinity of Lost City."

Lost City itself has been reported numerous times by Harrington (see Grosscup, 1957, pp. 30-32, for citations). M. R. Harrington (1925) shows a photograph of the pecked petroglyphs found here on the broken faces of the cliffs. Steward (1929, pl. 71) has pictures of these petroglyphs, but his plates 70 and 72, also labeled "Lost City," are actually photographs of other sites (cf. discussion under Cl-4 above).

The Donald Scott petroglyph data collection at Peabody Museum, Harvard University, contains four 8 x 10 inch photographs of the petroglyphs at this site. The photographs were evidently taken by Louis Schellbach at the same time that he photographed sites Cl-1 and Cl-4, and again there is some coincidence between these pictures and the negatives obtained by Steward from the magazine *Touring Topics*. The notations on the Schellbach photographs are presented herewith.

No. 18 [Fig. 63*c*, *d*; Steward pl. 71*b*]
Rock inscriptions in the Red Hills, north end of the Valley of Fire. The first series encountered after crossing the Muddy Ford. Called (*A*) set on the map. Note the numerous characters. Owing to the light failing the entire number could not be chalked in time for photographing.

No. 21 [Figs. 63c, 64e; Steward pl. 71a]

Set (C) in the vicinity of Photo No. 18, and the last in this canyon. Very difficult to photograph owing to being on the upper side of this rock. Marked on map — Set (C).

No. 22 [UC Mus. Anthro Print 15/8222D]

A closer view of Photo 21 before all figures were chalked, and taken the evening before.

Besides the figures indicated in the paragraphs above, illustrations of petroglyphs at this site also include some taken from M. R. Harrington (1925).

Cl-7 — Steward 291 (fig. 65a-f)

This site is recorded only by Steward (1929, p. 151). He says,

site 291 Pt. Virgin River, Nevada. — There is a group of petroglyphs in this region. We have been unable to locate them exactly. They are shown on plate 93a-d. Their affiliation with the petrography of southern Utah and a number of sites in northern Arizona is obvious from the representation of kachina-like figures (pl. 93c, d). Other figures are of the Great Basin curvilinear style (a, b, e) and dots are abundant in b.

Cl-9 — Steward 229 (figs. 65g, 68a)

This site is recorded by Mallery (1893, p. 95). He says,

Fig. 56 is a copy of a drawing made by Lieut. A. G. Tassin, Twelfth U. S. Infantry, in 1877, of an ancient rock-carving at the base and in the recesses of Dead mountain and the abode of dead bad Indians according to the Mohave mythology. This drawing and its description is from a manuscript report on the Mohave Indians, in the library of the Bureau of Ethnology, prepared by Lieut. Tassin. . . .

Selected elements from Mallery's figure 56 are reproduced in our figure 65g.

Cl-121 — Lewis Holes

The old A.T.&S.F. branch line to Searchlight, Nevada, crossed the Nevada-California border about 25 miles southeast of the point where the present Las Vegas to Los Angeles line of the Union Pacific crosses the border. Three miles southeast of the abandoned Searchlight branch line and just east of the Nevada-California border is a spring called Lewis Holes. Near this spring there are petroglyphs in the face of a cliff. They are said to have been pecked more deeply than is usual in this area. Below the cliff is a camp site with broken pottery and other debris.

This information is from Miss Arda Haenszel of San Bernardino, California, who visited the site in the 1920's. Unfortunately there is no exact information available on the nature of the design elements.

On the U.S.G.S. Crescent Peak Quadrangle, 1956, Lewis Holes is shown as a steep-walled canyon with water (Stray Cow Well) at the upper end. Again we have the common southern Nevada situation of petroglyphs at watering spots.

Cl-123 — Keyhole Canyon (figs. 65h-l, 66, 67, 68b)

Nevada Highway 5 (the Boulder City-Searchlight road) is intersected by a dirt road from the east about five miles south of Nevada Highway 60. A mile and a half along the dirt road is a power line, and east of this is Keyhole Canyon with petroglyphs pecked in its walls. Information on this site is from Dr. D. W. Ritter of Chico, California. Dr. Ritter, who photographed the site, kindly made his pictures available to us. Figures 65h-l, 66, 67, and 68b are from that source. Arda Haenszel of San Bernardino, California, also has visited the site. She reports that there is a row of bedrock mortars here and that a few of the petroglyphs are on the underside of the slanting rocks containing the mortars. Miss Haenszel also reports that this was a stop for freight wagons on the road from the Colorado River to Salt Lake City. Presumably there was water there then, although no spring is reported at the present time. The glyphs are in the mouth of a canyon (according to Dr. Ritter), and they thus conform to the southern Nevada pattern of occurrence at watering places at canyon mouths.

Cl-124 — Arrowhead Canyon (fig. 68c, d)

Arrowhead Canyon is a gorge through which the ancient White River flowed to its confluence with the Moapa River (nowadays the White River sinks in the desert of Nye and Lincoln counties). The old river channel is now a trail into the Moapa River Valley. Arrowhead Canyon is a narrow gorge with vertical walls (Hubbs and Miller, 1948, fig. 27), and game must have gone through here to water at the springs just below, which are the source of the Moapa River. Near the mouth of Arrowhead Canyon there are petroglyphs on the canyon's vertical walls. Hubbs and Miller (1948, fig. 29) show a picture of these glyphs, and our figure 68d is taken from that source. Other possible evidence for this site is the Donald Scott data collection at Peabody Museum, Harvard University. A photograph in that collection is marked "Arrow Canyon near Moapa, Clark County. Source: Unknown." Our figure 68c is taken from that photograph. The Nevada Highway Map for Clark County shows the canyon as Arrow Canyon rather than Arrowhead Canyon, so the two photographs probably illustrate the same site.

Cl-129 — Crystal Springs

Six miles west of the Valley of Fire and 24 miles east of Las Vegas, near Crystal Springs, petroglyphs are to be found on an eroded cliff face.

This information comes from the University of California Museum of Anthropology catalog of photographs (13-2157). The photograph shows circles and zigzag lines. Other elements cannot be distinguished.

Cl-130

This site consists of carvings "on a cliff beside the old road in the Muddy River canyon between Glendale, where the traveler left the main Arrowhead Trail, and the lower Moapa Valley" (M. R. Harrington, 1944, p. 196). Harrington (*loc. cit.*) shows a photograph of the petroglyphs, which consist of a great number of small holes forming straight and curved lines.

Cl-131 — Christmas Tree Pass (fig. 68e)

The magazine *Nevada Highways* (Vol. 17, No. 2 [1957], pp. 18-23) shows photographs of this site, located in southern Clark County on Christmas Tree Pass over the Newberry Mountains into the Lake Mead Recreation Area. The photographs show petroglyphs pecked into broken, vertical cliff faces. We have been unable to locate this site with precision, but it is evidently on a dirt road from U. S. Highway 95 to the Lake Mead Recreation Area. The road leaves Highway 95 a few miles north of Nevada Highway 77. The petroglyph site is evidently in the mountains above the Grapevine Canyon site (Cl-2).

Cl-143 (fig. 78a)

The Donald Scott collection at Peabody Museum, Harvard University, has a single photograph of this site with a notation reading, "No. 39. Petroglyphs on red sandstone in Red Rock Valley, 12.8 miles east of St. Thomas. With State warning signs to vandals."

This may be the place marked "Red Cliffs" on the General Highway Map of the region (Clark County Map No. 2), at T 19S, R 69E, Sec. 25. Figure 78a is taken from the Scott photograph.

Cl-145 — Mouse's Tank (figs. 69-76, 77a-c; pl. 6)

This site is about 2 miles north of Nevada Highway 40 (the road through the Valley of Fire) in T 17S, R 67E, Sec. 21. It was recorded for the U.C.A.S. in June, 1958, by Jay von Werlhof.

The petroglyphs here are found on both sides of a narrow box canyon (only 50 feet wide in places) extending about a half-mile to natural water tanks at its end. There are also petroglyphs on a rock at the mouth of the box canyon. The situation here is a natural game trap — when animals came to drink at the tanks they could easily be surrounded and dispatched.

The design elements taken from Mr. von Werlhof's photographs are shown in figures 69-76 and 77a-c. Mr. Von Werlhof also recorded the following story:

Cy Perkins, an elder of the town of Overton, has this story to tell about the area. In 1904 a renegade Indian from across the Colorado River killed two white men and fled into the Valley of Fire. He found the water holes, and made the area his hideout. For subsistence this Indian would raid gardens and farmfields near Overton.

When word was received of the killings the farmers around Overton were alerted. The renegade's name was Mouse, and any strange Indian seen in the area was feared to be the killer. After farmers noticed that their fields and gardens were being raided they began a 24 hour watch. They assumed the thief was Mouse. One evening an Indian was spotted entering a field. He was frightened and a posse was organized to track him down. Indians were recruited as guides, and footprints in the sand were traced into the Valley of Fire. The tanks were discovered and there was evidence that someone inhabited the scene. The search continued.

The trail of footprints crossed the hills and back into the valley toward Logandale. After two weeks of constant tracking an Indian was spotted running across an open field. He was shot down by a barrage of rifle fire, and his body taken to Overton. It was said he was Mouse.

Cl-146 (fig. 77d)

A quarter-mile north of Nevada Highway 40 at a point 4 miles from its junction with Nevada Highway 12 is a single large boulder with pecked petroglyphs. These were photographed by Jay von Werlhof and are shown in fig. 77d.

DOUGLAS COUNTY

Do-22 — Genoa (fig. 78b, c)

Two miles east of the town of Genoa are found pecked designs on granite boulders. The appearance of the designs indicates that they were made within the historic period. The significance of these designs has been discussed by Elsasser and Contreras (1958, p. 13, fig. 1), so they need not be gone into here.

Do-35

The Nevada State Museum at Carson City has in its collections a brown basalt boulder decorated with petroglyphs. It is said to have come from somewhere in the vicinity of Gardnerville; the donor had given no more exact location.

The boulder is about 2 feet long and 18 inches high. On one of its faces there are three wavy lines, like snakes, one of which continues over an edge to an adjoining face, where it ends with a pit about 2 inches in diameter. The petrography on the boulder is greatly weathered. This fact, together with the style of the glyphs, indicates that the specimen should be classified with the Pit-and-Groove style of petrography.

ELKO COUNTY

El-1 (fig. 78d)

Only one site from Elko County is recorded, and this is undoubtedly not of Indian origin.[3] Information on the site comes from a letter from Olaf T. Hagen, Regional Supervisor of Historic Sites, National Park Service, San Francisco, who

donated a photograph of the petroglyph to the University of California Museum of Anthropology in 1940.

Mr. Hagen's data on the site follow:

Located on ranch of Utah Construction Company on Old California Trail and about two miles northeast of junction of Goose Creek and little Goose Creek — near the Nevada-Utah line.

The figure is on a sandstone bluff which is also covered by emigrant inscriptions. The figure is maybe 15 to 20 inches in diameter. It is partly covered with lichen.

The figure mentioned by Mr. Hagen is in high relief. An adaptation from his photograph is shown in figure 78d.

ESMERALDA COUNTY

Es-1 — Steward 222 (fig. 78e)

Information on Es-1 comes from Steward (1929, p. 146). "[Site] 222 Pt. Fish Lake Valley, Nevada. — 'In the northwestern corner of Fish Lake Valley, Esmeralda county, Nevada, between the Old David Davis ranch and Trail canyon are hieroglyphics in great number carved on hard stone' (Douglas Robinson, Covelo, California, letter of August 19, 1924, to Edward E. Clarke, San Francisco Examiner)."

Another report on a site in this region, possibly the same one, is from the Nevada State Journal (newspaper) of April 29, 1951. An article in the newspaper of that date reports the discovery of an archaeological site in a valley on the western slope of Boundary Mountain which had associated with it some petroglyphs on boulders. This location is in approximately the same place as the site mentioned by Steward, and accordingly has been assigned the same number. The newspaper article shows a photograph of some of the petroglyphs at the site. Our figure 78e was taken from that source.

Es-2 — Steward 223

Of this site Steward (op. cit.) says: "[Site] 223 Pt. Fish Lake Valley, Nevada. — 'There is a cave on the road from Silver peak to Fish Lake valley that contains inscriptions' (A. L. Snider, Goldfield, Nevada, letter of October 20, 1924, to San Francisco Examiner)."

Es-3 — Steward 224

Steward (op. cit.) says: "[Site] 224 Pt. Near Goldfield, Nevada. — 'Fifty miles south of Goldfield is a rock with markings resembling those found near Yerington' (W. H. Barlow, Goldfield, Nevada, letter of September 15, 1924, to San Francisco Examiner)."

Es-5 — Steward 221

Of this site Steward (*op. cit.*) says: "[Site] 221 Pt. Brickyard Springs, Nevada. — 'This site is seven miles west of Goldfield' (A. L. Snider)." In 1957 D. W. Ritter of Chico, California, searched carefully for this site but was unable to find it.

EUREKA COUNTY

Eu-1 — Dunphy (pl. *3a*)

The Humboldt River, as it flows west from Elko County into Eureka County, turns south through Palisade Canyon and then north again to bypass the Shoshone Range. As the river comes past the Shoshone Range it is a mile and a half north of the mountain slopes. The mile nearest the river is dead-level plain, and the half-mile nearest the mountains is a gently sloping alluvial fan littered with large basalt boulders.

At a point 1.7 miles east of the Eureka-Lander county line, one of these large basalt boulders (it is actually scoria) near the edge of the fan is decorated with many pits or cups of varying sizes. The boulder is about 5 feet in length and stands to a height of about 3 feet. It is literally covered with pits (pl. *3a,* the largest of which is 5 inches in diameter by 6 inches deep (almost like a bedrock mortar), the smallest, mere dimples an inch or so in diameter and a half-inch deep. The boulder was originally buried to a depth of about 2 feet, but in 1958 it had recently been moved when the highway was widened, so that it is now completely above ground. The move had been so recent, in fact, that the original soil line still remained. Several of the smaller pits were found to be below the soil line, indicating that they had been made at a time before the alluvial deposit had attained its present level.

HUMBOLDT COUNTY

Hu-5 (fig. *78f*)

Information on this site comes from a letter published in *Natural History,* Vol. LXII, No. 8 (October, 1953), p. 338:

SIRS:

Several years ago some cowboys, sitting down to rest on top of a mountain in Nevada, noticed that the rock ledge was covered with Indian designs. No one in that part of the country knew about this writing, and they could find out nothing about who had done it or what it meant.

One of the cowboys told me about the find, and we made the four-hour climb to the summit. The mountain is north of Winnemucca and about 30 or 40 miles from the Oregon border. The writings cover the flat surfaces over an area of possibly 15 by 30 feet. . . .

The writing seems to be drilled or pounded into the rock. In a couple of places the hack marks, as though made with a chisel-shaped instrument, are half an inch or more deep.

The markings interested me a lot, and I would certainly appreciate it if you would let me know whether they can be interpreted and whether they are worth the trouble I took to get these and many more photographs of them.

ELMER E. JONES

Placerville, California

The photographs mentioned by Mr. Jones are shown in the same issue of *Natural History*. They show the designs to have been made on the flat faces of angular boulders. The design elements discernible in these photographs are shown in figure 78*f*.

Hu-7 (fig. 79*a*)

This site is located 2 miles northwest of Paradise, Humboldt County. Information is from a photograph donated by Mrs. Adell Jones of Paradise. The photograph was taken by Mr. and Mrs. J. S. Case in 1924. The petroglyphs are on a sandstone cliff, facing east, near old Fort Winfield Scott.

LANDER COUNTY

La-1 — Potts Cave (fig. 79*b-g*; pl. 16*a*)

This site is located on Pete's Summit in the Toquima Mountains, on the east side of the summit and the north side of the road under a basalt flow. The site is a small cave near a spring. There are pictographs on the wall of the cave in red, white, and yellow. Some of the pictograph elements are shown in figure 79*b-g*. Notes made in 1937 on this site refer to the smoke-blackened roof of the cave and to the painted walls. Small natural cavities or depressions in the walls, from one to three inches across, are often encircled with white paint. That the paint was applied in liquid form is indicated by the fact that occasionally the paint ran or dripped. Relic hunters who had dug holes in the cave deposits left open excavations along the walls, and it was noted that none of the painted designs occurred below the surface level of the deposits. This fact probably indicates that the designs were applied toward the end of one period of habitation of the site, or perhaps post-date occupation.

La-9 — Hickison Summit (figs. 79*h-i*, 80, 81*a*; pl. 7)

About halfway between the towns of Austin and Eureka, U. S. Highway 50 goes through a mountain pass called Hickison Summit, which divides the Toquima Range on the south from the Simpson Park Range on the north. There are actually two alternative passes here at about the same elevation (6,600 ft.), one on the southeast through which the present highway goes, and the other about

a mile northwest passing between two rather prominent buttes or hills which rise about 250 feet above the pass. The pass between the two buttes, the peaks of which are about a half-mile apart, is over a gentle saddle. On the southern side of the saddle there is a steep-walled draw leading up to a group of large tuff boulders or outcroppings partly blocking passageway to the saddle. On the north side of the saddle the pass is flanked by tuff cliffs from 10 to 40 feet high and separated by about 450 feet. At a distance of 500 feet north of the saddle

FIG. 6. Hickison Summit petroglyph site (La-9). Petroglyphs at *x*, hypothetical game diversion fences at *a, b, c.*

there are two tuff outcrops 6 or 8 feet in diameter and protruding 10 feet above the level ground.

Petroglyphs are found at three separate places on this pass (figs. 79h-i, 80, 81a). On the tuff outcrop south of the saddle are some deep pits, some lightly scratched hatching and crosshatching, and an angular edge with a series of deep notches. The second place that petroglyphs are found is on one of the outcroppings north of the saddle where an elaborate series of grooves and other design elements are found. Finally, on the eastern flanking cliff a number of pecked petroglyphs as well as some red paint are found on five different panels.

Before investigating the Hickison Summit site in the summer of 1958, we conferred with Gordon Gullion, at that time a field officer of the Nevada Fish and Game Commission who was stationed in Austin. Mr. Gullion informed us that Hickison Summit was on the migration route of a deer herd, probably one wintering in Big Smokey Valley and summering in the Simpson Park Range. Having this fact in mind when we found the site, we tried to envision what the circumstances would have been if the locality had been used as a kill site by its former inhabitants. Inspection of the terrain leads us to some tentative conclusions which should be read in conjunction with the sketch map of the area (fig. 6).

A deer herd on migration to summer range would be traveling south to north. They would go up the shallow wash, or along its banks, toward the summit and at point a would encounter partial obstructions in the large tuff boulders. A brush diversion fence here 100 feet long would force the deer around the east side of these boulders and over the saddle. At b it would be possible for the animals to veer east over the top of the tuff cliffs, but a very small man-made obstacle here would force them into the gap between the two cliffs. Once inside this enclosure they could have been driven by a diversion fence at c against the east cliff, where they could have been ambushed from above. Alternatively there may have been a corral at the north end of the gap where they could be held and killed. The relief features at this site make it an ideal location for an ambush or kill site.

LINCOLN COUNTY

Li-1 — Steward 217 (fig. 81b; pl. 15f)

Information on this site is from Mallery (1893, p. 95), who again quotes R. L. Fulton: "Ten miles south of Pioche are about 50 figures cut into the rock, many of them designed to represent mountain sheep."

The design shown in figure 81b is from the U.C.A.S. files.

Li-3 (fig. 81c-g)

In the same canyon as Etna Cave, near Caliente, Nevada. Wheeler (1942, p. 2), in his report on Etna Cave says:

On June 8 my wife and I, following Mr. Tennille's directions, proceeded southward down Rainbow Canyon (also known as Meadow Valley Wash) to Etna, a distance of six miles. Here we turned off the highway, crossed under the main line of the Union Pacific Railroad, and drove south about 500 feet, at which point it was necessary to leave the car and go afoot through a flood diversion tunnel.

Reaching the end of this passageway, we entered a narrow canyon which turned gradually westwardly. Around the turn we saw, about 300 feet ahead of us, a cliff of volcanic tuff, about 200 feet high, which formed the south wall of the canyon. A red coloring about four feet above the base of the cliff proved, on closer examination, to be ancient Indian pictographs, later identified by Mr. Harrington as of probable Pueblo origin (fig. 3).

Elements of Wheeler's figure 3 are reproduced in our figure 81*c-g*.

Li-4 — Hiko Springs

Hubbs and Miller (1948, figs. 25 and 28) show a petroglyph site near Hiko Springs in Lincoln County. The petroglyphs are found pecked on vertical canyon walls near the spring. Again we have the typical southern Nevada situation.

Li-5 (fig. 81*h-i*)

Information on this site is taken from Wheeler (1939). He reports (p. 220) that there are painted pictographs on the walls of a small side canyon near Stein (in the vicinity of Caliente). This may be the same site mentioned by Wheeler in an earlier report (1935, p. 8). In his later report Wheeler gives a photograph of the pictographs. They are shown in our figure 81*h-i*.

Li-6

The files of the Nevada State Museum give the location of a pictograph site in southern Lincoln County. The notes indicate that the site is on the west side of the Rainbow Canyon road at the Narrows, about 2 miles north of Elgin. The site is a rock with pictographs on it.

Lyon County

Ly-1 — East Walker River, Steward 202, 212 (figs. 82-95; pl. 8)

The Walker River, rising on the eastern flank of the Sierra Nevada, is for most of its course divided into two branches, the West Walker and the East Walker. The East Walker rises in the mountains behind Bridgeport, California, and from there flows in a northerly direction to its confluence with the West Walker a few miles south of Yerington, Nevada. Along the south to north course of the East Walker, at a point about 30 miles south of Yerington (T 9N, R 27E, Sec. 31, MDB & M), the river bends toward the west a few hundred yards to bypass

FIG. 7. East Walker River petroglyph site (Ly-1).

a westward-extending basalt ridge. On boulders covering this basalt ridge are found a large number of pecked and scratched petroglyphs, located in positions shown in figure 7.

The petroglyphs here are found in two large groups and several smaller ones. The westernmost of the two large groups is on a small north-south ridge (actually the point of the main ridge) which rises abruptly above the floodplain of the river. The top of this smaller ridge is littered with basalt boulders and for a distance of about 200 yards is covered with petroglyphs. The other large group of petroglyphs is to the east, across a low saddle separating the small north-south ridge from the main mountain chain. Here petroglyphs are on the many boulders scattered over the slope. Besides the principal concentrations, three smaller groups of petroglyphs are also present at the site. One of them is in the saddle between the main concentrations; a second is on the northeast edge of the saddle; and a few examples are found on boulders protruding from the floodplain sediments.

On the small north-south ridge at the western edge of the site, two groups of stone walls are found among the petroglyphs. The walls on the south end of the ridge consist of stones which have been thrown up in a linear pile along the western rim of the ridge. The stones for this wall were evidently obtained from a strip of land 50 or 60 yards in length and running along the top of the ridge. The strip of land is 10 to 15 feet wide and remains bare of large boulders so that even now it has the appearance of a cleared trail.

At the north end of the ridge is a second series of walls, circular in form and with the appearance of house remains (fig. 8). The walls of the stone rings are made of boulders varying from 6 inches to 2 feet in diameter and piled crudely on top of one another to a height of 1 to 2 feet. Stone rings such as these are found abundantly at this latitude in a zone running from the Sierra east at least as far as Walker Lake. Meighan (1955, p. 7) reported them in Mono County, California, and we also know of their occurrence in the Walker Lake region (see site Mi-5 below) by personal observation as well as through numerous reports by people living around Hawthorne, Nevada. The rings are usually found at high altitudes above the valleys and winter village sites, and they seem only rarely to be associated with a considerable accumulation of living debris or other evidence of intensive occupation. This being so, it is reasonable to doubt that the rings are actually the remains of permanent houses. They may have had a brush superstructure, however, and if so they could have been used either as temporary shelters or as hunting blinds.

If these structures were hunting blinds, they would have been admirably placed for an ambush of migratory game. We do not know whether migratory deer pass this way going to winter pastures. For the sake of argument, let us assume there was a herd wintering in the wide, well-watered valleys around Yerington, and summering on the eastern slopes of the Sierra Nevada. By following the course of the East Walker River, such a herd would pass the petroglyph site from south to north in the fall and from north to south in the spring. In their fall migration, coming from the south, the animals would approach the site on the floodplain east of the river, this being the only natural road. Upon reaching the site area they would be forced up over the saddle between the two areas of concentrated petroglyphs. They could not swing around the end of the point

FIG. 8. "House" rings at East Walker River petroglyph site (Ly-1).

here because sheer cliffs come up to the water's edge, completely blocking the passageway. The walls and stone rings east of the saddle would here provide an excellent ambush.

A spring migration, that is, a north-south movement, would provide hunters an opportunity to trap large numbers of animals. Traveling up the east side of the river, the herd would approach the petroglyph area in order to cross the saddle. It would be a simple matter to block the saddle with a diversion fence and then, by means of beaters stationed down the river (north), to drive the herd into the floodplain west of the point. Here they would be trapped and dispatched at will.

Concerning the petroglyphs themselves, at this site we were able to discern what are probably variations in age among certain of the specimens. The boulders at the site are all of tan basalt and have a black, even, metallic-looking desert varnish. Among the designs occurring on the east side of the saddle, some glyphs are covered with desert varnish and are therefore thought to be relatively old, whereas others show clean pecking with little desert varnish, and are obviously more recent. We list here the figures showing glyphs which seem to be early or late.

Early: 82b (left), j; 83e; 84b; 87a, g; 90o, r; 91g, j, k; 92a; 94e.
Late: 84i; 92c, e, f, l.

Another indication of chronology is found in the two small groups of petroglyphs separated from the main concentrations on the northeast edge of the saddle and on the floodplain. The petroglyphs in these groups appear to be very late; they are not patinated, and they are done in much cruder style than is usual in the two main concentrations.

Finally, we note that the fine-line scratching found at many places in the site seem to be very late.

It is, perhaps, worthwhile in completing the discussion of this site to clear up some confusion in Steward's site numbers. His site 202 Pt. is said to be "located on a large hill approximately 30 miles south of Yerington" (1929, p. 139). This location accords generally with that of the present site (Ly-1), and its identification is confirmed by Steward's photographs (*op. cit.,* pp. 57-64). Steward's site 212 Pt. is on "a point of black rocks that extends into and turns the course of the [East Walker] river. . . . It is thirty miles southeasterly of the town of Yerington, Nevada. . . ." (*op. cit.,* p. 144). Evidently this description also refers to site Ly-1.

Ly-2 — Smith Valley, Steward 211 Pt. (fig. 96a-k; pl. 9)

About 4 miles south of Wellington, Nevada, Highway 22 crosses Desert Creek, a stream coming out of the Sweetwater Mountains on the Nevada-California border and sinking in Smith Valley. The canyon of Desert Creek is steep-walled and abrupt to a point about 3 miles east of Highway 22, but there it opens out until, within a few hundred yards, it is meandering along the gentle alluvial fan toward Smith Valley. In the transition, where it flows in the bottom of a wide arroyo, a group of petroglyphs is found along the north side of the creek.

The stream bottom, 75 to 100 yards wide, is bordered by terraces or benches about 20 feet high. The main group of petroglyphs is found on the north bench, where they are concentrated on brown basalt boulders for a distance of about 100 yards. A few additional glyphs are found sporadically downstream for a half mile or more. Seventy-five yards downstream from the main petroglyph concentration, and on the edge of the terrace, are the remains of a rock enclosure. The enclosure consists of a series of large boulders in semi-circular alignment, with a diameter of 15 feet and with the appearance of having once formed a complete circle, perhaps a hunting blind. This rude construction appears to have been partly torn down.

Several features of the petrography here are worthy of special note. The first is the Pit-and-Groove style glyphs, of which there are several examples. One example occurs in the main petroglyph concentration, another is on one of the boulders in the semicircular alignment, and a third is downstream nearly a mile, on the alluvial fan. This glyph is in a gully, perhaps an old channel of Desert Creek, within a few yards of a small occupation area with obsidian chippage, bone, and grinding stones. No artifacts were recovered there which might indicate the possible time period of the occupation.

The second feature of special importance here is the occurrence of deer hoof designs (pl. 9c). What may be the same element is also recorded at sites Ch-57, Es-1, La-1, La-9, Ly-1, and Mi-4. Their form at these six sites is that of a bifurcate or split horseshoe, and their identification as deer tracks is somewhat doubtful. At Smith Valley (Ly-2) each track consists of two parallel ovoid pits and bears a quite specific resemblance to actual deer tracks impressed in soft ground. The tracks are arranged in a trail, with pairs of them in a line running

up one side of the boulder, over the top, and down the other side. Another set of these deer tracks appears to have been erased by grinding out a circular area over each pair until they were obliterated. That these actually are erasures is shown by a single instance in which the obliteration is incomplete.

The third notable feature at this site is four grinding surfaces (pl. 9a), "bedrock metates," similar to those recorded at the Grimes (Ch-3) and Garfield Flat (Mi-4) sites. Evidence from site Ly-2 enables us, we feel, to determine the function of these features which, until now, have been anomalies. At the Smith Valley site, and probably at others, they were paint grinding surfaces. At Smith Valley the case is quite clear, since some of the red paint still is packed in the tiny holes of the grinding area. The purpose of these grinding surfaces had always been a mystery. They have the appearance of an ordinary seed-grinding metate, but we had resisted interpreting them thus for two reasons: (1) they were not associated with an occupation midden, as metates ordinarily are; and (2) they often occur on a sloping surface so that if one were grinding seeds on them the meal produced would fall off and be lost on the ground. These surfaces, then, we believe, were for grinding pigment, presumably because paint was needed for application to the pecked petroglyphs. At Smith Valley traces of the pigment were found still adhering to the glyphs. We suggest the possibility, therefore, that many pecked petroglyphs in the Great Basin were painted as well as pecked. We feel that, if we had been looking carefully for such grinding surfaces, we would have found them at many more sites than we did.

One other speculation is perhaps worth while making. It may be that there exist sites which formerly had painted pictographs now obliterated by weathering. We suggest that one means of identifying such sites is the presence of these paint-grinding surfaces on boulders in contexts which are otherwise anomalous.

We talked with the foreman of the Desert Creek Ranch, who has lived at the place for many years. The information on deer movements past the site supports strongly our conclusion that this was a hunting site used in the autumn. Deer start moving east out of the eastern slopes of the Sierra Nevada from the area above Topaz Lake. They move across to Antelope Valley and then on, by way of the pass and canyon, past site Ly-2 to winter further east around Walker Lake and Mount Grant. The deer usually start to move in November, the first contingents appearing at Desert Creek Ranch about one week after the first heavy snow in the Sierras. The ranch foreman estimates that about a thousand animals pass the ranch and site Ly-2 in herds of 75 or more for about a month. About 150 deer remain to winter in Smith Valley, concentrating on Desert Creek Ranch, where they feed in the fields and sagebrush at night and spend the day hidden in the piñon forest in the hills which rise abruptly just west of the ranch. The deer return in April on their westward trek to the Sierran slopes, but, since they travel mostly at night this movement is not as conspicuous as their eastward trek, which is set off abruptly by snowstorms. The return movement to the west is perhaps at a slower pace and by smaller groups rather than herds, since there is no particular pressure causing this movement. The deer presumably gauge their

return trek to the Sierran summer habitat to coincide with the time that area is freed of snow.

The elements shown in figure 96a-k do not represent all those known to occur at site Ly-2.

Ly-3 — Prayer Cave

The roof of a small cave near Fort Churchill, on a high cliff overlooking the Carson River, has white pictographs overlying red pictographs. Three small sticks were found forced into a crack in the wall of the cave. Unfortunately no photographs showing the pictograph designs are available.

Ly-5 — Steward 209 (fig. 96l)

Mallery (1893, pp. 92-93) gives the following information on this site:

A communication from Mr. R. L. Fulton, of Reno, Nevada, tells that the drawing now reproduced as Fig. 54 is a pencil sketch of curious petroglyphs on a rock on the Carson river, about 8 miles below old Fort Churchill. It is the largest and most important one of a group of similar characters. It is basaltic, about 4 feet high and equally broad.

Mr. Fulton gives the following description:

"The rock spoken of has an oblong hole about 2 inches by 4 and 16 inches deep at the left end, which had been chipped out before the lines were drawn, if it was not some form of the ancient mill which is so common, as it seems to be the starting point for the whole scheme of the artist. The rock lies with a broad, smooth top face at an angle towards the south, and its top and southeast side are covered with lines and marks that convey to the present generation no intelligence whatever, so far as I can learn.

"A line half an inch wide starts at the hole on the left and sweeping downward forms a sort of border for the work until it reaches midway of the rock, when it suddenly turns up and mingles with the hieroglyphics above. Two or three similar lines cross the top of the stone, and one runs across and turns along the north side, losing itself in a coating of moss that seems as hard and dry and old as the stone itself. From the line at the bottom a few scallopy looking marks hang that may be a part of the picture, or it may be a fringe or ornament. The figures are not pictures of any animal, bird, or reptile, but seem to be made up of all known forms and are connected by wavy, snake-like lines. Something which might be taken for a dog with a round and characterless head at each end of the body, looking toward you, occupies a place near the lower line. The features are all plain enough. A deer's head is joined to a patchwork that has something that might be taken for 4 legs beneath it. Bird's claws show up in two or three places, but no bird is near them. Snaky figures run promiscuously through the whole thing. A circle at the right end has spokes joining at the center which run out and lose themselves in the maze outside."

This site has since been relocated. Mallery's figure 54 is here reproduced as figure 96l.

Ly-7 — Simpson Pass (figs. 96*m*, 97, 98*a-j*; pl. 10*b-d*)

As noted earlier in the discussion of Allen Springs petroglyph site (Ch-57) the natural road from Walker River to Carson Sink goes between the Desert Mountains and the Terrill Mountains through a narrow defile called Simpson Pass (figs. 3 and 12). At the mouth of the defile, as one enters from the Walker River side, there is an especially narrow place where petroglyphs are found on boulders on the south wall of the canyon and on a single boulder on the floor of the canyon.

The earliest notice of this site is from the journal of Capt. J. H. Simpson of the U.S. Topographical Engineers, who passed this way in 1859, in explorations for a wagon road across the Great Basin. On June 6, 1859, Simpson's party crossed from Carson Lake to Walker River. Simpson says (1876, p. 87): "In the pass, just before attaining summit of divide, noticed some hieroglyphics on detached boulders."

The modern Indians also have knowledge of the site. The single boulder in the floor of the canyon is often referred to as "Medicine Rock." It has small holes in it, into which Indians (and white men) deposit pennies, buttons, and glass beads. A brother of Walter Voorhees, recent chief of the Walker River Paiute, knew about Medicine Rock and the petroglyphs there. He attributed the petroglyphs to the Modoc (*Sai-i*) who, he thought, lived there about 500 years ago. He said the Modoc camped on Walker River but were chased from there by the Walker River Paiute to a cave near Lovelock, where they were annihilated (cf, Steward, 1938, p. 271; Loud and Harrington, 1929, p. 163).

The petroglyphs on Simpson Pass are pecked into boulders of a poor-quality, crumbly basalt on the east wall of the canyon. The canyon wall slopes up at about 45 degrees there and rises about 100 feet. The west wall, without petroglyphs, is about as steep as the east wall, but only about half as high. On the boulders of the east wall occasional petroglyphs are found for a distance of about 100 yards, and a few glyphs are also found on the south-facing slope, which curves back from the east wall at the mouth of the canyon.

The floor of the canyon near its mouth is about 100 feet wide. Highway U.S. 95 from Schurz to Fallon runs along the floor of the canyon here, up against the east wall. A dry wash runs along the west side the highway, and the single boulder known as Medicine Rock is found between the highway and the wash. This rock may have been moved lately in road-building operations.

One other feature of the Simpson Pass site worth noting is that one boulder with petroglyphs on several faces has a ground surface, as if the surface had been used for a metate (cf. Ch-3, Mi-4).

MINERAL COUNTY

Mi-2 — Cottonwood Canyon (figs. 98*k-m*, 99*a*)

Cottonwood Creek flows out of the Wassuk Range and into Walker Lake from the west, about 13 miles south of the inlet of the Walker River. In the mouth

of Cottonwood Canyon and about three-quarters of a mile from the lake there are pecked petroglyphs on boulders (figs. 98*k-m*, 99*a*). There is said to be a rock wall here along the southwest side of the canyon above the petroglyphs. (Information from Miss Nancy Crenshaw of Hawthorne).

Mi-3 (fig. 99*b*)

On the west shore of Walker Lake, 15.6 miles north of the Hawthorne Naval Ammunition Depot, red pictographs are to be found on one face of a large (granite?) boulder (*ca.* 10 feet high and 20 feet long). The designs are shown in figure 99*b*.

Mi-4 — *Garfield Flat* (figs. 99*c-h*, 100-102, 103*a-n*; pls. 11, 12)

In the area south of Walker Lake we found the best evidence of the association of petroglyph sites and game trails. Not only were the sites there in excellent ambush spots but the known present-day migration routes were found to pass along trails marked by the petroglyph sites. Our knowledge of the deer trails here was obtained from deer hunters in the Hawthorne area and is shown in figure 9.

The situation is this: the summer range of deer is in either the high mountains on the California-Nevada border near Bodie, California, or even farther west in the Sierra Nevada around Bridgeport, California. When the winter snows begin to fall, the deer migrate eastward, crossing the Wassuk Range over a high pass to debouch through Powell Canyon into Whisky Flat, about 15 miles south of Walker Lake. In this fall migration the deer do not move in one large herd, but come down fitfully in small bunches as they are driven by cold and snow from successively higher elevations. When these small herds of deer reach Whisky Flat they continue eastward on one of two alternative routes. Some bunches take a northern path to go up the canyon of Rattlesnake Well, past the few petroglyphs here designated as site Mi-14. This route carries them up over an easy pass in the Excelsior Mountains, past the petroglyph site Mi-4, and into Garfield Flat itself. It is believed that the deer winter somewhat east of here, but their route has not been traced farther.

The alternate route out of Whisky Flat turns to the right to go up a narrow canyon at the south end of the flat, where petroglyph site Mi-5 is found. By means of this canyon the deer pass over the Excelsior Mountains to Huntoon Valley, then over an easy pass into Teels Marsh and perhaps beyond. Figure 9 also shows a trail coming in from the south, down a narrow canyon past the petroglyph site Mi-22, to intercept the Huntoon Valley-Teels Marsh trail. We do not actually know that the deer follow the trail past site Mi-22, but it is a fact that this route leads over a very good pass into the country south of Mono Lake, California, and beyond where there is excellent summer range. There is a strong presumption, then, that this too was a deer migration route.

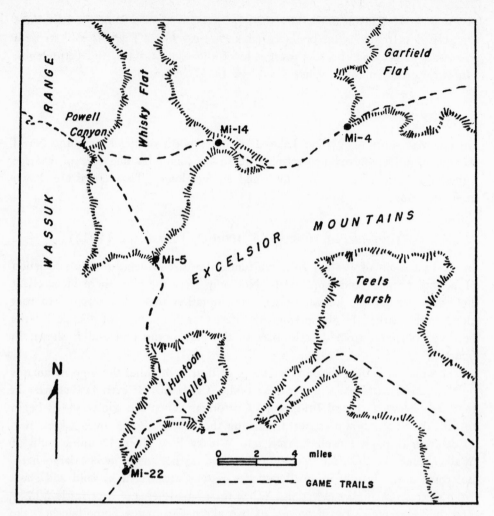

FIG. 9. Petroglyph sites and game trails near Whisky Flat (Mi-5).

It may be noted that the spring migration of the deer herd differs in some respects from the fall migration. Instead of moving singly or in small groups, the animals are now eager to return to the good forage of the mountains and tend to build up into large herds as they follow the snow melt westward. Moving in these large numbers they return by the passes where they could easily be trapped.

It is not known whether all petroglyph sites in the region have been recorded. The area in and around Whisky Flat has, we feel, been well covered, and hence there are probably no other sites there. There may be other sites in Huntoon Valley, or in the flat of Teels Marsh, or in the intervening mountains.

As for the Garfield Flat petroglyph site (Mi-4), it is found at the best ambush spot on the trail between Whisky Flat and Garfield Flat (fig. 10). The trail here runs in a general easterly direction, but about a mile from Garfield Flat it

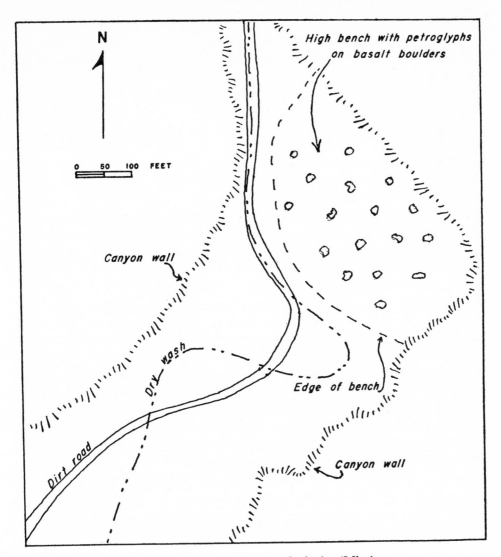

FIG. 10. Garfield Flat petroglyph site (Mi-4).

follows a dry wash that swings north briefly, to pass through a narrow constriction in the canyon. At the narrowest spot in the canyon the wash is flanked by an erosional bench rising about 8 feet high. The bench is covered with boulders varying from small cobble size to large boulders 10 or 12 feet in diameter. The boulders are covered with petroglyphs, shown here in figures 99c-h, 100-102, and 103a-n.

The boulders are of tan basalt covered with brown desert varnish. The petroglyphs remain relatively unpatinated, and so they show a definite but not marked contrast to the boulder surface. The condition of the petroglyphs indicates that they are not fresh, but neither do they appear to have great antiquity. There are no noticeable differences in weathering between one glyph and another so

that, with one exception, we were unable to discern evidence of relative chronology. The exception is the large, complicated glyph shown in figure 101. On this specimen it was noted that the right leg of the inverted human figure overlay the series of chevron or zigzag lines shown.

Besides the petroglyphs, other evidence of human activity at the Garfield Flat site included five "bedrock metates," one portable metate, three crude manos, and a half-dozen battered hammerstones. The bedrock metates, if that is what they are, are found on horizontal surfaces of the boulders here. They consist simply of smooth, ground surfaces with only a slight depression. One of these ground surfaces partially overlies, and therefore postdates, the petroglyph shown in figure 102*b*. The portable metate is a flat granite slab from 2 to 3 inches thick, 14 inches long, and 10 inches wide, with an ovoid, ground depression in one side measuring some 6 by 10 inches. The manos are untrimmed cobbles, from 4 to 5 inches long, each with a surface showing signs of slight wear.

The hammerstones found at the Garfield Flat site are angular cobbles varying from 2 to 4 inches in diameter, with quite noticeable battering along the edges. We hypothesize that these hammerstones were the tools used in making the petroglyphs. Over the past year or so we have personally inspected more than twenty petroglyph sites in Nevada and have been surprised that so few implements for making petroglyphs are to be found. If, as we believe, the petroglyphs had some magical significance and were made only by specialists, it may also be that special tools were used, tools not casually discarded after use. At some of the larger petroglyphs sites tens or hundreds of hammerstones must have been used, but these were not to be found near the glyphs. Perhaps the absence of tools is explained by their sacred or magical character. If so, those found at the Garfield Flat site evidently had no such significance.

Besides the petroglyphs and other evidence of human activity at site Mi-4 proper, there are a few petroglyphs to be found at two places nearby, which for convenience we may treat here. One such occurrence is a single boulder with a petroglyph pecked into one face (fig. 103*a*) on the trail between Whisky Flat and Garfield Flat, 1.1 miles west of the site proper.

The other occurrence of petroglyphs in the vicinity is 0.7 mile east of the site proper. There is a recent well at this point, and there may have been a spring originally. The few petroglyphs found on granite and basalt boulders here are shown in figure 103*m*. An occupation site appears to have existed here at one time, but it has since been destroyed by activity around the well. Some slight evidence of a midden deposit with quantities of obsidian chips remain, but most of the deposit is gone. One bedrock metate and two portable metates, like those described above, were observed here together with a reddish granite mano.

Mi-5 — *Whisky Flat* (figs. 103*o-r*, 104, 105, 106*a-c*; pl. 13)

In the discussion of the Garfield Flat site (Mi-4) above, it was explained that one of the routes taken by deer coming out of Powell Canyon on the west side

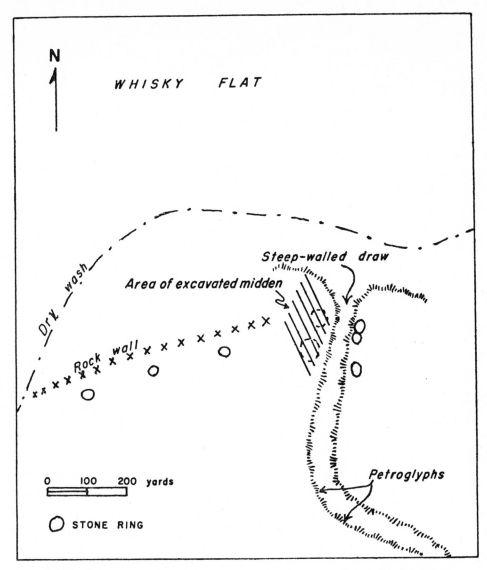

FIG. 11. Petroglyph site at Whisky Flat (Mi-5), near Hawthorne, Nevada.

of Whisky Flat was toward the south end of the flat (fig. 9). A steep-walled draw up which the deer go at the south end of the flat in order to cross the Excelsior Mountains has both petroglyphs and pictographs on its walls. The situation of this site is somewhat more complex than is usual for Nevada petroglyph sites. Briefly, it is this (fig. 11): Near the southeast corner of the flat a sandy wash meanders along the base of the hills in an easterly direction. At one point on its easterly course the wash swings north in a lazy bend around a low hill and then is intersected by another wash emerging from a draw to the south. This draw, with sheer basalt walls rising some 10 to 12 feet above its floor, has a north-south course for a short distance before curving to the east. Most of

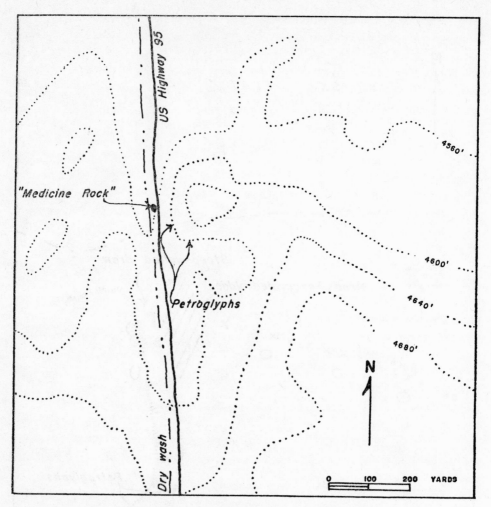

FIG. 12. Simpson Pass petroglyph site (Ly-7).

the petroglyphs are found on the west wall of the draw at the bend and just
north of it.

Stone rings like those at the East Walker River site (Ly-1) are present in
considerable numbers at the Whisky Flat site. On top of the bluff east of the
draw 3 such rings were found, each about 12 feet in diameter and with crude
walls built up to a height of about 2 feet. The rings had evidently been occupied
as houses. At one time there had been a considerable deposit of sandy midden
inside them, but when we observed them in 1958 they had recently been shoveled
out and screened by relic hunters. The screened midden piles contained quantities
of obsidian and flint chips and splintered bone.

Atop the bluff on the west side of the draw there had been other stone rings
(pl. 11a). These, however, had been removed by persons screening for artifacts.
The midden deposit had evidently been more extensive here than on the east

bluff. Numerous artifacts, especially chipped stone projectile points, are said to have been recovered. The specimens obtained here were not available for study, but conversations with the collectors disclosed that they had found many Desert side-notched projectile points (Baumhoff and Byrne, 1959), which are small side-notched points of chert or obsidian with a concave or notched base. A few potsherds of Shoshone Ware or Owens Valley Brown Ware (cf. Rudy, 1953, p. 94; Riddell, 1951) were also recovered at the site. The Desert Side-notched points and the pottery both indicate a very late occupation, within the last millenium. There may also have been an earlier occupation, but in talking to the collectors we failed to elicit descriptions of projectile points of earlier types. It is likely, then, that the occupation debris all dates from very recent times.

In addition to the stone rings on the bluffs overlooking the draw, other such rings were found on the low hill west of the draw. Figure 11 shows 3 such rings, but actually there are more, perhaps 10. Some of the rings here are so indistinct that they nearly defy detection, and so we were unable to map them systematically. The stone rings on the hill are smaller than the ones east of the draw — only from 6 to 8 feet in diameter. There was no midden or other occupation debris with these rings.

The other rock structure at the Whisky Flat site was a rock wall built on the hill west of the site. It begins near the edge of the draw and stretches from there nearly a half-mile over the hill. The wall, as it is now, is merely an alignment of stone slabs and boulders, but if the boulders were stacked the wall would have risen to a height of 2 feet or more. An occasional stub of juniper post may still be found among the stones of the wall.

The over-all configuration of this site lends itself admirably to interpretation as an aboriginal ambush spot. The deer, coming south in Whisky Flat, head in the direction of the draw, since they intend to go over the mountains here to Huntoon Valley. It is not necessary for the deer to enter the mouth of the draw; they can just as easily go over the gentle hill west of the draw and swing south of the petroglyph site to pick up the trail again to the southeast. To prevent this, the hunters built the long wall or fence, which forced the deer into the draw where they could be killed easily by men standing on the bluffs on either side. Dan Voorhees, a Walker Lake Paiute, saw the site several years ago and agreed that the wall was probably used as a drift fence for deer. He had not been previously acquainted with the site. Presumably the stone rings scattered near the wall are the remains of blinds used to conceal individual archers or beaters.

The rock writings at the Whisky Flat site are of three distinct kinds: the usual pecked petroglyphs, red-painted pictographs, and petroglyphs made up of very fine scratches (pl. 13c). The pecked petroglyphs and the pictographs are found only on the walls of the draw, as indicated in figure 11. The thin scratches occur with the pecked petroglyphs and pictographs and are also found in great numbers on the rocks of the stone rings on either side of the draw. On the walls of the draw some superposition can be observed among the various elements.

Figure 104*b*. The order of application on this glyph is as follows:

1. The thick wavy line is pecked and was the first element applied.

2. The single vertical line overlies the wavy line. The vertical line was evidently made by rubbing or grinding.

3. Next the diagonal lines were applied. They are very thin and were evidently made by scratching the surface with a sharp rock.

4. After the diagonal lines were made, the series of horizontal lines was applied, also by means of scratching. Red paint was rubbed into the horizontal lines either at the time they were made or some time later.

5. Finally the area shown circled by a broken line is covered with red paint applied over the thick wavy line, the single vertical line, and the thin diagonal lines. The red paint here may or may not have been put on before the horizontal lines.

Figure 104*d*. In this pictograph the circle overlies the hourglass figure.

Figure 104*f*. Here the grid is in fine-line scratching, whereas the remainder of the figure is very crudely pecked. The pecked element overlies the grid.

Figure 104*h*. The red-painted "baton" shown in the upper right overlies the grid done in fine-line scratching.

Figure 106*a*. Two elements are shown at the top of this panel. The left one is pecked and overlies the painted one to the right.

Mi-13 — Redrock Canyon (fig. 107*e-g*)

There are red and white pictographs on the wall of Redrock Canyon about 15 miles southwest of Gabbs. The canyon has vertical walls rising about 100 feet and is quite narrow at its mouth (about 50 feet). There is water here — a stream in the canyon was live in July, 1958. This would have been an excellent spot to ambush animals coming to water in the canyon.

Mi-14 — Rattlesnake Well (fig. 107*b-d*)

One of the game trails from Whisky Flat exits through a canyon at the head of which is Rattlesnake Well (fig. 9). At the mouth of the canyon are three large basalt boulders with pecked petroglyphs. The designs are shown in fig. 107*b-d*.

Mi-17 — Dutch Creek (fig. 107*a*)

Several small streams flow into Walker Lake from the Wassuk Mountains on the east. At the southernmost but one, Dutch Creek, a single petroglyph is found on a bench 50 feet above and north of the creek. There may have been more glyphs here originally; in June, 1958, we observed that the area had been recently bulldozed and only one large boulder remained in place.

Mi-22 — Huntoon Valley

In the trail leading southwest out of Huntoon Valley (fig. 9), there is a petroglyph site in the canyon about a mile from the valley. We have not visited this site, but according to the U.S.G.S. Huntoon Valley Quadrangle (1958), it is in a steep-walled canyon about a quarter-mile from a spring. The map also notes a "ruin" (hunting blind?) at the spring.

NYE COUNTY

Ny-1 — Steward 215

Information on this site is from Mallery (1893, p. 94): "Eight miles below Belmont, in Nye county, Nevada, an immense rock which at some time has fallen into the canyon from the porphyry ledge above it has a patch of marks nearly 20 feet square. It is so high that a man on horseback can not reach the top."

Ny-2 — Steward 219 (fig. 106d-i)

This site is also known from Mallery (*op. cit.*): "A number [of rocks] at Reveillé, in the same county [Nye], are also marked."

Mallery (*op. cit.*, fig. 55) shows a drawing of these petroglyphs at Reveillé. They are reproduced here as figure 106d-i.

Ny-3 — Steward 220 (figs. 106i, 108, 109a)

Information on this site is from Steward (1929, p. 146):

Twenty-eight miles east of Goldfield are carved rocks. There are others in the vicinity of Gold Crater (A. L. Snider, Goldfield, Nevada, letter to San Francisco *Examiner*, October 20, 1924).

Mr. W. H. James of Chalfant, California, also mentions petroglyphs near the mines at Gold Crater, Nevada. He states that they are "due north from the prospect dumps at a tufa bluff. At one point a large block of tufa has broken off from the cliff. This is inscribed with the main group of figures although scattered smaller boulders have wavy lines" (letter of May 17, 1929).

These petroglyphs were photographed by D. W. Ritter of Chico, California, who kindly made prints available to us. Figures 106i, 108, and 109a are from that source. According to Dr. Ritter, the steer-head element shown in fig. 108a, upper right, is known to be at least 50 years old but looks freshly made.

The petroglyphs are found on the walls of a narrow canyon. According to the U.S.G.S. Kawich Quadrangle (1908), there are "tanks" to the west of the petroglyph area. Again we find the southern Nevada pattern — a narrow canyon leading to a watering spot.

Ny-21, 22 — Steward 213, 214 (figs. 109b, 110a)

Of these sites Steward says (1929, p. 145):

Manhattan Valley, Nevada. "There are two such rocks near this place, some 12 to 15 miles distant, and say 10 miles apart. One on the east (site 213) and one on the west side (site 214) of Monitor Valley. They are reported to be covered entirely with 'Indian writing,' but even the oldest of the present tribes here know nothing of them" (H. G. Clinton, Mammoth Mining Company, Manhattan, Nevada, letter of February 24, 1920).

A later letter from Mr. Clinton (April 9, 1920), evidently not available to Steward, includes additional information as well as photographs of one of the sites (Ny-22). We quote from this letter:

I am enclosing in this 4 views of the hieroglyphic rock, on the west side of Monitor Valley, in Bald Mountain Canyon, Nye Co., Nevada, of which I wrote you from Manhattan, Nevada. . . . Note that the glyphs come clear to the ground on the rock. It may be that they are also below the present level of the surface . . .

The designs shown in figure 109b, 110a are adapted from Mr. Clinton's photographs.

Ny-25 — Big George Cave (fig. 110b, c)

Big George Cave is in Pahute Mesa about 45 miles east of Goldfield. The site was evidently excavated by S. M. Wheeler for the Civilian Conservation Corps and the Nevada Park Commission; the collections from the site are in the Nevada State Museum. There are petroglyph-covered boulders somewhere in the vicinity of the cave. The elements shown in figure 110b and c are taken from photographs by Wheeler now filed at the Nevada State Museum.

Ny-29 — Ammonia Tanks (fig. 110d)

"Pictured Rocks" are noted on the U.S.G.S. Kawich Quadrangle at Ammonia Tanks about 50 miles east of Goldfield. The glyphs shown in figure 110d are copied from a photograph taken by S. M. Wheeler in the files of the Nevada State Museum.

Ny-33

A rock shelter on Pahute Mesa, about 40 miles east of Goldfield, was excavated by S. M. Wheeler in the 1930's. According to the records of the Nevada State Museum there were painted pictographs on the wall of the shelter. No other details regarding them are available.

Ny-44 (fig. 110e, f)

A cave 10 miles north of Pahrumps ranch in the extreme south of Nye County was at one time excavated by M. R. Harrington for the Museum of the American Indian-Heye Foundation, New York City. The materials recovered are now deposited there. The Heye Foundation Museum catalog does not mention petro-

glyphs here, but the Donald Scott petroglyph file at Peabody Museum, Harvard University, records a petroglyph at the same locality. Figure 110e and f is taken from a photograph in the Scott collection.

PERSHING COUNTY

Pe-10 — Pole Canyon (figs. 110g-i, 111a-f)

The site lies in the saddle or divide at the head of Pole Canyon on the summit of the Eugene Mountains, north of the Humboldt River. There are pecked petroglyphs here on a flat outcropping of schist measuring about 12 x 12 feet. The outcropping lies on a south slope, and other isolated boulders, scattered up the slope over an area of 500 yards in radius, have pecked petroglyphs. Near the petroglyphs and lying just along the edge of the saddle is a stone circle made of piled-up angular schist boulders. The circle, actually a U-shape, is 10 feet across with walls about three feet high and the opening toward the saddle. We interpret this crude structure as a hunting blind in which archers crouched to shoot animals crossing the divide or passing to visit the nearby springs (cf. Muir, 1922, p. 320).

There is a spring about 500 yards down the slope from the schist outcrop. At the spring is an occupation site (Pe-32) with a midden deposit about 2 feet thick indicating a permanent or semipermanent settlement.

In addition to the site near the spring, two other archaeological sites are associated with the petroglyphs. One (Pe-30) is located in the saddle between two peaks of the Eureka Mountains, from 200 to 300 yards upslope from the schist outcrop. There is a shallow midden deposit here (about 6 inches deep), probably indicating a summer hunting camp. Petroglyph boulders occur in and around this site.

The final site in this complex of camp sites, occupation sites, and petroglyph sites is a surface site located on the northern slope, on the opposite side of the ridge from the schist outcrop. Here, in an aspen grove near a small spring, were found scattered occupation debris including a mano, basalt and obsidian projectile points, and many flakes. There is little or no depth of deposit at this site.

Pe-14 — Leonard Rock Shelter (fig. 111g-i)

This site is described by Heizer (1951, pp. 90-91):

The rock shelter site is located in the protection of a vertical extrusive rock dyke whose main axis is approximately east-west and which runs diagonally down the lower slope of the Humboldt Range about 17 miles due south of the town of Lovelock, Nevada, and near the northeast end of the Humboldt Lake basin along the very lowermost course of the river. The north face of the cliff is so tilted outward at the top that the area at the base of the cliff is kept completely dry. . . . This situation has apparently obtained for the past 10,000 years. The north face of the

cliff is heavily encrusted with calcareous tufa draperies deposited during the Provo Pluvial stage of Lake Lahontan by algae colonies.

There are petroglyphs pecked in the calcareous tufa. They occur at a level well above the present surface of the deposit and are therefore to be correlated with either the Lovelock Culture or the latest Northern Paiute Culture. In earlier times the petroglyph area would have been quite out of reach from the surface of the deeper levels of the site.

Elements of the petroglyphs at Leonard Rock Shelter are shown in figure 111*g-i*.

Pe-27 — *Medicine Rock* (fig. 112*a*)

Loud says of this site (Loud and Harrington, 1929, p. 132):

Site 17 is a burial ground at the foot of a cliff on a rock outcrop 9 miles northeast of the lake [Humboldt Lake]. . . . In prospecting for nitrate deposits at the base of the cliff half a dozen skeletons have been found. Pictographs [in red, yellow, and white] on the cliff were also uncovered. Northern Paiute Indians formerly visited the place to lick nitrate salts from the face of the cliff, hence it was known as "Medicine Rock."

Pe-36 — *Star Canyon, Steward 200* (fig. 112*b*)

Steward (1929, p. 139) says of this site:

These petroglyphs occur on a vertical rock surface, about three hundred feet southeast of portal, . . . tunnel in Star canyon, Pershing county, Nevada. This is on the NE ¼, SW ¼, Sec 32, T 31 N, R 34 E. The markings are one-half to three-quarters inches wide, about one-eighth inch deep, and very smooth and regular. (John A. Runner and Paul S. Reid, Lovelock, Nevada) These figures are entirely curvilinear, the main design being the circle which occurs in various sizes and arrangements, although usually several circles are associated and connected by straight lines (fig. 71).

This is doubtless the same site referred to by Mallery (1893, p. 95), who quotes Fulton: "Humboldt county [what is now Pershing County was part of Humboldt County before 1918] has its share [of petroglyphs], the best being on a bluff below the old Sheba mine."

Steward (*op. cit.,* fig. 71) reproduces a drawing of this petroglyph. A photograph of the design is now available, and our figure 112*b* is from that source.

Pe-40 — *Painted Cave*

A cave 4 miles south of the Miller Ranch in Dixie Valley has red painted pictographs on its walls. No illustrations of these are available.

Pe-59 (fig. 112*c*)

In the Eugene Mountains, 40 miles southwest of Winnemucca. A petroglyph was found by F. W. Richards of Eureka, California (*Sacramento Bee*, February, 1957). The newspaper story contains a photograph of a petroglyph pecked into a smooth boulder. The design of the glyph is shown in our figure 112*c*.

This may be part of the Pe-10 complex, which is also located in the Eugene Mountains, but it cannot be specifically identified from the photographs in the U.C.A.S. collection.

STOREY COUNTY

St-1 — Lagomarsino, Steward 208 (figs. D-1–D-11; pls. 16*b-d*, 17)

The only petroglyph site known from Storey County is the Lagomarsino Site north of Virginia City. This site has recently been reported in detail (Baumhoff,

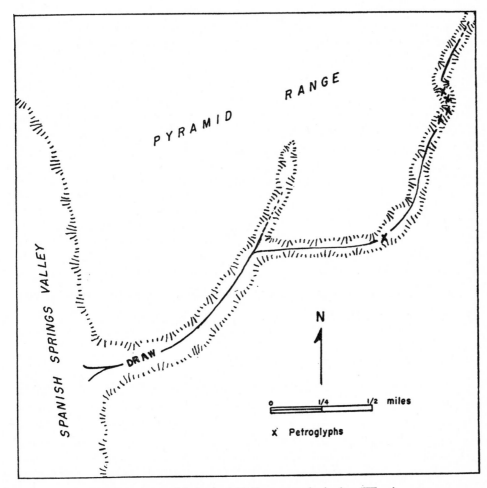

FIG. 13. Spanish Springs Valley petroglyph site (Wa-5).

Heizer, and Elsasser, 1958). As an example of the analysis of a single site we have adapted that site report here as Appendix D.

WASHOE COUNTY

Wa-5 — Spanish Springs Valley, Steward 205, 208 (figs. 113, 114; pl. 14*a*)

Spanish Springs Valley is a large flat lying 15 miles northeast of Reno. There is a spring in the flat feeding a substantial pond and maintaining a tule marsh vegetation on its margins. Some 4 miles northeast of the spring, a canyon with steep walls opens on the valley (fig. 13). Up the canyon about 1.5 miles, a single panel of petroglyphs is found on the south wall of the canyon. Beyond this a half-mile the main concentration of petroglyphs is found on the walls of the canyon. The canyon, at the point of occurrence of the main petroglyph group, narrows until the canyon floor is no more than 10 feet wide. The floor is marked by a number of catchment basins which trap water and retain it for some time — in June, 1958, considerable water remained. No good map of the area is available, but so far as we could tell the canyon did not constitute a trail of major importance, hence was probably not used by migratory game.

Steward has recorded this site as 205 Pt. Reno, Nevada and also as part of his 208 Pt. Virginia City, Nevada. Site 205 is undoubtedly the Spanish Springs site, as it is said to be 15 miles northeast of Reno. Under site 208, Steward includes the Lagomarsino site (St-1) and also the Spanish Springs site. He attributes two photographs to the Spanish Springs site (pl. 66*c, d*) but his plate 66*c* actually shows a Lagomarsino site petroglyph (compare Steward's pl. 66*c* with Baumhoff, Heizer, and Elsasser, 1958, fig. 7*m*).

Wa-7 — Steward 203 (fig. 112*d, e*)

Mrs. Margaret Wheat of Fallon reports pecked petroglyphs on the west side of Pyramid Lake. They are said to be on the first or second tufa dome north of the mouth of the Truckee River. Figure 112*d* and *e* is taken from photographs by Mrs. Wheat. The site had previously been reported by Mallery (1893, p. 92) and Steward (1929, p. 141).

Wa-20 — Smokey Flat

On the north edge of Smokey Flat, in foothills about 3 miles from the outskirts of Reno and about one mile from the airport. The site is near a small, interior drainage seep against the slope of the hills. There is a campsite and petroglyph area here. On the opposite side of the flat is a large granite boulder on which petroglyphs appear. Manos and metates, as well as chert points and drills have been found at this site (information from Dr. Ira La Rivers, University of Nevada).

The petroglyphs at the site consist of small pits an inch in diameter and from a quarter- to a half-inch deep and of shallow grooves connecting some of the pits. The style of these glyphs indicates that they belong to the older style at the Grimes petroglyph site (Ch-3).

Wa-26 — Paul Bunyan's Corral (fig. 112f)

On the east shore of Pyramid Lake on the road from Nixon to the Pyramid and about 10 miles north of the mouth of the Truckee, the rock formation of dendritic tufa has a number of small caves. Mrs. Margaret Wheat of Fallon photographed some archaeological specimens at one of the caves, including coiled basketry and Lovelock wicker basketry (cf. Heizer and Krieger, 1956). There are pecked petroglyphs on boulders outside these caves. Those shown in our figure 112f are taken from photographs by Mrs. Wheat.

Wa-29 (figs. 112g, 118a, b)

Site Wa-29 is 21.3 miles north of Nixon on the west shore of Winnemucca Lake. There is a small knoll projecting perhaps 20 feet above the surrounding terrain. On the knoll are many large tufa-covered boulders, some more than 8 feet high, which have petroglyphs pecked into the tufa.

Photographs of these petroglyphs were obtained by O. C. Stewart (1941, p. 418) in the course of his ethnographic research among the Northern Paiute. Elements from the photographs are shown in our figures 112g and 118a and b. Stewart's informants knew about the petroglyphs but denied that they were made by the recent Indian tribe of the area.

There is also a small camp deposit here as well as some stone rings. A photograph of one of the rings shows a large circular row of stones some 10 feet in diameter, which apparently once rose to a height of 2 to 3 feet.

Wa-35 — Court of Antiquity, Steward 204 (figs. 115-117; pl. 14b, c)

The Truckee River begins as an outlet for Lake Tahoe and runs from there eastward into Pyramid Lake. After flowing out of the Sierra Nevada, the river comes out into the flat of Truckee Meadows at Reno. East of Truckee Meadows it passes through a narrow gorge separating the Pyramid Range on the north from the Virginia Range on the south, and then eastward to the flat country around Wadsworth.

At the western mouth of the canyon, some 8 miles from Reno, the river comes through an especially narrow place (fig. 14). On the southern bank, a 20- or 30-foot-wide floodplain borders the river before the Virginia Mountains rise abruptly. On the north bank, the flood plain is at one point only about 5 feet wide and is bordered by a rhyolite terrace 2 feet high. Ten feet back of the terrace is a second terrace rising some 6 feet. The second terrace extends

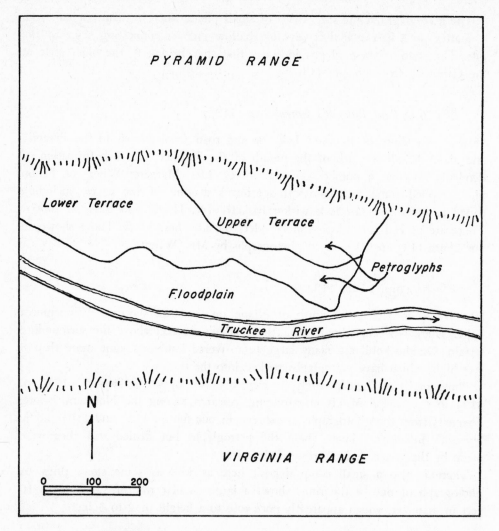

FIG. 14. Court of Antiquity petroglyph site (Wa-35).

north 20 feet where the steep slope of the Pyramid Range begins. The petroglyphs are found on the horizontal surfaces of the two cliff terraces and on the vertical face of the upper terrace.

The Court of Antiquity site is admirably placed for a game ambush site. Since the canyon of the Truckee River is the best trail between Truckee Meadows and the flatland to the east, it was almost certainly used by migratory animals, either deer or antelope or both, in prehistoric times. Animals on the north side of the river, moving either east or west, would be crowded between the river and the rhyolite terraces at the petroglyph site, and here they could be killed by hunters standing above on the terraces.

Wa-67 (fig. 118*c*)

On the tufa on the northwest corner of Pyramid Lake there are red painted pictographs. Those shown in our figure 118*c* are taken from a photograph by Mrs. Margaret Wheat. No other information on the site is available.

Wa-68 — Verdi (fig. 118*d, e*; pl. 5*b*)

At Verdi there is a single large granite boulder near the Truckee River covered with petroglyphs. Both Steward and Mallery knew of the site but had no illustrations of it (see Steward, p. 141, under site 204 Pt.). The petroglyph shown in our figure 111*e* is from a photograph taken by Martin Mortensen of Verdi in about 1925. The designs are quite clear in this photograph, but ones taken in 1958 (fig. 118*d*) indicate that the glyph has much deteriorated in the intervening years. James (1921, p. 27) says that the Washo "showed me rocks near to the present town of Verdi, on the line of the Southern Pacific, on which their ancestors had made certain inscriptions *which they interpreted* (italics ours) as warnings to the Paiutis not to dare trespass beyond that sign, and the Paiutis had similar notices inscribed upon boulders near to their boundary lines." While we do not doubt that James was told this by Washo Indians, it is worth noting that the Paiute-Washo boundary is not near Verdi, and the phrase "which they interpreted" sounds very much like an Indian explanation to the white man which was only a guess.

Wa-69 — Massacre Lake (figs. 119-125, 126*a, b*; pl. 10*a*)

The Sheldon National Antelope Refuge is an area 40 miles long and 25 miles wide in Northern Washoe County and northwestern Humboldt County, set aside by the federal government for the protection of antelope herds. A series of five petroglyph sites is known in around the Sheldon Refuge. One of these (Wa-69) was reported by D. W. Ritter of Chico, California, who was kind enough to make his extensive photographic record available to us. Figures 119-125 and 126*a* and *b* were taken from Ritter's photos. The other four sites (Wa-135, -137, -139, and -142) lying within the boundaries of the Sheldon Refuge were made known to us by B. M. Hazeltine, Refuge Manager. In September, 1958, A. B. Elsasser and J. T. Davis of the University of California Archaeological Survey visited the sites on the Refuge, recorded the petroglyphs found there, and at the same time obtained information on the migration habits of the antelope.

The precise trails used by the antelope — if indeed they use the same trail year after year — are not known, but a general idea of the animal's movements is given in figure 15. The summer herd gathers in the country around Swan Lake Reservoir. The land here is at high elevations, 6,500 feet and higher, so that browse is available throughout the summer months. Between October 15

FIG. 15. Petroglyph sites and antelope migration routes in northeastern Nevada.

and November 1 the antelope leave the Swan Lake area for winter range. One herd goes south (of Sheldon Refuge) to winter in the country south of Massacre Lake. A second route is northward along Swan Lake Creek, through Catnip Canyon, and northeast to Sagehen Spring. At Sagehen Spring the route is intercepted by another trail from the north, a trail used by a herd summering in Oregon, and then moving south to winter in Nevada. From Sagehen Spring both herds, the Oregon herd and the Swan Lake herd, go east to the winter range at Big Spring Table. Some of the antelope wintering at Big Spring Table and summering at Swan Lake use an alternative migration route. When they leave Swan Lake, instead of going north through Catnip Canyon, they go due east to Gooch Table before turning north to Big Spring Table. Gooch Table is apparently an intermediate range; the animals stay there a few days or weeks before going on to their proper winter range. The winter ranges, both at Big Spring Table and at Massacre Lake, are occupied until spring. Between March 1 and March 15 the animals leave the winter range and, by the same routes, return to summer range around Swan Lake.

The known petroglyph sites in the area occur along the migration routes. North of Swan Lake Reservoir there are three sites in the canyon of Swan Lake Creek (Wa-135, -137, -139) which is known to be a segment of the migration route. South of Swan Lake Reservoir, site Wa-142 is in the vicinity of a migration route, but the exact location of the trail here is not known. Site Wa-69, about halfway between Massacre Lake and Swan Lake Reservoir, consists of a large series of petroglyphs found on the face of a basalt outcrop. The outcrop stretches continuously north and south for more than a mile here, and petroglyphs are found sporadically along its entire length. The petroglyphs shown in figures 119-125 and 126a and b are given in their sequence of occurrence from south to north. It may be that the basalt outcrop flanks the migration route between Swan Lake and Massacre Lake but this is not certainly known, since the exact location of the trail is not recorded.

Wa-119

This site is on the southern flank of Peavine Mountain a few miles west of the Nevada-California state line and a mile north of Highway 40. Mrs. Ralph W. Smith of Reno, who discovered the site, says that to find the site one leaves the highway (40) and takes the road opposite River Bend leading about a mile above Louis Canepa ranch. She goes on to say,

To the best of my knowledge these are the only petroglyphs on Peavine Mountain. They cover the surface of the multiple pitted boulder. Although we had ridden past them hundreds of times it was not until the light was just right one December morning at 7 o'clock that they revealed themselves.

The design elements consist of circles and lines, appearing to be "stick men" and also possibly phallic symbols. They are older than the grinding pits on the big flat boulder, for these holes have destroyed parts of the designs and others are mostly obliterated by erosion of the granite surface.

From Mrs. Smith's description it seems clear that these petroglyphs are in the pit-and-groove style, the older style at the Grimes site (Ch-3).

Wa-130

Central Lake is a small playa lake in northern Washoe County, 35 miles south of the Oregon border and 9 miles east of the California border. There is said to be a petroglyph site in a canyon south of the lake. No other details are available.

Wa-131 — Pipe Spring (fig. 126c-g; pl. 15a-e)

The Smoke Creek Desert extends north of Pyramid Lake for some 30 miles. Five miles west of the desert at a point about 12 miles north of Pyramid Lake there is a high valley a thousand feet or more above the desert. The valley is

some 4 miles in length (east-west) and 2 miles wide. In the valley near its west end is a rocky butte rising 40 feet above the floor. On the southern rim of the butte there is a seep spring and catchment basin (evidently dry in summer) and a wash thence out into the valley. Pecked petroglyphs are found here on vertical faces around the margin of the basin.

There is a differential patination here between certain of the glyphs, a possible indication of difference in age. The elements are shown in our figure 126e.

Wa-135 (fig. 127b)

A few petroglyphs are to be found on the wall of a small shelter in a rock face 2 miles north of Swan Lake Reservoir in northern Washoe County (fig. 15). They are pecked into basalt rock on the west side of the canyon here. The glyphs are shown in our figure 127b. The canyon here is known to be a trail for migrating antelope (see discussion under site Wa-69 above).

Wa-137 (fig. 127c-l)

There are pecked petroglyphs on a basalt face on the east side of the canyon of Swan Lake Reservoir (fig. 15). They are shown in our figure 127c-l. The canyon here is a migration route for antelope (see discussion under Wa-69 above).

Wa-139 (figs. 127a, 128a-f, 129h-j)

There are pecked petroglyphs on a basalt face on the east side of the canyon of Swan Lake Creek 1.5 miles north of Swan Lake Reservoir (fig. 15). They are shown in our figure 127c-l. The canyon here is a migration route for antelope (see discussion under Wa-69 above).

Wa-142 (figs. 128g-j, 129a-g)

There a few pecked petroglyphs on a rock face on the crest of a low hill 1.5 miles southwest of Swan Lake Reservoir (fig. 15). The possible relationship of this occurrence with antelope migration routes has been discussed under Wa-69 above.

WHITE PINE COUNTY

In White Pine County a number of pictograph caves are known from Baker Creek near Lehman Caves National Monument. We quote here from Steward (1929, pp. 145-146), who cites the *Nevada State Journal* (newspaper) of August 24, 1924:

216 Pc. Ely. Nevada. — Pictures painted but not incised upon the walls of several caves bearing evidence of human occupation in the way of a large number of artifacts of various sorts.

The pictures are located in a series of caves on Baker Creek, White Pine County. The caverns are a mile and a half from Lehman caves. The caves containing the pictographs are three in number, the middle one however being, strictly speaking, a deeply receding rock shelter. Cave number three, so designated in the report of Drs. Chappelle and Fransden to Governor Scrugham, is the most important of the three from the point of view of the petroglyphs [pictographs?] already exposed. The realistic representations of Rocky mountain sheep in black are unusually striking. The older drawings in the cave are red, geometric forms, conventionalized figures and realistic portrayals of animals. Pictographs of the human hand in red also occur. The drawings in this cave extend to its innermost recesses and some of them have been uncovered by partial excavation along the right hand wall. Still more drawings have been found as the excavation work proceeds and remnants of crude pottery, teeth, bones and bits of flint are uncovered daily. Cave number two has for its chief drawing card, eight circular marks and a series of lines in red on the right wall. Cave number one is richly decorated with drawings in red ocher which represent primarily conventionalized human figures and counting signs. The former are represented in groups on the flat rock surfaces to the right of the entrance on the lower levels. They have been partially destroyed through erosion. Larger figures of the same type and material appear in an excellent state of preservation on the upper levels. On the surface facing the interior of the cave the drawings are very numerous, both in red and black. To the left of the entrance the red ocher drawings are also numerous, although many of them have been partly defaced by vandals of present years. Perhaps the most striking figure of this cave is a representation of a reclining human being drawn in red. All of the pictographs are formed by colors laid on the flat rock surfaces. There are no pecked or incised forms. The materials used in their production are red ocher (hematite) for the greater part of cave number one, for all the markings in cave number two, and for about one-third of the drawings exposed in cave number three. The blacks are made up of ochers, dyes extracted from plants possibly, and charcoal. They are most richly represented in cave number three. The drawings in red appear to be the oldest as is shown in the numerous cases of superimposition. All are monochromes with the exception of one pictograph which appears to be a polychrome.

From other sources (E. P. Harrington, 1933; Lange, 1952) we have been able to identify two of the caves mentioned above. These are discussed below under site numbers Wh-3 and Wh-12. Other caves on Baker Creek are also known (Lange, op. cit.), but their pictographs (if they exist) are not recorded.

The archaeology of the Baker Creek caves has been investigated by both Wheeler (1937, 1939) and M. R. Harrington (1934). Harrington recovered chipped stone implements, mammal bones, fire-cracked rocks, and other evidence of habitation in Upper Baker Creek Cave (Wh-3), but there is no pottery or other evidence of Puebloid culture, which one would expect from the Katchina-like pictographs found in the cave. There is, however, a large Puebloid site less than 10 miles from the caves (Wheeler, 1936, 1937), indicating an intensive Puebloid occupation in the vicinity of Baker.

Wh-3 — Steward 216 (fig. 130*a-i*)

This site is probably M. R. Harrington's (1934) Upper Baker Creek Cave and the middle one of the three caves mentioned in the *Nevada State Journal* of August 24, 1924 (Steward, 1929, p. 145). The cave is on the north side of Baker Creek, about 6 miles above the town of Baker and only about a mile and a half from Lehman Caves.

Lange (1952) says of the cave, "It is an essentially horizontal cave about 75 feet deep. . . . Pictographs occur on walls in many places, and most of these are believed genuine, although in cases touched up."

Both E. P. Harrington (1933) and Vogel (1952) present illustrations of the pictographs in this cave. Harrington's are shown in our figure 130*a*, and Vogel's in our figure 130*b-i*. The Katchina figures holding hands are evidently representations of the same figure, but no further identifications can be made. The pictographs are said to be either in burnt sienna (fig. 130*b-e*, *g*, *h*) or in black (fig. 130*f*, *i*).

Wh-11 — Tunnel Canyon (fig. 130*k*)

This site is recorded by Malouf (1946). He says of it (p. 118):

Pictographs and petroglyphs are fairly abundant in the surrounding hills. In Tunnel Canyon, about thirteen miles west of the Deep Creek range, near Tippets, Nevada, there are several small groups of pictographs, most of which are painted in red. . . . The largest group is located in a small recess just 500 yards from the mouth of the canyon, but a few others are scattered up the canyon walls nearly to the summit of the range.

Malouf's figure 45*b* is reproduced here as figure 130*k*.

Wh-12 (figs. 130*j*, *l*, 131*a*, *b*)

A short distance downstream from the main pictograph cave on Baker Creek is another cave, also with painted pictographs. Drawings of some of these were made by E. P. Harrington (1933) and also by Vogel (1952). The drawings of both are shown in our figures 130*j* and *l* and 131*a* and *b*.

Wh-13 — Katchina Rock Shelter (fig. 131*c-f*)

This site is about one and one-quarter miles above the mouth of Smith Creek Canyon (about 35 miles north of Baker). Some Katchina figures are found on the walls of the shelter. They are illustrated by M. R. Harrington (1932) and are shown here in figure 131*c-f*. The height of these figures is, respectively, 12.5 inches, 16 inches, 11.5 inches, and 13 inches.

Harrington performed minor excavations here which yielded evidence of fire, cracked deer bone, and a single corncob.

Wh-14 — Chokecherry Creek (fig. 131g)

This site is at the head of Chokecherry Creek, six miles southwest of the Goshute Indian Agency at Ibapah, Utah. Reagan (1934, p. 43) describes the site:

The pictographs are exposed in a cliff-cave. The cave is in yellow limestone in a branch canyon on the west side of the upper headwaters of Choke-cherry Creek. The mouth of the cave faces the south, is forty feet long and ten feet high, but the roof pitches to the floor twenty feet inward. The drawings are on the back, upper wall. They are made of large, wide, heavy lines, blotches, and crude drawings in red, yellow, and blue — apparently of mineral paint. Besides these the whole roof-face is run over in almost all directions by numerous black lines drawn in a promiscuous manner and apparently without any design. The surface on which the drawings are made is much weathered and some of the pictographs can hardly be made out, or are entirely obliterated.

Reagan shows a drawing of the pictographs, here reproduced as figure 131g.

Wh-15 — Mosier Canyon (fig. 131h)

In Mosier Canyon six miles east of Ely there are painted pictographs. These were photographed by Mrs. Ralph W. Smith of Reno. Figure 131h is taken from Mrs. Smith's photograph, and her description of the site follows:

These red pictographs occur on an insloping face of a huge granite boulder. Hard by another boulder shows faint red remains of another pictograph panel which has been eroded away. The figures range in size from 4 to 13 inches and some are in outline, others painted solid.

The surface of the ground in this canyon is profusely strewn with crumbling stones from the surrounding heights, thereby making it impossible to find any artifacts. At the present time (1949) there is no water here, the nearest source being a spring near the head of Mosier which is separated a half mile or so from the site by a deep spur.

III
Elements
and Their
Distributions

For a total of 71 Nevada petroglyph sites we have either drawings or photographs showing the glyphs. Since some of the sites have hundreds of rocks covered with glyphs, the total amount of pictorial evidence is very great. Our aim is to divide this material into categories, called styles, which have differences in distribution, either chronological or geographical or both. Definition of styles requires a preliminary step: analysis of the corpus of materials into design elements. To perform this analysis we have constructed a typology of 58 elements (table 2). Our typology is basically a modification of that proposed by Steward (1929) for the petroglyphs of the western United States. We have added some new elements and have modified or subdivided others until we feel the classification is suitable for known Nevada petroglyphs.

The problem of typology has been refractory. Designs which obviously represent something in the real world are not difficult to deal with, but nonrepresentative designs resist categorization. For the nonrepresentative designs, therefore, we resort largely to intuition — we simply group those which seem to us to be similar. Since others will not always agree with our classification or judgment, we present black-and-white drawings of all Nevada glyphs for which pictorial record was available. We have tried, on the whole, to split rather than lump in our classification, and hence we probably have more elements than are necessary in the definition of styles. This is unavoidable, though, since we cannot tell a priori which distinctions will be culturally meaningful; if we could we would not have to go through this phase of analysis.

We present here the 58 elements with brief descriptions, references to figures, and maps showing the geographic distribution of the elements. On

TABLE 2

DESIGN ELEMENTS OF NEVADA PETROGLYPHS

Element	Figure number	Element	Figure number
1. Circle	16a	30. Star or asterisk	23b
2. Concentric circles	16b	31. Ladder, one pole	23c
3. Bisected circle	16c	32. Ladder, two poles	23d
4. Sectioned circle	16d	33. Rake	24a
5. Spoked circle	17a	34. Rain symbol	24b
6. Spoked concentric circles	17b	35. Rectilinear meander	24c
7. Tailed circle	17c	36. Chevrons	24d
8. Circle and dot	17d	37. Radiating dashes	25a
9. Circle cluster	18a	38. Crosshatching	25b
10. Connected circles	18b	39. Plant form	25c
11. Chain of circles	18c	40. Bird	25d
12. Sun disc	18d	41. Lizard	26a
13. Spiral	19a	42. Mountain sheep	26b
14. Curvilinear meander	19b	43. Sheep horns	26c
15. Convoluted rake	19c	44. Quadruped (not sheep)	26d
16. Connected dots	19d	45. Snake	27a
17. Dumbbell	20a	46. Many-legged insect	27b
18. Dots or dot design	20b	47. Foot or paw	27c
19. Wavy lines	20c	48. Hand	27d
20. Deer hoof	20d	49. Human	28a
21. Oval grid	21a	50. Horned human	28b
22. Rectangular grid	21b	51. Human stick figure	28c
23. Blocked oval	21c	52. Human, stick limbs	28d
24. Cross	21d	53. Katchina figure	29a
25. Bird tracks	22a	54. White man	29b
26. Parallel straight lines	22b	55. Atlatl	29c
27. Triangles	22c	56. Arrow	29d
28. Lozenge chain	22d	57. Deer	30a
29. Zigzag lines	23a	58. Fish	30b

the distribution maps each known petroglyph site is represented by a dot; sites with the element in question present are shown as ringed dots. The designation of any site can be determined by referring to the key map (fig. 1). In the following lists the numbers in parentheses give the number of examples of the element in the entire corpus. In Appendix G are given the number of examples of the element at a given site or on a specific figure.

1. *Circle* (443). Circles are among the simplest elements in the corpus. Designs so designated occur alone rather than in clusters or chains, which form distinct elements listed below. Geographic distribution of these elements is shown in figure 16a.

2. *Concentric circles* (139). Concentric circles have from two to six or eight constituent circles. Concentric semicircles are also included here. Many seem to be semicircles merely because they are cut off by the edge of a rock. Geographic distribution is shown in figure 16b.

3. *Bisected circle* (98). Bisected circles have single lines running through them. The line may terminate at the perimeter of the circle or may extend beyond the perimeter. Geographic distribution is shown in figure 16c.

4. *Sectioned circle* (8). In these designs the circle has two or more straight lines running through it, dividing it into sections or sectors. Geographic distribution is shown in figure 16d.

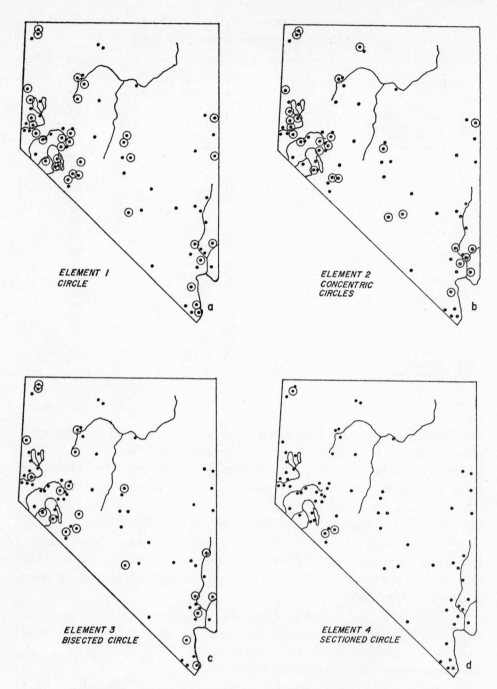

FIG. 16. Distribution in Nevada of petroglyph elements 1-4.

5. *Spoked circle* (11). The circles in this element have three or more lines radiating from the center of the circle to its perimeter. Geographic distribution is shown in figure 17*a*.

6. *Spoked concentric circles* (17). This is merely a combination of elements 2 and 5. Geographic distribution is shown in figure 17*b*.

7. *Tailed circle* (163). This element consists simply of a circle to which is attached one or more straight or curving lines. The lines are usually short

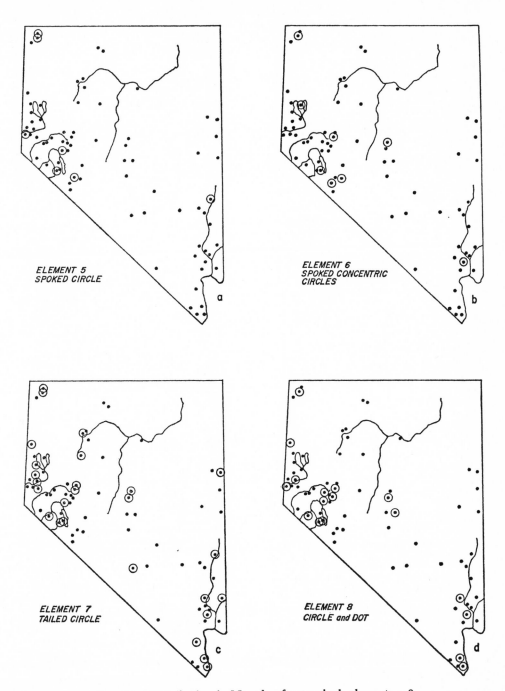

FIG. 17. Distribution in Nevada of petroglyph elements 5-8.

(less than twice the length of the diameter of the circle), but in a few examples they are quite long. In most of the examples there is only one such line, but in a significant minority there are two lines, and a few even have three or more. Geographic distribution is shown in figure 17c.

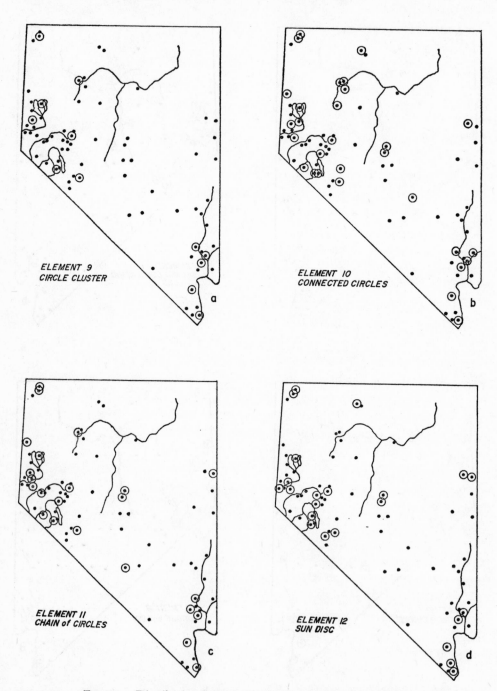

FIG. 18. Distribution in Nevada of petroglyph elements 9-12.

8. *Circle and dot* (60). The circle and dot design is simply a circle with a dot at its center. Geographic distribution is shown in figure 17*d*.

9. *Circle cluster* (28). The circle cluster is a group of three or more circles adjacent to one another, like a bunch of grapes. Geographic distribution is shown in figure 18*a*.

10. *Connected circles* (130). Here the circles are connected by short lines between their perimeters. There may be only two circles so connected, or there may be three, four, or more. Geographic distribution is shown in figure 18*b*.

11. *Chain of circles* (122). This element is a series of two or more circles arranged contiguously so that each circle is adjacent to either two other circles (the interior links) or one other circle (the end links). Geographic distribution is shown in figure 18*c*.

12. *Sun disc* (100). This element is a circle with several lines radiating from its perimeter. Geographic distribution is shown in figure 18*d*.

13. *Spiral* (41). These are single lines coiled around a center point. Geographic distribution is shown in figure 19*a*.

14. *Curvilinear meander* (443). Designs in this category are the most ill-defined in the corpus of Nevada petroglyph material. They consist of a various number of lines wandering, apparently indiscriminately, over a rock surface. It is difficult to believe that rules governed the form in which the designs were made. If any such rules existed they were only loosely applied. Geographic distribution is shown in figure 19*b*.

15. *Convoluted rake* (11). A rake is a design with a horizontal line and other lines descending vertically from it. A convoluted rake is a rake in which one or more of the descending lines or teeth loop back on themselves. Geographic distribution is shown in figure 19*c*.

16. *Connected dots* (22). Dots are small round areas with complete pecking or painting over them. In the present element the dots are connected by lines. Geographic distribution is shown in figure 19*d*.

17. *Dumbbell* (5). A dumbbell is a pair of connected circles in which the circles are pecked over their entire area. Geographic distribution is shown in figure 20*a*.

18. *Dots or dot design* (199). The dots here may be scattered randomly, arranged in lines, or used to block in or stipple an area. Geographic distribution is shown in figure 20*b*.

19. *Wavy lines* (388). Wavy lines are found singly or in parallel series. Geographic distribution is shown in figure 20*c*.

20. *Deer hoof* (34). This element consists of a semicircular or arch-shaped design with a short line segment between and parallel to the arms or piers of the arch. Many examples look very much like a deer's cloven hoof, but it is not, of course, known that this is what they are meant to represent. Geographic distribution is shown in figure 20*d*.

21. *Oval grid* (65). In this element an oval has one or, usually, more lines crossing it but ending at its perimeter. The lines are usually, but not invariably, perpendicular to the long axis of the oval. Geographic distribution is shown in figure 21a.

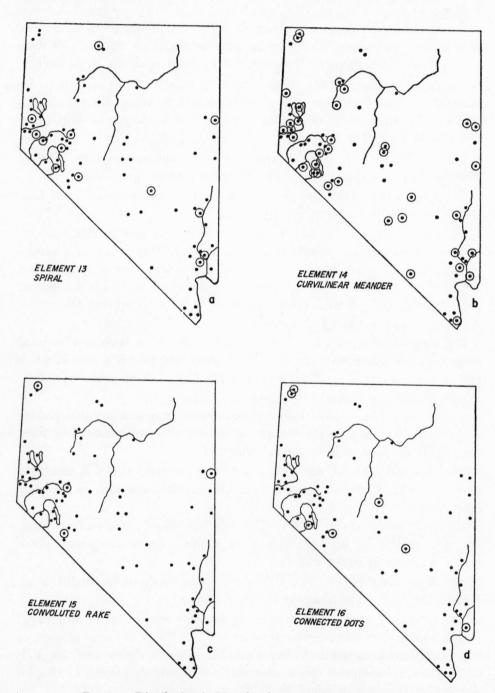

FIG. 19. Distribution in Nevada of petroglyph elements 13-16.

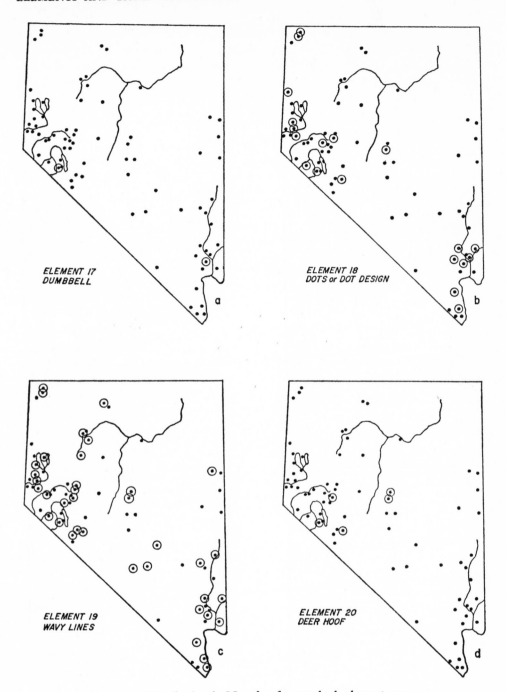

FIG. 20. Distribution in Nevada of petroglyph elements 17-20.

22. *Rectangular grid* (106). This should actually be designated rectangular or semirectangular grid; in many examples one end is rounded, the other rectangular. The truly rectangular figures may or may not be square. If not,

the grid lines are usually parallel to the short sides. Geographic distribution is shown in figure 21*b*.

23. *Blocked oval* (15). This rare element is an oval (sometimes almost a circle) divided into two or more zones, of which part are left unmodified and

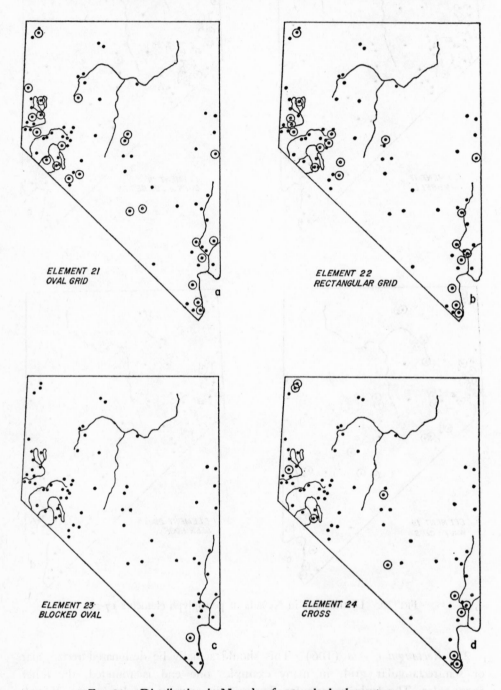

FIG. 21. Distribution in Nevada of petroglyph elements 21-24.

part are pecked. The figure is thus a blocked design ringed by an oval. Geographic distribution is shown in figure 21c.

24. *Cross* (51). The four arms of each cross are usually the same length. Geographic distribution is shown in figure 21d.

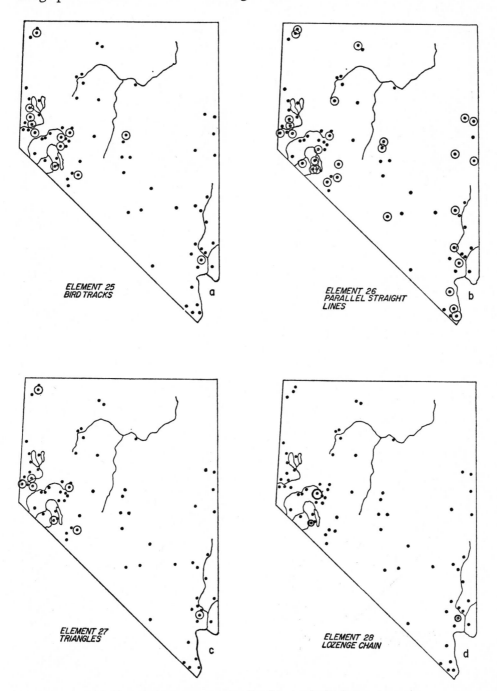

FIG. 22. Distribution in Nevada of petroglyph elements 25-28.

25. *Bird tracks* (35). This element is made up of an arc-shaped or V-shaped line which is bisected by a shorter straight line. The straight line is in the cup of the arc. In some, but not all, examples it extends outward on the convex side of the arc as well. We do not, of course, know whether these

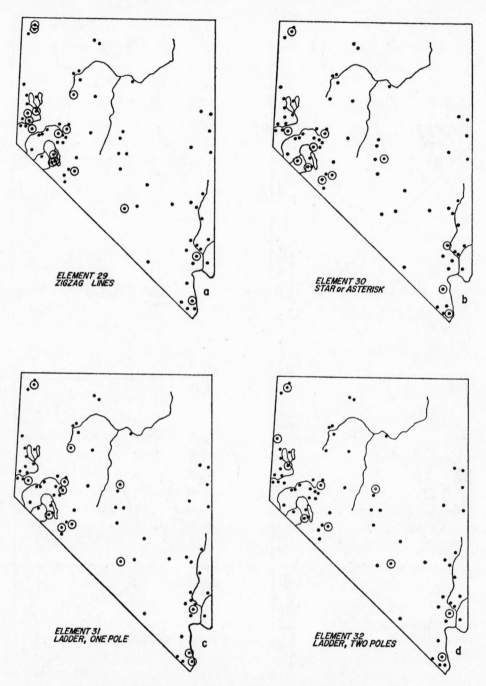

FIG. 23. Distribution in Nevada of petroglyph elements 29-32.

were actually supposed to represent bird tracks. Geographic distribution is shown in figure 22a.

26. *Parallel straight lines* (117). There may be two or more lines in an example of this element. Geographic distribution is shown in figure 22b.

27. *Triangles* (19). The triangles may be blocked solidly or merely outlined. In a few examples the element is a series of triangles arranged as if pendant from a line. Geographic distribution is shown in figure 22c.

28. *Lozenge chain* (5). This is a series of two or more lozenges point-to-point. Geographic distribution is shown in figure 22d.

29. *Zigzag lines* (53). Zigzag lines are simply the rectilinear counterpart of wavy lines. Geographic distribution is shown in figure 23a.

30. *Star or asterisk* (27). Most of these designs are three-stroke asterisks. The few stars are five- or six-pointed and are poorly made. Geographic distribution is shown in figure 23b.

31. *Ladder, one pole* (27). A one-pole ladder is a single long line bisected at right angles by two or more shorter lines. Geographic distribution is shown in figure 23c.

32. *Ladder, two poles* (26). This element is like a true ladder with rungs not extending beyond the poles. Geographic distribution is shown in figure 23d.

33. *Rake* (306). This element is usually a horizontal line with shorter lines extending vertically down from it (in a few examples up). The crossbar is occasionally diagonal rather than horizontal. Geographic distribution is shown in figure 24a.

34. *Rain symbol* (2). This element is similar to a rake but has a curved line attached to the crossbar opposite the teeth. It may be a schematic representation of a mountain sheep. Geographic distribution is shown in figure 24b.

35. *Rectilinear meander* (20). This, like the curvilinear meander, is apparently an indiscriminate effort to fill space, but the lines here are straight and change direction with distinct angularity. Geographic distribution is shown in figure 24c.

36. *Chevrons* (4). The chevrons may appear singly, doubly, or in greater numbers. Geographic distribution is shown in figure 24d.

37. *Radiating dashes* (9). There may be from four to seventeen dashes in an example of this element. Available information suggests that all examples are either scratched or painted (see definitions of styles in chap. iv). We cannot be sure of this, as some of the photographs do not make clear distinctions between pecked and scratched designs. Geographic distribution is shown in figure 25a.

38. *Crosshatching* (113). This element is usually oblique crosshatching. The hatched area may be enclosed by a circle, oval, or rectangle; it may be semi-enclosed by a curvilinear or rectilinear figure; or it may not be enclosed at all. Geographic distribution is shown in figure 25b.

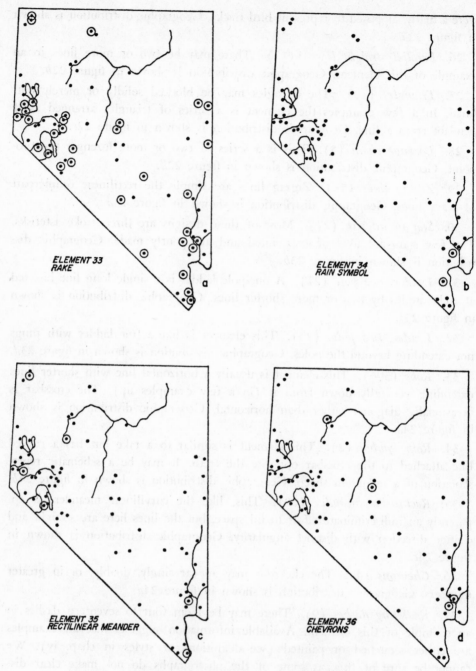

FIG. 24. Distribution in Nevada of petroglyph elements 33-36.

39. *Plant form* (50). Most examples of this element have a long line or stem with shorter lines branching off either side. Whether all such examples are meant to represent plants cannot be determined, but in some the representation seems unmistakable. If the designs are meant to picture an actual plant,

the most probable species is the joint pine (*Ephedra* sp.). The designs bear a specific resemblance to the joint pine, and this plant was known to have been medicinally important to the Indians. It was used as a specific for syphilis, for kidney or bladder disorders, for colds, as a tonic, as a physic, or as a

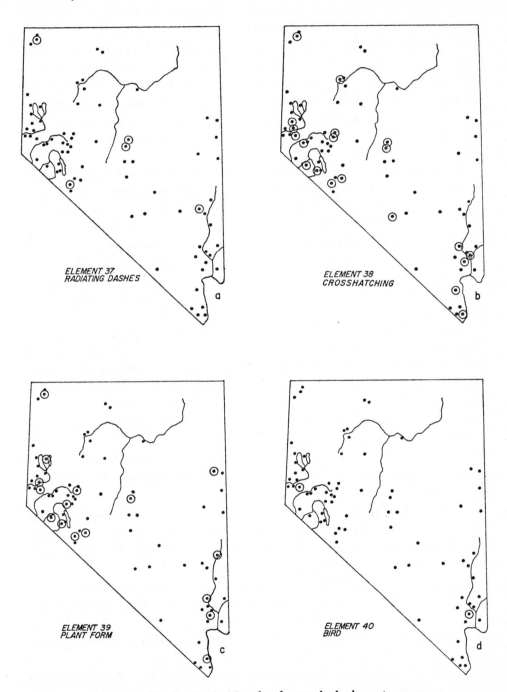

FIG. 25. Distribution in Nevada of petroglyph elements 37-40.

86 ELEMENTS AND THEIR DISTRIBUTIONS

cure for diarrhea (Train, Henrichs, and Archer, 1941, pp. 70, 71). A plant so widely used as medicine may well have had an aura of magic associated with it, making it a subject for petroglyphic portrayal. Geographic distribution is shown in figure 25c.

40. *Bird* (3). Only three bird figures are recorded, and none of the identifications is certain. Geographic distribution is shown in figure 25d.

41. *Lizard* (11). This design represents a four-legged animal with a rather long tail. It is always depicted as viewed from above, with all four legs visible. It is possible that the animal was visualized as split up the middle and stretched out so that its entire surface is viewed at once (as in Northwest Coast art). That the animal is a lizard seems certain in most examples, since it has a long body, short legs, and a long, thin tail. Geographic distribution is shown in figure 26a.

42. *Mountain sheep* (259). Mountain sheep are the most faithfully realistic of any design in Nevada petroglyphs. The usual representation shows them with a heavy body, solidly blocked, with a straight back and rounded belly. All four legs and both horns are nearly always visible. In a few examples the design is merely schematic, with body and legs shown as a stick figure and only the curving horns to identify the animal. Nearly all examples of the design are found in southern and western Nevada; possible significance of the distribution will be considered later. Geographic distribution is shown in figure 26b.

43. *Sheep horns* (20). This element has the appearance of a lower-case omega turned upside down. It has two loops curving outward from a central stem, with the tips pointing back toward the stem. The central stem is sometimes very much elongated. Identification of this design as sheep horns is by no means sure. Geographic distribution is shown in figure 26c.

44. *Quadruped* (not sheep) (78). The designs included here represent several different species. A few may be antelope or deer (cf. Element 57), and others seem to be coyotes or dogs. Others were probably meant to be mountain sheep but do not have the identifying horns; they may be unfinished. Geographic distribution is shown in figure 26d.

45. *Snake* (244). We include here any design having a straight or wavy line and a headlike thickening at one end. Some of these designs are unquestionably meant to represent snakes, and a few even have the rattles of a rattlesnake. Geographic distribution is shown in figure 27a.

46. *Many-legged insect* (28). Most examples of this element have three or more legs on either side at right angles to the body. The body may be simply a line or may be ovoid or subrectangular. A few examples are spiderlike, with legs radiating from a roundish body. Geographic distribution is shown in figure 27b.

47. *Foot or paw* (92). This element usually resembles a bear paw, with a large palm and short toes or claws. Since bears in Nevada are reported

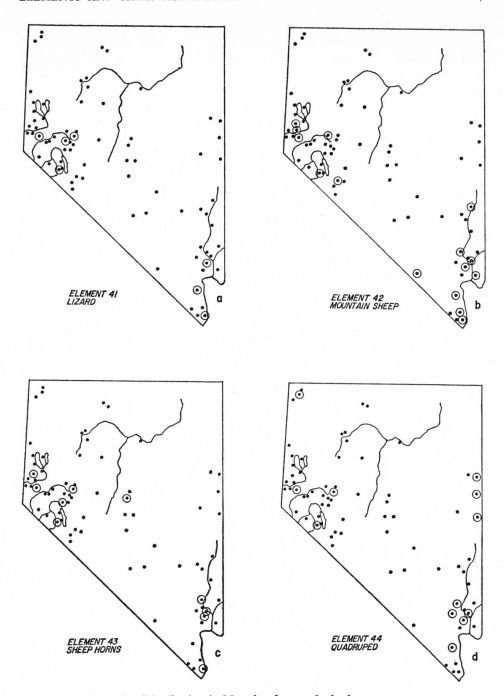

FIG. 26. Distribution in Nevada of petroglyph elements 41-44.

only for the region around Lake Tahoe (Hall, 1946, p. 175), the designs are probably representations of human feet. Geographic distribution is shown in figure 27c.

48. *Hand* (44). The hand element is similar to the foot element but has longer digits. The hand and foot elements are also closely related in occurrence, and may be mere variations of a single theme. Geographic distribution is shown in figure 27*d*.

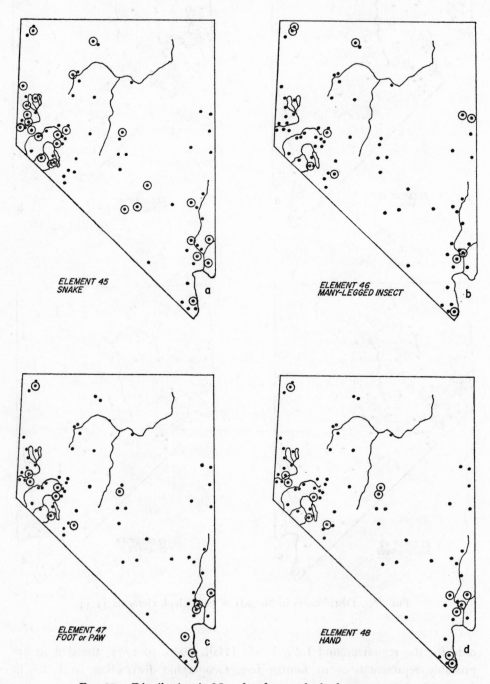

FIG. 27. Distribution in Nevada of petroglyph elements 45-48.

49. *Human* (91). We come now to the first of six elements portraying humans. Element 49 is the least conventionalized or schematic of any of the six except the "white man" figure. Here the body and limbs are shown with proportionally realistic dimensions, not as stick figures. The form is also more

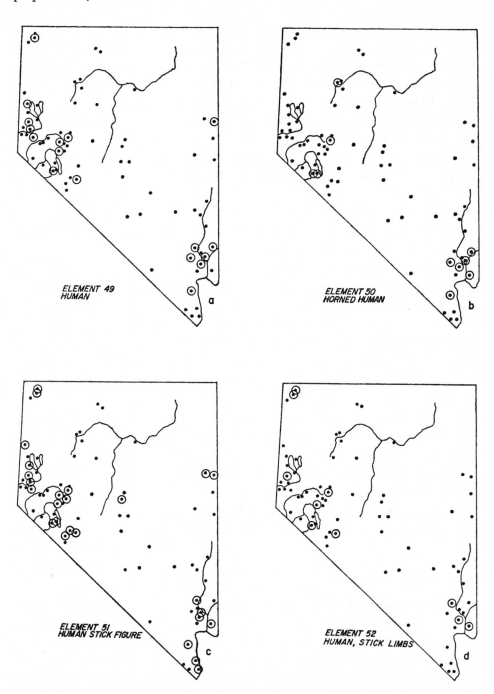

FIG. 28. Distribution in Nevada of petroglyph elements 49-52.

or less realistic, not conventionalized as in the "Katchina" figure. Geographic distribution is shown in figure 28*a*.

50. *Horned human* (33). The humans in this element may be either naturalistic or schematic, but all are distinguished by curved horns projecting from the head. With one possible exception (fig. 93*e*), the horns are always single-pronged, not antlers. It is very probable that this element is meant to represent a man in antelope disguise. Such disguises were used in the Great Basin during the ethnographic period both by shamans in antelope drives and by lone hunters when stalking the animals (cf. Steward, 1933, p. 253; 1938, p. 36; Kelly, 1932, pp. 82-86). If, as we suppose, petroglyphs were employed as hunting magic, then it would be only natural to portray the hunt shaman. Geographic distribution shown in figure 28*b*.

51. *Human stick figure* (258). These are the simplest and most schematic human figures in Great Basin petroglyphs. Geographic distribution is shown in figure 28*c*.

52. *Human, stick limbs* (34). These figures have heads and bodies done in realistic proportions, but arms and legs which are mere lines. Geographic distribution is shown in figure 28*d*.

53. *Katchina figure* (60) These figures are stylized humans, usually with triangular heads and bodies. They are undoubtedly related to the Puebloan occupation of southern Nevada, and will be discussed further in the analysis of styles in chapter iv. Geographic distribution is shown in figure 29*a*.

54. *White man* (10). These may not actually be Caucasians, but they certainly date from the historic period. Some of them are riding or leading horses, one is in a cart, and all are shown wearing sombreros. Geographic distribution is shown in figure 29*b*.

55. *Atlatl* (4). This element is a longish line with a circle near one end. These figures have been thought to be atlatls or throwing sticks. It may be noted that they are virtually identical with designs attributed to the Upper Perigordian of southern France, which clearly represent feathered darts. Geographic location is shown in figure 29*c*.

56. *Arrow* (1). We have record of only a single figure in Nevada petroglyphs seeming to represent an arrow. Geographical location is shown in figure 29*d*.

57. *Deer* (2). In only two instances are animals portrayed with the branching antlers of deer. Geographic distribution is shown in figure 30*a*.

58. *Fish* (3). Only three fish figures are recorded for Nevada petroglyphs. Distribution is shown in figure 30*b*. The painted figure at site Mi-3 (fig. 99*b*) seems to be swimming into the mouth of a stream. Since the site is on Walker Lake, near the mouth of the Walker River, it has been assumed that the river is the stream represented. The fish is probably a trout. Walker Lake trout were evidently very large and were a main source of food for the people living

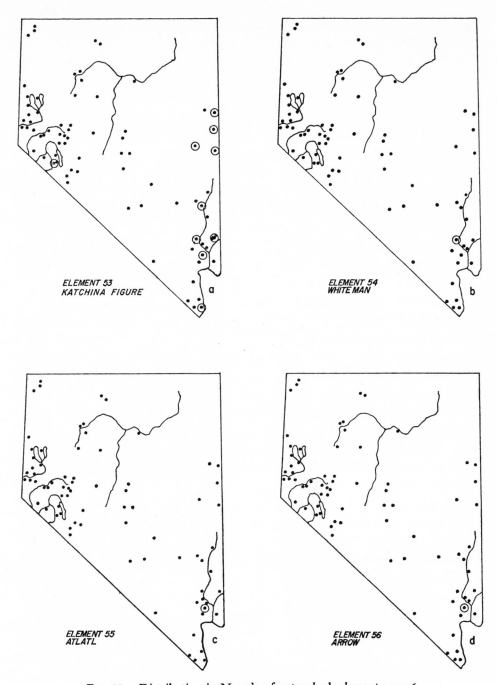

FIG. 29. Distribution in Nevada of petroglyph elements 53-56.

at the mouth of the river; the Paviotso band there was called Aga'idokado or trout eaters (Stewart, 1939, p. 141).

The other two fish figures are from the Massacre Lake site in northwestern Nevada (site Wa-69). One of them (fig. 88f) is only vaguely similar to a

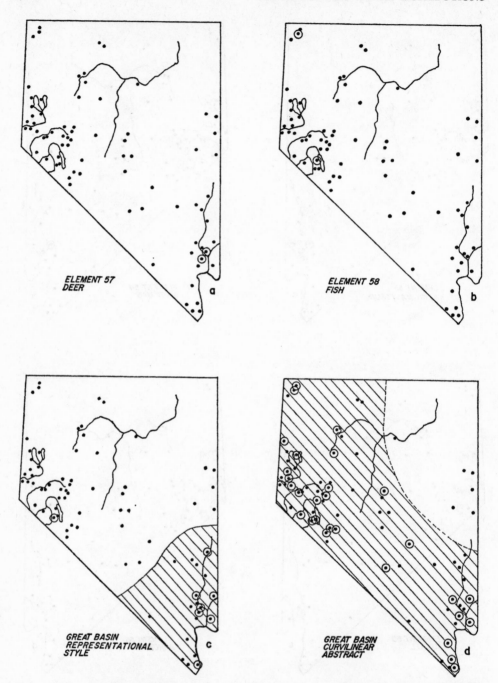

FIG. 30. *a,* distribution in Nevada of petroglyph element 57; *b,* distribution of petroglyph element 58; *c,* distribution of Great Basin Representational style; *d,* distribution of Great Basin Curvilinear Abstract style.

fish. The other (fig. 88*b*) is certainly a fish; in fact it shows considerable anatomical detail. Photographs of the fish figure taken by Dr. D. W. Ritter of Chico, California, were submitted by him to Professor Carl L. Hubbs of the

University of California, La Jolla. We quote here Professor Hubb's letter of December 17, 1958, to Dr. Ritter.

The photographs that you sent me of petroglyphs from the northwestern corner of Nevada in the Massacre Lakes area are indeed very interesting and intriguing. I take it that the petroglyph approaches 6 ft. in length. It is certainly odd to see this with the axis of the fish vertical.

I am sorry to report that I see no way to give a really definitive identification. From a number of circumstances, particularly the slender form, the elevated eye, the long and somewhat pronounced snout, the suggestions of a sucker mouth below the tip of the snout, and the slight suggestions of dorsal and anal fins, all seem to suggest a member of the sucker family more than any other. There is the line from near the margin of the head below the front of the eye to the gill opening that does not seem to represent a large mouth, but rather the lower end of the cheek and opercle region. I do not believe that the fish represents a sucker of the Cui-ui type that is so important to the Indians in the Pyramid Lake and Truckee River area, and also in the Klamath Lake. Nor does it seem to represent any such large fish as a salmon or a sturgeon.

I found no fish life in the region of the Massacre Lakes, that is within the particular drainage involved, except for one population of a very small and common minnow type in Vya Spring. This fish reaches a length of only about 2½ or 3 inches, and I do not believe that the petroglyph represents it, even with any imaginative magnification. However, it is not impossible that a large fish, sucker or other, did occur in the basin during a period of greater rainfall. It was determined by I. C. Russell, in 1884 and 1885, that a large lake existed in this basin, which has generally been called Long Valley. We do not have definitive datings for this lake, but suspect that it existed during the Pluvial period that probably ended around ten or eleven thousand years ago.

Suckers, but none of huge size, still occur, or until very recently did occur, in the basins of Lake Lahontan to the southeast of Long Valley, and in Surprise Valley and tributary waters (I was unable to collect specimens in Surprise Valley, but did take some in Wall Creek, which lies just south of Long Valley). Rather similar suckers also occur in Goose Lake, and in the Warner Lake basin.

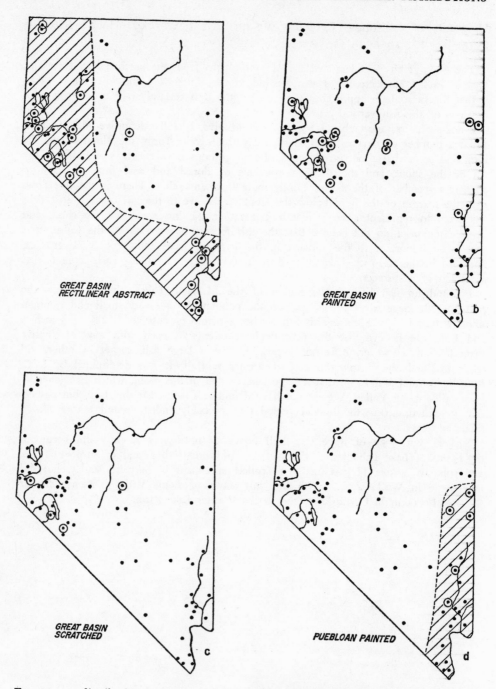

FIG. 31. *a*, distribution in Nevada of Great Basin Rectilinear Abstract style; *b*, distribution of Great Basin Painted style; *c*, distribution of Great Basin Scratched style; *d*, distribution of Great Basin Puebloan Painted style.

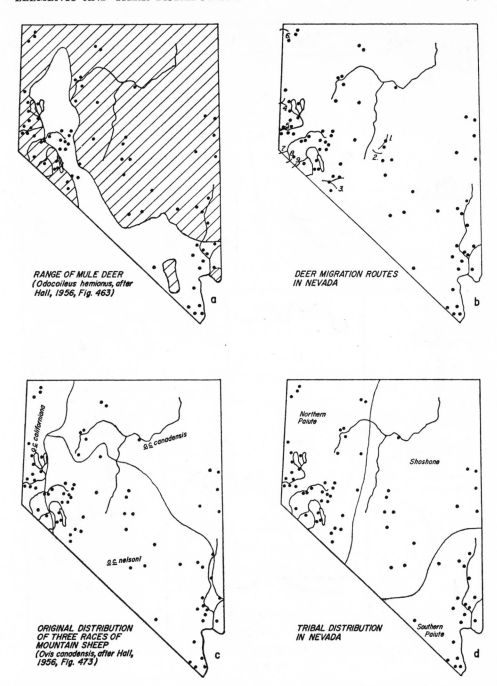

FIG. 32. *a,* range of mule deer in Nevada; *b,* deer migration routes in Nevada; *c,* original distribution of three races of mountain sheep in Nevada; *d,* Indian tribal distribution in Nevada.

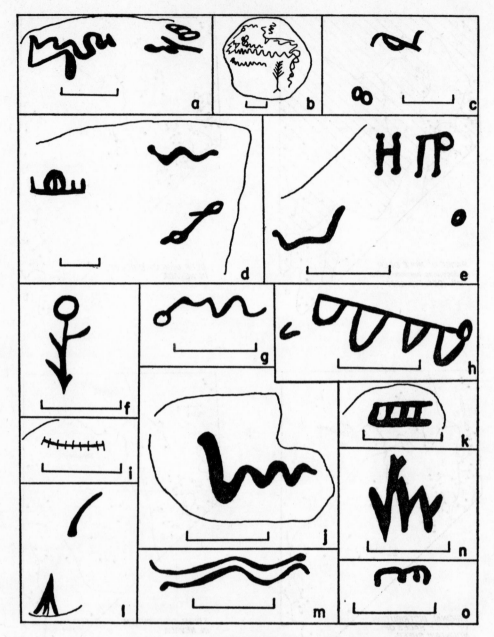

FIG. 33. *a-o*, Ch-3, Grimes site. Scale indicated on this and following figures represents one foot.

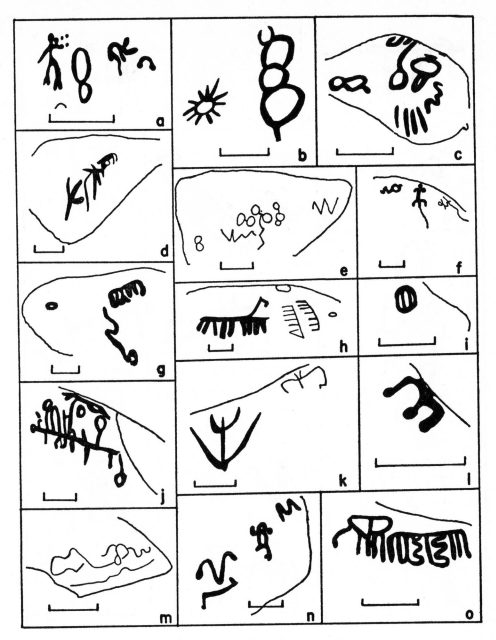

FIG. 34. *a-o*, Ch-3, Grimes site.

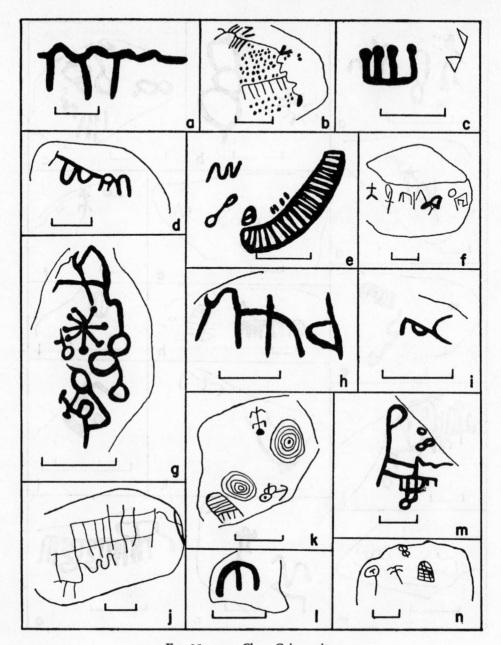

FIG. 35. *a-n*, Ch-3, Grimes site.

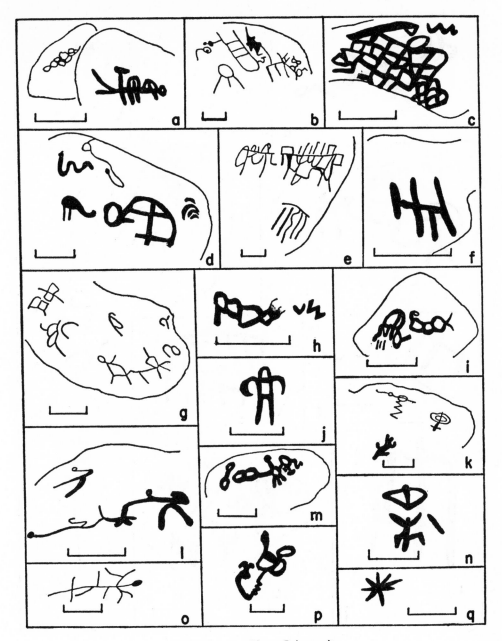

FIG. 36. *a-q*, Ch-3, Grimes site.

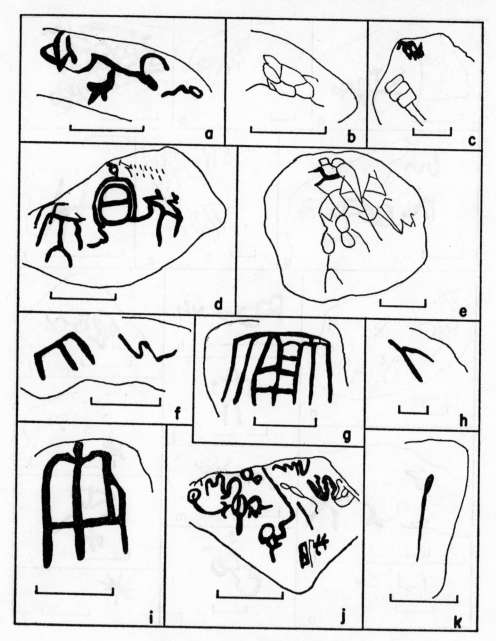

FIG. 37. *a-k*, Ch-3, Grimes site.

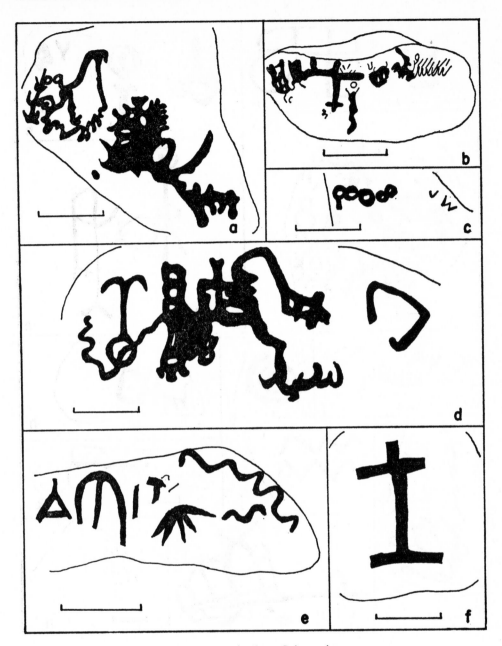

FIG. 38. *a-f*, Ch-3, Grimes site.

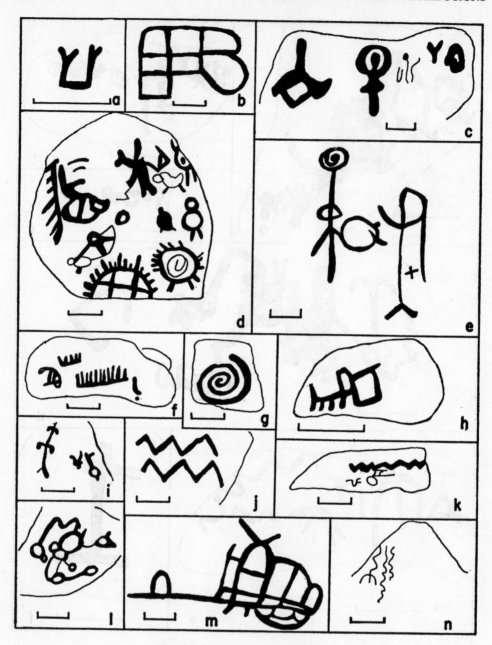

FIG. 39. *a-n*, Ch-3, Grimes site.

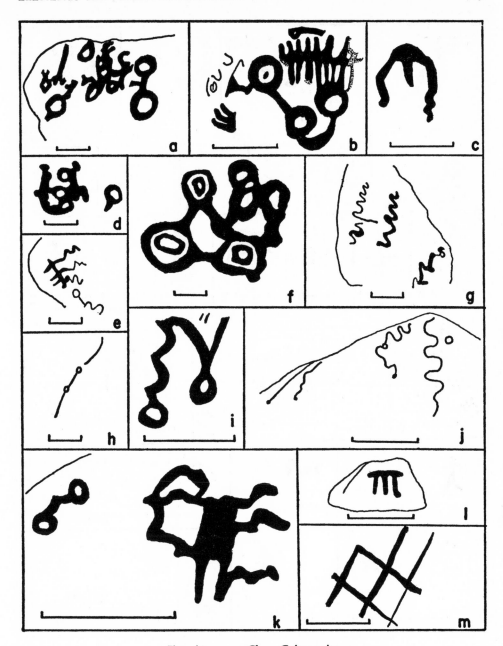

FIG. 40. *a-m*, Ch-3, Grimes site.

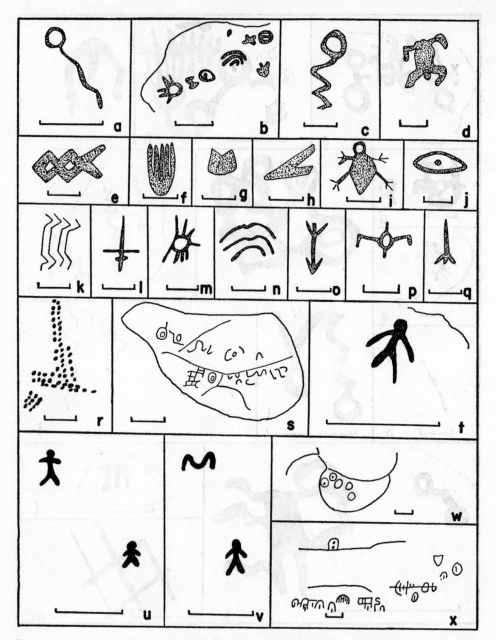

FIG. 41. *a*, Ch-49, Dynamite Cave site; *b-r*, Ch-55, Salt Cave site; *s-x*, Ch-57, Allen Springs site.

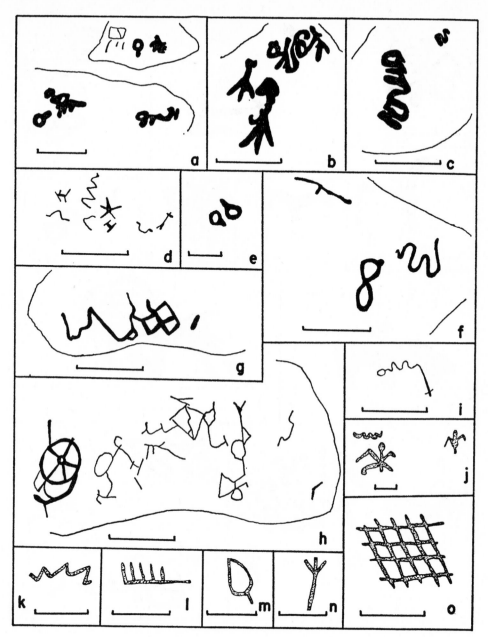

FIG. 42. *a-f*, Ch-16, Hidden Cave site; *g-i*, Ch-20, Fish Cave site; *j*, Ch-26, Burnt Cave site; *k-o*, Ch-49, Dynamite Cave site.

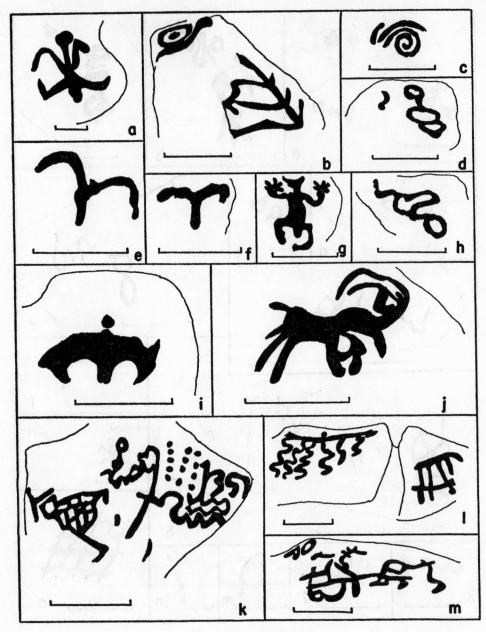

FIG. 43. *a-m*, Ch-71.

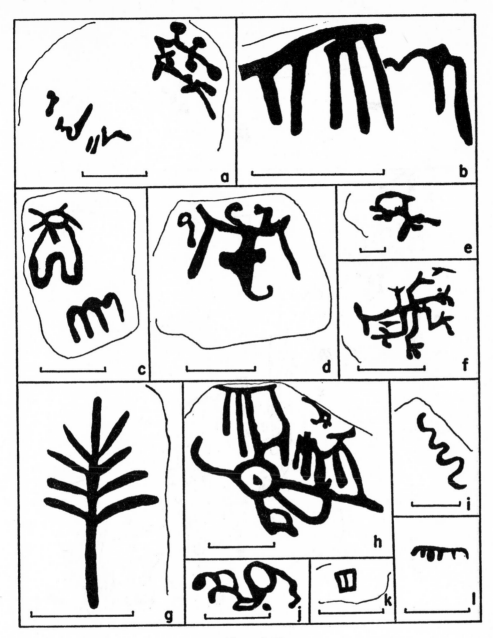

FIG. 44. *a-l*, Ch-71.

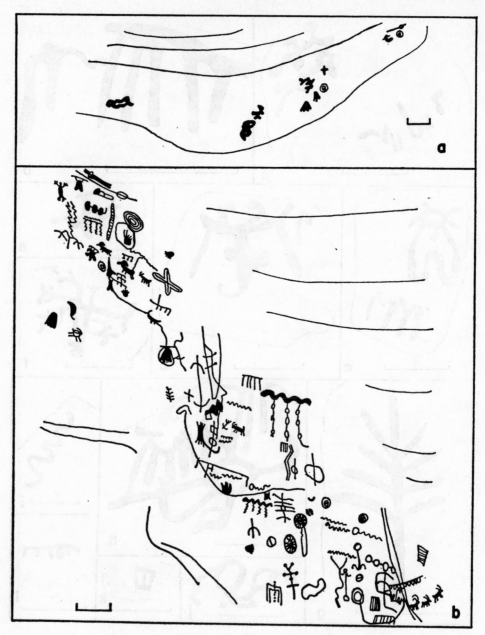

FIG. 45. *a-b*, Cl-1, Valley of Fire, Atlatl Rock site.

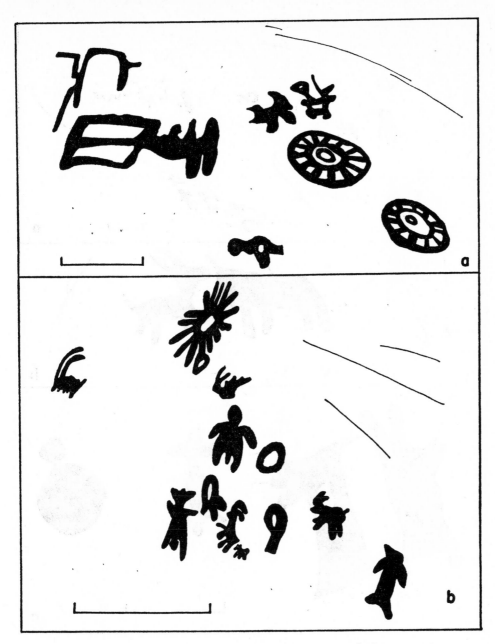

FIG. 46. *a-b*, Cl-1, Valley of Fire, Atlatl Rock site.

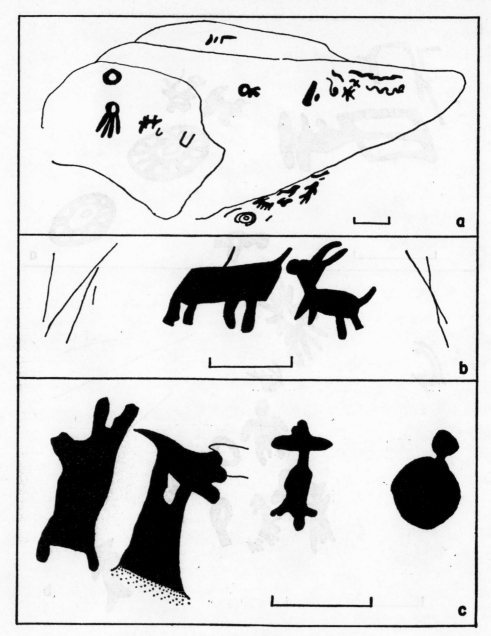

FIG. 47. *a-c*, Cl-1, Valley of Fire, Atlatl Rock site.

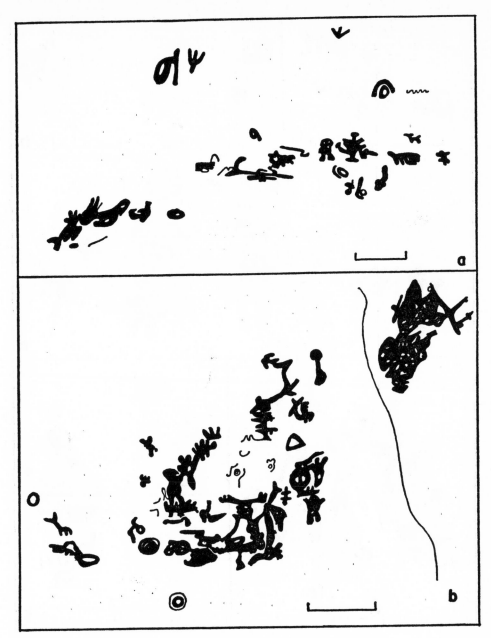

FIG. 48. *a-b*, Cl-1, Valley of Fire, Atlatl Rock site.

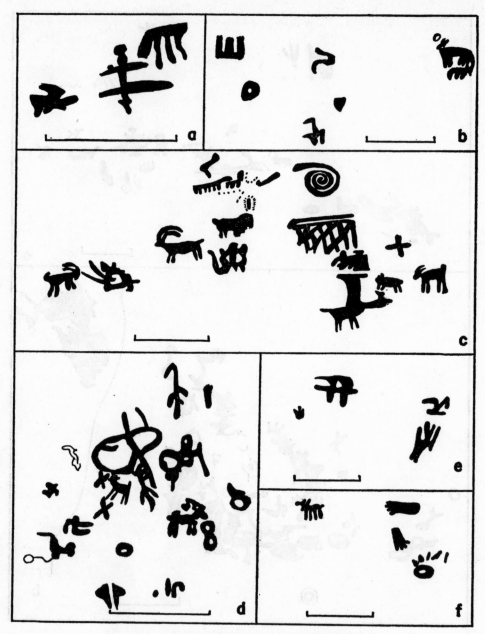

FIG. 49. *a-f*, Cl-1, Valley of Fire, Atlatl Rock site.

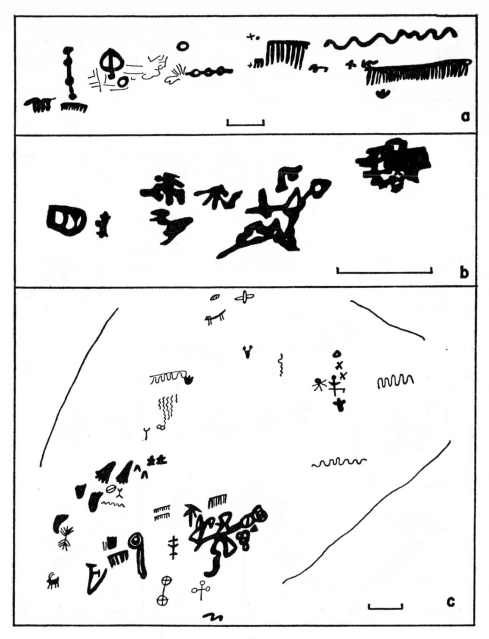

FIG. 50. *a-c*, Cl-1, Valley of Fire, Atlatl Rock site.

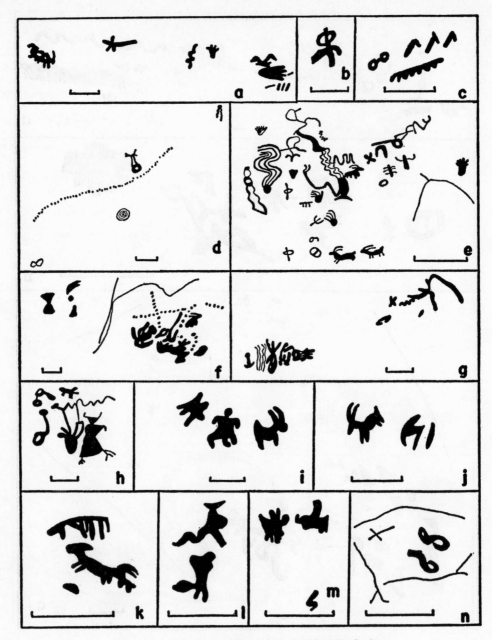

FIG. 51. *a-n*, Cl-1, Valley of Fire, Atlatl Rock site.

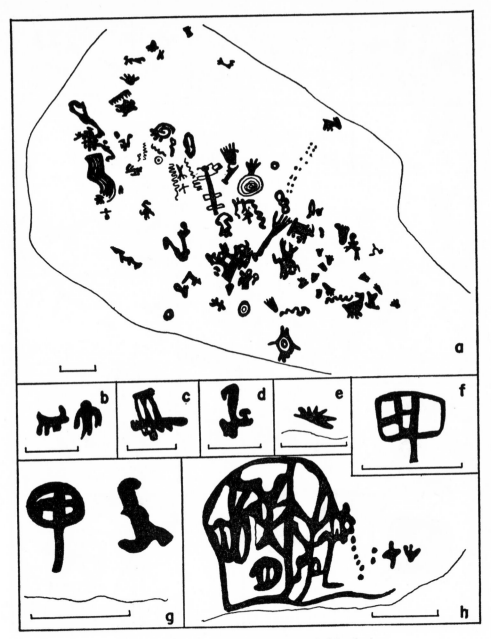

FIG. 52. *a-h*, Cl-1, Valley of Fire, Atlatl Rock site.

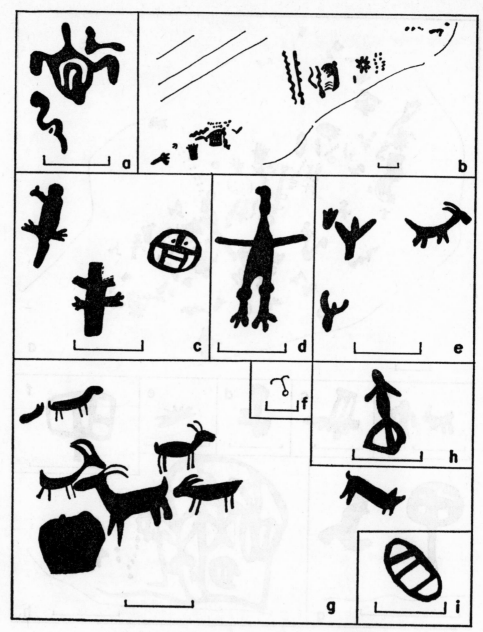

FIG. 53. *a-i*, Cl-1, Valley of Fire, Atlatl Rock site.

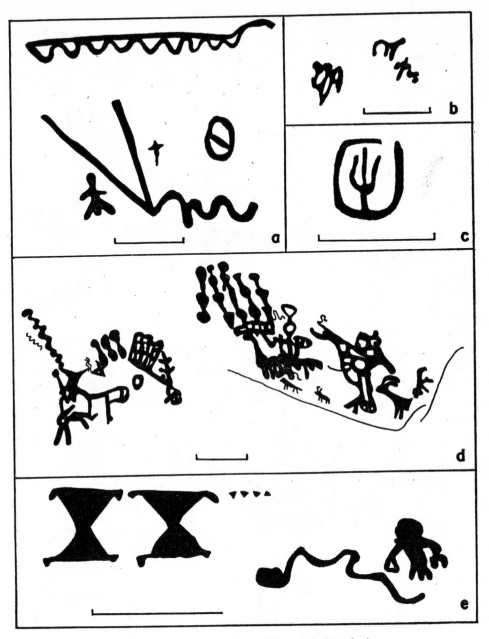

FIG. 54. *a-e*, Cl-1, Valley of Fire, Atlatl Rock site.

118

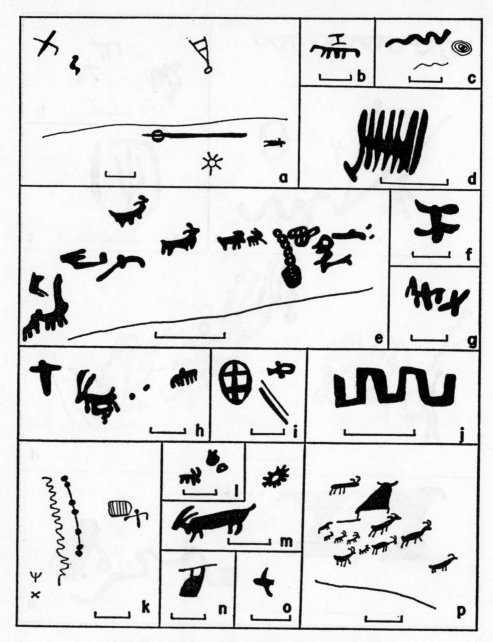

FIG. 55. *a-p*, Cl-1, Valley of Fire, Atlatl Rock site.

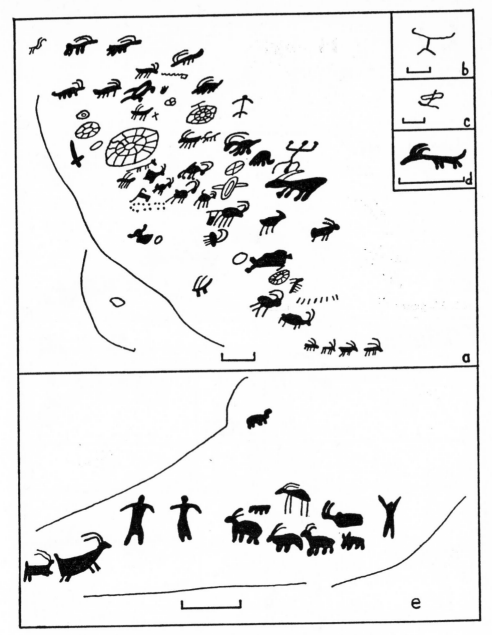

FIG. 56. *a-e*, Cl-1, Valley of Fire, Atlatl Rock site.

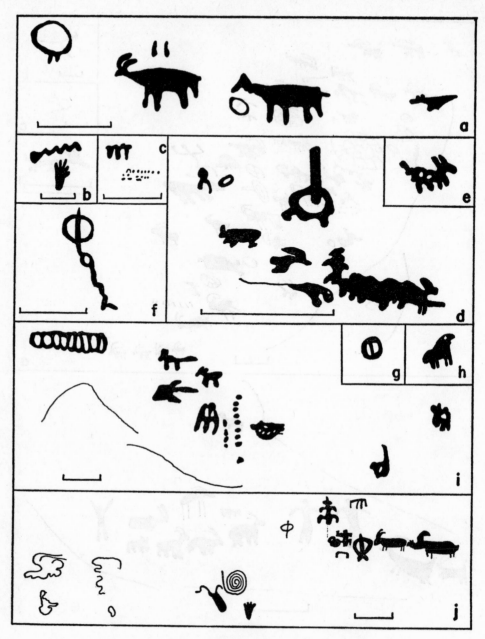

FIG. 57. *a-j*, Cl-1, Valley of Fire, Atlatl Rock site.

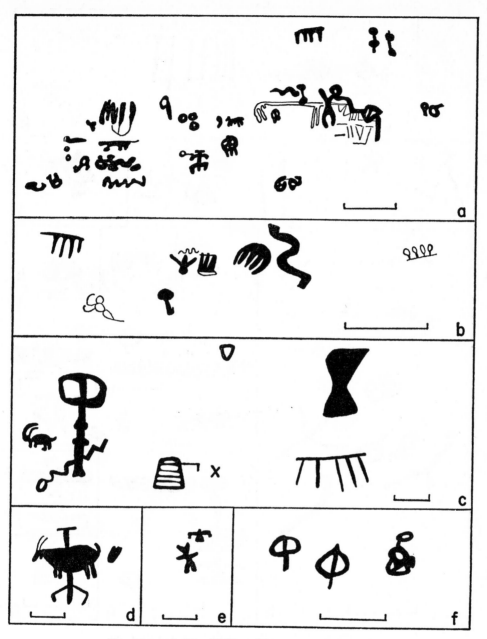

FIG. 58. *a-f,* Cl-1, Valley of Fire, Atlatl Rock site.

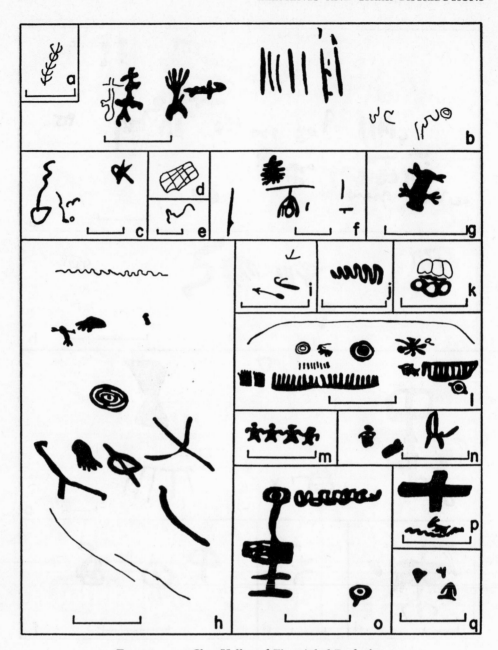

FIG. 59. *a-q*, Cl-1, Valley of Fire, Atlatl Rock site.

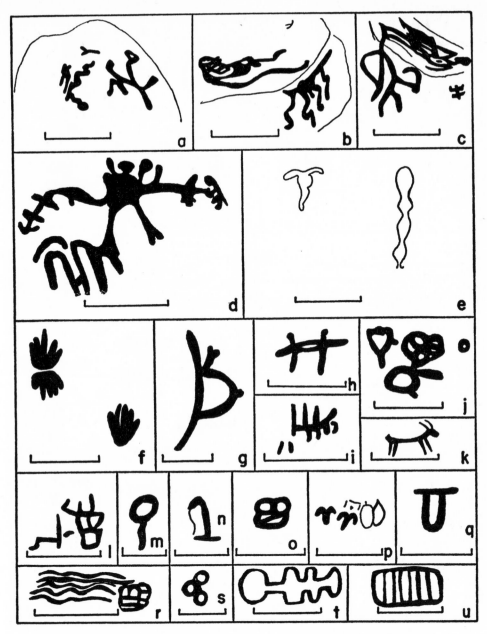

FIG. 60. *a-d*, Ch-71; *e*, Ch-95; *f-u*, Cl-3, Hiko Springs site.

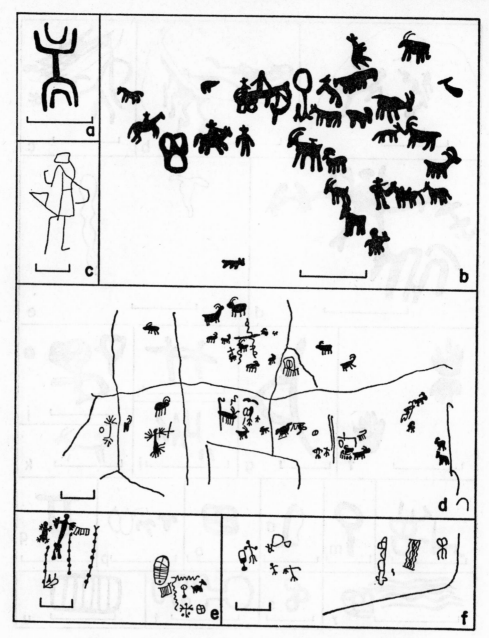

FIG. 61. *a*, Cl-3, Hiko Springs site; *b-f*, Cl-4, Cane Springs site.

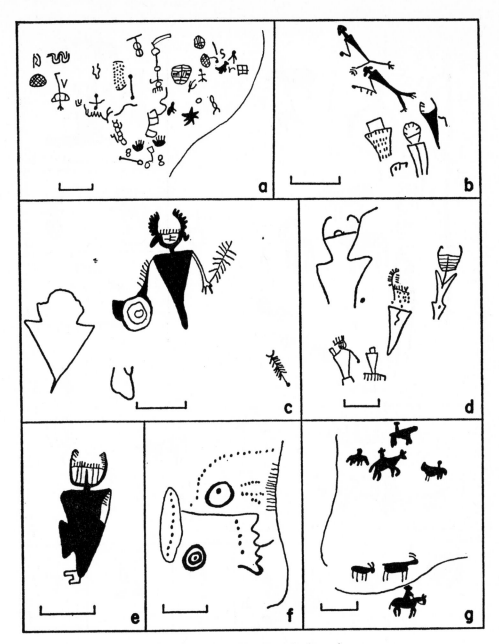

FIG. 62. *a-g*, Cl-4, Cane Springs site.

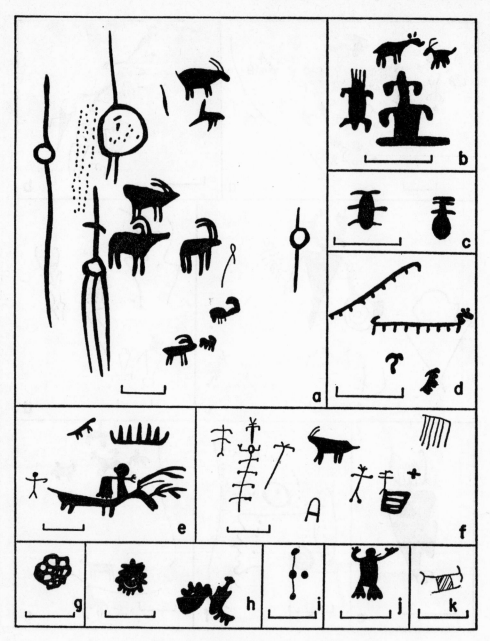

FIG. 63. *a*, Cl-4, Cane Springs site; *b-k*, Cl-5, Lost City site.

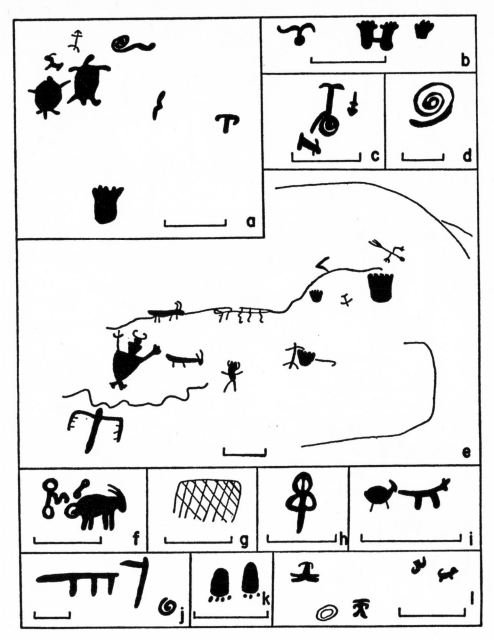

FIG. 64. *a-l*, Cl-5, Lost City site.

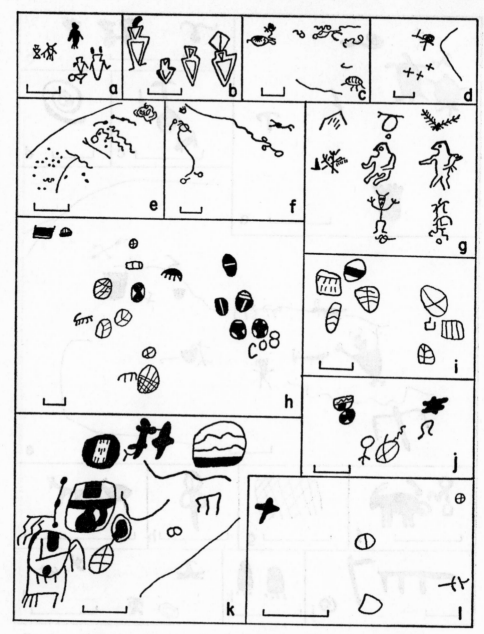

FIG. 65. *a-f*, Cl-7; *g*, Cl-9 (not natural grouping); *h-l*, Cl-123, Keyhole Canyon site.

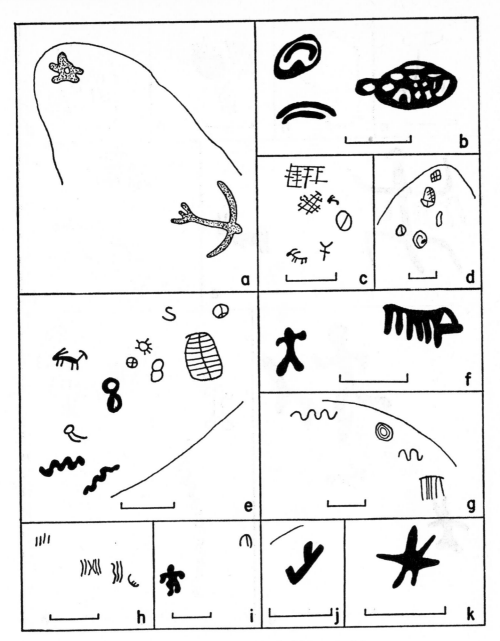

FIG. 66. *a-k*, Cl-123, Keyhole Canyon site.

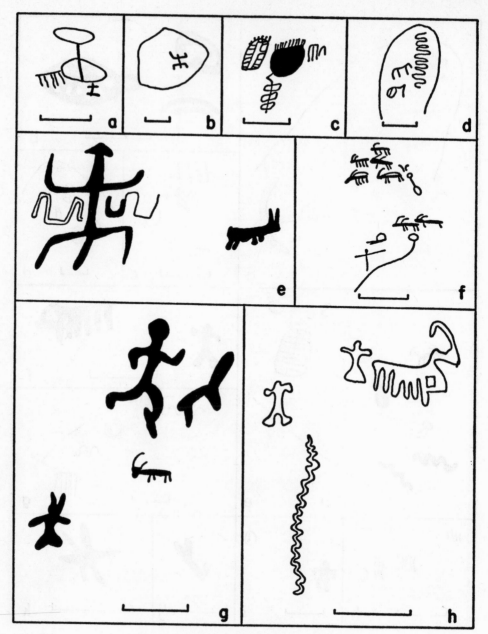

FIG. 67. *a-h*, Cl-123, Keyhole Canyon site.

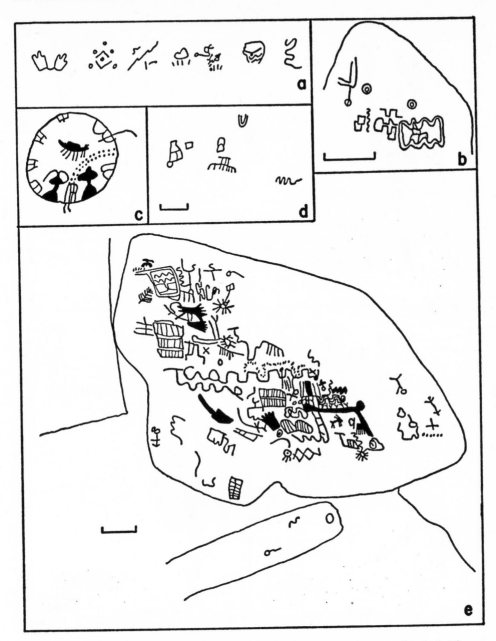

FIG. 68. *a*, Cl-9 (not natural grouping); *b*, Cl-123, Keyhole Canyon site; *c-d*, Cl-124, Arrowhead Canyon site; *e*, Cl-131, Christmas Tree Pass site.

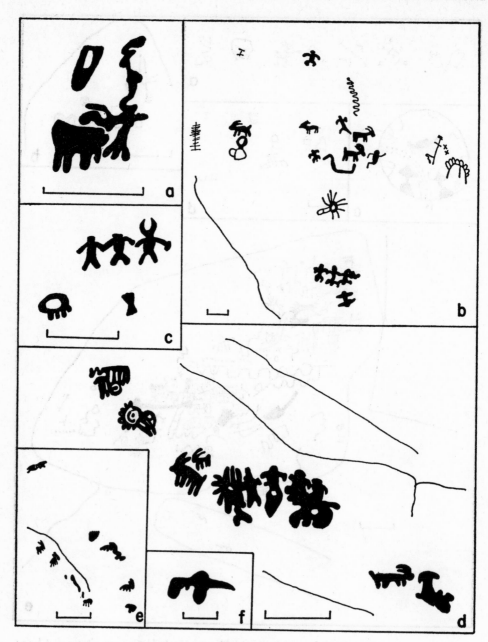

FIG. 69. *a-f*, Cl-145, Mouse's Tank site.

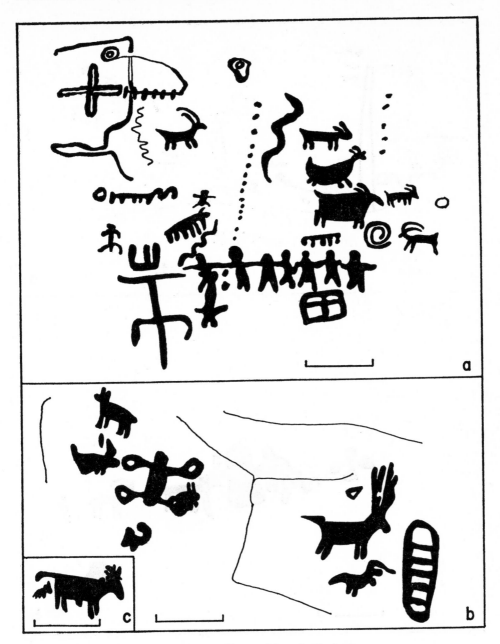

FIG. 70. *a-c*, Cl-145, Mouse's Tank site.

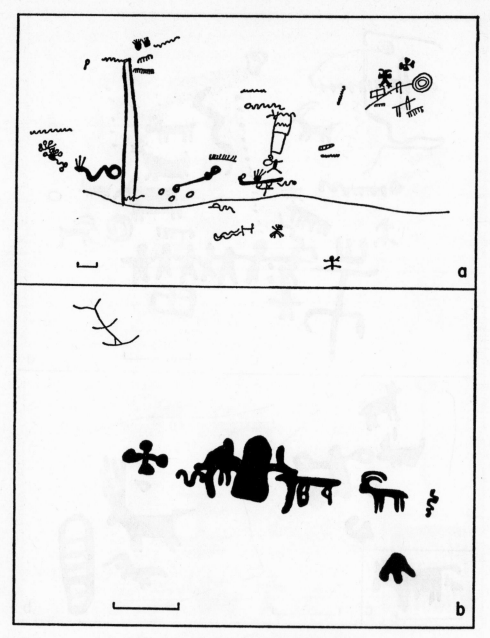

FIG. 71. *a-b*, Cl-145, Mouse's Tank site.

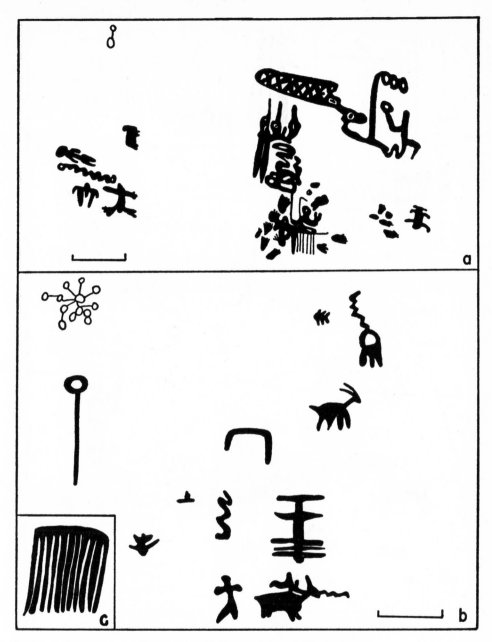

Fig. 72. *a-b*, Cl-145, Mouse's Tank site.

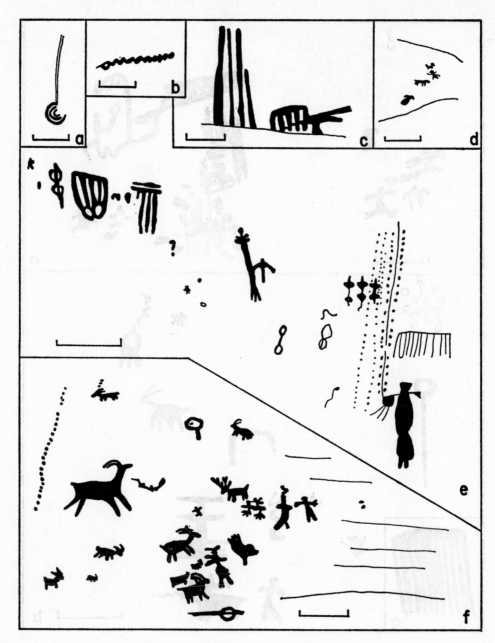

FIG. 73. *a-f*, Cl-145, Mouse's Tank site.

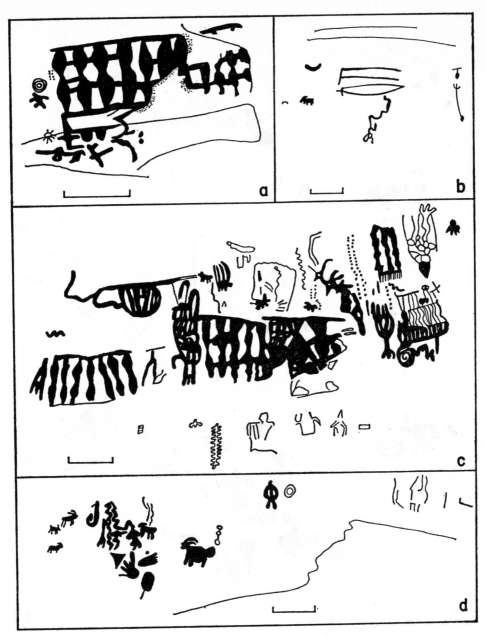

FIG. 74. *a-d*, Cl-145, Mouse's Tank site.

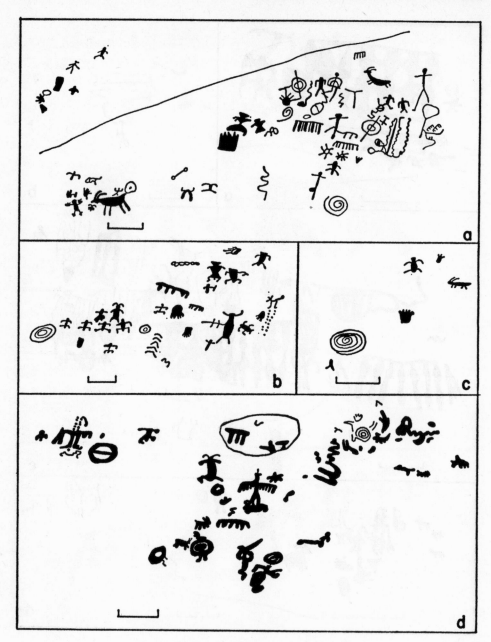

FIG. 75. *a-d*, Cl-145, Mouse's Tank site.

FIG. 76. *a-e*, Cl-145, Mouse's Tank site.

FIG. 77. *a-c*, Cl-145, Mouse's Tank site; *d*, Cl-146.

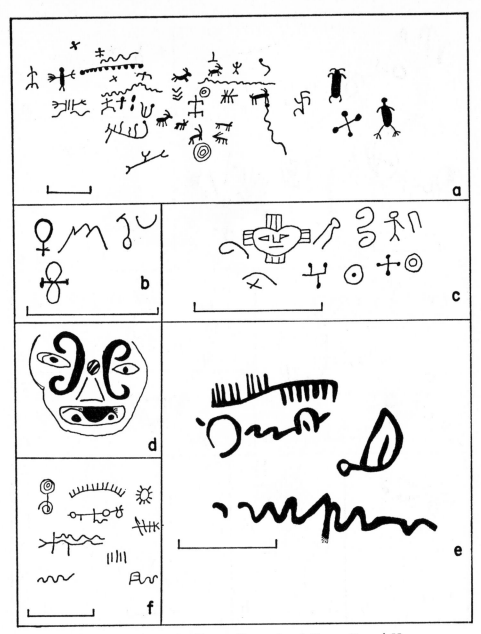

FIG. 78. *a*, Cl-143; *b-c*, Do-22, Genoa site; *d*, El-1; *e*, Es-1; *f*, Hu-5.

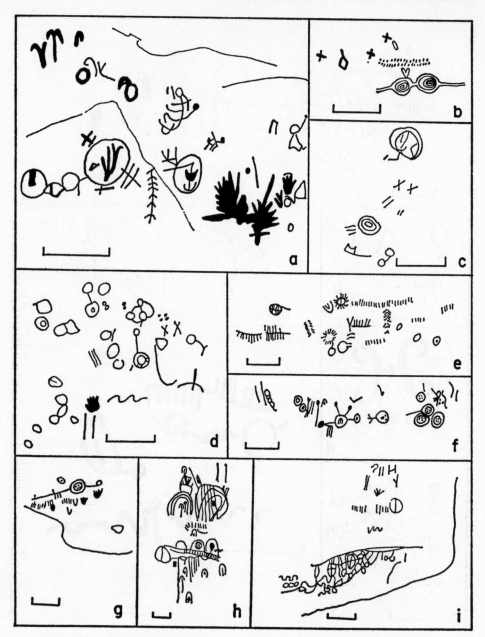

FIG. 79. *a*, Hu-7; *b-g*, La-1, Potts Cave site; *h-i*, La-9, Hickison Summit site.

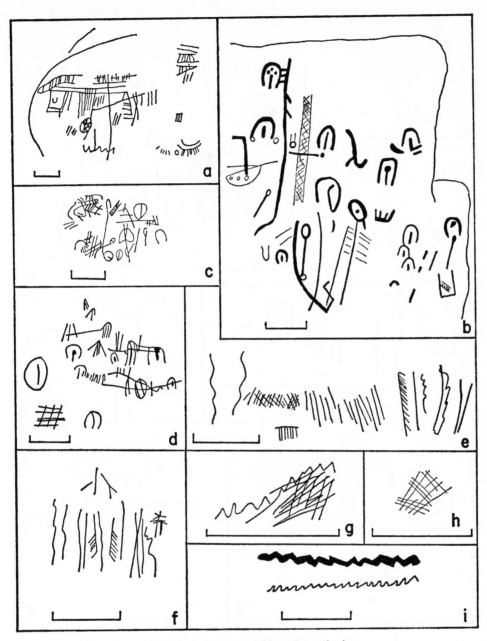

FIG. 80. *a-i*, La-9, Hickison Summit site.

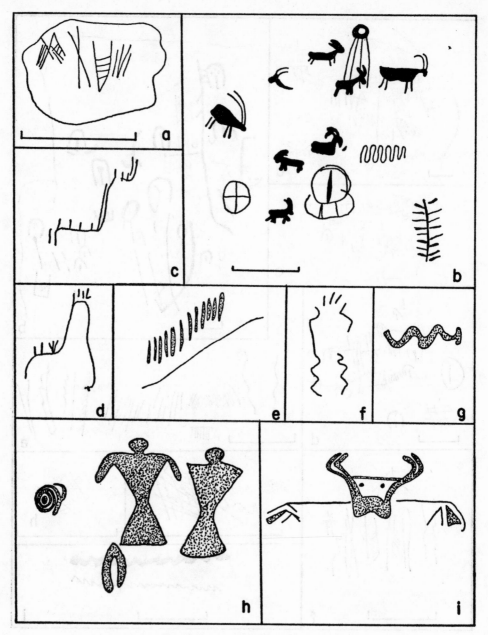

FIG. 81. *a*, La-9, Hickison Summit site; *b*, Li-1; *c-g*, Li-3; *h-i*, Li-5.

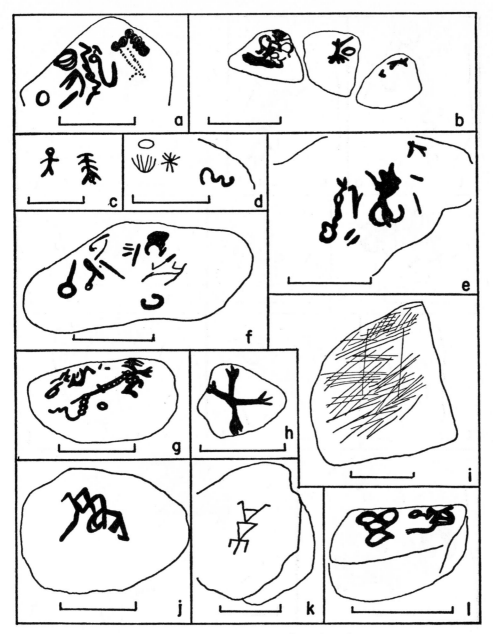

FIG. 82. *a-l*, Ly-1, East Walker River site.

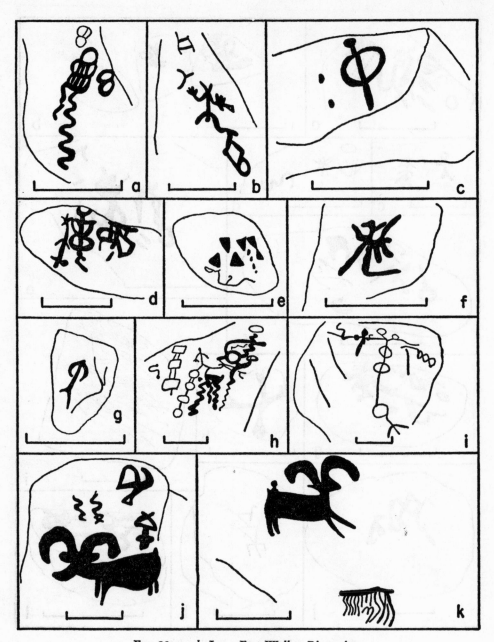

FIG. 83. *a-k*, Ly-1, East Walker River site.

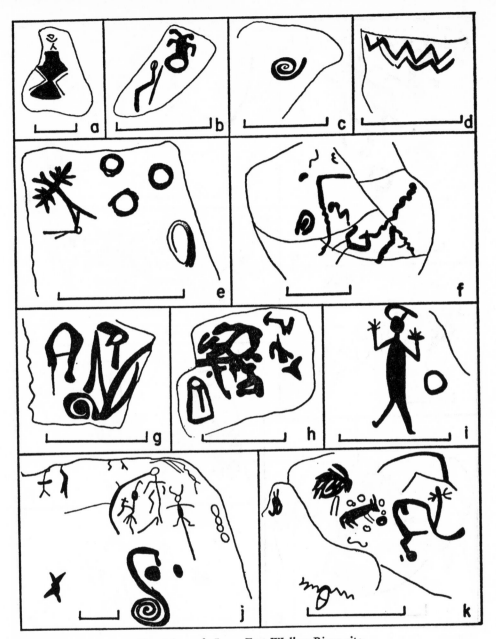

FIG. 84. *a-k*, Ly-1, East Walker River site.

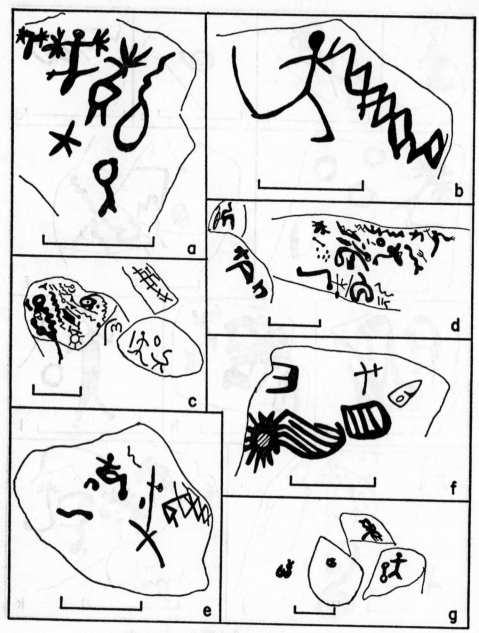

FIG. 85. *a-g*, Ly-1, East Walker River site.

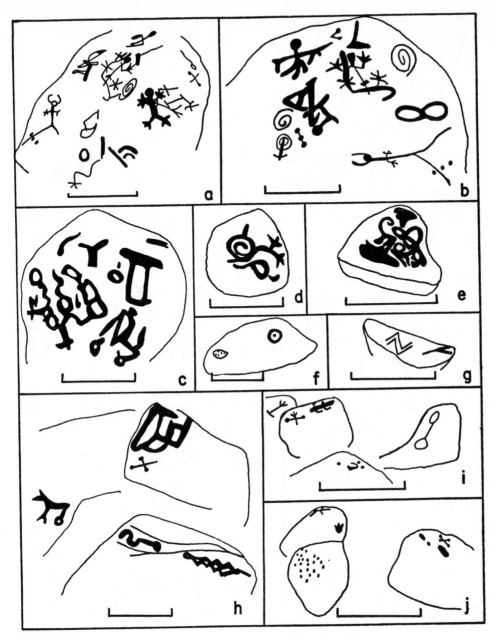

FIG. 86. *a-j*, Ly-1. East Walker River site.

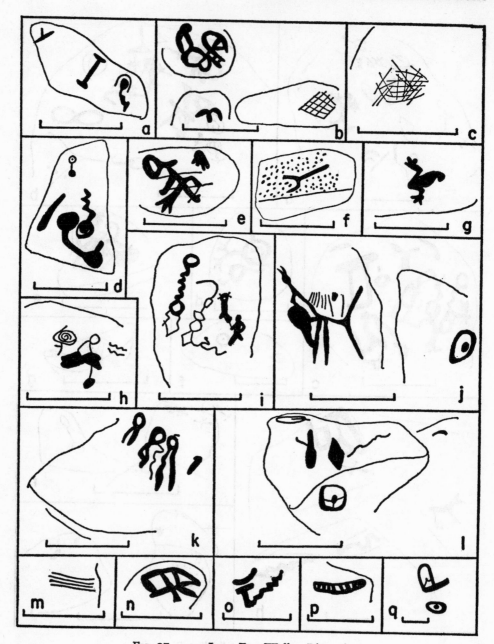

FIG. 87. *a-q*, Ly-1, East Walker River site.

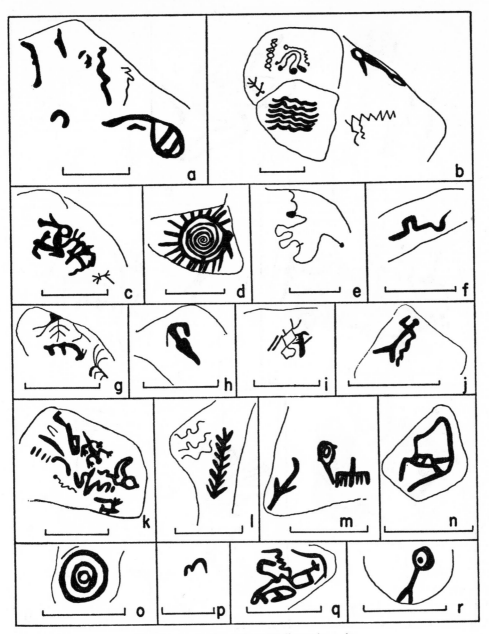

FIG. 88. *a-r,* Ly-1, East Walker River site.

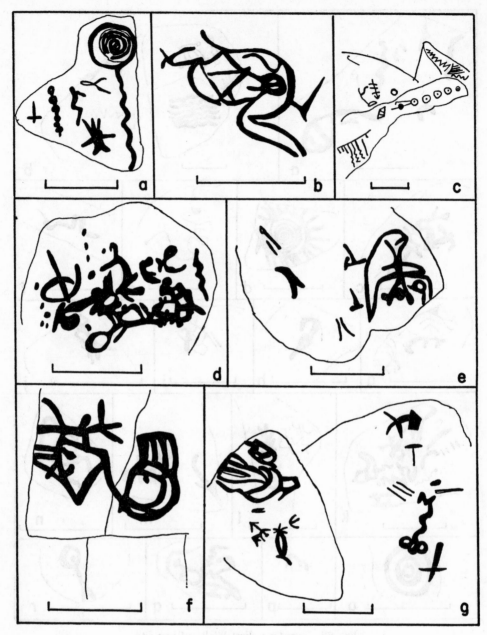

FIG. 89. *a-g*, Ly-1, East Walker River site.

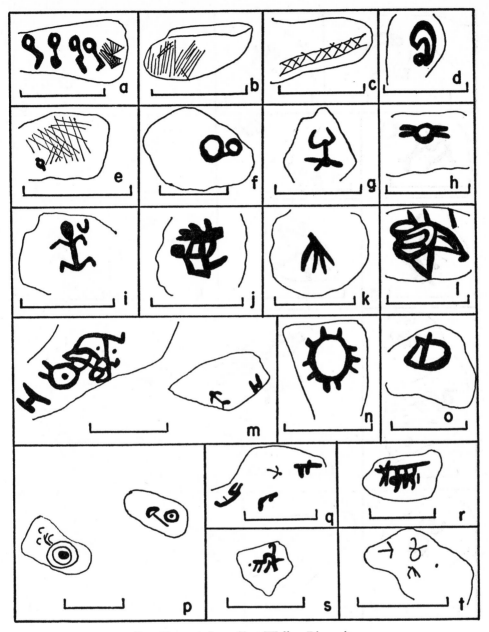

FIG. 90. *a-t*, Ly-1, East Walker River site.

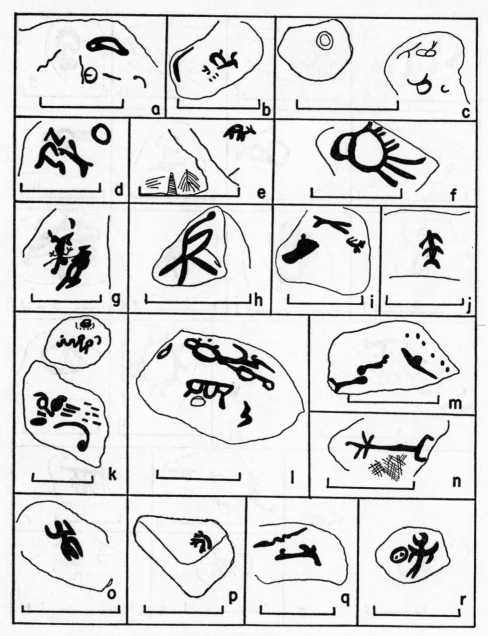

FIG. 91. *a-r*, Ly-1, East Walker River site.

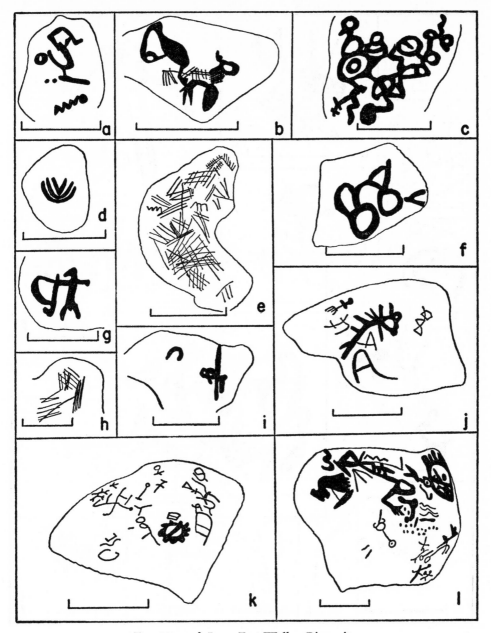

FIG. 92. *a-l*, Ly-1, East Walker River site.

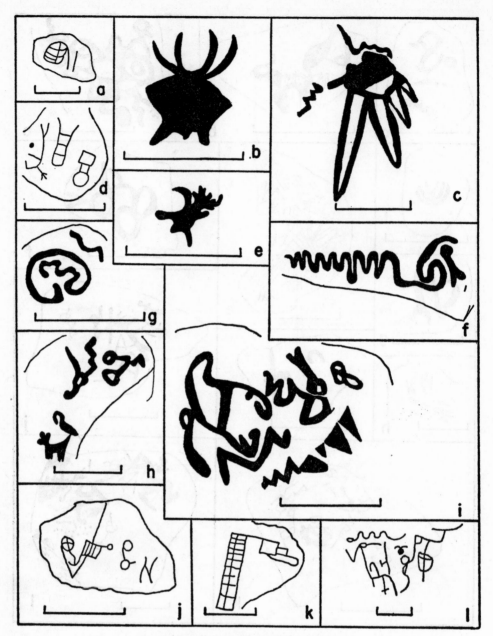

FIG. 93. *a-l*, Ly-1, East Walker River site.

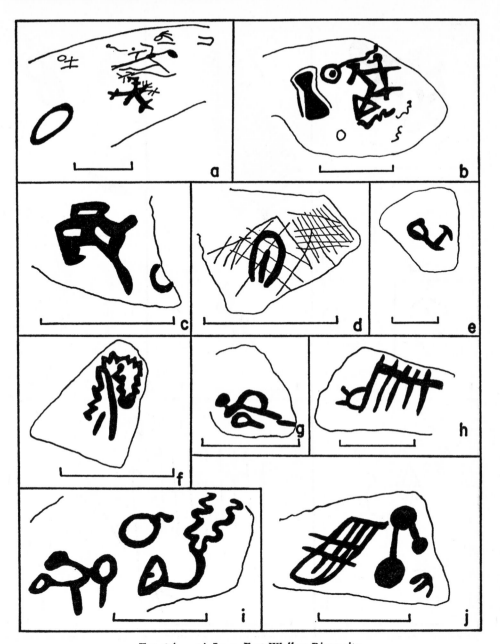

FIG. 94. *a-j*, Ly-1, East Walker River site.

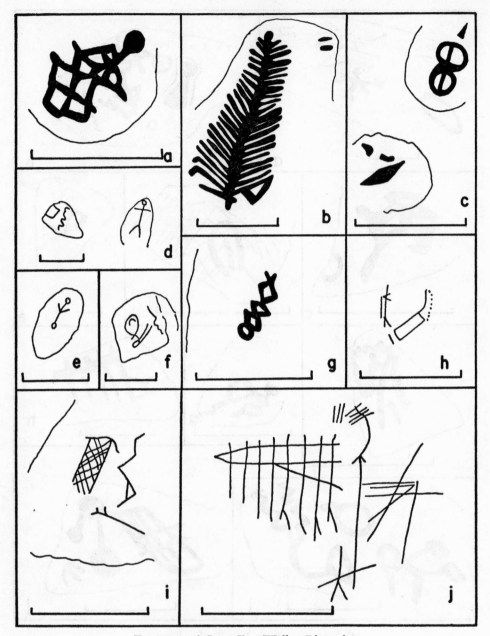

FIG. 95. *a-j*, Ly-1, East Walker River site.

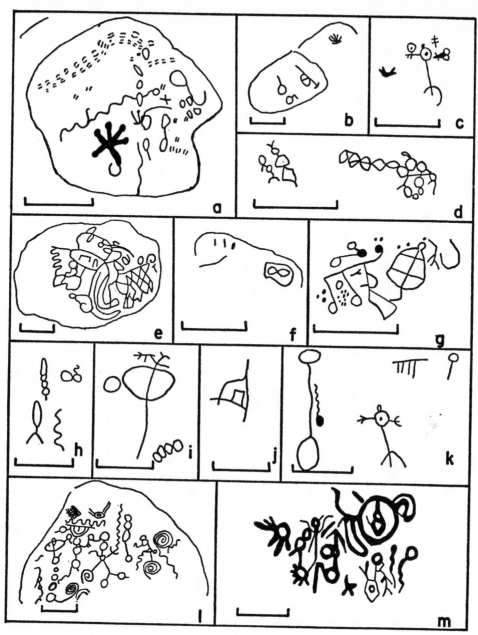

FIG. 96. *a-k*, Ly-2, Smith Valley site; *l*, Ly-5; *m*, Ly-7, Simpson Pass site.

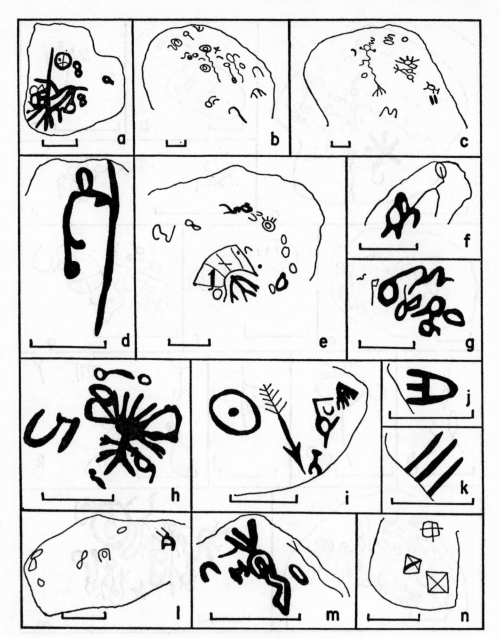

FIG. 97. *a-n*, Ly-7, Simpson Pass site.

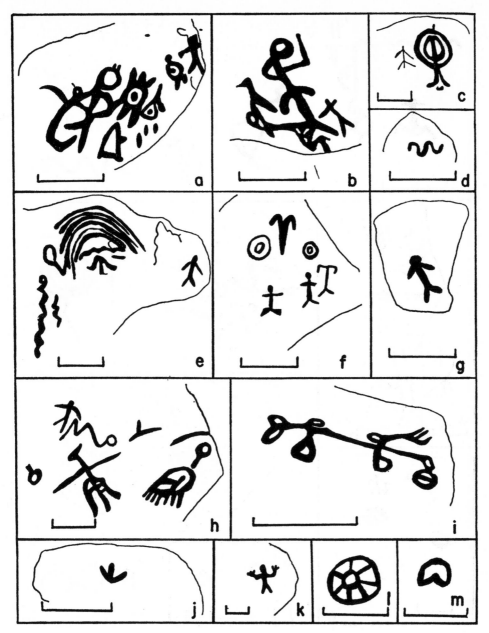

FIG. 98. *a-j*, Ly-7, Simpson Pass site; *k-m*, Mi-2, Cottonwood Canyon site.

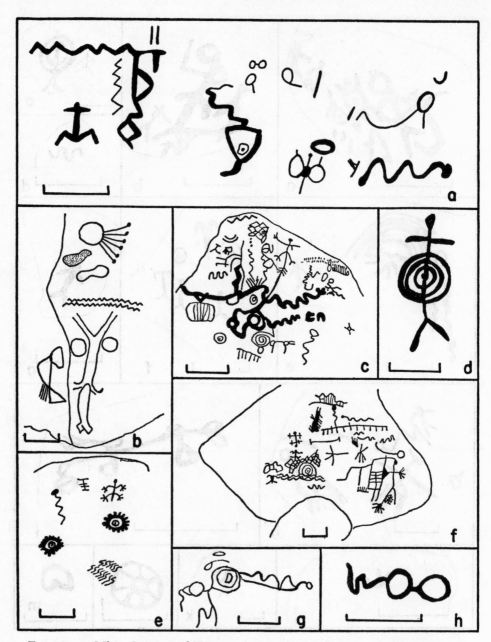

FIG. 99. *a*, Mi-2, Cottonwood Canyon site; *b*, Mi-3; *c-h*, Mi-4, Garfield Flat site.

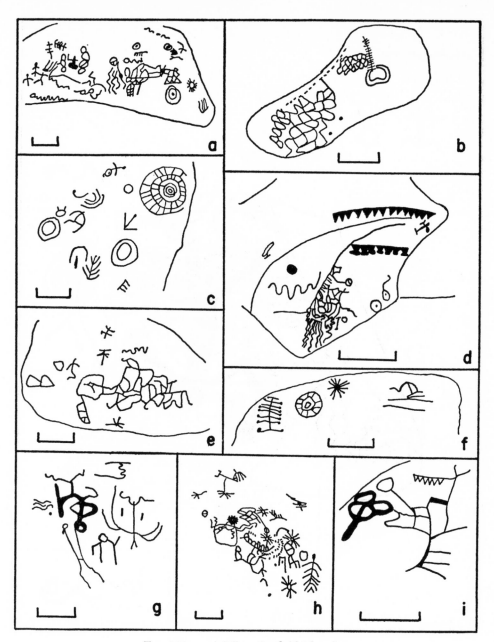

FIG. 100. *a-i*, Mi-4, Garfield Flat site.

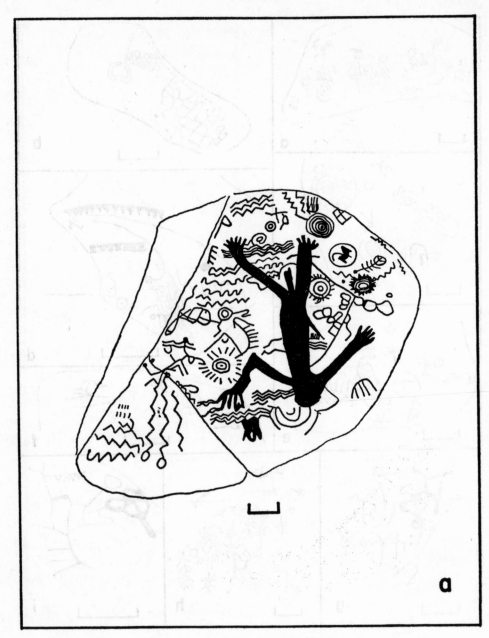

Fig. 101. *a*, Mi-4, Garfield Flat site.

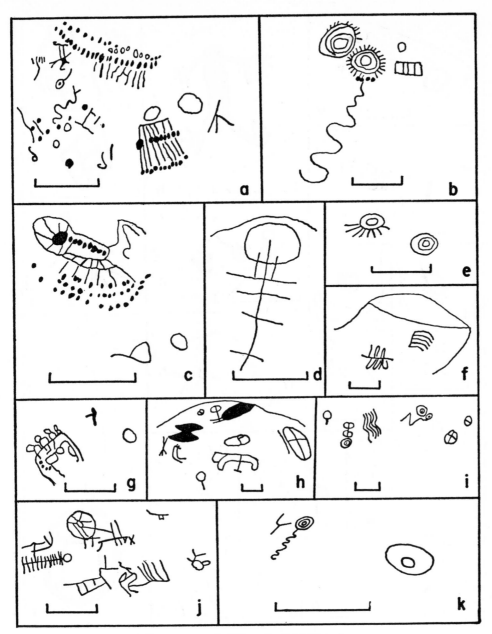

FIG. 102. *a-k*, Mi-4, Garfield Flat site.

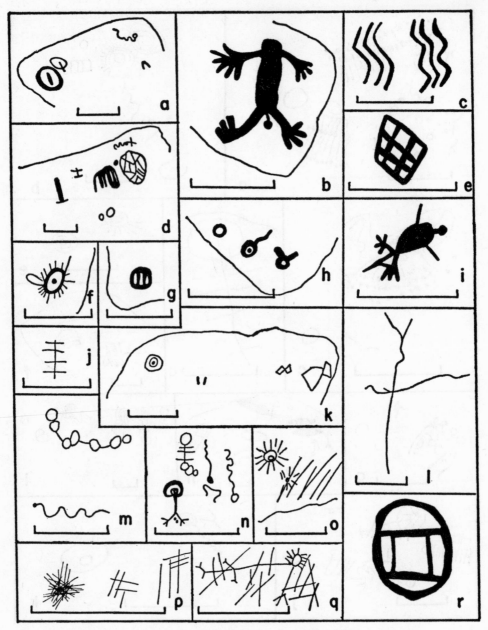

FIG. 103. *a-n*, Mi-4, Garfield Flat site; *o-r*, Mi-5, Whisky Flat site.

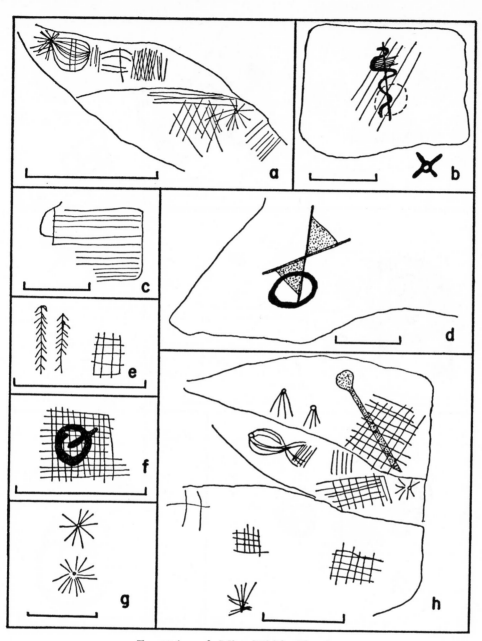

FIG. 104. *a-h*, Mi-5, Whisky Flat site.

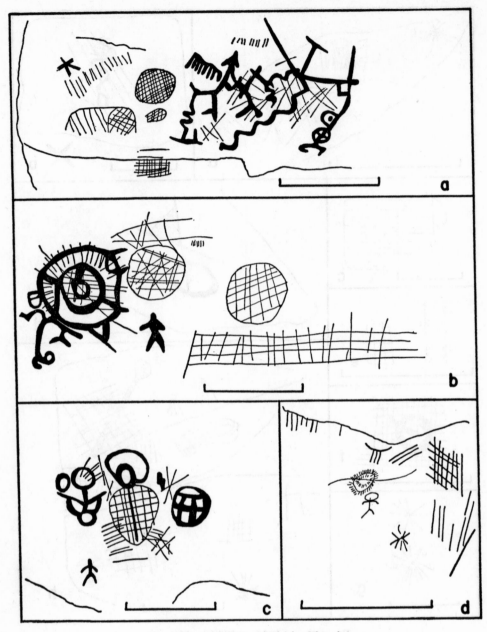

FIG. 105. *a-d*, Mi-5, Whisky Flat site.

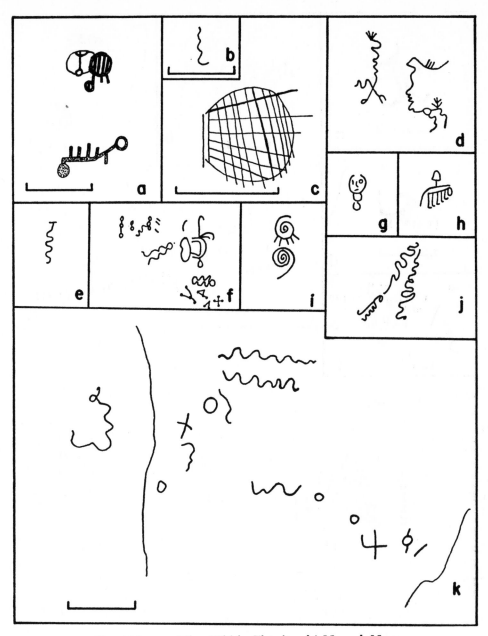

FIG. 106. *a-c*, Mi-5, Whisky Flat site; *d-j*, Ny-2; *k*, Ny-3.

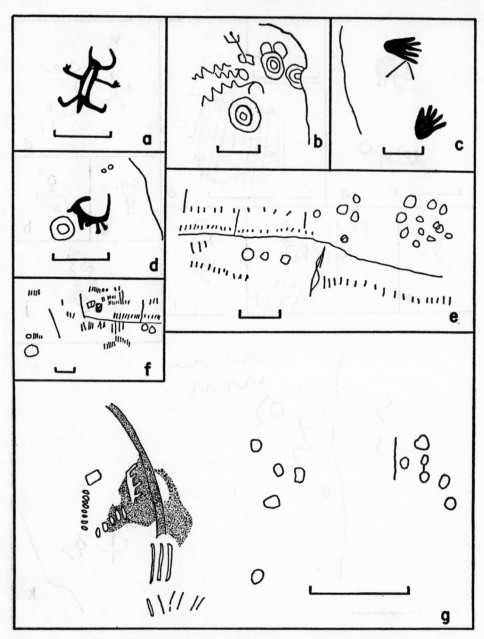

FIG. 107. *a*, Mi-17, Dutch Creek site; *b-d*, Mi-14, Rattlesnake Well site; *e-g*, Mi-13, Redrock Canyon site.

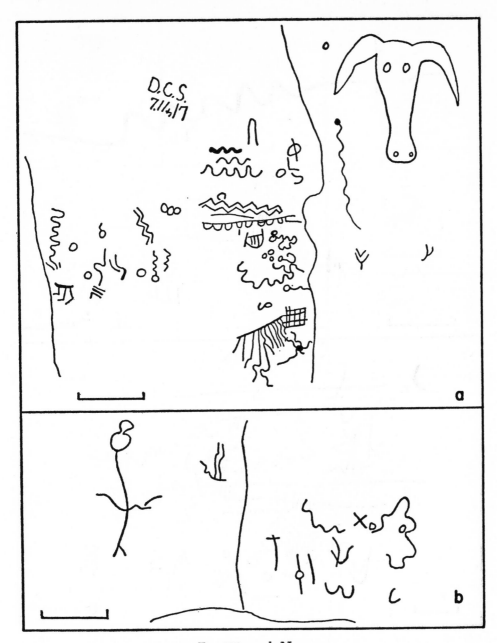

FIG. 108. *a-b*, Ny-3.

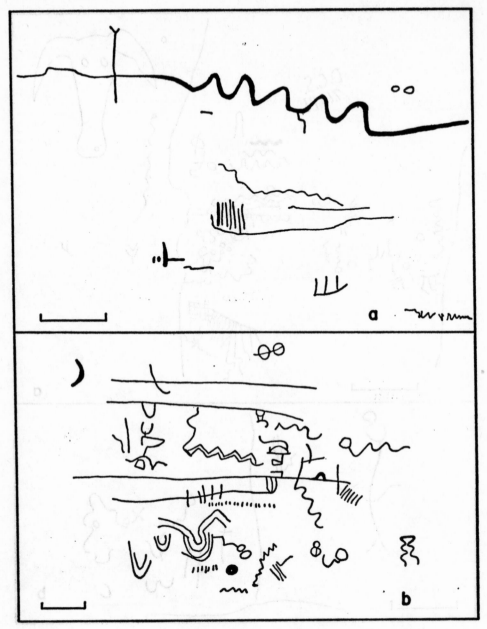

FIG. 109. *a*, Ny-3; *b*, Ny-22.

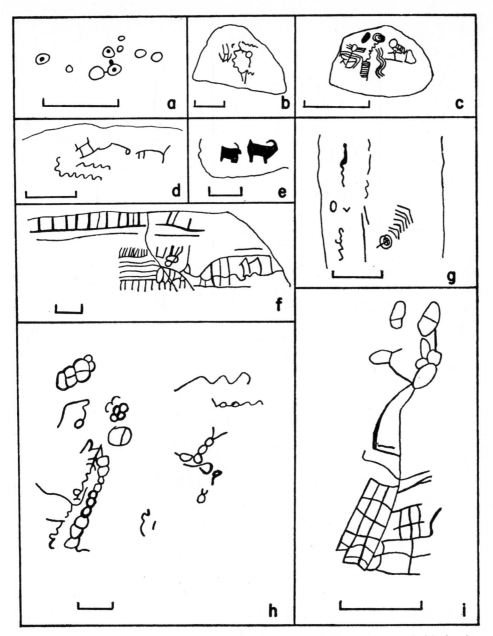

FIG. 110. *a*, Ny-22; *b-c*, Ny-25, Big George Cave site; *d*, Ny-29, Ammonia Tanks site;
e-f, Ny-44; *g-i*, Pe-10, Pole Canyon site.

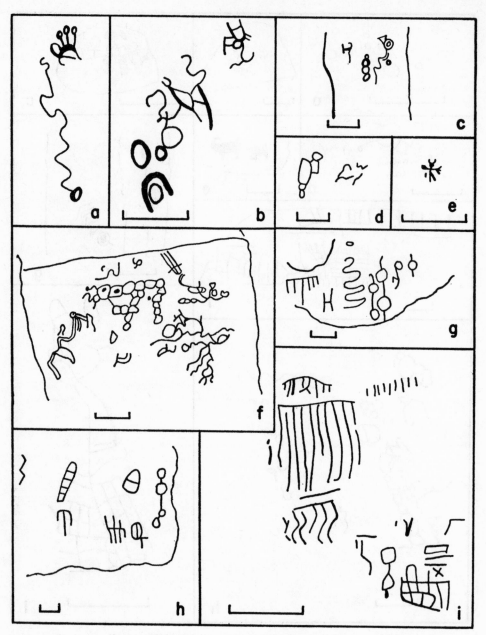

FIG. 111. *a-f*, Pe-10, Pole Canyon site; *g-i*, Pe-14, Leonard Rock Shelter site.

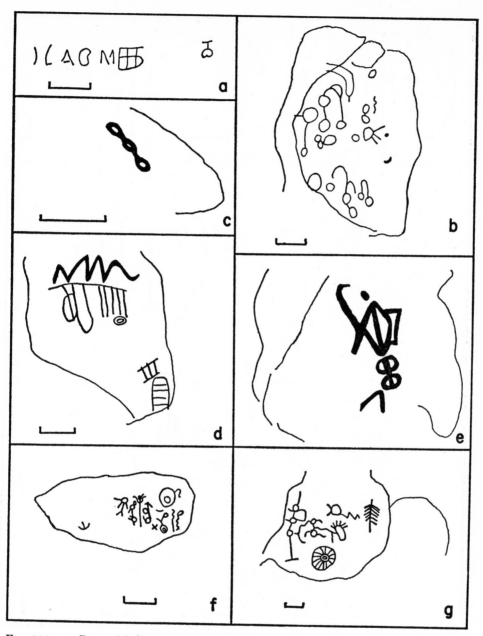

FIG. 112. *a*, Pe-27, Medicine Rock site; *b*, Pe-36; *c*, Pe-59; *d-e*, Wa-7; *f*, Wa-26, Paul Bunyan's Corral site; *g*, Wa-29.

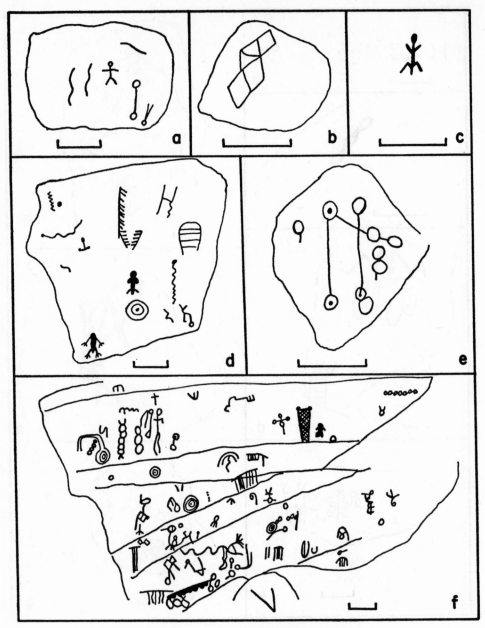

FIG. 113. *a-f*, Wa-5, Spanish Springs site.

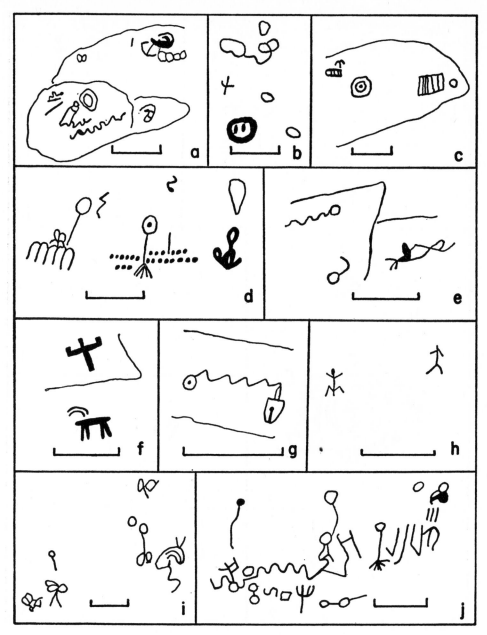

Fig. 114. *a-j*, Wa-5, Spanish Springs site.

178

ELEMENTS AND THEIR DISTRIBUTIONS

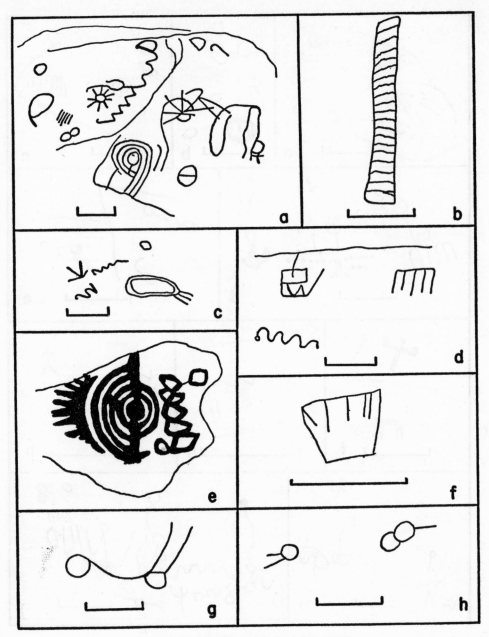

FIG. 115. *a-h*, Wa-35, Court of Antiquity.

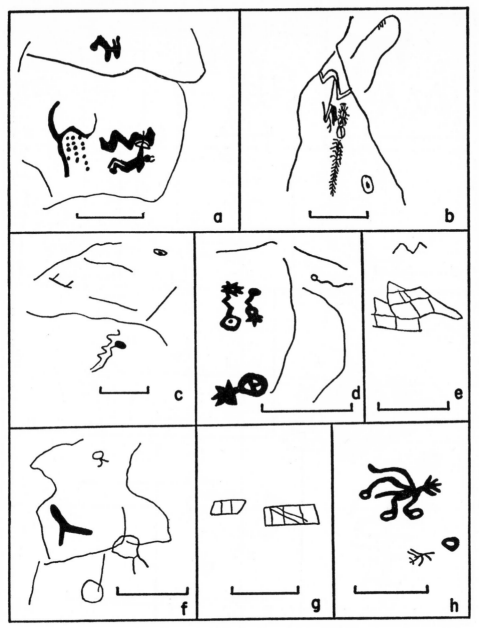

FIG. 116. *a-h*, Wa-35, Court of Antiquity.

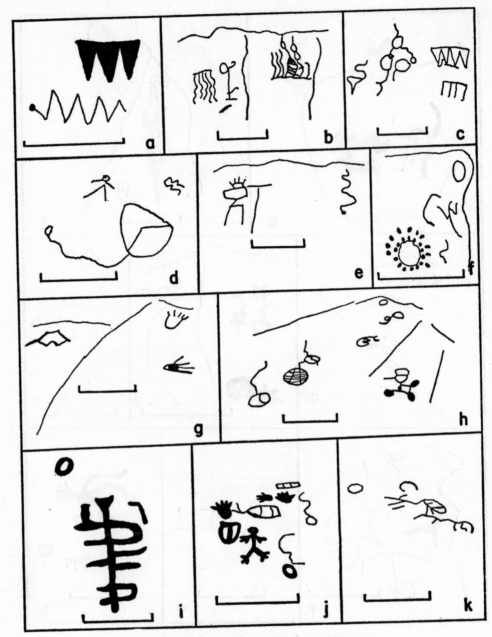

FIG. 117. *a-k*, Wa-35, Court of Antiquity.

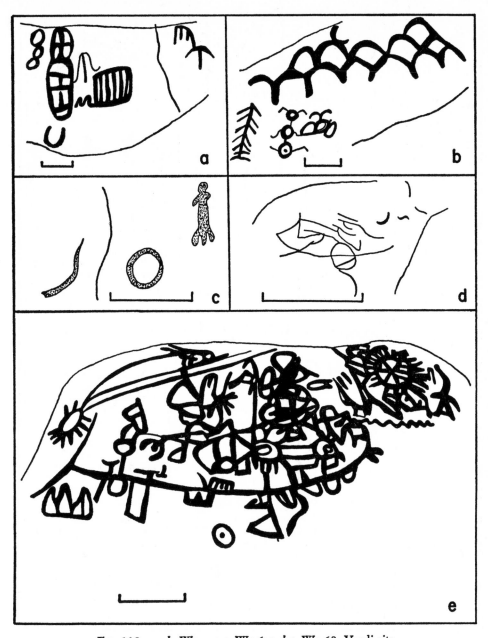

FIG. 118. *a-b*, Wa-29; *c*, Wa-67; *d-e*, Wa-68, Verdi site.

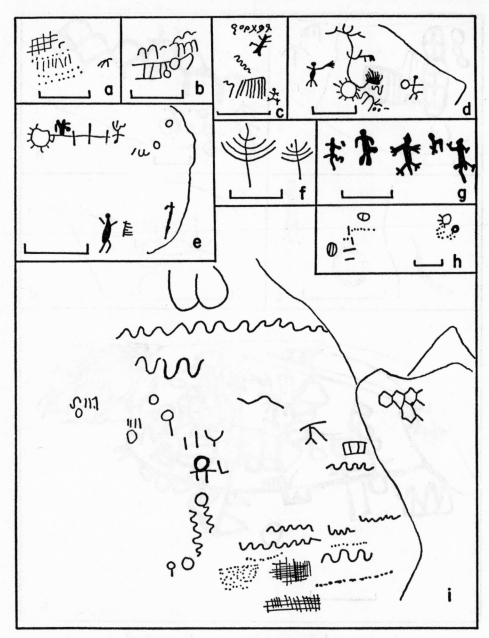

FIG. 119. *a–i,* Wa-69, Massacre Lake site.

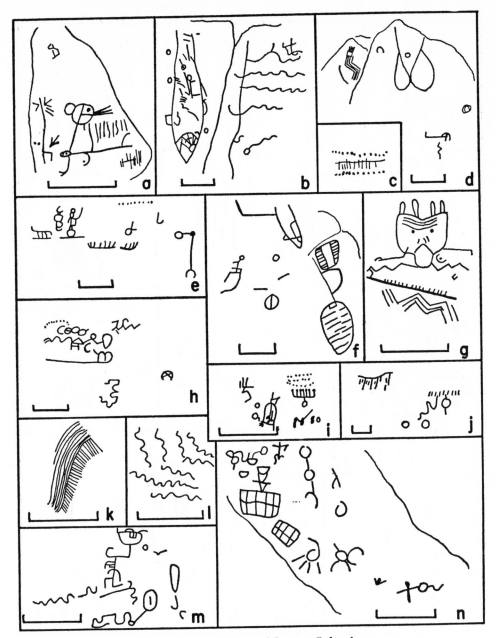

FIG. 120. *a-n*, Wa-69, Massacre Lake site.

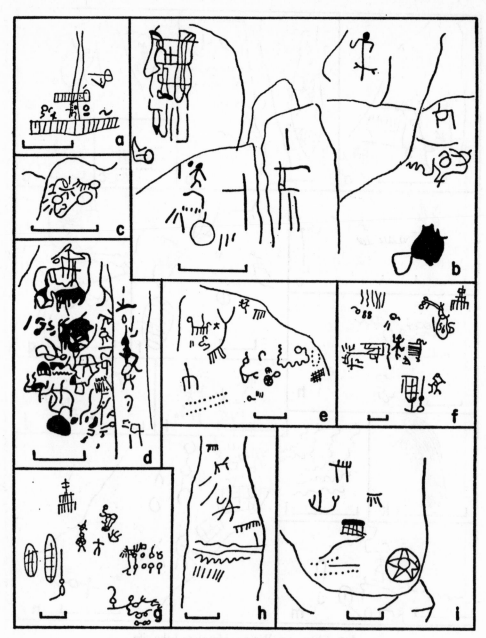

FIG. 121. *a-i*, Wa-69, Massacre Lake site.

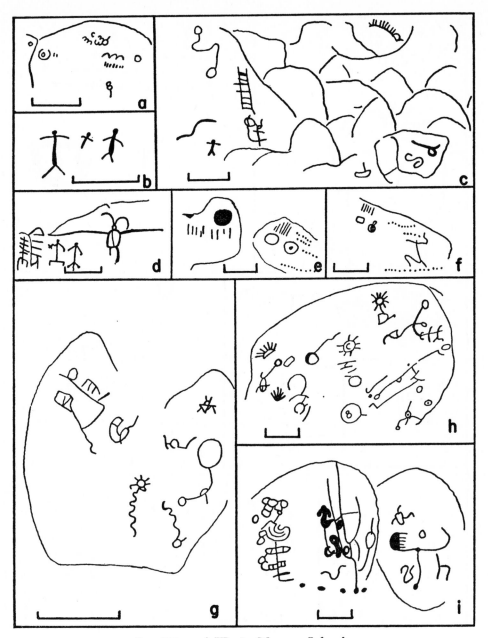

FIG. 122. *a-i*, Wa-69, Massacre Lake site.

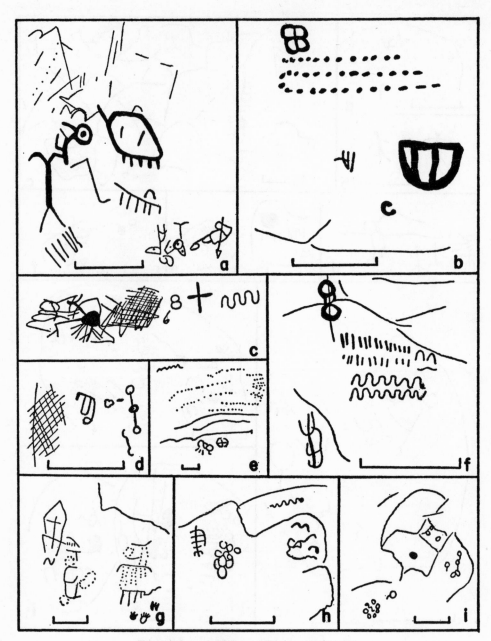

FIG. 123. *a-i*, Wa-69, Massacre Lake site.

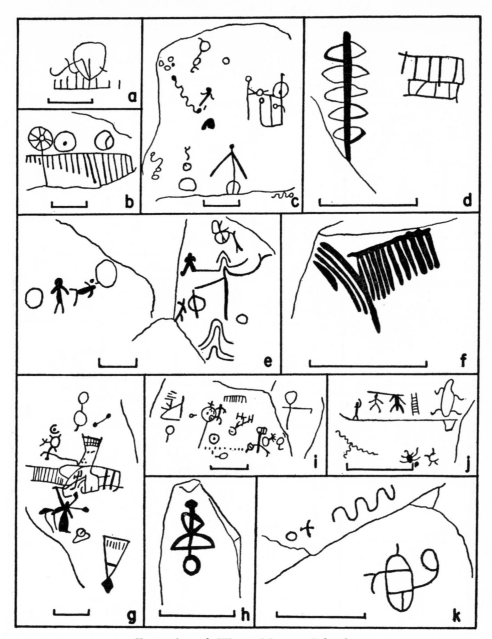

FIG. 124. *a-k*, Wa-69, Massacre Lake site.

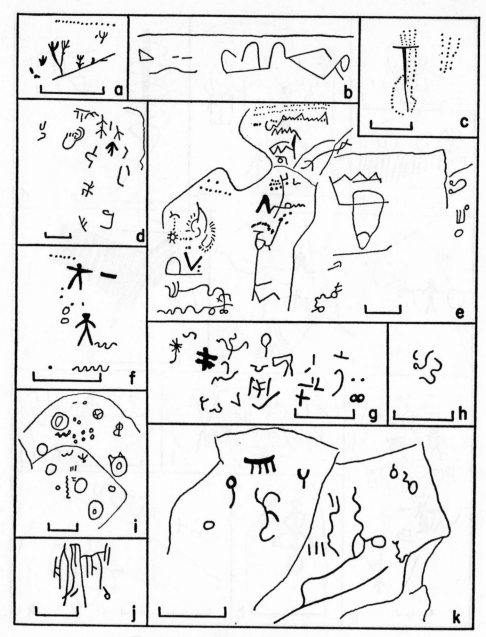

FIG. 125. *a-k*, Wa-69, Massacre Lake site.

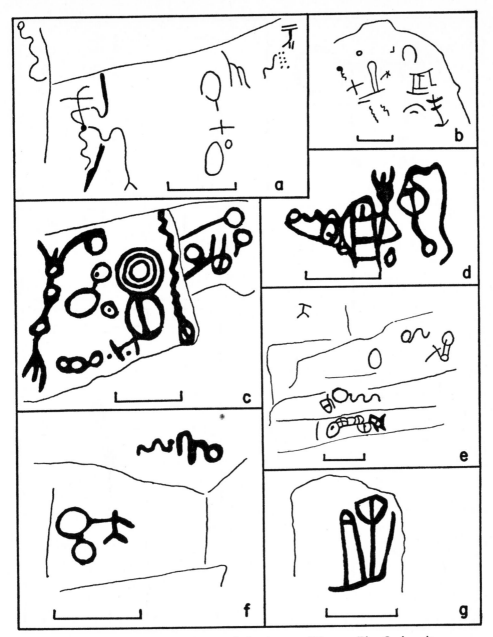

FIG. 126. *a-b,* Wa-69, Massacre Lake site; *c-g,* Wa-131, Pipe Spring site.

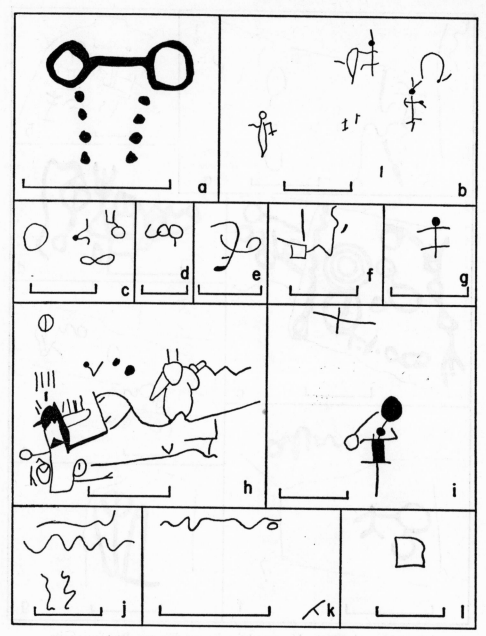

FIG. 127. *a*, Wa-139; *b*, Wa-135; *c-l*, Wa-137.

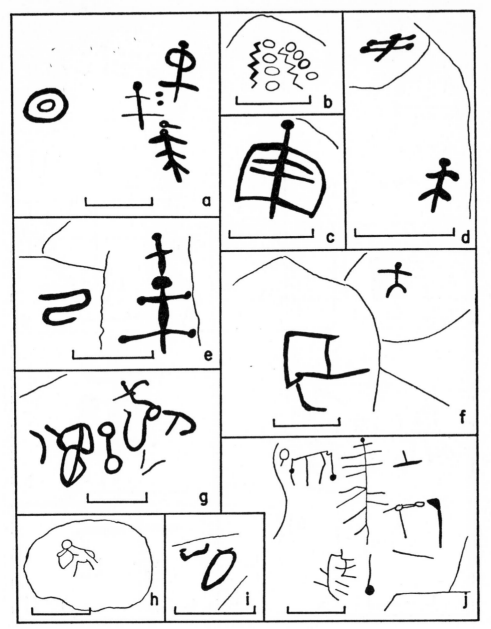

FIG. 128. *a-f*, Wa-139; *g-j*, Wa-142.

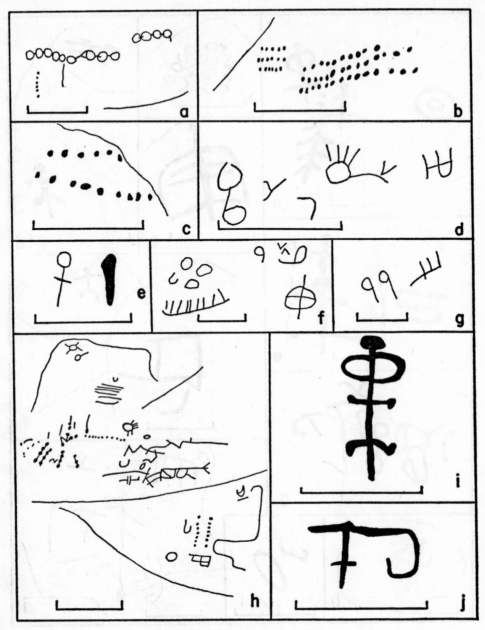

FIG. 129. a-g, Wa-142; h-j, Wa-139.

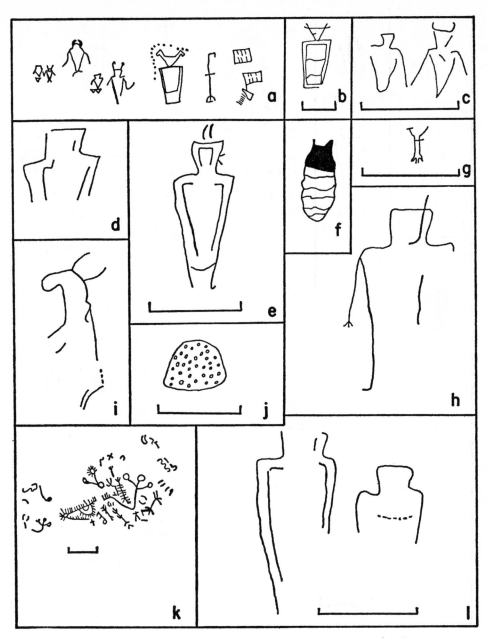

FIG. 130. *a-i*, Wh-3; *j*, Wh-12; *k*, Wh-11, Tunnel Canyon; *l*, Wh-12.

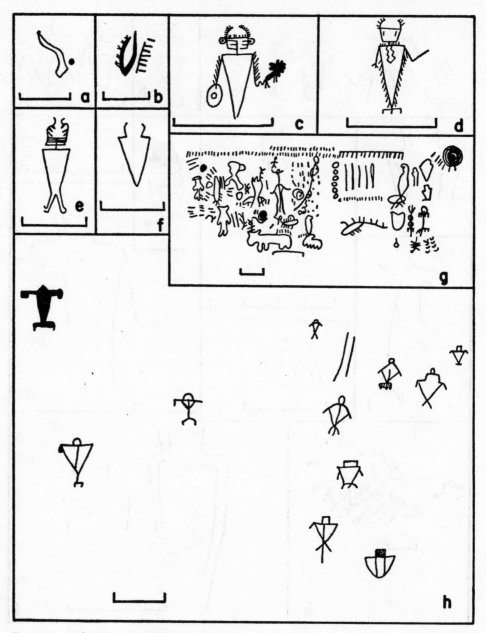

FIG. 131. *a-b*, Wh-12; *c-f*, Wh-13, Katchina Rock Shelter site; *g*, Wh-14, Chokecherry Creek site; *h*, Wh-15, Mosier Canyon site.

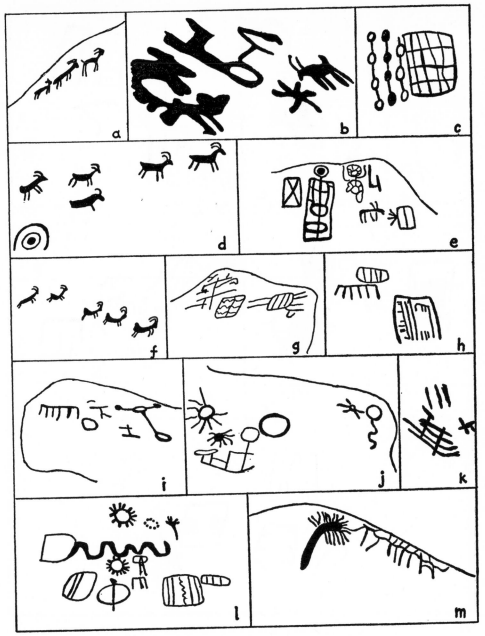

FIG. 132. *a-m*, Cl-2, Grapevine Canyon site.

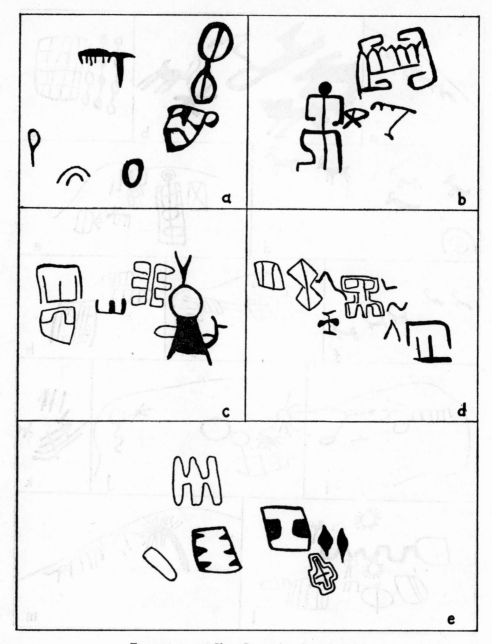

FIG. 133. *a-e,* Cl-2, Grapevine Canyon site.

IV

Styles

For the archaeologist, style is exemplified in a motive or pattern, or in some directly grasped quality of the work or art, which helps him to localize and date the work and to establish connections between groups of work or between cultures. Style here is a symptomatic trait, like the nonaesthetic features of an artifact. It is studied more often as a diagnostic means than for its own sake as an important constituent of culture. For dealing with style, the archaeologist has relatively few aesthetic and physiognomic terms (Shapiro, 1953, p. 287).

Shapiro's definition of style is much to the point in our study of Nevada petroglyphs. We have tried to isolate features characteristic of certain times. Our purpose is twofold: (1) to infer historic events (culture spread or population migration), and (2) to test our previously stated hypothesis of the use of petroglyphs as elements of hunting ritual. The latter goal is the more crucial. We have already noted that the hunting ritual hypothesis does not apply equally to all petroglyph styles; the question is to what degree each of the separate styles may be regarded as conforming to this hypothesis. To answer such a question we must first isolate and define the styles.

Style definition has been easy in some cases, but difficult in others. Mere inspection of the materials, both in the field and in published or manuscript form, reveals that styles can be broken down initially into five groups:

1. Great Basin Pecked
2. Great Basin Painted
3. Great Basin Scratched
4. Puebloan Painted
5. Pit-and-Groove

This gross breakdown is clear; that is, most observers would make the same distinctions. Beyond this, distinctions are subtle, and hence liable to varying interpretations. The Puebloan Painted style is a version of the Southwestern pictographic art and could probably be divided into substyles as are the Southwestern art styles (cf. Haury, 1945, pp. 64 ff.). The Nevada examples of this

style, so far as our data indicate, are probably all evidence of a single style, and this supposition we shall consider further in due course. The Great Basin Painted style is not uniform, but again our data are not adequate to define substyles. The Pit-and-Groove style is uniform throughout Nevada but is also found in California, where some examples are identical to those of Nevada but others show significant variations. There are evidently substyles here, but they will have to wait until more evidence is accumulated. The Scratched style does not occur widely and probably is not susceptible to further subdivision.

Great Basin Pecked style, comprising the bulk of the occurrences, is evidently most difficult to analyze. It has already been shown that the style can be broken down into two substyles: Great Basin Rectilinear and Great Basin Curvilinear (Baumhoff, Heizer, and Elsasser, 1958). We are able here to show a further division — Great Basin Representational as against Great Basin Abstract, and so we now propose the following classifications:

 Great Basin Pecked
 Great Basin Representational
 Great Basin Abstract
 Curvilinear
 Rectilinear

Before going on to discuss these styles, we will describe the method used for determining them. The distinctness of the representational and abstract styles was determined through a method similar to that proposed by Robinson (1951) and Brainerd (1951) for a seriation of archaeological materials. More specifically, a method worked out by Professor Paul Dempsey of the Department of Psychology, University of California, Davis, was used:

1. The number of occurrences of each element is tabulated for each site. A hypothetical example follows, in which we have six elements found at four sites.

Element	Number of Occurrences at Site			
	A	B	C	D
1	100	6	0	0
2	76	20	8	5
3	22	12	9	20
4	10	143	7	23
5	7	121	0	12
6	8	87	0	0

2. Each element is then categorized as "common" or "uncommon" at each site. These are determined by arranging the elements at a site in order of frequency and designating those in the upper 50 percentile as "common" and those in the lower 50 percentile as "uncommon." The table above, for example, would be reduced to the table following, where a plus indicates "common" and a minus indicates "uncommon."

		Site		
Element	A	B	C	D
1	+	−	−	−
2	+	−	+	−
3	+	−	+	+
4	−	+	+	+
5	−	+	−	+
6	−	+	−	−

3. Each of the sites is then compared with the other sites to determine which are similar and which are dissimilar. The similarity is measured by the percentage of elements in which two sites agree or disagree in having "common" or "uncommon" occurrences. The measure then yields a matrix of agreement like the following, where 100 is complete agreement and 0 complete disagree-

	A	B	C	D
A	*	0	67	33
B	0	*	0	33
C	67	33	*	33
D	33	67	67	*

ment. The matrix of agreement permits arranging sites in a rank order in which the sites with greatest similarity will be closest to each other. Thus, in the present example, we obtain rank order, A, C, D, B (which might also be written B, D, C, A, since the process gives no indication of which site should be first and which should be last).

In this analysis it develops that some elements will have been more important than others in determining the rank ordering. The more important elements will correlate highly with the rank ordering (either positively or negatively), whereas the less important elements will have only low correlation with the rank ordering. In the present instance we have used Spearman's rank correlation (cf. Siegel, 1956, pp. 202-213) to determine which elements are most important. The elements with significant positive correlation we take as the defining criteria for one style, and those with negative correlation for the other style. Actually, these only define two ends of a style "dimension"; we will use them to determine whether one end of the "dimension" has geographical and chronological significance with respect to the other end.

The rank correlation analysis indicates that the elements mountain sheep, quadruped, foot, hand, horned human, and Katchina show significant negative correlation with our "dimension," and we therefore choose these as the defining elements of the Great Basin Representational style. On the other hand the circle, tailed circle, chain of circles, curvilinear meander, bird tracks, zigzag lines, and snake have significant positive correlation with our "dimension," and so we choose these as the defining elements for our Great Basin Abstract style.

As shown by our analysis of the Lagomarsino site petroglyphs (site St-1; Baumhoff, Heizer, and Elsasser, 1958), the Great Basin Abstract style can be

further divided into curvilinear and rectilinear styles. The definitive elements in the rectilinear style are dots, rectangular grid, bird tracks, rake, and crosshatching. In the curvilinear style the definitive elements are circle, concentric circles, chain of circles, sun disc, curvilinear meander, star or asterisk, and snake.

We summarize our findings on style characteristics in table 3.

TABLE 3
STYLE CHARACTERISTICS OF NEVADA PETROGLYPHS

Style	Method of application	Characteristic elements
Great Basin Representational	Pecking	Mountain sheep, quadruped, foot, hand, horned human, Katchina
Great Basin Curvilinear Abstract	Pecking	Circle, concentric circles, chain of circles, sun disc, curvilinear meander, star, snake
Great Basin Rectilinear abstract	Pecking	Dots, rectangular grid, bird tracks, rake, crosshatching
Great Basin Painted	Painting	Circles, parallel lines
Great Basin Scratched	Incising or scratching	Sun disc, parallel lines, crosshatching
Puebloan Painted	Painting	Katchina
Pit-and-Groove	Pecking	Pits and grooves*

*Pits and grooves are not tabulated with the other elements in table 4.

In table 4 are presented the data concerning the styles at each site for which we have pictorial evidence. For the Great Basin pecked styles, that is, Great Basin Representational, Great Basin Curvilinear Abstract, and Great Basin Rectilinear Abstract, we give the number of diagnostic elements present at each site. For the other styles we merely note presence or absence. The last column gives the total of all recorded elements at each site.

TABLE 4
DIAGNOSTIC ELEMENTS PRESENT AT EACH NEVADA PETROGLYPH SITE

Site	Great Basin Representational	Great Basin Curvilinear Abstract	Great Basin Rectilinear Abstract	Great Basin Painted	Great Basin Scratched	Puebloan Painted	Pit and Groove	Total elements
Ch-3	—	96	35	—	—	—	+	204
Ch-16	—	8	—	—	—	—	—	19
Ch-20	—	3	—	—	—	—	—	4
Ch-26	—	—	—	+	—	—	—	3
Ch-49	—	—	—	+	—	—	—	6
Ch-55	—	—	—	+	—	—	—	16
Ch-57	—	5	5	+	—	—	—	19
Ch-71	3	17	6	—	—	—	—	44
Ch-95	—	—	—	+	—	—	—	2
Ch-120	—	—	—	—	—	—	+	—
Cl-1	201	182	75	—	—	—	—	699
Cl-2	16	17	16	—	—	—	—	68
Cl-3	4	7	1	—	—	—	—	19
Cl-4	57	14	23	—	—	+	—	150
Cl-5	28	2	7	—	—	—	—	70
Cl-7	9	7	1	—	—	—	—	31
Cl-9	—	5	—	—	—	—	—	15
Cl-123	—	8	27	—	—	—	—	96
Cl-124	2	—	2	—	—	—	—	7
Cl-131	5	13	16	—	—	—	—	59
Cl-143	9	7	—	—	—	—	—	30
Cl-145	105	49	56	—	—	—	—	356
Cl-146	—	5	1	—	—	—	—	14
Do-35	—	—	—	—	—	—	+	—

Site	Great Basin Representational	Great Basin Curvilinear Abstract	Great Basin Rectilinear Abstract	Great Basin Painted	Great Basin Scratched	Puebloan Painted	Pit and Groove	Total elements
Es-1	—	1	2	—	—	—	—	7
Eu-1	—	—	—	—	—	—	+	—
Hu-5	—	3	1	—	—	—	1	10
La-1	—	—	—	+	—	—	—	79
La-9	1	9	21	+	+	—	—	106
Li-1	8	—	—	—	—	—	—	13
Li-3	—	—	—	+	—	—	—	8
Li-5	—	—	—	—	—	+	—	3
Ly-1	22	195	61	—	+	—	—	526
Ly-2	—	17	6	—	—	—	—	47
Ly-5	—	8	1	—	—	—	—	17
Ly-7	2	53	7	—	—	—	—	98
Mi-2	—	4	—	—	—	—	—	11
Mi-3	—	—	—	+	—	—	—	7
Mi-4	1	119	45	—	—	—	—	289
Mi-5	1	19	24	+	+	—	—	66
Mi-13	—	—	—	+	—	—	—	60
Mi-14	3	8	—	—	—	—	—	13
Mi-17	1	—	—	—	—	—	—	1
Ny-2	—	6	1	—	—	—	—	19
Ny-3	—	37	7	—	—	—	—	76
Ny-22	—	7	—	—	—	—	—	10
Ny-25	—	4	—	—	—	—	—	7
Ny-29	—	1	—	—	—	—	—	3
Ny-44	2	1	4	—	—	—	—	7
Pe-10	1	24	1	—	—	—	—	40
Pe-14	—	2	4	—	—	—	—	18
Pe-36	—	5	—	—	—	—	—	10
St-1	5	107	146	—	+	—	—	439
Wa-5	1	49	19	—	—	—	—	112
Wa-7	—	2	1	—	—	—	—	7
Wa-20	—	—	—	—	—	—	+	—
Wa-26	—	2	1	—	—	—	—	10
Wa-29	—	4	1	—	—	—	—	13
Wa-35	6	37	13	—	—	—	—	78
Wa-67	—	—	—	+	—	—	—	2
Wa-68	—	4	1	—	—	—	—	9
Wa-69	8	188	111	—	—	—	—	512
Wa-119	—	—	—	—	—	—	+	—
Wa-131	—	13	1	—	—	—	—	27
Wa-135	—	1	—	—	—	—	—	4
Wa-137	—	9	2	—	—	—	—	23
Wa-139	—	9	2	—	—	—	—	23
Wa-142	—	16	11	—	—	—	—	46
Wh-3	—	—	—	—	—	+	—	17
Wh-11	—	—	—	+	—	—	—	16
Wh-12	—	—	—	—	—	+	—	7
Wh-13	—	—	—	—	—	+	—	5
Wh-14	—	—	—	+	—	—	—	26
Wh-15	—	—	—	—	—	+	—	12

Given these data, there is still some difficulty in deciding which one or ones of the Great Basin pecked styles are represented at a given site. At the Hickison Summit site (La-9), for example, elements of all three styles are found, but only a single diagnostic element of Great Basin Representational, a hand design, and that a rather dubious example, so we have not counted the Representational style as present at the site. The problem is twofold. First, since the classification of elements is a matter of judgment, it is desirable to have a considerable number of diagnostic elements present before concluding that a given style is actually represented at a site. Second, even if there are a few examples of un-

doubted diagnostic value, these may indicate the presence of a foreign visitor rather than a local style. The mountain sheep at the Lagomarsino site (St-1) for example, is quite unmistakable, but at that site only 5 elements characteristic of the Great Basin Representational style are found out of a total of 439 recorded elements. One can hardly say that the style is characteristic of the site.

To deal with this problem we have adopted the following procedure. No site will be assigned a style designation unless it has more than 10 recorded elements. Of each site counted we will say a style is represented there if (a) more than 10 diagnostic elements of that style are present or (b) more than 20 per cent of all diagnostic elements are of that style. This is a rather arbitrary procedure, but we believe it to be justified on the grounds that any solution to the present problem has to be mechanical lest it be subject to bias. Table 5 gives the results of the procedure. A plus (+) entry indicates occurrence of the style at the site designated.

TABLE 5
DIAGNOSTIC ELEMENTS REPRESENTED AT NEVADA PETROGLYPH SITES

Site	Great Basin Representational	Great Basin Curvilinear	Great Basin Rectilinear	Site	Great Basin Representational	Great Basin Curvilinear	Great Basin Rectilinear
Ch-3		+	+	Ly-5		+	
Ch-16		+		Ly-7		+	
Ch-57		+	+	Mi-2		+	
Ch-71		+	+	Mi-4		+	+
Cl-1	+	+	+	Mi-5		+	+
Cl-2	+	+	+	Mi-14		+	
Cl-3	+	+		Ny-2		+	
Cl-4	+	+	+	Ny-3		+	
Cl-5	+		+	Pe-10		+	
Cl-7	+	+		Pe-14		+	+
Cl-123		+	+	St-1		+	+
Cl-131		+	+	Wa-5		+	+
Cl-143	+	+		Wa-29		+	
Cl-145	+	+	+	Wa-35		+	+
Cl-146		+	+	Wa-69		+	+
La-9		+	+	Wa-131		+	
Li-1	+			Wa-137		+	+
Ly-1	+	+	+	Wa-139		+	+
Ly-2		+	+	Wa-142		+	+

GREAT BASIN PECKED STYLE

Great Basin Representational

Great Basin Representational petroglyphs are the most skillfully executed of the pecked or scratched glyphs in our material. The most characteristic element is the mountain sheep, of which we have recorded 259 examples. The sheep figures are often in bunches, perhaps representing herds. Many figures which may be mountain sheep have been designated as quadrupeds because they have no horns. They may represent ewes of the same species, as they are often found in the same panels with rams. The herd scenes come closest to having deliberate composition of any designs in the corpus.

Other notable elements in this style are Katchina figures and horned human figures. These are often carefully made but seem never to be grouped. Both

elements also occur in the Puebloan Painted style and seem clearly to be related to Southwestern petroglyphs and pictographs. Since the mountain sheep element also occurs in the Southwest, it would be reasonable to assume that the entire style diffused into Nevada either by tribe-to-tribe borrowing or through the agency of invasion of Puebloan farmers between A.D. 900 and 1000.

This all seems clear and reasonable enough, but the geographic distribution of the style is nevertheless curious. As shown in figure 30c, the Nevada occurrence of the style is almost entirely confined to Clark and Lincoln counties. It is definitely not found at the cluster of five sites in central Nye County (Ny-2, 3, 25, 29, 33), and hence the western boundary given is probably correct. To the east the position of the boundary is less certain. We know a half-dozen sites in White Pine County, but all these have painted pictographs. There has been considerable archaeological activity in White Pine County by Wheeler and by Harrington; one would have expected at least a few petroglyph sites to have been recorded if they had been at all common there.

The East Walker River site (Ly-1) is the only place where the Representational style is found in substantial quantity outside the hachured area in figure figure 30c. Here we find some 22 elements diagnostic of the following styles: mountain sheep, 3; quadruped, 4; foot, 2; hand, 2; horned human, 11. For the mountain sheep 2 elements are undoubted (fig. 83j, k), while the third (fig. 84k) is questionable. The quadrupeds are all questionable and seem coyotelike, not sheeplike as do the quadrupeds in southern Nevada. None of the foot or hand figures are striking examples of their kind. As for the horned humans, one (fig. 82k) is actually a horned Katchina figure, while most of the others seem to be stick figures with variously shaped horns. There are too many genuine Representational elements at East Walker River to set the occurrence aside as accidental; we must find some other explanation.

Some evidence on dating by means of differential patination is available at this site (see discussion above, p. 232). From this evidence any element can be assigned to one of four categories: early, late, very late, or indeterminate. For the Representational style elements we have the following situation: One hand figure is early (fig. 87e), but it is an extremely dubious example of that element. One clear horned human is late (fig. 84i), and on a boulder separated a short distance from the main concentration of glyphs are the very late and crude but unmistakable figures of a foot, a hand, and a horned human. Other examples of the Representational style are indeterminate as to time. If we ignore the early hand figure — and we think we can properly do this in view of its ambiguous character — the remaining evidence suggests that the Representational style as late at the Walker River site. If so, this style may have been brought in by the invading Northern Paiute. We have already indicated in some detail the possibility that the knowledge of petroglyph manufacture may have been lost to the Great Basin peoples during their migration out of eastern California northward through Nevada (above, pp. 14-15). The suggestion was made that, as the people moved into unfamiliar territory, their

knowledge of local game movements diminished, and hence the apparent efficacy of petroglyph hunting magic diminished as well and the practice was abandoned. If these people moved north along the Owens River in California and on to the headwaters of the Walker River, then they may have gone down the East Walker River and early in their invasion may have been in the vicinity of the petroglyph site. It may be that they tried their hunting magic here at an obvious game trap, and because they were not familiar with local conditions (they might have been hunting mountain sheep, for example, at a site appropriate only for deer hunting) the magic failed and the practice was abandoned. This assumption has the advantage of accounting for the apparent newness of the Representational-style glyphs at the East Walker River site, for the relative scarcity of Representational glyphs at the site, and for the fact that the style is not found farther east or north in Nevada.

If our assumption is correct, we can estimate the speed at which the Northern Paiute invasion proceeded. Investigation of the eastern California petroglyphs (see Appendix F) reveals that the Representational style is found in California only as far north as site Iny-429, near Lone Pine, Inyo County. It may be that the ancestral Northern Paiute occupied Owens Valley this far north before they began their migration. In this connection it may be significant that great stylistic similarities in the mountain sheep element are found between the East Walker River glyphs (Ly-1) and those of a site on Owens Lake, a few miles south of Lone Pine (site Iny-272). Compare, for example, the elements in figure 83j and k from site Ly-1 with those in figure 19a of Appendix F from site Iny-272. It is as though the same individual made both sets of glyphs. In any case an invasion from the neighborhood of Lone Pine would have gone up Owens River to a point near its headwaters, crossed over the ridge into the valley of Mono Lake, and gone from there to the present town of Bridgeport, altogether about 125 miles. From Bridgeport it is about 30 miles downstream to the East Walker River site. In all, the invaders would have gone about 155 miles air line. Now the person or persons who made the Representational-style glyphs at East Walker River must have learned the technique while still at Lone Pine; these are bold specimens, not hesitant, not as if done by an old man who vaguely remembered seeing such things in his youth. This means, then, that the migration or invasion journey did not take more than 50 years and probably took 25 years or less. In other words, the slowest possible migration rate would have averaged 3 to 6 miles per year. At this rate the peoples would have taken 100 to 200 years to reach the northernmost point of their territory in Snake River drainage.

Another curious fact about the Representational style concerns the distribution of the most diagnostic and abundant element within the style, the mountain sheep. These designs are found abundantly in Clark County and to a lesser extent in Lincoln County, so far as we have evidence. North and west of that area they are scarce; there is 1 dubious example at Rattlesnake Well (Mi-14), 1 dubious and 2 good specimens at East Walker River (Ly-1) discussed above, 1 good specimen at site Ch-71, 1 good example at Lagomarsino

(site St-1), and 1 dubious specimen each at Spanish Springs Valley (Wa-5) and the Court of Antiquity (Wa-35). Thus there are only 4 certain occurrences in the north as against hundreds in the south; to all intents and purposes the element does not occur in northern Nevada. But in spite of this the design does occur in southern Oregon (Cressman, 1937, pp. 30, 31, 61), southern Idaho (Erwin, 1930, pp. 55, 95, 109), and along the Columbia River (Cain, 1950, p. 36; Strong, Schenck, and Steward, 1930, pl. 28). The sources for these areas do not give frequency counts for the element, but their illustrations indicate a fair quantity, many more than in northern Nevada. The figures are very similar in design and execution, and must certainly be of a common origin with those of southern Nevada. Did knowledge of these designs spread through southern Nevada and Utah and thence north into Idaho and Oregon while completely avoiding northern Nevada? If so, why? It is possible that a north-ward diffusion through Utah to the Snake and then to the Columbia rivers and from there south into Oregon may account for the Oregon occurrences. It is true the mountain sheep is today extinct through northern and central Nevada, but this was not so in the early historic period. Fremont, for example, reports that he saw many in the mountains around Pyramid Lake in 1847 (Hall, 1946, p. 637), and we have identified their bones from archaeological sites in eastern Churchill County and the Lovelock region (Heizer and Baumhoff, n.d.*a*; Heizer and Krieger, 1956, p. 108). One can only assume that the Rep-resentational style was at one time peculiar to the Puebloan and Puebloid peoples of Utah, southern Nevada, and the Southwest. From them it spread west to the ancestral Northern Paiute and at the same time went north with the Puebloid peoples through Utah and thence west to whatever group was occupying southern Idaho and Oregon. There must have been a cultural barrier in north and central Nevada. The peoples of northeastern Nevada evidently did not make petro-glyphs at all (see discussion under Great Basin Curvilinear style below), and that would presumably have constituted a sufficient barrier. The peoples of northwestern Nevada did make petroglyphs, but evidently were too conservative to accept innovations from their southern neighbors.

Great Basin Abstract

Great Basin Curvilinear. — Great Basin Curvilinear was defined originally by Steward (1929, p. 220) and has been further discussed by us in an earlier work (Baumhoff, Heizer, and Elsasser, 1958). Although we are now able to analyze the style with greater precision, our earlier conception remains essentially unchanged. Our statement of 1958 follows:

> The circle, in one context or another, is the common element of this style but perhaps a more characteristic element is the curvilinear meander. These meanders have a vague sort of composition in that they tend to fill an area defined by the outline of a single boulder. But aside from two restrictions — curving lines without abrupt discontinuities and spatial restrictions provided by the areas of a single boulder face — there seems to be no aesthetic discipline imposed on the style. The lack of discipline

is no doubt attributable to the nature of the materials. Petrography is essentially a decorative art — an attempt to embellish an object without reshaping it. But the objects that are decorated, in this case the boulders, are not themselves made by man and therefore they do not possess any degree of uniformity to provide a consistent set of restrictions within which the art might develop. The shapes of the boulders are endlessly and randomly varied so that no uniform set of artistic principles can be applied to their decoration.

The geographic occurrence of the Curvilinear style in Nevada is coincident with that of all pecked petroglyphs, as shown in figure 30d; that is, it is found everywhere in Nevada except the northeast corner of the state. The only petroglyph site in White Pine County is in Tunnel Canyon (site Wh-11), and the glyphs there may be scratched rather than pecked petroglyphs. White Pine County has been extensively surveyed by Harrington and Wheeler, and presumably any notable petroglyph sites would have been observed by them. In Elko County we know of only one aboriginal petroglyph site (see Appendix E), although we made extensive surveys there in 1958 and 1959. The single exception is in the extreme north of the state, in the Snake River drainage. Additional field work in northeastern Nevada, then, although it may disclose a few small sites, is unlikely to make a major addition to our knowledge.

It is difficult to say why petroglyphs are absent from this area when they are abundant in much of the surrounding territory. It may be thought that environmental differences were responsible. It is true that northeast Nevada is comparatively well watered and correspondingly more productive of plant and animal life than many other parts of the state, but this factor cannot have been decisive; there are even more favorable areas, to the north in the Snake River drainage, for example, or on the Carson and Truckee rivers, where petroglyphs are abundant. The reasons must have been cultural; that is, the northeast must have been inhabited by peoples with traditional patterns distinct from those of other parts of the state. In the historic period northeastern Nevada was Shoshone territory and these people were nearly identical, culturally, to the central and western Nevada Northern Paiute. But neither the Northern Paiute nor the Shoshone made petroglyphs, according to their own testimony, so we would not expect prehistoric cultural demarcations as exemplified by petroglyph distributions to find expression in historic times. Nevertheless it is curious that the apparent boundary between the areas where petroglyphs are present and the areas where they are absent coincides so neatly with the recent Northern Paiute-Shoshone boundary. A possible explanation may lie in the pre-Shoshonean or pre-Numic tribal distributions in northern Nevada. We presume that the Shoshone and Northern Paiute spread from the Owens Valley-Death Valley region (see above, pp. 14-15). The migrations of the two groups evidently occurred at about the same time, but there is no reason to believe that they were precisely concurrent. Now suppose that before these migrations there were two distinct peoples or groups of peoples in northern Nevada with a dividing line, either a natural boundary or a well-established cultural boundary, about where the present Northern Paiute-Shoshone boundary is. Suppose further that the Northern

Paiute began their migration first, and that they successfully invaded or infiltrated the area north of them (their myths suggest that there were pitched battles) until they had occupied their historic territory. During this migration, though, they ran into a different people on the east whom they were unable to drive out, perhaps because the Northern Paiute style of warfare was ill-suited to defeat the eastern group or because the eastern group was more belligerent and more difficult to overrun than the western group. All Northern Paiute bands on the western boundary had access to parts of the Walker, Carson, or Humboldt rivers (Stewart, 1939, map 1). Perhaps if they had gotten farther east they would have been too far from these rivers, to which they were so well adapted and on which they were dependent.

Later the Shoshone pushed north from the same general area of Owens and Death valleys but could occupy only the eastern part of the state, since the Northern Paiute were already in occupation to the west. Thus an ancient tribal boundary would have been preserved in the later Northern Paiute-Shoshone boundary.

The same sort of argument can be applied if we assume that the Shoshone migration was earliest. In either case there would have been an ancient boundary here, and the original people in northeast Nevada for their own historical reasons did not make petroglyphs. This remark may not apply to pit-and-groove style petroglyphs. We know of one such site in northeast Nevada (Eu-1), and in any case this kind of glyph is so easily overlooked that present absence of evidence may only reflect failure of observers to report occurrences. We are willing to speculate that the pit-and-groove style in the Great Basin may predate the pre-Shoshone and pre-Northern Paiute peoples and refer to a scattered, wide-ranging hunting population of early postglacial times.

Great Basin Rectilinear. — As we said earlier (Baumhoff, Heizer, and Elsasser, 1958, p. 14), "This style has only slightly more artistic merit than the curvilinear style. The elements themselves have a bit more consistency while the composition, or relationship between elements, has a comparable lack of discipline."

The distribution of the style is shown in figure 31a. It has a generally western occurrence, evidently west of Reese River drainage and not far into Nye County except in the extreme south. This style is more abundantly represented and better developed in the southern California desert and in Baja California (Steward, 1929, pls. 46, 92) than in western Nevada. It evidently centers to the southwest, and only weak impulses reached Nevada.

GREAT BASIN PAINTED STYLE

This style is characterized by circles and parallel lines done in red or white mineral pigment. Distribution of the style is shown in figure 31b. Its original distribution was presumably wider than is attested at present if our assumption is true that painted designs have been obscured by smoke on cave walls or have weathered away in exposed positions.

Great Basin Scratched Style

This style has a very limited geographic occurrence (fig. 31c). Its elements are straight lines, sun figures, and crosshatching. They were evidently made with a sharp rock (like obsidian or chert), and each line is made with a single stroke. The style seems very crude. Possibly it is very late copying of earlier glyphs. It might be thought that the scratched glyphs are artists' sketches made to provide rough patterns for the pecked petroglyphs. This is not the case, though, for the scratching seems usually to be later than the pecked petroglyphs, and is so shallow that desert varnish would obliterate it in a very short time.

Puebloan Painted Style

This style is found only at a few Nevada sites and is confined to that region of southern Nevada known to have been occupied by Puebloid and Anasazi peoples (fig. 31d). In Clark and Lincoln counties there are Anasazi remains dating from Basket Maker II to Pueblo III (Dick Shutler, Jr., personal communication). Two pictograph sites in these counties seem to be attributable to that occupation: Cane Springs (Cl-4) and Li-3, sometimes called Painted Cave. The diagnostic element of these pictographs is a stylized human. At Cane Springs the figures are a foot or two high, have a triangular body, and look very much like some of the White Pine County figures (compare, for example, fig. 62c with fig. 131c). At site Li-3 there are two figures with hourglass bodies which must be 5 or 6 feet tall. This is a rock shelter site, and the deposit there has buried the larger figure almost to the shoulders. Haury (1945, p. 71) maintains that at Painted Cave, Arizona, large figures such as this are characteristic of Basket Maker occupation. That may also be the case at Li-3. Haury asserts that hourglass figures at the Arizona site are attributable to Navajos. Presumably this is not true of such figures in Nevada.

The White Pine County pictographs probably date from the Puebloid occupation (A.D. 900 to 1100). Some of the figures here are complex, but most are greatly simplified, even schematic.

Pit-and-Groove Style

This style was named by us in an earlier report (Baumhoff, Heizer, and Elsasser, 1958) largely on the basis of evidence from a single site. More thorough investigation of Nevada and California petroglyphs (fig. 134) indicates that most occurrences of this style consist simply of pits, only a few having grooves as well. The pits vary in size. Most of them are only an inch or two in diameter, but some are as much as 12 inches across. Grooves, when present, are from a half-inch to an inch in width. Pits are usually a half-inch to an inch in depth, whereas the grooves are much shallower — seldom more than a quarter-inch in depth. Both pits and grooves were evidently pecked or battered into boulder surfaces and were not further smoothed. The pits seem to be randomly placed on a rock surface, not patterned in a regular or definite

fashion. When grooves are present they do not lend composition but merely connect some of the pits or, in one example, encircle pits.

We have recorded a total of six Pit-and-Groove petroglyph sites in Nevada, all of them in the northern half of the state. These instances no doubt represent only a small portion of the total of such sites in the state, for they are most unobtrusive and there must be many as yet unnoted. The distribution of the style is far more extensive than the area covered by the present work; it is spread over most of western North America and perhaps even farther. We comment in detail on the distribution and historical significance of this culture in the next chapter.

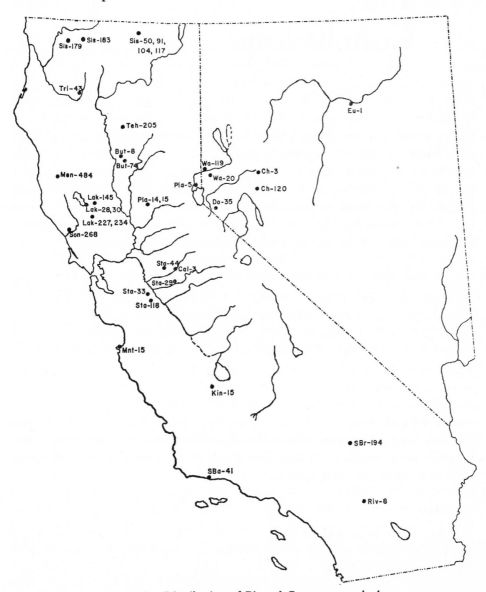

FIG. 134. Distribution of Pit-and-Groove petroglyphs.

V

Analysis and Conclusions

In this section it is our purpose to analyze the data thus far presented in order to establish the probable function or meaning of petroglyphs and also to establish, so far as possible, the relative age of each of the styles. Since it has been our intention to test the question of whether and to what extent Great Basin petroglyphs were made in connection with big game hunting, it will first be necessary to discuss the behavior of the game and the hunting techniques which may have been used by the prehistoric inhabitants of this area.

ANIMAL BEHAVIOR IN RELATION TO HUNTING

As to the behavior of game animals, it is possible to limit our attention to three species — mule deer (*Odocoileus hemionus hemionus* Rafinesque),[1] pronghorned antelope (*Antilocapra americana americana* Ord), and mountain sheep (*Ovis canadensis*). The elk or wapiti (*Cervus canadensis nelsoni* Bailey) was at one time also found in Nevada (Heizer and Baumhoff, n.d.) but was evidently confined to the northeast part of the state. We have found almost no petroglyphs in that area, and hence the rock writings presumably had no connection with elk hunting. Since the other three species differ markedly in their behavior, we shall consider each separately, with special reference to migration behavior and to feeding and watering habits. At the same time we will discuss hunting methods for each species.

Deer

The deer of the western Great Basin were all of the species *Odocoileus hemionus* and in Nevada were virtually all of the race *o. h. hemionus*. In this connection Hall (1946, p. 623) says:

It is possible that in the vicinity of Lake Tahoe *Odocoileus hemionus columbianus* [California black tailed deer] or *Odocoileus hemionus californicus* [California mule deer] will be taken but none of the specimens seen from Nevada are of these races. Further south, in the White Mountains of Esmeralda County, deer may be of the subspecies *Odocoileus hemionus inyoensis* [Inyo mule deer], but at this writing no specimens of deer of any kind are available from there.

It may be that indisputable record for Nevada of an entirely different species of deer, *Odocoileus virginianus* [white tailed deer], probably subspecies *ochrourus,* will yet come to light. . . . Although I suppose white tailed deer once occurred in Nevada and although some still may be found there, there is no one record known to me which excludes all reasonable doubt of its authenticity.

Thus, in spite of some question as to race and species, it will be most profitable to concentrate attention on the behavior of the mule deer. According to Hall (*op. cit.,* fig. 463) the mule deer in Nevada at present is abundant above the Lower Sonoran life zone and present everywhere except in the following areas: most of Clark County; southern Nye County; and a north-south strip covering most of Esmeralda County, eastern Mineral County, western Churchill County, western Pershing County, and a narrow tongue into Humboldt County (fig. 32*a*). Except for two of these areas, this range is in fair accordance with the distribution of petroglyphs. The two exceptions — the area east and southeast of Fallon in Churchill County and the area around Lake Mead in Clark County — will be discussed further below.

The migration of mule deer in Yosemite and Yellowstone national parks has been studied in detail by C. P. Russell (1932). While neither of these areas is comparable to the Great Basin desert type of land, the probable causes of migration within the regions in question are evidently similar. After considering breeding activity, birth of young, condition of feed, and various climatic factors as possible causes, Russell (*op. cit.,* p. 37) concludes that deep snow is the decisive factor in bringing about migration. Where there is a moderate amount of snow some deer will leave for snow-free winter grounds, but when the snow becomes deep, low-growing plants are rendered inaccessible to the deer and they all must leave for lower country.

Russell (*op. cit.*) discusses another fact of considerable interest, namely, that deer follow the same migration routes year after year. They evidently learn the routes as fawns and use them repeatedly. In one instance, in Yellowstone, they are known to cross a major divide rather than follow up a single drainage. Since this "unnatural" trail is used repeatedly, they are evidently obeying habit rather than following the path of least resistance.

As to the migratory habits of individual herds within our area of study, we have specific information for some areas but find it completely lacking in others. The migration routes we know of are shown in figure 32*b* and are described herewith.

1. From Big Smokey Valley into the Simpson Park Range. Reported by Gordon Gullion, field officer of the Nevada Fish and Game Commission, who in 1958 was stationed at Austin.

2. From the Toyabe Mountains across Big Smokey Valley (Linsdale, 1938, p. 199).

3. From the Wassuk Range across Whisky Flat to Garfield Flat and Huntoon Valley. Reported by John Demchak, a hunter who lives in Hawthorne, Nevada.

4. "A sizeable portion of the [Doyle] herd is known to pass into the Fort Sage Mountains and Redrock Areas, thence eastward into Nevada" (Leach, 1956, p. 262).

5. It is evident from Leach's data (*op. cit.*, pp. 274-279) that Truckee Canyon is winter range for a herd summering around Sierra Valley.

6-9. These routes are shown by Adams (1959, fig. 8), who does not discuss any one trail in detail. Except for No. 6, which leads from the Warner Mountains out toward Massacre Lake, all trails lead from the Sierra Nevada into dry Nevada valleys.

This is not by any means sufficient documentation, but it is a beginning. It is our hope that a more detailed study of the concurrence of deer migration trails and petroglyph sites would test our present hypothesis more thoroughly. In any case the present data indicate that the deer do summer in the higher mountains and leave the mountains when there is deep snow. Russell's studies, discussed above, further suggest that there would be habitually used migration routes, and hence that repeatedly used hunting sites would be found along them.

But what deer hunting methods would we presume were used by the prehistoric inhabitants of the area? The ethnographic inhabitants, the Northern Paiute, Shoshone, and Southern Paiute, were probably recent immigrants, and hence it is dangerous to presume that their methods were also used by their predecessors. Nevertheless let us describe their methods and see what evidence there is that any of them are prehistoric.

Steward's statement in his *Basin-Plateau Aboriginal Sociopolitical Groups* can be taken as a prototype for historic Basin peoples.

Occurring thus in the lower altitudes of mountains and limited to small bands, deer were taken by lone hunters or by small groups of men. As the country is less heavily covered with brush than the west coast, snares and ambushes on deer trails were of minor importance. Most hunting was by individual men who stalked or pursued the animals, shooting them with poisoned arrows.

Cooperative hunting was much less important for deer than for antelope and rarely warranted special trips for that purpose. Such hunting was most feasible in the fall when deer descended from the mountains in fairly well-marked trails into a warmer region or in the spring when they returned to the mountains. At such times people in the northern part of the area constructed V-wings between which was a hurdle with a pit beyond. The deer's propensity to jump carried him over the hurdle into the concealed pit. In a few localities a shaman charmed deer for these drives. At other times small groups of men who happened to be in the locality attempted to surround deer in the mountains or, if they could find a deer trail, to drive the animals past concealed hunters.

Steward's description of communal hunting squares tolerably with our proposal that many petroglyph sites were used in such enterprises. At the same

time his de-emphasis of co-operative hunting suggests that it would not be of sufficient importance to warrant elaborate magical preparations. Steward's lack of emphasis on co-operative hunting applies only to Shoshone and a few Northern Paiute, among the groups we are interested in, but his conclusion is borne out for other groups by the Culture Element Distribution Survey. Thus Stewart (1941, p. 366) indicates that, although deer were driven past an ambushed hunter among all but one of the twelve Northern Paiute bands, only three of the twelve bands had communal drives, one of the twelve drove deer into enclosures, and none drove them into enclosures with pits or into traps, nets, or snares. According to the Southern Paiute element list (Stewart, 1942), the case is even more striking; although all bands admit conducting drives, none admits driving deer into an enclosure. The burden of evidence suggests that the historic tribes placed more emphasis on individual deer hunting than on communal hunting. This is in contrast to their attitudes toward antelope hunting, which were just the reverse.

The fact that the historic tribes did not greatly emphasize communal deer hunting does not mean that their predecessors were similarly disposed. The communal hunt involves some kind of enclosure or fence and usually some ceremonial treatment of the hunt. Both the ceremonies and the technical aspects of the enclosure for antelope hunting were known to the historic tribes. They had probably also been known in the area for some considerable time past; their widespread distribution in North America indicates this (Driver and Massey, 1957, map 15, p. 253). Evidently the critical question is whether deer are profitably hunted in this fashion. The Shoshone, Northern Paiute, and Southern Paiute ostensibly thought not, mainly because the deer are usually alone or in small bands. There is one important circumstance in which this is not so — when they are suddenly driven off their summer range by a heavy snow. Thus Russell (1932, p. 10) says, referring to the Yellowstone herd, "Severe storms usually occur in November. The restlessness, which for some weeks has been evident in the animals, culminates in a determined descent when the first severe storm arrives. The deer move in numbers to the true winter ranges and frequently seem to occupy their ancestral winter homes overnight." Of the Yosemite herd he says (op. cit., p. 27), "On December 10, three inches of snow fell in regions above 6500 feet. Indian Canyon fairly spewed deer. Three days later no deer were to be found about Bridal Veil and Peregoy Meadows, but one buck could be noted in the canyon of Indian Creek. In the logged-off basins below Chinquapin and just outside of the park (5000 feet), the animals flocked like sheep."

Surely occasions like these must have provided the Great Basin peoples with opportunities to take migrating deer, especially along the eastern flank of the Sierra. Perhaps the historic tribes had come from country where deer were scarce or unknown, and they had not had time to develop skills and ceremonies for communal hunting. If so, this may be an indication that their native home lay in Death Valley or farther south, where there are virtually no deer.

Prong-Horned Antelope

Most of the authors of the published sources concerning the prong-horned ante-
lope are of the opinion that it was once common in the Great Basin, and in
Nevada lived in all parts of the state in and below the Transition life zone (see
Hall, 1946, p. 629; E. W. Nelson, 1925, p. 38). Einarsen (1948, pp. 5-6),
however, doubts that it was ever plentiful in eastern Oregon. Even if we accept
its "abundance" we cannot say today exactly what this means. Were there more
antelope than deer or bighorn? We cannot yet answer this because not enough
archaeological sites have been excavated to permit quantitative studies. However,
the number must have varied greatly according to local conditions. Egan de-
scribes a hunt in the dry and forbidding country of the Gosiute and concludes
his remarks by saying, "The Indians told me the last drive, before this one at
this place, was nearly 12 years ago and the old men never expected to see
another at this place, for it would take many years for the animals to increase
in sufficient numbers to make it pay to drive" (quoted in Steward, 1938, p.
35). In more favorable areas they might assemble once or even twice a year
for a hunt (Steward, 1941, p. 219).

There is some difference of opinion about the migration habits of antelope.
Hall (1946, p. 630) says, "The animals are migratory in the sense that those
on the higher part of the summer range move down to lower territory where
there is less snow in the winter." McLean's (1944) observations on the north-
east California antelope indicate a greater regularity in migration pattern there.
He shows a summer range (his fig. 86) covering most of Modoc and Lassen
counties, and winter range (his fig. 87) restricted to a few valleys. He says
(*op. cit.*, p. 226) they "usually occupy their winter range from November to
early April. This varies from year to year because of weather." McLean has
mapped some of the migration routes in the area (his fig. 88). He says of these:

During their migration from summer to winter range and in traveling from one area
to another on either the summer or winter range, antelope ordinarily move over
definite and well established routes.

Antelope from various valleys will converge toward the main travel line and upon
reaching it all take the same route toward their ultimate destination. Some of these
antelope highways are so well worn that they show up plainly even during the seasons
when no antelope are using them. The trails are easily identified as those of antelope
and not of deer. Deer go from one brush patch to another or from tree to tree,
especially in the juniper area whereas antelope keep to the open slopes and flats
and their trails are much more direct and maintain a more even grade. Deer occasionally
travel antelope trails but antelope rarely travel deer trails. Antelope tend to keep
together, often in single file, when traveling, whereas deer commonly spread out with
stragglers along the sides of the band. Deer herds are always much more loosely knit
than are those of antelope.

According to Einarsen (1948), the Oregon herds are not migratory in this
sense. He says (*op. cit.*, pp. 11-12), "They may change feeding grounds
several times within the year, but their drift from one range to another is not
usually a long trek, lacks rhythm, and will as often be northward as southward

in winter." Jack O'Conner, an Arizona hunter familiar with herds in the Southwest and in Mexico, maintains (1939, pp. 110-113) that antelope prefer plains in both summer and winter, but have learned to be migratory because their former range is greatly restricted by modern settlement.

Antelope have one quality which makes them especially subject to large-scale hunts: their habit of herding together in large groups in winter time (McLean, 1944, p. 225; Hall, 1946, pp. 629-630; Einarsen, 1948, pp. 41-42). Einarsen says (*loc. cit.*), "On Drakes Flat, in 1941, a band of nearly 1000 animals were using only about 10 sections of land." Their winter-time gregariousness made them more subject to mass hunts than were any other large mammals of the desert.

Antelope hunting methods of the historic tribes of the Great Basin were considerably more elaborate than were deer hunting methods. Steward gives the following description (1941, p. 219) for the Nevada Shoshone.

Living in open country in large herds, they could not be stalked, trailed, or ambushed as readily as deer. The most effective method for individual hunting was stalking with an antelope disguise.

Most antelope hunting was communal, large numbers of persons assembling from considerable distances once or twice a year for that purpose. The complex included practical and magico-religious measures and social features, and closely resembled the Plains and northern impounding of various species, from whence it was probably derived. The practical elements were: a leader (who was also a shaman); a drive to the corral by several hunters (in some localities the antelope were said to have been attracted to the corral by the shaman's power, driving being unnecessary); a corral with wings converging to its opening (often the corral was of poles supporting brush to resemble people and spaced from 10 to 28 feet apart with people stationed in between them; in this case it approximates a surround rather than a true corral . . .); shooting with arrows as the animals mill around inside the corral; an equal division of the kill.

The magico-religious measures were based upon the assumption that a man with special supernatural power (the shaman-leader, who dreamed his power) could capture the antelopes' souls (the soul-loss theory of disease is important among Shoshoneans), rendering them subservient to his will, and thus bring them into the corral from which they were powerless to escape unless some person had broken a taboo during its construction. This assumption capitalized upon antelope herd behavior and would have been less effective with other species in this area. Shamanizing comprised other ritual elements which were accessory to the central concept and partly depended upon the shaman's vision. They were consequently somewhat variable: dances, songs, musical instruments . . . and the special archer. Some of these elements had been taken from the generalized Basin shaman's complex — songs, smoking, pipe passing.

Social features were dancing, singing, gambling, feasting, courting, and visiting with people rarely seen during the remainder of the year. These large gatherings could be fed only by the temporarily increased food supply produced by a large hunt.

The same procedures are found among the Northern Paiute, most of whose groups drove into a corral and usually had a ceremony associated with the hunt (Steward, 1941, pp. 366-367). Among the Ute and Southern Paiute a communal hunt was nearly universal, but specific methods and religious or ceremonial

association were not uniform (Stewart, 1942, p. 241). Among the Yuman-Piman tribes antelope, where present, seem to have been hunted in ways similar to those of the Great Basin tribes (Drucker, 1941, pp. 98, 103). In California the technique was evidently different. Although game fences were used by some tribes in the Sierra Nevada (R. B. Dixon, 1905, pp. 192-193), these seem to have been only for deer. In the Central Valley, where antelope abounded, the game fence or corral seems not to have been used, perhaps because there was not sufficient brush available to make one. Instead the participants formed a circle over two miles in diameter and slowly closed in on the herd until they could easily make the kill (Kroeber, 1925, p. 528; Voegelin, 1938, p. 13). The ceremony in this drive seems as fully developed as that in the Basin.

The basic similarity of antelope hunting techniques in the area surrounding the Great Basin (except California) and the almost universal ceremonialism accompanying the hunts suggests that these practices are old in the Basin and may well have been there before the historic Shoshonean inhabitants arrived.

Many petroglyph sites are very well situated for antelope drives, which were often from an open valley into a corral against the hills. In addition, the ceremonial and religious behavior associated with antelope hunts would fit very nicely with our postulation of petroglyphs as hunting magic.

Mountain Sheep

Three races of mountain sheep were present in Nevada at the opening of the historic period: *Ovis canadensis californiana, O. c. canadensis,* and *O. c. nelsoni* (fig. 32c). The literature does not mention differences in behavior for the three subspecies; we believe that they would not be significant.

Apparently in the early days mountain sheep were sometimes found on plains and in valleys, but even then they were never far distant from a mountain (Buechner, 1960, p. 16). Now that their lives are endangered by hunters armed with rifles, they have retreated to their mountain fastnesses. Allen (1939, pp. 253-258) makes the following statement about the Clark County sheep:

The mountain sheep, or bighorns, are not migratory in the true sense of the word, their movements being entirely local and largely governed by mechanical barriers. From the point of view of the bighorn itself, "preferable terrain" definitely excludes canyon bottoms, alluvial fans, valleys, washes, and the apparently better travel ways of the lower country. The bighorn's preference for the location of feeding routes, bedding grounds, and all-round living quarters is invariably for the roughest, most precipitous, and cut-up country, chiefly on or near mountain tops. The bighorn always seems to be somewhat uneasy when it is unable to look down and off in all directions. It is this preference that leads the sheep into the higher altitudes where igneous intrusions, dikes, ridges, and the general contour of the country permit an almost unlimited view in all directions. Even when the mountain sheep are forced to travel in lower country, they seek every high spot that offers an opportunity to get a better look at the surrounding country.

During the summer and early fall there is little change in the daily routine of the bighorns. In the latter part of the morning and [the first part] of the afternoon they bed down, usually in the shade of a tree or in the lee of a rock, and sleep until hunger starts them along the feeding route. After a certain amount of horn butting and leg stretching by the adults and play among the youngsters, they are off for the afternoon and evening feed. After their hunger is satisfied, sometime during the night, they again bed down. In the morning they feed again until time for their midday rest.

Each local band has its own regular feeding route, usually terminating at a familiar bedding ground. The sheep travel these routes with monotonous regularity throughout the year except during winter storm periods. Owing to snow and cold the animals are then forced from their habitual terrain and feeding routes to browse thickets in the lower country. There is usually some snow in winter on the sheep ranges, and to a strip along its lower border or "snow line" the bighorns confine their feeding activities as long as snow is present in any considerable quantity.

For drinking, where a choice exists, the bighorn selects springs or waterholes in the most inaccessible higher altitudes.

Naturalists who have studied mountain sheep provide remarkable confirmation of our hypothesis of the petroglyph-game hunting association. J. S. Dixon (1939, pp. 92-93), in speaking of the Death Valley sheep, says:

This spot [a watering place] has always been a favorite rendezvous for bighorn, according to Mr. Day, who has been a resident in the region for many years, and even before this the prehistoric Indian residents of the area had evidently visited the locality to secure water and probably also to secure bighorn for food. Many petroglyphs, or uncolored rock carvings, were found on the walls of this canyon. The native rock here consists of dark gray dolomite and in one place the Indians, by pounding on the rock, had created a series of images, most of which were those of bighorn. In one small area, approximately eight by ten feet, a band of 14 bighorn is depicted, besides many scattered individuals. Several lizards are also depicted. *It has been our experience, where such petroglyphs of bighorns have been sculptured or carved by the Indians, that it is a relative index to the bighorn population in the area.* [Italics ours.]

The same point is made by Buechner (1960, p. 56), who says, "Petroglyphs further attest to the importance of native sheep among the Indians." He then goes on to correct some of the Clark County petroglyph site locations given by Steward (1929).

One of the best descriptions of hunting methods for mountain sheep is given by John Muir (1922, pp. 320-322):

In the more accessible ranges that stretch across the desert of western Utah and Nevada, considerable numbers of Indians used to hunt in company like packs of wolves, and being perfectly acquainted with the topography of their hunting grounds, and with the habits and instincts of the game, they were pretty successful. On the tops of nearly every one of the Nevada mountains that I have visited, I found small, nest-like inclosures built of stones, in which, as I afterward learned, one or more Indians would lie in wait while their companions scoured the ridges below, knowing that the alarmed sheep would surely run to the summit, and when they could be made to approach with the wind they were shot at short range.

Still larger bands of Indians used to make extensive hunts upon some dominant mountain much frequented by the sheep, such as Mount Grant on the Wassuck Range to the west of Walker Lake. On some particular spot, favorably situated with reference to the well known trails of the sheep, they built a high-walled corral, with long guiding wings diverging from the gateway; and into this inclosure they sometimes succeeded in driving the noble game. Great numbers of Indians were of course required, more indeed than they could usually muster, counting in squaws, children, and all; they were compelled, therefore, to build rows of dummy hunters out of stones, along the ridge-tops which they wished to prevent the sheep from crossing. And, without discrediting the sagacity of the game, these dummies were found effective; for, with a few live Indians moving about excitedly among them, they could hardly be distinguished at a little distance from men, by anyone not in the secret. The whole ridgetop then seemed to be alive with hunters.

The corral hunt described by Muir probably refers to the Northern Paiute. Steward (1933, p. 253) affirms a similar practice among the Owens Valley Paiute, but Stewart (1941, p. 367) denies it for all other Northern Paiute. The Nevada Shoshone also deny using the corral for sheep. Steward (1941, p. 220; see also Spears, 1892, p. 73) says of the sheep,

living among precipitous mountain summits, they were difficult to hunt. Ambushing, stalking, or driving onto cliffs were the most effective. For the last, dogs, which were little used for other hunting, were employed.

A special device to attract rams to the ambush was thumping logs together. The animals, thinking other rams were fighting, came to investigate and were shot by the concealed hunters. . . . Disguises, though used elsewhere, were rare, S-BtlM [Battle Mountain Shoshone] stating that a sheep's head with horns was too heavy. S-Hmlt [Humboldt River Shoshone], however, said that a headgear with short horns, like those of the ewe, was used to attract rams.

In neighboring areas we have the following situations: The Northern Shoshone and Gosiute deny using an enclosure; most stalk individually or drive past individual hunters (Steward, 1943, p. 294). The Yuman-Piman tribes evidently do not drive into corrals, but only stalk sheep individually or drive them past hidden hunters (Drucker, 1941, p. 98). Among the Ute and Southern Paiute, sheep are never driven into a corral, but they may be surrounded and driven to a peak, stalked by individual hunters, or ambushed by a trail or at a salt lick (Stewart, 1942, p. 242). The mountain sheep was not found in the territory of most California tribes, and reports on the areas within its range lack information on the subject. Driver (1937, p. 61) says only that, in three of the eight Yokuts and Western Mono groups reported on by him, sheep were driven past concealed archers.

Throughout the Great Basin the predominant hunting techniques are: (1) stalking, (2) driving past a concealed hunter, and (3) ambush. Driving into a corral was evidently not much practiced. This is understandable since sheep do not often gather in large enough herds to make it an effective technique. We find no mention of ambush at springs, but this method must have been practiced. Sheep go to drink once a day when water is available, and the Indians undoubtedly would have known this and made use of the knowledge.

LOCATION OF SITES IN RELATION TO HUNTING

In table 6 we summarize some of the situational characteristics of Nevada petroglyph sites and also give the styles represented at each site. A word of explanation concerning these characteristics is in order.

On trail. Here we have used three symbols: "+" indicates that the site was on a known game trail; "L" that it was on what was likely to have been a game trail; "U" that it was on what was unlikely to have been a game trail. No symbol indicates that we cannot tell whether there may have been a trail near the site. We say there was likely to have been a game trail where there is a natural passageway, especially between summer and winter range. Open flats and box canyons accordingly are marked as unlikely.

In draw. We mark "+" in this column when the site is in a constricted canyon or draw especially suited as an ambush site. It is marked "0" if it is not so situated, and left blank if we do not know.

Near spring or tank. This column is marked "+," "0," or left blank according to whether the site is near a watering place, not near a watering place, or is of unknown setting. We have deliberately left lakes, rivers, and live streams out of consideration here. The location of a petroglyph site on a river, for example, would not be indicative of its use as a hunting spot unless there was a single passageway to the river at that point.

Corral. We have marked this column "+" if the site is in a suitable spot for an antelope corral, "0" if it is not, and have left it blank when we are unable to settle the question. We call a spot suitable when it is on the edge of a large valley where antelope are likely to have lived. We call it unsuitable when it is far into the mountains or out in the center of a valley.

Fence. These are indicated as present only where there are actual remains. Many more fences of wood (sagebrush, juniper, or piñon) not preserved may once have existed at these sites.

Blind. Blinds are marked "+" or "0" depending on whether or not rock rings (in which archers may have crouched) have been found.

Cave. We indicate which of the sites are in caves and which are not. Caves could have been used for blinds, and they may also have been good places to hunt mountain sheep since these animals commonly use caves for shelter from heat or cold.

What can we learn from this compilation? First, let us deal with caves. There are eight cave sites with petroglyphs for which we have sufficient data to assign styles. Of these five have Great Basin Painted pictographs, and three have Puebloan Painted pictographs. It is to be expected, of course, that painted pictographs would be found more commonly in caves than in the open; they would not usually be preserved at open sites. But they are preserved at eight open sites (two in Puebloan style and six in Great Basin style), so that if they had ever been truly abundant in the open more of them would probably remain. What is more notable, however, is that no pecked petroglyphs are known from within caves. There are a few instances which nearly qualify (Pe-14, for

TABLE 6
NEVADA LOCALE AND PETROGLYPH STYLES REPRESENTED

Symbols Used:

STYLES	OTHER
1. Great Basin Representational	+ = Present
2. Great Basin Curvilinear Abstract	O = Absent
3. Great Basin Rectilinear Abstract	L = Likely
4. Great Basin Painted	U = Unlikely
5. Great Basin Scratched	No symbol = no information
6. Puebloan Painted	
7. Pit-and-Groove	

Site	Style	On trail	In draw	Near spring or tank	Suitable for corral	Fence	Blind	Cave
Ch-3	2, 3, 7	L*	0	0	+	+	0	0
Ch-16	2	U	+	0	0	0	0	0
Ch-26	4		0	0	0	0	0	+
Ch-49	4		0					+
Ch-55	4	U	0	0				+
Ch-57	2, 3, 4	L*	+	+	0	0	+	0
Ch-71	2, 3	L*	0	0	+	0	0	0
Ch-120	7	U	0	0	0	0	0	0
Cl-1	1, 2, 3	U	0	+	+	0	0	0
Cl-2	1, 2, 3		+	+	+			0
Cl-3	1, 2		+	+	+			0
Cl-4	1, 2, 3, 6			+				0
Cl-5	1, 3							0
Cl-7	1, 2							
Cl-123	2, 3		+	+				0
Cl-131	2, 3							0
Cl-143	1, 3							0
Cl-145	1, 2, 3		+	+				0
Cl-146	2, 3			0				0
Do-35	7							0
Eu-1	7	U	0	0	0	0	0	0
La-1	4	L	0	+	L			+
La-9	2, 3, 4, 5	+	+	0		0	0	0
Li-1	1							0
Li-3	4		+					0
Li-5	6		+					0
Ly-1	1, 2, 3, 4, 5	L	+		+	+	+	0
Ly-2	2, 3	L	+	0	+			0
Ly-5	2							0
Ly-7	2	L*	+	0	0	0	0	0
Mi-2	2	L	+	0	+			0
Mi-3	4		0	0				0
Mi-4	2, 3	+	+		0	0	0	0
Mi-5	2, 3, 4, 5	+	+	0	+	+	+	0
Mi-13	4		+	+	+	0	0	0
Mi-14	2	+	0	0	+	0	0	0
Ny-2	2							
Ny-3	2		+	+				
Pe-10	2		0	+	0	0	+	0
Pe-14	2, 3	U	0	0	0	0	0	0
St-1	2, 3, 5	L	+	+	0	+	0	0
Wa-5	2, 3	U	+	+	0	0	0	0
Wa-20	7		0	+				0
Wa-29	2						+	0
Wa-35	2, 3	L	+	0	+	0	0	0
Wa-67	4							
Wa-69	2, 3	+	0	0	0			0
Wa-119	7							0
Wa-131	2		+	+	+	0	0	0
Wa-137	2, 3	+	+			0	0	0
Wa-139	2, 3	+	+			0	0	0
Wa-142	2, 3	+	0			0	0	0
Wh-3	6							+
Wh-11	4		+					
Wh-12	6							+
Wh-13	6							+
Wh-14	4							+
Wh-15	6							

*Ch-3, -57, -71, and Ly-7 are marked as being on "likely" game trails because they are all on a natural road or passageway. According to Hall (1946) there are no deer in this region, but the trails may well have been antelope trails.

example, where petroglyphs are found on the cliff above a shelter, or Ch-16, where they are outside the entrance of a cave), but none of them is actually within a true cave. This circumstance indicates that pecked petroglyphs had a function different from that of most painted pictographs. At three open sites painted pictographs occur with pecked petroglyphs, and there may have been more where the painted elements have weathered off. Such pictographs may have been used for the same purpose as the petroglyphs. Cave pictographs must have been intended for a different purpose, or we should occasionally also find petroglyphs in caves.

As for fences, we find these at four sites; of these, all have Great Basin Abstract style (both Curvilinear and Rectilinear), three have Great Basin Scratched style, two have Great Basin Painted style, one has Great Basin Representational style, and one has Pit-and-Groove style. Three of the four sites are marked as suitable for antelope corrals, and it is likely that the fences were parts of corrals. The single site marked as unsuitable, the Lagomarsino site (St-1), was so classified because it is in a narrow canyon in the mountains, not near a large valley. In spite of this setting it may have been the site of an antelope corral because a broad plateau extends some miles north of and slightly higher than the petroglyph area. A herd of antelope wintering there could have been driven south on the plateau, some animals perhaps being driven off the edge of the cliff where the petroglyphs are found, whereas others perhaps went around the edge of the cliff to be impounded in the canyon (see Appendix D).

Blinds are found at five of the sites, and are associated with a diversity of petroglyph styles similar to that found in combination with fences. Two of the blinds are found together with fences and must have been used in connection with corrals. Others may have been used as single ambuscades, as for example, in the mountain sheep hunting described by John Muir (1922, p. 20).

The situation of petroglyph sites with respect to game trails, draws, watering places, and suitability for antelope corrals is summarized in table 7. Probable trails and known trails are here lumped under "+," and improbable trails are under "0." A given site may be tabulated several times in a single column because some sites have several styles.

We first deal with the minor styles, those of least numerical significance. Great Basin Painted style is found on known or probable game trails three times out of four, but such a small sample can hardly be the basis of a generalization. The position of the sites in draws or near watering places is evidently irrelevant, the sample splits half and half with respect to each factor. Only one out of four sites is suitable for an antelope corral but again the sample is too small to be useful. The burden of this evidence, such as it is, indicates that if Great Basin Painted pictographs were made in connection with hunting, then they were used at trail-side ambush spots. Perhaps caves, in which this style is so often found, were used as natural blinds. Again, one could surmise that the painting was done in caves frequented by mountain sheep. On the whole, though, we feel that for the most part this style was not used with hunting. Where one can build an excellent case for the use of scratched and pecked

glyphs in such a connection, the corresponding case for painted pictographs is very weak.

TABLE 7
SITUATION OF NEVADA PETROGLYPH SITES

Style	On trail		In draw		Near spring or tank		Suitable for corral	
	+	0	+	0	+	0	+	0
Great Basin Representational	1	1	4	1	5	0	4	0
Great Basin Curvilinear Abstract	17	4	20	8	12	13	12	9
Great Basin Rectilinear Abstract	14	3	14	5	8	9	8	6
Great Basin Painted	3	1	5	5	3	4	1	3
Great Basin Scratched	4	0	4	0	1	2	2	1
Puebloan Painted	0	0	1	0	1	0	0	0
Pit-and-Groove	1	2	0	4	1	0	1	2

The Great Basin Scratched style is always found in draws along known or probable game trails. This is, as we shall see, the usual situation of the Great Basin Abstract styles in the northern part of Nevada. Since this is the case, and since the Scratched style has elements similar to those of the Pecked style, it is probably true that the two styles are closely related.

For the Puebloan Painted style we have too few data to permit much speculation.

There are six sites in Nevada which exhibit the Pit-and-Groove style. With one exception these seem unsuitable as hunting sites. The exception is the Grimes site (Ch-3), where we also find Great Basin Abstract designs. In the other sites the Pit-and-Groove style is found alone. There is only one way that we can explain these in connection with hunting: they might possibly have been used with the antelope-surround technique. The surround is a circle of humans who close in slowly on a herd of animals, keeping them within the ring until they are near enough to be dispatched. This hunting method was very common in North America and was found sporadically from the Pacific to the Atlantic and from northern Canada to southern Mexico (Driver and Massey, 1957, map 13). One of the characteristics of a surround is that it requires a large local population for its performance; a ring of people several miles in diameter (Kroeber, 1925, p. 528) is bound to require many participants. In the ethnographic period, the arid Great Basin with its sparse population could hardly have furnished such a large group. Indeed the Great Basin antelope corral seems to be a substitute for the surround method made by a people with sparse population ("the corral was of poles supporting brush to resemble people," Steward, 1941, p. 219). If the population of the Basin was at one time considerably denser, that is, dense enough to manage a surround, then the Pit-and-Groove petroglyphs might have been used in this connection, for they are so located that they could have served such a purpose. A denser population would imply a rather wetter climate, though, and this would in turn imply a considerable lapse of time since the manufacture of the glyphs — probably more than 7,000 years, as the climate has not been significantly better in the Basin since then (cf. Antevs, 1953). This is not a serious objection; the Pit-and-

Groove style is obviously very old and could very well date back that far. A graver difficulty is that the large population implied by the surround method should be reflected in large and numerous archaeological sites dating from that period. We do not find such sites. Indeed, we are hard put to find more than the barest cultural remains from that period. We must therefore conclude that, while the Pit-and-Groove petroglyphs may have been used in connection with surround hunting, supporting evidence for such use is minimal.

For the Great Basin Pecked petroglyphs we have an abundance of data, which are complex enough to require a regional distinction wherein northern Nevada sites are distinguished from those of southern Nevada (table 8). The southern Nevada sites are those in Clark, Lincoln, and southern Nye counties (Nye County south of Ny-2).

TABLE 8
DATA ON GREAT BASIN PECKED PETROGLYPHS

Area	Style	On trail		In draw		Near spring or tank		Suitable for corral	
		+	0	+	0	+	0	+	0
Northern Nevada	Great Basin Representational	1	0	1	0	0	0	1	0
	Great Basin Curvilinear Abstract	17	3	15	7	5	12	9	9
	Great Basin Rectilinear Abstract	14	2	11	4	3	8	6	6
Southern Nevada	Great Basin Representational	0	1	3	1	5	0	3	0
	Great Basin Curvilinear Abstract	0	1	5	1	7	1	3	0
	Great Basin Rectilinear Abstract	0	1	3	1	5	1	2	0
		32	8	38	14	25	22	24	15

There are two, possibly three, patterns to be observed in these data. We first note that there are marked distinctions in site situations in northern and southern Nevada. The sites in the southern part of the state show a remarkable adherence to an occurrence pattern which can be summarized as of "narrow draw leading to a watering place." The incidence is actually higher than is shown in table 8; there are two sites (Cl-121 and Cl-124) which have been omitted because we lack style data but which clearly conform to the same pattern. There are really only two exceptions: Atlatl Rock (site Cl-1), which has a watering place but is not in a draw (it has been tabulated three times because all three Great Basin Pecked styles are represented there), and site Cl-146, which is in a draw but is not at a watering place (tabulated twice). The latter may not actually be an exception; it is a quarter-mile from the nearest watering place but is quite close to the mouth of the canyon leading to the water at Mouse's Tank (Cl-145). Thus, available evidence suggests that nearly all southern Nevada petroglyph sites are placed at spots where animals coming to drink could be ambushed.[2] This is true even at Atlatl Rock, where they could be ambushed from the rock above the tank. Mountain sheep, rather than deer or antelope, were most probably the species hunted at these sites. Hall (1946) claims that

southern Nevada is not deer country, and, although antelope were said to have
been present in the vicinity, they were evidently very scarce. The journals of
the people who came through this county in 1849 from Salt Lake (Hafen and
Hafen, 1954) do not mention either deer or antelope but do note the presence
of mountain sheep and small game. Since the mountain sheep was the only
abundant large game it was probably this that was predominantly hunted. In
support of this suggestion, we note that the glyphs themselves frequently portray
this animal and only rarely other species.

Regardless of the animal hunted, the position of these sites with respect to
watering places is evidently related to the extreme aridity of southern Nevada.
Virtually the entire area has an annual precipitation of less than 5 inches,
whereas the remainder of the state, except for isolated areas, has precipitation
greater than 5 inches (Leighly, 1956, fig. 9). This dryness assured the hunter
that animals would utilize any available water. Even the mountain sheep, which
can survive without water by eating desert succulents, will always go to a spring
when one is at hand.

In the northern part of Nevada the petroglyph sites conform to a different
location pattern. Most sites here are also in draws, but instead of being near
watering places they are on known or probable game trails. This suggests that,
instead of hunting animals that were going to drink, the people in the north
ambushed or trapped animals that were on their annual migration or were simply
traveling from one part of the range to another. There are several reasons why
the northern sites differ thus from those in the south. For one, there is more
rainfall in the north, and hence there are more rivers, creeks, and springs, with
the result that the movements of animals in search of water would be less
predictable and hunting near springs less rewarding. Another factor is the
greater biotic variation in the north (cf. life zone map in Hall, 1946, fig. 4),
which would lead to a more definite pattern of annual migration from Alpine and
Transition zones to Upper Sonoran zones and the reverse. Finally, there were
more antelope and deer in the north, and both these animals tend to be more
regularly migratory than do the mountain sheep which predominated in the south.
Thus the ecology of the northern part of the state is such that hunting patterns
were necessarily different from those in the south, and the differing patterns
of petroglyph site locations are a precise reflection of this situation.

If it is granted that most of the northern sites are located on trails and
were used in the hunting of migrating game, then two questions remain to be
answered: (1) Were the hunting sites used for ambush hunting or corral
hunting? and (2) Were the petroglyph sites which were not on game trails also
at hunting spots and, if so, for what sort of hunting were they designed?

As to the first question, we note that the sites are almost equally divided
as to their suitability for corrals. Some of the game trail sites certainly had
corrals; physical evidence of them still remains. Other game trail sites probably
had corrals which were built completely of brush or wood and have since dis-
appeared. At some of the sites where corrals are not likely to have been used,

the position is such that large-scale ambush would have been easy. At the Simpson Pass site (Ly-7), for example, or the Garfield Flat site (Mi-4), the natural trail is bordered on either side by steep canyon walls from which hunters could shoot animals passing through. Still another pattern is illustrated at Allen Springs (Ch-57), where there is a single blind, evidently for hiding one or two hunters. At all sites on game trails either corraling or ambushing, or in some cases both, might be practiced.

For sites not on trails there are circumstances essentially like those of southern Nevada (especially at Wa-5 and Wa-131), where the petroglyphs are found at narrow draws leading to watering places. Thus, in nearly dry valleys where migratory game was not hunted, some animals could be killed from ambush when they came for water at a spring or tank. Possibly such sites were more important in very dry years.

Thus in northern Nevada petroglyphs occur in a greater diversity of situations, but almost all are in good spots for one or another kind of hunting. The diversity is to be expected because there were more kinds of game than in southern Nevada, and also a greater diversity of environmental conditions.

We have said that almost all the Great Basin Pecked petroglyphs in northern Nevada are at good hunting spots. The chief exception, Leonard Rock Shelter (Pe-14) is difficult to account for in these terms. It is hard to imagine either deer or antelope at this spot, since it is difficult to climb there and the immediate area is without feed. Perhaps mountain sheep were driven by dogs over the edge of the cliff above the shelter, as is alleged for the Battle Mountain Shoshone (Stewart, 1941, p. 329), and the petroglyphs were made in connection with this practice. This may be stretching the imagination, and perhaps at this site petroglyphs were not used in connection with hunting at all. Another possibility is that mountain sheep sheltered in winter under the cliff and that the petroglyphs are in some way connected with their seasonal chase (cf. Allen, 1939).

The differences in the pattern of occurrence of petroglyph sites between northern and southern Nevada are, we feel, additional evidence in favor of our hypothesis of petroglyphs as hunting magic. There are marked differences in the ecology of the two areas; southern Nevada is predominantly in the Lower Sonoran life zone whereas northern Nevada is mostly Upper Sonoran, and the mountain sheep is the most abundant large game animal in the south while antelope and deer are of comparatively greater importance in the north. If, in spite of these differences, the two areas proved to have petroglyph sites in the same settings, one would suspect that location was unrelated to the behavior of game animals and that sites were located in relation to some intrinsic qualities. In this case one would suspect that the rock art was not hunting magic but perhaps a kind of shrine, possibly connected with puberty ceremonies or the vision quest. But when there are two distinct patterns, each more or less consistent within itself, and each is explainable by the behavior of game in its own area, then confidence in the general hypothesis is increased.

AGE OF PETROGLYPHS

A variety of methods exist for determining the age of rock art, but none is precise or accurate in providing absolute age in years. The methods used here included the following (cf. Jackson, 1938, p. 461).

Ethnographic Identification

We begin with the first method. We asserted previously that Nevada Indians deny authorship of petroglyphs and pictographs. Although this is literally true, so far as we know, it is also true that some Indians outside Nevada do claim to have performed some rock writing, especially painted pictographs. Let us briefly review the literature on this situation, beginning in the west. West of the Sierra Nevada there seems to be no unambiguous record of Indians' claiming to have made pecked petroglyphs. Although J. P. Harrington's Culture Element Distribution list for the coast tribes south of San Francisco does indicate both petroglyphs and pictographs for many of the tribes, it is unclear whether the data are from informant testimony or from Harrington's personal observation. In discussing arrow points, for example, Harrington (1942, p. 44) comments, "Archaeological specimens more dependable than informants' statements." This may be so, but it is also true that archaeological specimens do not necessarily impart information about the ethnographic time level. Harrington's evidence is best ignored on such points of imperishable material culture.

With regard to painted pictographs, however, there is clear ethnographic evidence of use and authorship. Pictographs were evidently used for at least two distinct purposes by some aboriginal California tribes. Among the Luiseño of the southern California coast pictographs were painted as a part of the girls' puberty ceremony (Du Bois, 1908, p. 96; Kroeber, 1908, pp. 174-176). Among some of the tribes of the San Joaquin Valley and the neighboring Sierra Nevada the painting is said to have been done by shamans. Gayton (1948, p. 113) says of the Wukchumni Yokuts on the Kaweah River:

It was believed that most shamans had private caches . . . where they kept not only their sacred outfits of talismans, but their wealth, and even the stuffed skins of dead women adorned with valuable ornaments. The cache would be in a cliff or rock pile; cracks indicated the door, which opened at the owner's command. The rocks were usually painted; in fact any rocks with pictographs were thought to be a cache.

This was evidently also the pattern among most Yokuts and Western Mono (Driver, 1937, p. 86).

East and south of the Yokuts and Western Mono is territory of more immediate concern to the present effort. There are tribes here of two linguistic families — Tübatalabalic and Numic — both within the Utaztekan stock (Lamb, 1958). The Tübatalabalic family is represented by a single language, Tübatalabal, the speakers of which are found in the extreme southern Sierra Nevada. The Tübatalabal deny having made pictographs, attributing them to "brownies"

(Voegelin, 1938, p. 61). The Numic family is divided into three subfamilies, each represented in the state of Nevada: Panamint-Shoshone, Kawaiisu-Ute, and Monachi-Paviotso (including Owens Valley Paiute and the Paviotso or Northern Paiute. Of the Panamint-Shoshone groups, three groups of the Panamint branch attribute pictographs to the "water baby," a supernatural being, and one of the groups (the Koso) claims that they were also made by recent human beings (Driver, 1937, p. 86). There is no information on the subject for the Shoshone. For the Kawaiisu-Ute we have the following data:

> Kawaiisu: "Baby" (a supernatural being) made pictographs (Driver, 1937, p. 86).
>
> Southern Paiute (of Utah and Arizona): Petroglyphs and pictographs were not made by present Indians but by former inhabitants or by animals when they were men (Stewart, 1942, p. 321).
>
> Ute: Petroglyphs and pictographs among most groups were made by ancients or by mythical creatures but were also made by recent peoples (Stewart, 1942, p. 321). Often they imitated the older figures "just for fun" (cf. Haury, 1945, p. 70).

Finally we have data for both branches of Monachi-Paviotso. According to Driver (1937, p. 86) the Owens Valley Paiute (Monachi branch) denied making pictographs and did not attribute them to supernaturals. Steward (1933, p. 335) gives a more complete and circumstantial account. He says,

> The pictographs at the last three sites [Deep Springs and Eureka Valley] may be of Paiute origin, for they appear comparatively recent, they are near or definitely associated with artifacts and sites of Paiute culture, and, at a house ring site with pottery [hunting blinds?], north of Bishop . . . are similar pictographs in red. Somewhat similar, recent pictographs in red occur in Western Mono territory. The art, whatever its purpose, spread somewhat into Paiute territory. E. L. [an Owens Valley Paiute] thought Paiute of his grandfather's time made petroglyphs of "extinct animals and birds" (perhaps meaning mythological or visionary) at Fish Springs. Geometric figures he thought older, and said there was a superstitious feeling about them.[3]

For the Paviotso branch we have information from Stewart (1941, p. 418), who says informants in all bands knew about petroglyphs but all denied that the recent inhabitants had made them. Some said they were made by coyote, some attributed them to the devil, and some to "old time" (pre-Paiute) Indians. Stewart also asked whether petroglyphs occurred within band areas and several informants said they did not, even in cases where this was palpably false. It is especially odd that the Stillwater band denied the presence of petroglyphs when there are about a dozen sites recorded in their territory, including the large one at Grimes (site Ch-3).

The burden of evidence from Nevada indicates that neither petroglyphs nor pictographs were made by recent Indians, although Steward's data (1933) noted above suggest that they may not all be ancient. Some of the Great Basin Scratched and Great Basin Painted elements may also have been made recently "just for fun," as among the Utes, but were not important enough for the

informants to have remembered. Gifford's data on the Ute, noted below, indicate that the recent and "just for fun" elements were made by painting or
by scratching, not by pecking. One Apache group and one Papago group claim
to have made pecked glyphs "just for fun," but the Nevada Indians are likely
to have had customs more similar to the closely related Utes than to those of
either the Apache or Papago. Gifford (1936, p. 290) records for the Northeastern and Western Yavapai of Arizona that young people sometimes made
petroglyphs "in imitation of ancient ones, which were not understood," and
observes that his informants believed the ancient petroglyphs were of ancient
origin. Reagan (1929, pp. 115-116) asked a Deep Creek Gosiute of eastern
Utah about the authorship of pictographs in local caves and records the Indian's
answer:

> The pictographs are in caves along Warm Creek, also in the canyons of the Deep
> Creek range, and in the hills toward Pleasant Valley. They were made by short,
> heavy-set giants of the long ago. The thunderbird preyed upon this people. Once my
> grandfather, you know my grandfather was a medicine man, well, he had a dream to
> cure the sick. What he saw in his dream was his helper in driving the "sick" out
> of people, his guiding spirit. At times when looking for his guiding spirit he would
> go out hunting in yonder [Ibapah Peak] mountains. Once while there fasting and
> praying he came along below a ridge on which the thunderbird had its nest. There
> he saw the bones of the little giants the great birds had discarded and thrown
> down from its nest after it had eaten all the flesh from them. The bones were
> many in number and very heavy. [Regan's footnote reads: It is probable that the
> petrified bones of some prehistoric animal may be exposed in some of the hills of
> these mountains and were seen by the medicineman.] These were the bones of the
> men who made the drawings in the caves and along the canyon walls.

To the north we find that pictographs were made ethnographically in connection with puberty rites; we find no mention of the manufacture of petroglyphs
here. Teit (1930, p. 283) discussed the rites of the Okanagan:

> In connection with the training period, adolescents of both sexes made records of
> remarkable dreams, pictures of what they desired or what they had seen, and the
> events connected with their training. These records were made of red paint on
> boulders or cliffs, wherever the surface was suitable. Rock paintings in their territory
> are plentiful, but I heard of no petroglyphs, except that sometimes figures of various
> kinds were incised in hard clay. Rock paintings were also made by adults as records
> of notable dreams, and more rarely of incidents in their lives.

Driver (1941) has tabulated the occurrence of rock painting in western North
America in connection with girls' puberty rites. He notes them for the Luiseño,
Cupeño, and Mountain Cahuilla in southern California and for the Shushwap,
Lillooet, Thompson, and Okanagan on the Columbia-Fraser plateau. The strikingly similar function of pictographs in the two areas might be taken to indicate
a common origin for the custom, but the styles of the two regions are so
dissimilar that it is probably best to discount it as convergent or coincidental.
The Plateau style is crudely naturalistic while in southern California it is

stiffly geometric (compare Teit, 1930, figs. 20-24, with Kroeber, 1908, fig. 4; see also Teit, 1896).

The only other information we have for the north is for the Oregon Klamath, who associate pictographs with shamanism. Spier (1930, p. 142) has this to say about them:

The Klamath do not make pictographs. There are however a few in their country, said to have been made by KEmŭ'kumps, the culture hero. They refer to them as shaman's mŭ'lwas, paraphernalia or, better, objects pertaining to a shaman. They are repainted from time to time by old men, "who work for a shaman" by which my informant may have meant shaman's interpreters. They are all of simple form. My informants knew of only two pictographs (su'malo'ta) in the whole Klamath country.

The pictographs shown by Spier (*op. cit.,* fig. 9) are clearly in the Great Basin Painted style.

We now turn to the Southwest. Many, perhaps all, of the Great Basin styles are found also in the Southwest, and hence we might hope that some clue as to age might be derived from there. Gifford's Culture Element Distribution list is discouraging in this respect. He indicates (1940, p. 59) that of all groups he questioned (2 Navajo groups, 11 Apache groups, 2 Papago groups, 1 Ute band, and at Walpi, Zuñi, Santa Ana, and San Ildefonso) only the Ute admitted making pictographs, and only the White Mountain Apache, the Ute, Zuñi, Kikimai Papago, and possibly the Walpi admitted making petroglyphs. Thus, of twenty groups questioned, only one admits manufacture of pictographs and five the manufacture of petroglyphs. Gifford's notes (*op. cit.,* p. 154) read:

Rock pictures made . . . by men. ST [Southern Tonto Apache] said "wicked" to make rock pictures and all in their territory made by ancients.

SU [Southern Ute] pictographs made with ashes, not red pigment, deer only represented; for amusement only. SU petroglyphs by scratching with sharp edged stone; no pecking or chopping.

WM [White Mountain Apache] by pecking, "just pastime." Gan (spirit) represented as standing; deer, bear, etc., in cave to S of Black r. Those on White r. near Ft. Apache made by ancients. Wa [Walpi] informant thought ancient Wa people made rock pictures in Grand Canyon. Zu [Zuñi] petroglyphs of masked dancers in cave in Thunder mt. by early Zuni. KP [Kikimai Papago] petroglyphs pecked. Pictures of clowns, people. "No meaning." Nothing to do with ceremonies or purification. "For fun only."

In spite of Gifford's information it seems clear that neither the Papago nor the Pima Alta are responsible for most of the pecked petroglyphs in their area; they were probably made by earlier peoples. One site in Pima country is noted by Russell (1908, p. 254), who says:

Hahatesumiehin or hahatai s'maihisk, Stone Strike, is a large block of lava located in the eastern Santan hills. The largest pictograph [petroglyph] ever seen by the writer in the Southwest is cut upon it and 2 or 3 tons of small angular stones foreign to the locality are piled before it. There are also many pictographs on the boulders round about. This was probably a Hohokam shrine, though it is regarded

with reverence by the Pimas, who still place offerings of beads, bits of cloth, and twigs of the creosote bush at the foot of the large pictograph. [Cf. Ly-7 above.]

In the Papagueria the evidence of Haury (1950, pp. 468-472) and of Fontana, Greenleaf, and Cassidy (1959, p. 46) indicates that, although the Papagos painted pictographs, they did not usually make pecked petroglyphs.

The Ute, Athapascans, Papago, and Pima, even if they admit having rock writings at all, usually do not take them seriously. This is in line with what we have already seen for the Ute. The use here seems to be imitative of the older glyphs (Haury, 1945, p. 70). The pueblo Walpi and Zuñi, on the other hand, claim them as having been made by their own ancestors (see Colton and Colton, 1931). This indicates that the art was probably indigenous to the Puebloans but was largely lost, perhaps during the Athapascan invasion or even earlier.[4] If the Athapascan invasion was about A.D. 1500 (Bennyhoff, 1958, fig. 1), then most Southwestern petroglyphs may be attributed to the period preceding that date.

Only one Nevada petroglyph site lends itself to historic dating. This site is at Cane Springs (Cl-4) in Meadow Valley Wash, a few miles north of Moapa. The glyphs there show, among other things, wheeled carts and mounted horsemen who wear sombreros. What date should be assigned to these figures? They could be as early as 1604. In that year Oñate went down the east bank of the Colorado past the mouth of the Virgin River, and he may have been seen there by the Indians and his journey commemorated by the petroglyphs. But Cane Springs is about fifty miles air line from the mouth of the Virgin, and it is unlikely that the artists would have traveled that far before making the glyphs. More probably these historic glyphs date from the nineteenth century. The Old Spanish Trail through this country was not established until 1830, and that date probably marks the earliest appearance of wheeled carts in Meadow Valley Wash.

The appearance of the petroglyphs in photographs of the site (Steward, 1929, pl. 70) indicates that some of the historic figures were applied later than some of the mountain sheep figures shown there. It is not clear, though, whether this is true of all of them. The site will have to be inspected at first hand before we can tell with certainty whether some of the mountain sheep and other figures are as late as the historic figures.

Superposition of Elements

For our second method of dating rock art there are two sites of interest. The first is in Inyo County, California, and is reported by Steward (1929, p. 72):

This site evidently marks a point of contact between the curvilinear style from the north and the rectilinear style which centers at Grapevine Canyon in the south. Judging from the photograph, the rectilinear gridirons near the top of the boulder are the most recent. Associated with them and below are circular gridirons and below these and apparently still older are spirals, circles, and other elements characteristic of the Great Basin curvilinear style.

This site gives good evidence that Great Basin Curvilinear is older than Great Basin Rectilinear. Indeed, there are implied here three substyles which become progressively more rectilinear through time. We could not isolate all three substyles in our data, though, and so we will not press the point.

The second site with superposition of elements is at Whisky Flat (Mi-5). At this site are elements of Great Basin Painted pictographs, Great Basin Scratched petroglyphs, and Great Basin Pecked petroglyphs. The details of superposition are given in the site description above (p. 52) and may be summarized as follows:

Scratched overlies Pecked	twice
Painted overlies Pecked	twice
Pecked overlies Scratched	once
Painted overlies Scratched	twice
Pecked overlies Painted	once

It is clear that this gives us little information about relative dating unless we take it to mean that all three styles are of equal age. The only combination that does not occur is Scratched overlying Painted. This may mean the Scratched style is earlier than the Painted style at this site, but the totality of evidence here is so ambiguous that it is best not to insist on it.

Designs Covered by Deposits

In our third category we include three sites. The first of these is at Grapevine Canyon in southern Nevada (site Cl-2). The detail of the deposition is given in the description of the site above (p. 28). As we noted there, there is no possibility at this time of using the circumstances for determining relative age of styles because the position of individual elements with respect to the deposit are not known to us.

The second example of designs covered by deposit is at site Li-3. Here there is a Katchina figure in red paint buried nearly up to the shoulders, apparently by occupation debris. If the design is shaped as these usually are, 4 or 5 feet of the figure must be buried. This amount of deposit in a rock shelter need not have required an enormous amount of time to accumulate, but certainly a few hundred years were needed and the design must therefore have been made at least that long ago.

The third case differs slightly; here it is not a matter of a deposit having buried designs but rather of the necessity of the deposit's having reached a certain height (or depth) before the designs could be made. The site is Leonard Rock Shelter (Pe-14), and the pecked petroglyphs, both Great Basin Curvilinear and Great Basin Rectilinear, are high on the cliff above the shelter, where they could be reached only if the deposit were at its present level or nearly so. The upper levels of Leonard Rock Shelter contain materials of the Lovelock Culture and of the historic Northern Paiute (Heizer, 1951). These

would not go back much earlier than 1000 B.C. (Bennyhoff, 1958). Underlying the Lovelock materials are earlier remains, dating about 4000 B.C. From the position of the petroglyphs on the cliff, we presume that they could not have been made by the early inhabitants, since they are on a part of the cliff that was about 20 feet above ground surface at the time of the oldest occupation. They are therefore to be attributed to the Lovelock Culture peoples or the recent Northern Paiute and must have been made within the last 3,000 years. In our opinion the possibility that the occupants used stages from below or ropes to hang from above is hardly to be considered.

Differential Patination

We have observed only two sites in Nevada where the accumulation of desert varnish or patina on the surface of petroglyphs differs enough from element to element that one can determine relative age of the elements. One site is the East Walker River site (Ly-1). Here some of the elements are quite obviously new and others are obviously old; most of the elements are indeterminate in this respect (see references under site description above). We list "new" and "old" elements which are diagnostic of styles.

	New	Old
Circle	—	3
Sun disc	1	—
Curvilinear meander	4	4
Snake	3	5
Bird track	1	—
Rake	3	1
Crosshatching	1	—
Foot	1	—
Hand	1	—
Horned human	2	1

This tabulation may be summarized by styles.

	New	Old
Great Basin Curvilinear	8	12
Great Basin Rectilinear	5	1
Great Basin Representational	4	1

The second table indicates clearly that the Great Basin Curvilinear style is older than either the Rectilinear or Representational styles. The Representational and Rectilinear styles each have only one element classified as old, and neither classification is certain — the horned human (fig. 84b) and the rake (fig. 90r) are both poor examples.

The other site with differential patination is the Grimes site (Ch-3). The situation there (see site description above) indicates that the Pit-and-Groove style is older than the Great Basin Curvilinear style.

Association of Petroglyphs with Archaeological Deposits

The only possible example of this is found at the Whisky Flat site (Mi-5). At this site there is a considerable deposit which seems to have dated from the late prehistoric period (see site description above). The problem here is

ANALYSIS AND CONCLUSIONS

to decide whether the petroglyphs were made by the occupants of the village or not. It seems likely that some were — most probably the painted and scratched elements. Whether all elements can be thus identified is another question. It may be that some were already there when occupation began and were imitated casually, as among the Utes and Navajos. Our guess is that the Scratched and Painted glyphs and perhaps a few of the Pecked glyphs were made by the occupants of the village, who were presumably the Northern Paiute, while others predate village occupancy.

SUGGESTED DATING OF STYLES

Our estimate of the dating of the various petroglyph styles is given in table 9. It will be obvious that these dates are tentative and uncertain; it would seem that this must always be so with petroglyphs. The key style is Great Basin Curvilinear. If this can be dated, then other styles can be assigned dates relative to it. We first note that the curvilinear style was, for the most part, probably not being made in the historic period. All informants deny that their people made the figures, and in any case none of the figures has a fresh appearance. One often finds that vandals have pecked initials or dates into the rocks at petroglyph sites, and these always contrast markedly with the aboriginal glyphs. The site at Cane Springs (Cl-4) has some undoubted historic figures, but these seem to be later than the other figures there. If the Curvilinear style was not made in the historic period, what was the latest date at which it was being made? If we assume cessation was coincident with the invasion of Numic speakers, then the date would be perhaps A.D. 1300 (see p. 14). But this is too speculative. Although concrete evidence comes from Steward's Owens Valley Paiute informant, who thought they had been made during his grandfather's time (i.e., in the nineteenth century), we should not rely heavily on what was obviously a very tentative statement. The best evidence comes from Leonard Rock Shelter (Pe-14), where we can, with fair certainty, say that glyphs in the Curvilinear style were made by people of the Lovelock Culture. This being so, in table 9 we indicate dating of the style coincident with that culture, that is, roughly 1000 B.C. to A.D. 1500. Actually, even if petroglyphs in this style were made by bearers of the Lovelock Culture, we cannot be certain that the culture and style began and ended at exactly the same time. The suggested dating is simply a first approximation.

For the Rectilinear and Representational styles we indicate the same terminal date as for the Curvilinear style, but we show somewhat later initial dates. In support of this, we cite (a) more restricted distribution of the Rectilinear and Representational styles, (b) differential patination at the East Walker River site, and (c) the superimposition of elements at Steward's site at Bishop, California (Iny-265; see Appendix F). Even if this relative dating is correct, it cannot be precise; we say simply that these two styles were present during the later part of the period when the Curvilinear style was in vogue.

TABLE 9
SUGGESTED DATING OF NEVADA PETROGLYPH STYLES

Date	Great Basin Representational	Great Basin Curvilinear Abstract	Great Basin Rectilinear Abstract	Great Basin Painted	Great Basin Scratched	Puebloan Painted	Pit and Groove
1500							
1000							
500							
A.D.							
B.C.							
500							
1000							
2000							
3000							
4000							
5000							
6000							
7000							
8000							

The Great Basin Painted and Scratched styles we feel must be very recent. Some of the painted elements are at open sites and could not be very old. The scratched glyphs must also be recent; they are so shallow that even a slight patination would obscure them, and it has not done so, of course, in the observable glyphs. It is possible that many of these scratched and painted glyphs were made by recent peoples as crude imitations of older elements.

The Puebloan Painted style we date as concurrent with Puebloan and Puebloid occupation of southern Nevada. In this respect we quote a letter from Dick Shutler, Jr., of the Nevada State Museum, dated April 12, 1960, who has recently made an intensive study of the region.

The Puebloid, rather than the Anasazi, were the sedentary inhabitants of White Pine County. The Puebloid occupation was between 900 and 1100 A.D.

The Pueblo peoples of southern Nevada (Clark and Lincoln counties) belong to the Virgin Branch of the Anasazi. The remains appear to be from Basketmaker II (? to 500 A.D.) to early Pueblo III (1150 A.D.).

We turn now to the Pit-and-Groove petroglyphs, the simplest, but in some ways the most interesting, style we have encountered. There is good evidence at the Grimes location (site Ch-3) that this style is much older than the other styles there. It seems also to be very old at the other Nevada sites. The question is how much older the Pit-and-Groove petroglyphs are than other styles. Since we presume Great Basin Curvilinear petroglyphs date from about 1000 B.C., and since there is evidently a time gap between these and the Pit-and-Groove petroglyphs, then we tentatively assign dates of 5000 B.C. to 3000 B.C. to the latter. We reason that the time gap coincides with a period of non-occupancy indicated in the nearby cave archaeology. We outline our position as follows: At Leonard Rock Shelter deposits of the Lovelock Culture, which has an initial date of about 1000 B.C., are underlain by sterile deposits dating back to about 3000 B.C. Beneath these are deposits attributed to the Leonard Culture and the Humboldt Culture, with radiocarbon dates of 3787 B.C. ± 250 years and 5088 B.C. ± 350 years, respectively (Heizer, 1951; Bennyhoff, 1958;

Grosscup, 1960). A similar situation is found at Hidden Cave, where a layer of sterile deposit separates two culture-bearing layers. A radiocarbon determination from the deepest part of the upper culture-bearing level reveals a date of 1094 B.C. ± 400 years (Grosscup, 1956, 1958). Evidently the sterile layer here was deposited during approximately the same period as that at Leonard Rock Shelter, and hence there was probably a period of nonoccupancy of the region or, at least, a period of culture change. Since we have a time gap between the petroglyph styles and between the occupation levels of the caves, and, further, since the terminal point of the gap is very likely the same, then the two gaps are probably part and parcel of the same phenomenon — nonoccupancy or culture change — and are therefore to be equated in their entirety. In sum, the dating argument here suggests the two following equations:

Great Basin Curvilinear = Lovelock Culture (or variants)
Pit-and-Groove = Leonard Culture (or variants)

It is not going to be an easy task, but it is obvious that these equations should be subjected to stringent tests in the future.

Although it is clear that there is considerable question about the specific dating of the Pit-and-Groove style in Nevada, there can be no doubt that it has a respectable antiquity there. That this is so is curious, since what appears to be the same style was being made in California up into the ethnographic period. Before we go into this question, we will discuss the California sites in greater detail. We give here a list of the California sites that have come to our attention. Their locations, together with the locations of known Nevada sites, are shown in figure 134.

Butte County

But-8. On the south bank of Mud Creek, about 1.5 miles west of Richardson Springs.

But-74. East of Clear Creek and west of Dry Creek, about 12 miles air line from the center of Oroville.

Calaveras County

Cal-3. Three hundred yards east of the Stanislaus River bridge on State Highway 49.

Kings County

Kin-15. On Avenal Creek, a few miles east of State Highway 41.

Lake County

Lak-28. On the northern tip of Garner Island, which is at the southern end of Clear Lake.

Lak-30. On Slater Island in Lower Lake.

Lak-145. In Grizzly Canyon, 4 miles southwest of Wilbur Springs.

Lak-227. On a tributary of Putah Creek, 10 miles south of Morgan Valley.

Lak-234. On the north shore of Upper Bohn Lake.

Mendocino County
 Men-484. On the north edge of Little Lake Valley, 3 miles north of Willits.

Monterey County
 Mnt-15. On the grounds of Monterey Presidio.

Placer County
 Pla-5. On Martis Creek a few miles from Truckee. This is the type site for the Martis Complex described by Heizer and Elsasser (1953).
 Pla-14. Three miles west of Lincoln.
 Pla-15. Three miles northeast of Lincoln.

Riverside County
 Riv-8. Two miles east of Cabezon.

San Bernardino County
 SBr-194. Two miles northwest of Daggett.

Santa Barbara County
 SBa-41. In Goleta, a mile north of U. S. Highway 101 (Rogers, 1929, p. 136).

Siskiyou County
 Sis-50. On the southwest shore of Tule Lake.
 Sis-91. Near Hospital Rock in Lava Beds National Monument.
 Sis-104. In Lava Beds National Monument, about 1 mile northeast of Captain Jack's Stronghold.
 Sis-117. In Lava Beds National Monument at Canby Bay, on the south shore of Tule Lake.
 Sis-179. On the north slope of Scott Canyon, in a small meadow on the old Lighthill Ranch (Heizer, 1953, p. 35).
 Sis-183. On the Klamath River, at the mouth of Lumgrey Creek (Heizer, 1953, p. 34).

Sonoma County
 Son-268. Near Cazadero (Steward, 1929, p. 57).

Stanislaus County
 Sta-29. On the south bank of the Tuolumne River, 1 mile east of La Grange.
 Sta-33. On Salado Creek, about 10 miles southwest of Patterson.
 Sta-44. On the west bank of Hoods Creek, a half-mile up the creek from State Highway 4 (Treganza, 1952, p. 17).
 Sta-118. On Garzas Creek, about 10 miles southwest of Newman.

Tehama County
 Teh-205. At the confluence of the north and south forks of Antelope Creek (Baumhoff, 1957, p. 42).

Trinity County

Tri-43. On the east fork of the Trinity River, about 30 miles north northeast of Weaverville.

These California petroglyphs differ from the Nevada specimens in that, for the most part, they are simply pitted boulders; they do not also have grooves. This differentiates them slightly, but the pits themselves are so similar and at the same time so arbitrary that one cannot help thinking they must be part of the same tradition. In any case, three of the California petroglyphs (Sis-176, Sis-183, and Sta-29) have grooves as well as pits, whereas one of the Nevada sites (Wa-119) has pits but no grooves.

The problem of dating the California sites is difficult. Some of them, at least, were being made into the historic period. Among the Shasta they served as "rain rocks," and ceremonies were performed at or near them to cause rain to fall or to make it stop falling (Heizer, 1953, p. 34). There are said to have been rain rocks also among the Hupa, the Tolowa, and the Karok (*ibid.,* pp. 33-34), but none of these has been observed by us, so we do not know whether they are pitted or not. Pitted boulders are also found in Pomo territory, where they served as "baby rocks"; that is, they were pecked by women desirous of conceiving children (*ibid.,* p. 35). These instances clearly indicate that the knowledge and manufacture of the glyphs persisted up to modern times. On the other hand, there is some evidence that they are also very ancient in California. Such evidence is from a site of the Farmington Complex (Sta-44). The site is an extensive midden deposit resulting from occupation during the historic period and for some undetermined period of time before that. Beneath the midden is sterile alluvium and beneath that a cemented gravel deposit containing tools of the Farmington Complex (Treganza, 1952, p. 17). The Farmington Complex consists "primarily of core tools and large reworked percussion flakes" (Treganza and Heizer, 1953, p. 28). The age of the complex is uncertain, but geological evidence suggests that it dates from Anathermal times (*ibid.,* p. 31) or within the time range we have already suggested for the Nevada examples of this style. If the petroglyphs at the Farmington sites were made by the authors of the Farmington Complex, then we have additional evidence that these glyphs are indeed as old as we suggest.

One other California site which yields dating evidence for these petroglyphs is at Martis Valley (Pla-5). The petroglyphs are here associated with a midden deposit which, as we indicated above, is the type site of an assemblage of stone artifacts termed the Martis Complex (Heizer and Elsasser, 1953; Elsasser, 1960). The dating of the Martis Complex is not yet certain, but the best current guess places it between 1000 B.C. and A.D. 500 (Elsasser, 1960, table 15). If the dating is accurate and if the Martis peoples were responsible for the petroglyphs, then we have an occurrence intermediate in time between the early Farmington and Nevada petroglyphs on the one hand, and the historic occurrences among the Pomo and Shasta on the other.

The totality of evidence is not large but it is consistent in suggesting an ancient and widespread petroglyph style that was abandoned in some areas but persisted in others up to the historic period. The over-all distribution of the style cannot now be determined, but we suspect that it will be found over most of western North America. One cannot easily tell from verbal descriptions whether he is dealing with the same Pit-and-Groove style, but a cursory survey of the literature suggests that it is also found near Skamania, Washington, on the Columbia River (Strong, Schenck, and Steward, 1930, p. 27); near Arkansas City, Kansas (Wedel, 1959, p. 492); and in the extreme southeast corner of Colorado (Renaud, 1931, p. 68). If these are in fact examples of the style, then it is certainly very widespread.

Concluding
Remarks

The mass of data presented here is too complex to attempt to summarize, but a few final observations may be made at the conclusion of our study.

We feel that for the first time we have demonstrated that petroglyphs in Nevada and eastern California are evidence of the purposeful and rational action of prehistoric peoples. They are not aimless "doodling," nor are they deliberate and planned expressions of the artistic impulse. We think that we have proved that petroglyphs in the area we have studied are to be understood as a part of the economic pursuit of hunting large game (deer, antelope, and mountain sheep). We have found few or no indications that suggest an association with seed collecting, rabbit hunting, or fishing. Thus, petroglyphs are part of the magical or ritual aspect of taking large game. The petroglyph designs themselves must have had some meaning to their individual makers, but what a spiral, a snake, a lizard, or a grid design actually signified in the maker's mind at the time he fashioned it we are not, and probably never will be, able to say. Certain design elements having wide distributions are sufficiently specific to enable us to assume that they have diffused from one (or possibly several) sources. The joint occurrence of numbers of such elements has enabled us to identify six styles of painted and pecked rock art (see table 3). These styles differ from each other in time, and we have attempted to determine their sequence or relative chronology and to define their distributions (figs. 30 and 31).

While we have endeavored to make our survey as complete and accurate as possible, we are certain that many sites remain to be found or reported. The distributions of the various styles shown in figures 30 and 31 are, therefore, subject to correction when more data are known. The distributions of styles, will, however, never be as neatly defined as they once existed for the reason that discontinuities and lacunae must occur because of the absence at certain places of proper kinds of rock surfaces on which petroglyphs could be inscribed. One of the problems that students who follow us will wrestle with

is whether petroglyphs *might* have been made at certain sites *if* proper rocks had been available for that purpose.

We admit that every single occurence of petroglyphs in Nevada cannot be directly and conclusively proved to be associated with the taking of game animals, but at the same time we think that the evidence for over 90 per cent of the sites in Great Basin Pecked style overwhelmingly supports this conclusion. Later researchers, we hope, will look more carefully into this matter and provide more specific explanations. Petroglyphs at watering spots or along migration routes may prove to show, after more careful analysis, subtle differences in style or types and frequency of elements which reflect the variable techniques involved in the hunt in different locations and under different conditions. Without the least feeling of false modesty, we believe that we have only made a beginning in the study of this aspect of human activity in the Desert West, and we fully expect other workers to correct and amplify our conclusions.

Hunting blinds may have had a dual purpose, first to conceal the hunters, and second to protect them from the weather while they waited for the animals to appear. The late fall, in October and November, when the snows start and force the animals to migrate, is very cold, and hunters sitting in the blinds must have suffered, especially since they were probably unable to build fires, which would have alarmed the animals.

The wide occurrence of hunting blinds made of piled-up boulders in western North America may provide one avenue of exploration into the extent to which the function of petroglyphs is to be understood as a part of hunting magic. Baillie-Grohman (1882, p. 176-178) refers to hunting blinds in western Wyoming, around which were numerous bones of bighorn sheep. While he does not mention associated petroglyphs, it would be interesting to know with certainty whether these occur at such hunting sites. Renaud (1932, pp. 13, 39) describes, in eastern Wyoming, game blinds of piled-up boulders "used by the Indians for hunting game migrating from one slope to the other." He describes

stone breastworks scattered along the crest of a ridge overlooking the valley and game trails going from the bluff to the water below. Those small curved stone fences had probably been erected to hide hunters spying upon the game and better able from behind these screens to shoot at closer range the animals unaware of their presence.

At another site Renaud reports,

At this time I was guided by Mr. Ed Kelly, well versed in Indian lore. He explained to me that these round breast works made of large red stones were game-blinds. There are still 8 or 10 standing, although they used to be more numerous. . . . They are circular or horseshoe shaped, that is lower on one side, and still two or three feet high on the South side. A couple of men could easily squat and hide themselves behind these stone fences, watching for the game coming up the cañon, northward, in order to migrate into the neighboring Crescent basin. The blinds were so placed as to cover the width of the narrow pass, a few steps apart and not on the same front but in a zig-zag formation to increase the chance of shooting down the game even though some animals had succeeded in passing between the advance posts.

Renaud reports large numbers of petroglyph sites in the same general area where he found the hunting blinds, but does not provide us with either maps or topographic descriptions so that we may judge whether the petroglyphs occur at possible ambush sites. Presence of hunting blinds along migration trails, however, gives us two out of three variables, and provides an easy test case for our hypothesis that petroglyphs might occur at or in the immediate vicinity of ambush sites.

We also believe that we have reoriented study of the subject in a more meaningful direction which aims to discover *why* petroglyphs occur where they do, and *why* they were inscribed. While we do not feel very hopeful about the possibilities of finding specific meanings for all the elements, we do not think that the effort toward such an end will necessarily end in complete failure. Our negativistic attitude on this point derives from our belief that petroglyphs were probably an individual rather than a highly patterned group activity, and therefore in the Great Basin area there never existed any uniformity of belief in the specific meaning of particular design elements or symbols.

The practical absence of petroglyphs in Nevada at spots which are not suitable for game taking (or, to put it the other way, their occurrence only at places such as springs or ambush spots along seasonal migration trails or where driven animals could be shot) constitutes the essential *pattern*. In view of the strong adherence to the pattern, we believe that there follows the conclusion that the actual making of petroglyphs was a magical or ritual act, and that there existed a powerful taboo against making petroglyphs in places, for purposes, and by persons other than those directly associated with the hunt. While the Great Basin Indians were fairly simply cultured, they did not lack interest or ability in decorative art. Why, then, on rare occasions, did not some person make petroglyphs for amusement on an inviting rock face? If petroglyphs have been made in Nevada for several thousand years, one might expect that the amount of "doodling" would be fairly large. Our explanation for the absence of such unpatterned evidence is that a ritual prohibition existed against it. The wide occurrence of specific elements is another aspect (the stylistic one) of the pattern. The wide distribution of certain styles (see figs. 30c-31d) must mean that these diffused. Setting aside the problems of the source, relative age, and direction of spread of the several styles, it is clear that these styles must have diffused relatively slowly from local group to local group. Among recent Great Basin groups shamanistic supervision of the antelope hunt led to the "hiring" of such shamans from distant groups (Steward, 1938) when a hunt was planned and the group lacked such a shaman among its membership. If, among recent Great Basin groups petroglyphs had happened to be associated with the shaman's activities in the antelope hunt (which they were *not*), a means of slow diffusion over a wide area would thus have been afforded. Or, to select another possible situation which might lead to the distribution of petroglyph styles, let us cite the fact, pointed out by Steward (1938), that the composition of small Great Basin groups was not permanent, but rather varied in accord with food resources

available. The shifting of persons from group to group, each occupying and exploiting an area temporarily, could be the means of communicating, over a long span of time and over a vast and thinly populated area, the details of petroglyph-aided hunting. Although we do not have any evidence that petroglyph styles actually were so diffused, the diffusions nevertheless substantiate the hypotheses, which are in conformity with the narrowly channeled way of life characteristic of the Great Basin. We cannot, ourselves, see in the available data any clear indication as to who actually made the petroglyphs, but we believe that either the hunters themselves or hunt-shamans (of the type known among recent Great Basin tribes) made them. If, as we suppose, ambush hunts along regular migration trails were carried out each fall, it seems not improbable that at least one design was made each year to bring the deer or ensure a successful hunt. That a special practitioner (a shaman) would have had to make this design in order to ensure that deer would be taken seems less probable to us than that one hunter, acknowledged as the group leader or hunt chief during the particular season at that one spot, would have had the responsibility for making the (annual?) petroglyph or petroglyphs. The variable quality of work — some careful and precise, some hasty and irregular — at a site may be interpreted as indicating that the petroglyph makers over the years differed greatly in ability. Of course, shamans themselves would be no exception to this proposition, and in view of the fact that sites were used for long periods, one could argue that the variations in technique simply are indications of differing abilities of a series of generations of symbol makers. A possible way to approach this problem would be to make a very careful study of the *entire* corpus of designs of certain styles at several large sites, with the aim of identifying designs which might be attributed to individuals. The chances of conclusively settling the problem outlined above would presumably be quite poor, we believe, but at the same time some interesting conclusions might result. Any immersion in the details of variable data inevitably produces unexpected and worthwhile results because it forces concentration of thinking.

Future work may lead to some explanation of why one site has a great abundance of petroglyphs and another site shows only a few. Does a large number of elements reflect a deficiency of game and the necessity of more magic to bring it to the spot? Or does an abundance of elements mean that there were more animals and more hunters and, as a result, more petroglyphs? We have been unable to suggest an answer to this problem.

We have searched the lower eastern slopes of the Sierra Nevada from Reno south to Bridgeport for petroglyphs, since we know that the deer moved over these when the heavy snows drove them from the higher mountains. Petroglyphs are absent here. Since this was an area of summer camping for peoples from further east (Heizer and Elsasser, 1953), the snows that forced the animals out would also cause the temporary residents to withdraw to the valley areas at lower elevation, where they could spend the winter living on stored seeds (especially pine nuts) and hunting. In the summer camps (between 5,000 and

8,000 feet in elevation) deer could be hunted singly and petroglyph magic would have been ineffective. In the valleys just to the east of the base of the Sierra, some deer stayed over the winter and could be hunted as needed for food. Thus the local pattern of animal distribution and human occupation provides us with an adequate explanation for a longitudinal strip where petroglyphs are absent. If this reasoning is correct, the non-petroglyph area lying along the eastern toe of the Sierra Nevada marks the territory of groups who spent the summer on the Sierra slopes and the winter in the valleys at the base of the Sierra. The north-south line drawn to connect the easternmost petroglyph sites therefore would mark the eastern border of the territories of permanent Great Basin groups who did not visit the Sierra, and who depended for large-scale deer killing on the fall migration out of the Sierra when the heavy snows came. A careful study of the easternmost extent of the several styles might (we are admittedly indulging in speculation) mark ancient fixed tribal boundaries.

Another problem we leave unanswered is the identity of the peoples who made the Nevada petroglyphs. If the linguists have not misled us in suggesting a spread within the last 1,000 years of the Northern Paiute tribe and language (fig. 32d) through western Nevada, there is a strong possibility that petroglyphs here were made by a pre-Northern Paiute tribe or tribes. If this is so, who were these ancient petroglyph makers?

As a problem for future research, we pose the question of determining the importance of chocolate-colored basalt in providing proper surfaces for inscribing petroglyphs. Where this ideal material was lacking, petroglyphs may not have been attempted, or pictographs (applied to surfaces exposed to the weather and long since vanished) may have been substituted. This matter is important from the standpoint of plotting distributions of elements or styles, since some areas where petroglyphs do not occur may represent places where the proper rock surfaces are lacking rather than indicating a cultural disinclination to employ the art.

Another unsolved problem is the purpose which the pitted rocks served. We believe that they are probably connected with the hunting of animals (probably antelope), but have been unable to define any pattern in their location. Beyond any doubt there are numerous other pitted rocks to be discovered, and when a sufficient number of sites are on record we anticipate that their purpose may become clear.

Local informants in the Sierra Nevada region where the rocks are predominantly granite have on occasion pointed out vertical rock faces which they believe bear "Indian markings." All of these have proved to be "designs" caused by the disappearance of lichen because of the application of commercial oil-based paint at some previous time for advertising purposes. The paint has disappeared, but the lichen has not regenerated in the once paint-covered areas. We mention this as a caution to later students, since even partial regrowth of lichen may require over sixty years. It is worth keeping in mind the pains to which modern

despoilers of nature (vacationers, hunters, fishermen, or campers) will go in carrying a brush and can of paint (or a pressure spray can of paint) or a hammer and chisel to remote spots for the purpose of leaving designs, names, or initials.

We urge all persons interested in furthering the study of petroglyphs in the area of Nevada and California to send to

Coördinator
Archaeological Research Facility
University of California
Berkeley 4, California

information on the location of additional petroglyph sites (a sketch map showing roads, distances, and so on, is preferable), sketches, and photographs (with indication of size clearly given). The reader is referred to Appendix A, with the reminder that the fuller the record, the more useful the information will be. All such contributions will be acknowledged upon receipt, and all data used in later publications will earn the donor a gratis copy of that publication in which appears the information he volunteered.

Plates

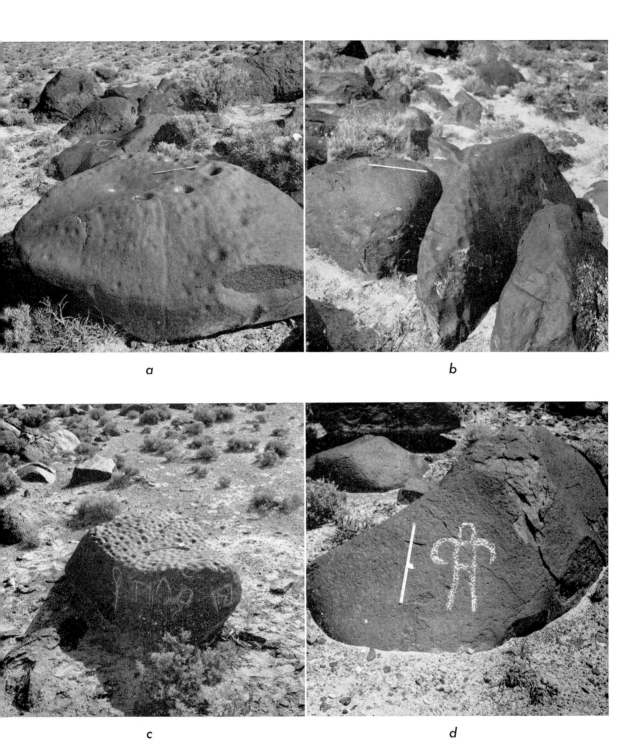

a

b

c

d

PLATE 1

Ch-3, Grimes site.

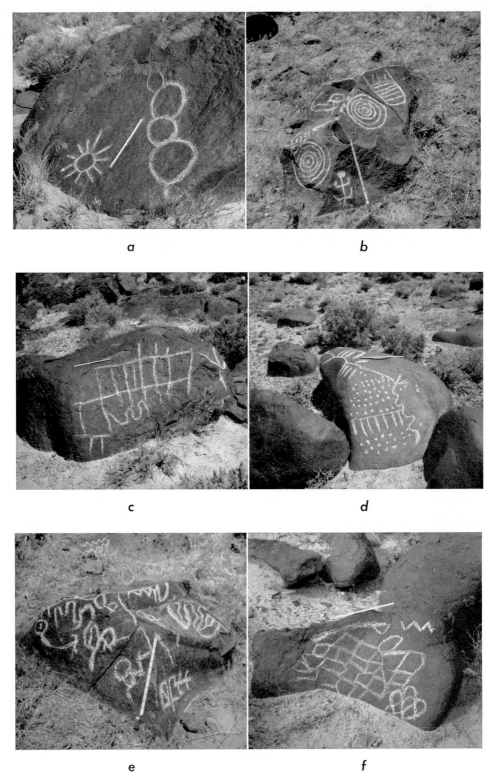

a

b

c

d

e

f

PLATE 2

Ch-3, Grimes site.

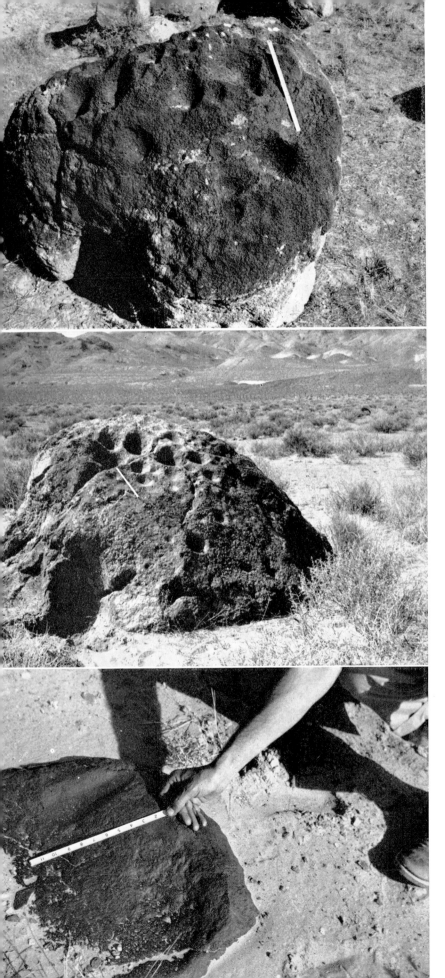

a

b

c

PLATE 3

a, Eu-1, Dunphy site; *b,* Ch-120,
Rawhide Flats site; *c,* Ch-3,
Grimes site.

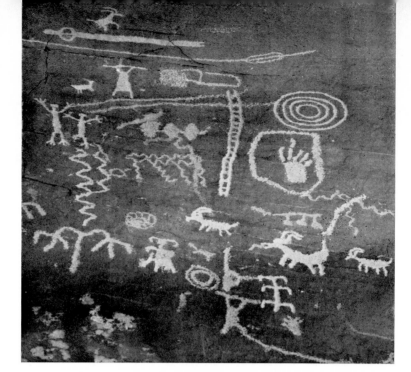

a

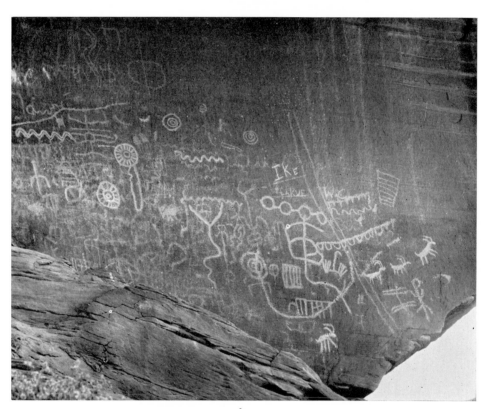

b

PLATE 4
Cl-1, Atlatl Rock site.

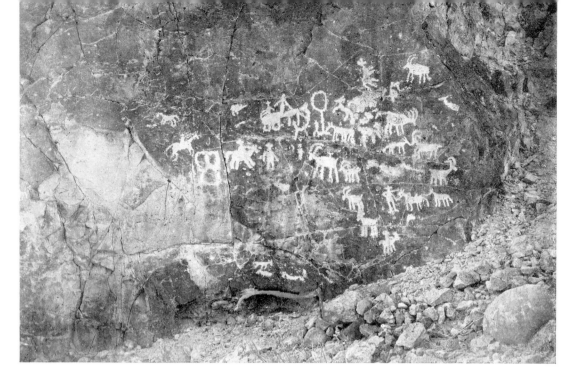

a

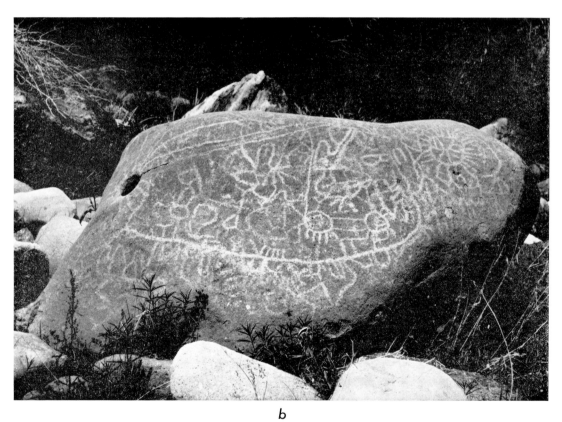

b

PLATE 5

a, Cl-4, Cane Springs site; *b,* Wa-68, Verdi site.

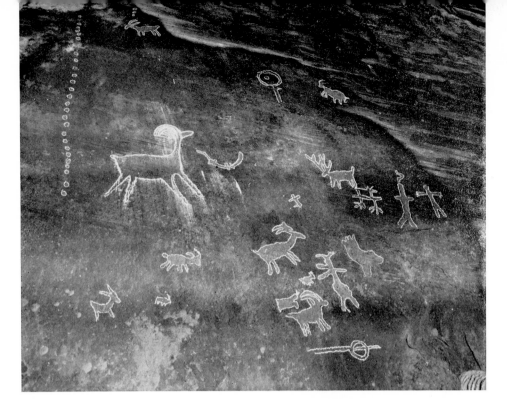

a

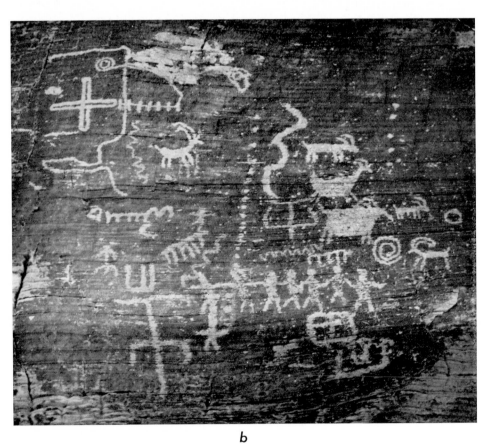

b

PLATE 6
Cl-145, Mouse's Tank site.

a

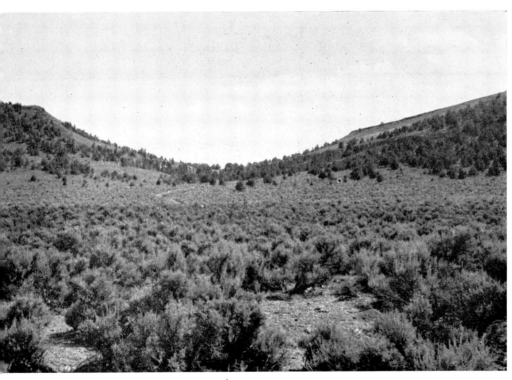

b

PLATE 7

.a-9, Hickison Summit site. *a,* view of west tuff cliff; *b,* view from north end of saddle, showing cliff bearing petroglyphs.

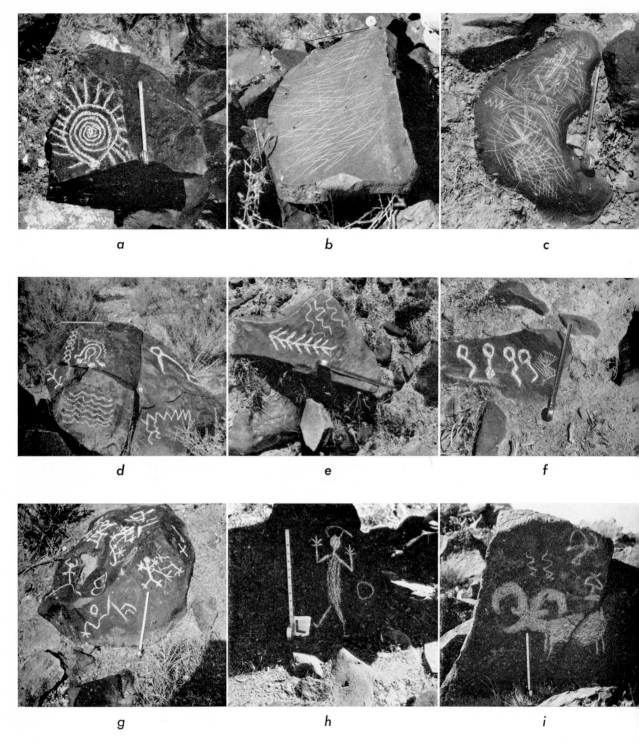

a

b

c

d

e

f

g

h

i

PLATE 8
Ly-1, East Walker River site.

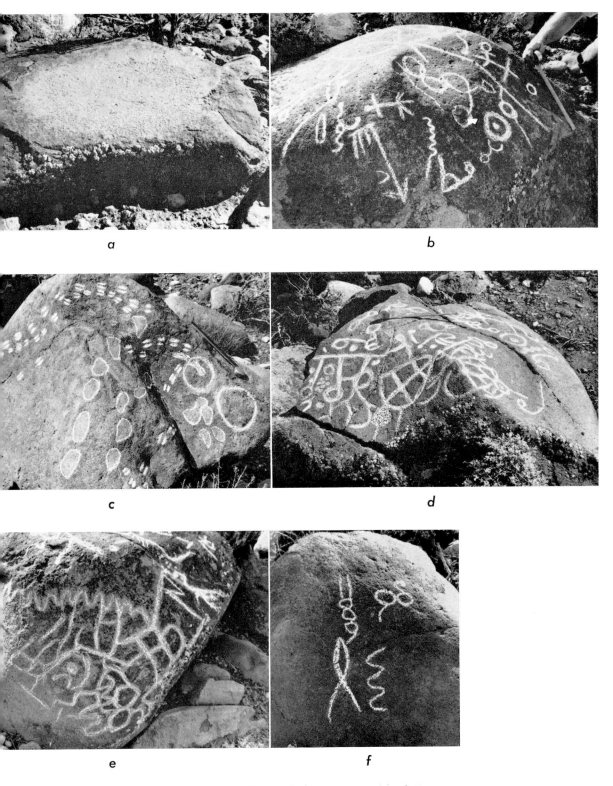

a

b

c

d

e

f

PLATE 9

Ly-2, Smith Valley site. *a,* paint-grinding area; *b-f,* petroglyphs.

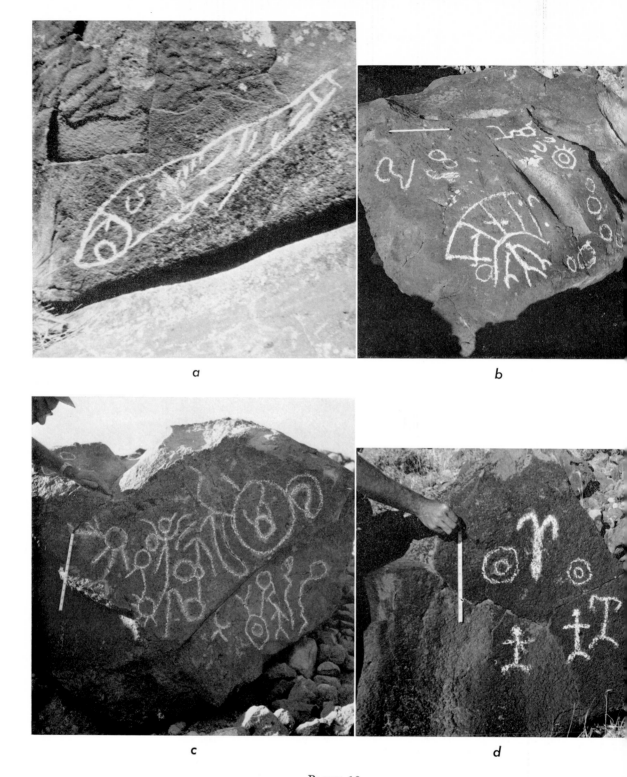

a

b

c

d

PLATE 10

a, Wa-69, Massacre Lake site; *b-d,* Ly-7, Simpson Pass site.

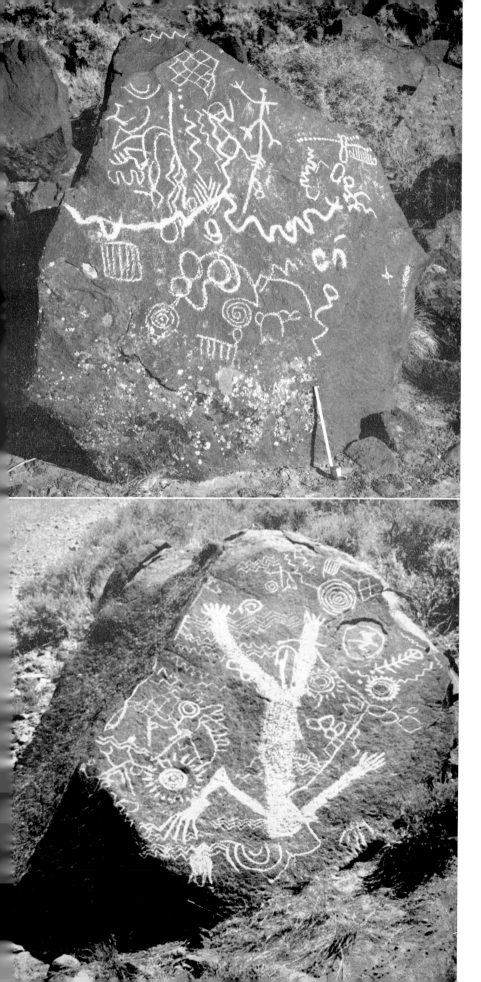

a

b

PLATE 11
Mi-4, Garfield Flat site.

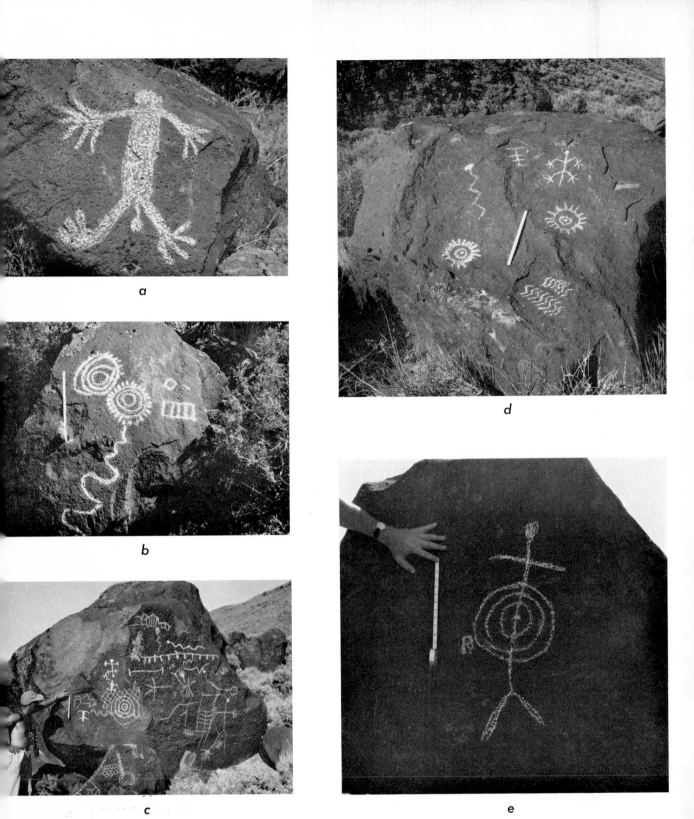

a

b

d

c

e

PLATE 12
Mi-4, Garfield Flat site.

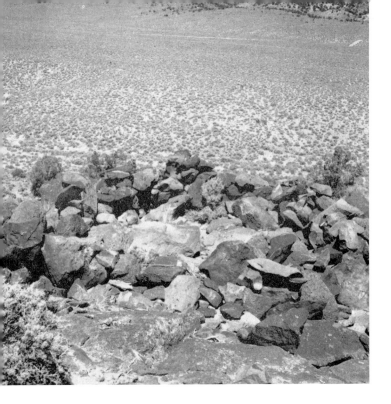

a

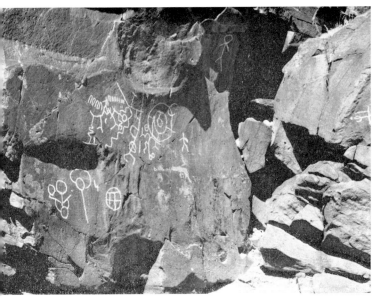

b

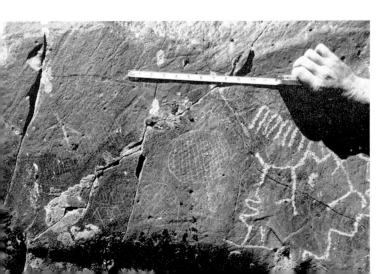

c

PLATE 13

Mi-5, Whisky Flat site.
a, rock enclosure (hunting blind);
b, petroglyph; c, scratched and
pecked styles on same surface.

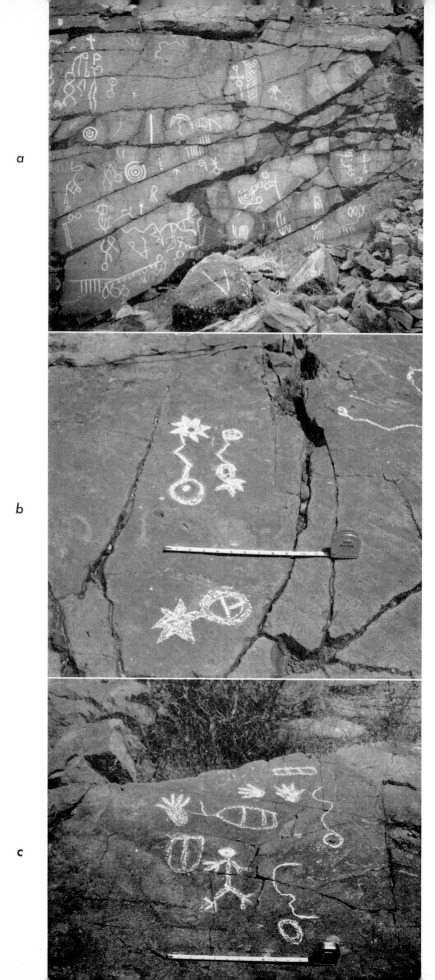

PLATE 14

a, Wa-5, Spanish Springs
Valley site; *b-c*, Wa-35,
Court of Antiquity.

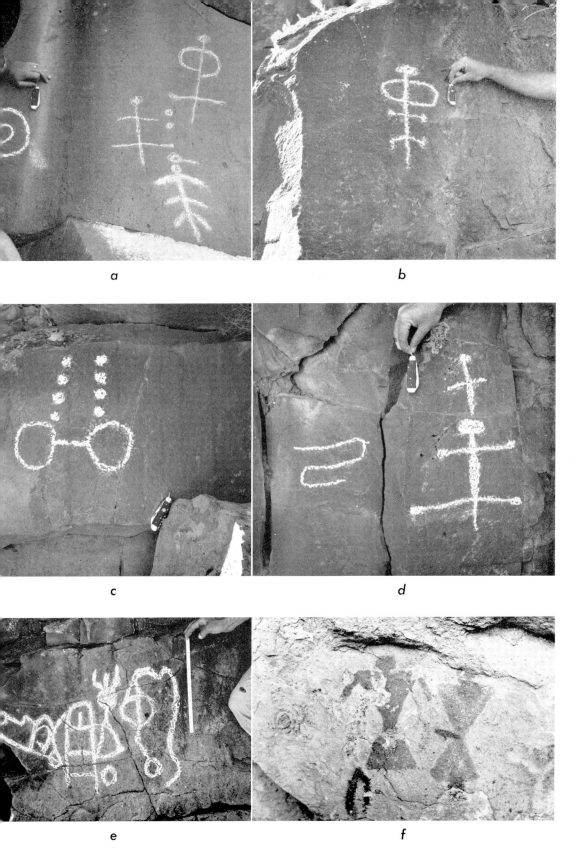

PLATE 15

a-e, Wa-131, Pipe Spring site; *f*, site Li-1.

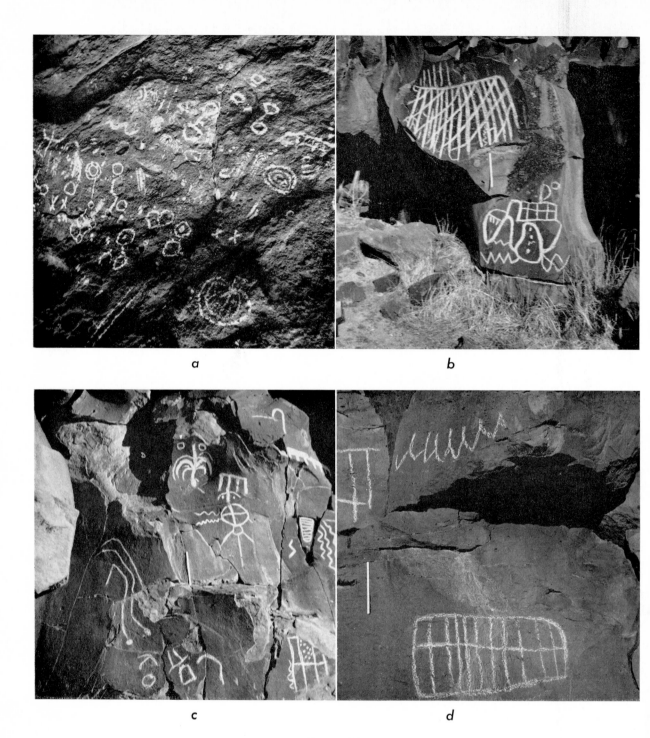

PLATE 16

a, La-ɪ, Potts Cave site; *b-d,* St-ɪ, Lagomarsino site.

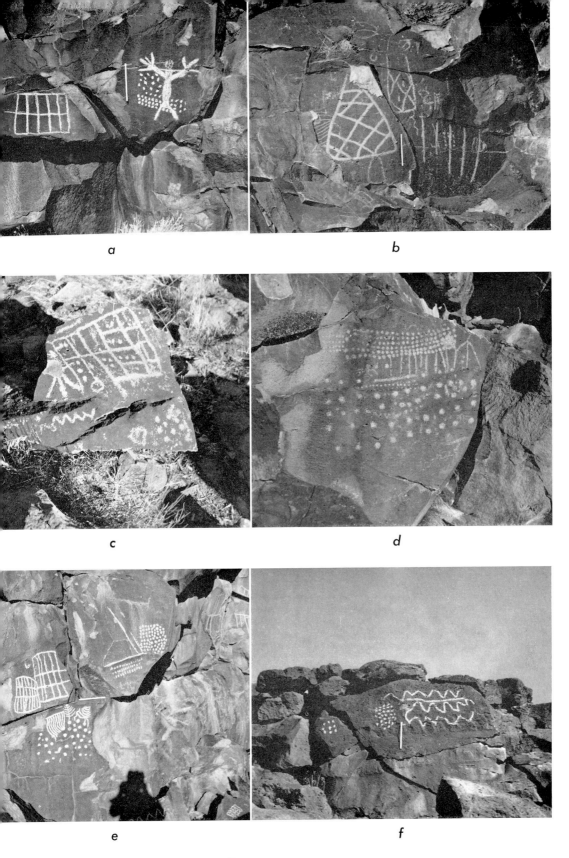

a

b

c

d

e

f

PLATE 17
St-1, Lagomarsino site.

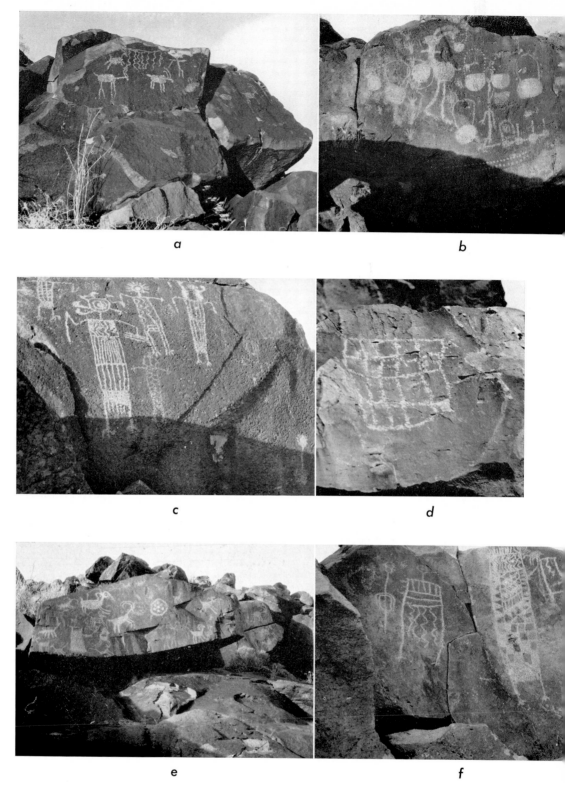

a

b

c

d

e

f

PLATE 18
Site Iny-281.

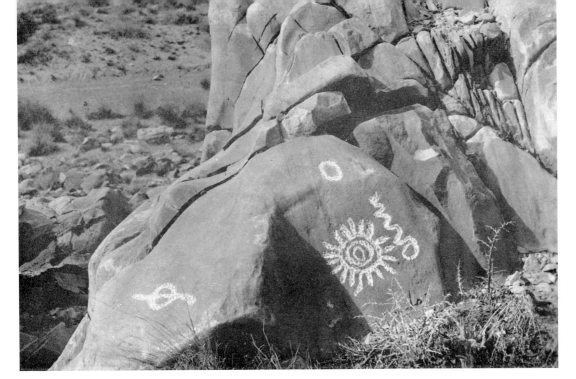

a

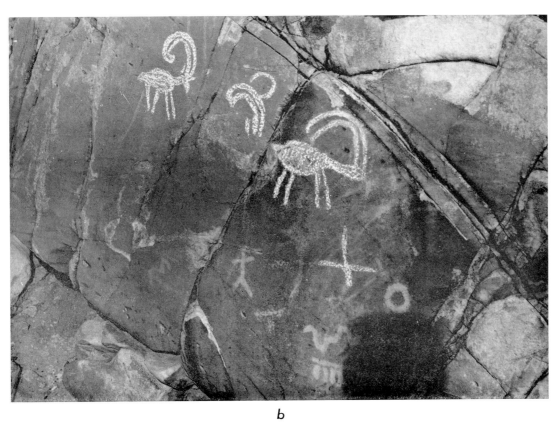

b

PLATE 19
Site Iny-272.

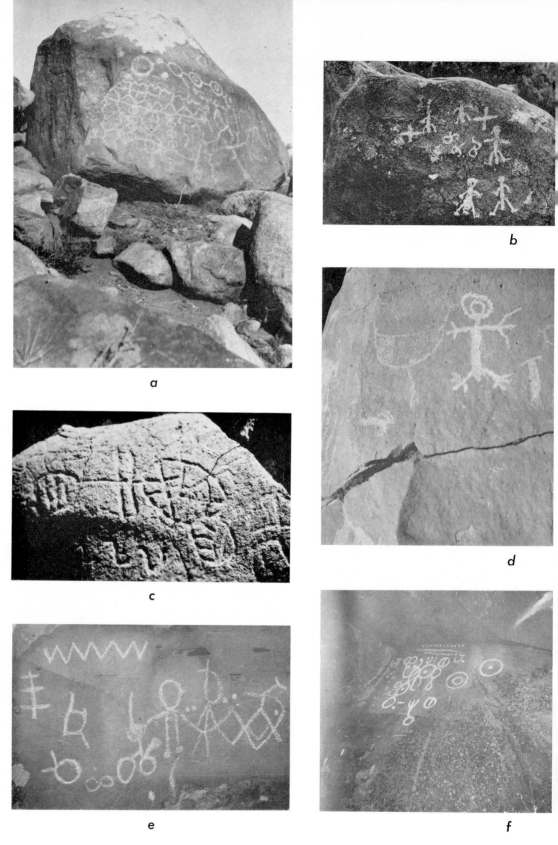

PLATE 20

a-b, site Iny-259; *c*, site Iny-267; *d*, site Iny-274; *e-f*, site Mod-21.

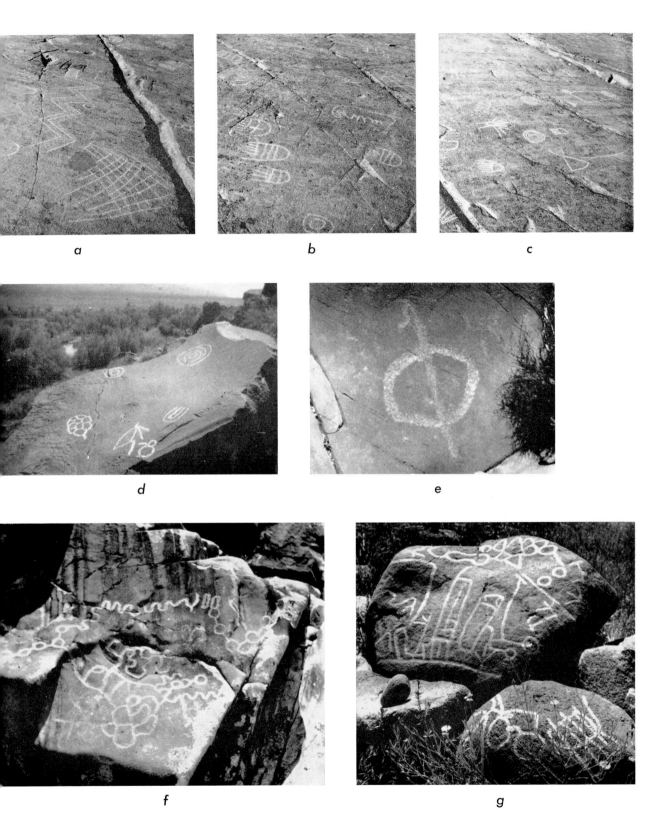

PLATE 21

a-c, site Pla-26; *d*, site Iny-28; *e-f*, site Iny-272; *g*, site Mno-12.

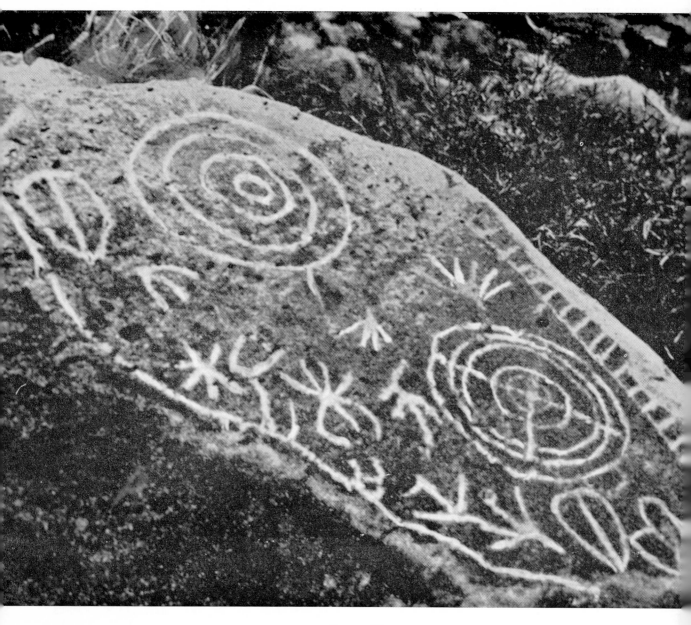

PLATE 22
Site Iny-268.

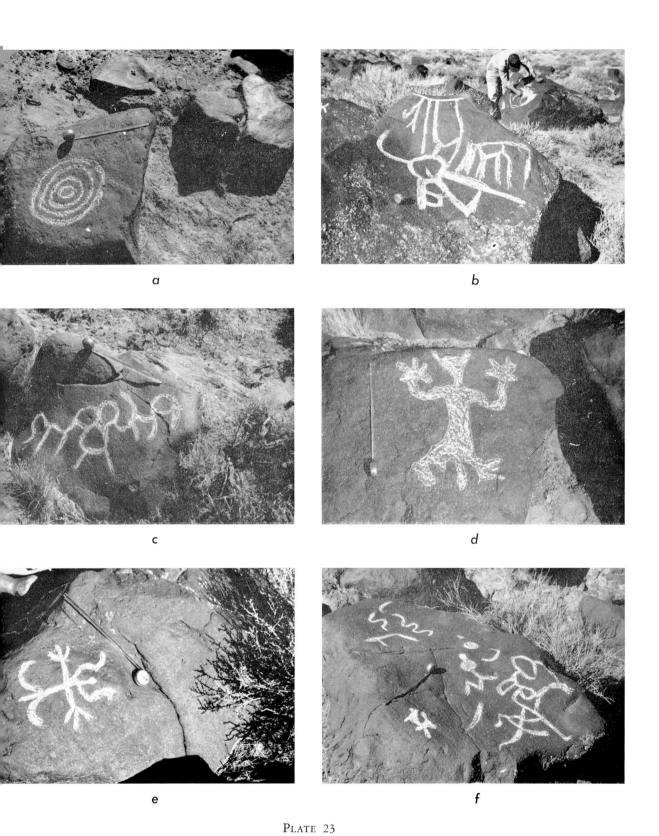

a

b

c

d

e

f

PLATE 23
Site Ch-71.

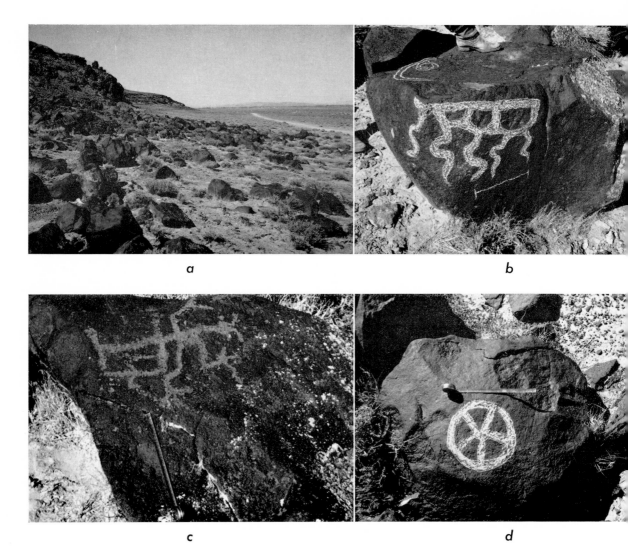

a

b

c

d

PLATE 24
Site Ch-71.

Appendixes

The writers cited in parentheses in the Appendixes are listed in the references at the end of the respective Appendix.

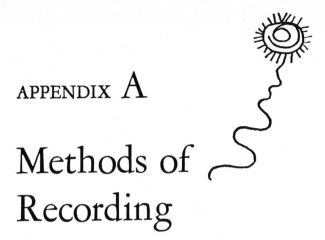

APPENDIX A

Methods of Recording

Documentation of a petroglyph site entails a considerable amount of effort. A sketch map of the site area is first made. This should be drawn to scale and should show significant details of terrain as well as the location of those rock surfaces which bear petroglyphs. If the site is one where a number of boulders have pecked designs, the individual boulders may be numbered on the plan, and these numbers cross-referenced to photographs, notebook sketches, or tracings of design elements. If the area is large, it may be easier to lay out the site into an arbitrary grid where each square is numbered and all photographic or drawn design records are located within the proper grid subunit.

Petroglyphs are recorded by one of several means. In our own work we have endeavored to be as complete as possible and have tried to make our recording sufficiently full so that in theory we need never revisit the site. Photographs of petroglyphs are a quick and accurate means of making a record. Since a large site may have several hundred individual elements displayed, it is more economical to take pictures with a 35 mm. camera. Kodachromes, if exposures are accurate and color is in register, are useful in providing an exact record of the color of the rock surfaces and the pecked designs. In our recording we have taken both color and black-and-white pictures, attempting to have the black-and-white record as complete as possible. We have used 35 mm. cameras as well as a Rolleiflex (which takes 120 roll film and yields a 2¼ x 2¼ inch negative) and for general site pictures a 4 x 5 inch film pack Speed Graphic camera.

If possible, both black-and-white and color pictures should be made of the petroglyphs *before* they are chalked for emphasis. The practice of rubbing ordinary white blackboard chalk into the pecked area will not, under ordinary

273

circumstances, cause any damage to the petroglyphs. Chalking gives a high degree of contrast, and in many cases one simply cannot make out the details of petroglyphs in unchalked photographs. It is scarcely necessary to say that colored oil-base paints or crayons should *never* be used, since these may leave a color residue which may be mistaken by later observers for aboriginal coloring of pecked petroglyphs. On an exposed surface ordinary white school chalk will disappear in a matter of a few weeks. The extent of destruction and vandalism of petroglyph sites in California and Nevada is enormous. Some of this is deliberate, as evidenced by persons who cut their names or initials with a chisel over ancient petroglyphs, or who paint their names on rock surfaces. Some destruction is nondeliberate, or at least may be called thoughtless, as when road-building operators have blasted off decorated cliff surfaces or bulldozers have cut through boulder fields and buried or pushed aside decorated stones. This sort of destruction is so common that one could scarcely take umbrage at an effort to secure information with the aid of a camera and a stick of chalk!

Pictographs should never be covered with chalk, since it may damage the aboriginal painted surface. If absolutely necessary, pictographs can be lightly *outlined* with white chalk.

All photographs should have a scale showing. We have adopted the system of showing a one-foot scale in all photographs, and use for this purpose a 12-inch section cut from a white-painted flexible steel pocket tape. A 12-inch wooden ruler, a marked strip of white paper, or any simple substitute for a one-foot rule will serve satisfactorily. Older photographs of petroglyphs usually lack any scale, so that one can rarely even guess at the probable size of the petroglyph figures. Anati (1960, p. 37), who was recording a large number of petroglyphs inscribed on extensive rock surfaces, laid out a grid of rectangles measuring 1.0 by .75 meters on a north-south axis and indicated the coordinates of the grid by letters running east-west and meter measurements running north-south. For smaller decorated areas, say up to 2 or 3 meters across, this technique would not be necessary.

Petroglyph photographs preferably should be taken full-face, since such pictures contain the least amount of angular distortion. An oblique view of a flat cliff face or of the rounded surface of a boulder provides a picture that is practically useless for determining actual size and spatial arrangement of the inscribed elements. Since the position of the elements pecked on a boulder may have relational significance to each other, it is usually good practice to take a photograph showing the outline of the whole boulder, since this outline forms the bounds of the decorated area. Since the rock surface is rarely perfectly smooth or flat, the angle of the natural light upon the surface will affect the appearance of the petroglyph to the eye and to the recording camera. Consideration of intensity and direction of light must be given when photographing petroglyphs (Renaud, 1938, p. 27). An excellent review of techniques of recording pictographs is given by Gebhard (1960, pp. 14-17; see also Frasetto, 1960, p. 383). Anati (1960, pp. 36-38), in his book on the petroglyphs of

the Val Camonica, which lies about 50 km. north of Brescia, Italy, discusses the use of special illumination of surfaces by electric lights to bring out faintly incised designs, and describes a technique of covering decorated surfaces with dilute water-color and then washing the coated surface so that the color is removed from the polished (natural) surface while remaining in the engraved areas. Anati also describes in detail the photographing of petroglyphs and the making of mosaic prints of large engraved surfaces.

Notebook records should be made while the petroglyph site is being studied. Observations on the technique by which the petroglyphs were made should be recorded; the size and characteristics of the pecking-stones which were used should be accurately noted if found; the nature and variations of patination of the designs should be carefully observed and noted; and any indications of age differences (such as superimposition and different degrees of freshness) must be recorded in detail with exact reference to specific design elements. Within a petroglyph site area the observer may note one section where a particular style is more abundant, or where the designs appear fresher (and therefore more recent), or some other intra-site peculiarity. These observations are important, and should be recorded in the notebook in detail and photographic or sketch references made. Some petroglyphs will be inscribed in places where they cannot be satisfactorily photographed without a scaffold. Then a scale sketch will normally be the only record that can be made.

It is obviously impossible to set forth all the specific information which should be collected at a petroglyph site. As in any phase of archaeology, the keen observer who thinks about what he is looking at will see points of significance, and it is upon the quality of his observation and thinking that the results which he achieves will directly depend.

In 1948 the University of California Archaeological Survey drew up a form sheet for recording petroglyph and pictograph information. This form is reproduced here (fig. A-1), with the observation that it has proved to be of such general utility that about seven hundred California and Nevada petroglyph sites have been adequately recorded on them in the past dozen years. Detailed instructions for filling out the form are contained in the publication by Fenenga (1949). Gebhard (1960, pp. 18, 78-79) discusses a similar type of record sheet.

Reference may be made to alternative techniques of recording petroglyphs and pictographs. Fenenga (*op. cit.*, p. 5) describes a method of directly copying pecked or painted designs as follows:

The entire decorated surface of the rock was covered with cellophane sheets which were affixed to the stone by taping at the corners. (The trade brand 'Clearcel,' .003, obtainable in 40 inch wide rolls has been used, but experimentation indicates that much thinner, hence less expensive, grades of cellophane can be used almost equally well.) The designs were then traced with appropriate colored pencils of the type designed to be used for writing on glazed surfaces (Dixon "Phano" or Blaisdell "Cellophane"). The separate sheets were numbered and a grid key was prepared to identify the location of each sheet. The sheets thus prepared are designed to be patterns from which a museum mural may be made, but reduced scale copies can be

UNIVERSITY OF CALIFORNIA ARCHAEOLOGICAL SURVEY
PETROGLYPH RECORD

1. Site_____ 2. Cross Reference Survey Record_____

3. Face_____ 4. Dimensions of Decorated Area_____

5. Horizontal location _____

6. Kind of rock _____

7. Position of rock _____

8. Method of decoration: Pecked (); rubbed grooves (); painted ();
 other ()

9. Colors _____

10. Design elements _____

11. Superimposition _____

12. Natural defacement _____

13. Vandalism _____

14. Associated features _____

15. Additional remarks _____

16. Published references _____

17. Sketch_____ 18. Scale of sketch_____

19. Photo nos. _____

20. Recorded by _____ 21. Date_____

FIG. A-1. Form sheet for recording petroglyph and pictograph information.

made from them by the use of a pantograph. The colors of the original pigments were duplicated by the use of a small set of water colors and these were identified by a key to the color approximations used on the cellophane.

Goodwin (1953, pp. 132-133) describes a similar technique as follows:

Paintings should be traced. Cellophane is held in position by means of Scotch-tape, and tracing done direct with photo-tinting colors mixed to exact shade on a palette. Yellow soap is added as the simplest means of preventing the color from beading on the cellophane surface. Tracings should be retraced over glass above a light, onto cartridge-paper which can be tinted with a correct background-wash. This last is best done with poster-colors (first reduced to tints by mixing one part in ten of the right color to nine of white), washed on lightly and unevenly with a cotton-wool swab. Retracing should be in the same photo-colors, and carried out in daylight if possible, to avoid contamination of yellows.

Anati (1960, p. 38) made records of superpositions of petroglyphs by using inks of different colors on tracings.

Renaud (1938, p. 3) refers to the making of direct copies of paleolithic cave paintings using a special transparent paper as "the only completely scientific and satisfactory method." The making of tracings is described and illustrated by Anati (*op. cit.*, pl. 48) and Lhote (1957, plate opposite p. 9).

D. Cadzow, acting for the Pennsylvania Historical Commission, spent two years salvaging petroglyphs in the pool area of a dam being built on the Susquehanna River. Scale drawings were made, some petroglyphs were cast, and some blocks of stone bearing designs were separated by drilling and removed (Cadzow, 1934).

M. Hedden (1958) has developed and published in detail an account of his method, which entails "placing the cloth or paper to be printed over the engraved image and then rolling ink directly on the surface of the material." He recommends thin muslin or "Webril," a lightweight filter cloth which is taped to the rock and over which is run a soft printer's brayer with a composition or gelatin roller. Oil-based printing ink is rolled over the cloth and there is produced a positive or direct image print. The method is inexpensive, rapid, and provides an accurate full-scale record. A detailed account of the application of this recording technique is given by Frasetto (1960, p. 382).

E. P. Gorsline (1959) describes a technique developed by C. La Monk for reproducing petroglyphs. A sheet of masonite is coated with white lead. Erosion sand from the base of the cliff or boulder face is then sprinkled on the white lead undercoat so that the petroglyph is reconstructed by the building up of sand. The technique, while ingenious, is probably too difficult and time-consuming to serve as a standard method of reproduction. The same article refers to reproducing pictographs by painting them upon a sand-coated masonite sheet.

We have not seen accounts of reproducing petroglyphs with latex molds, but believe that for deeply pecked or cleanly incised petroglyphs this method would be effective. Strong (1960, p. 113) has a brief description of the tech-

nique of making wax impressions for casts of petroglyph designs in the Columbia River area. Paper presses or "squeezes" for recording petroglyphs are discussed by Goodwin (1953, p. 138). Plaster casting instructions for petroglyphs on rock surfaces are presented in detail by Goodwin (*op. cit.*, pp. 136-138). Ruppert and Denison (1943, p. 99) give details of a method of making rubbings of Maya inscriptions which seems to us of possible application in making exact copies of petroglyphs.

REFERENCES

Anati, E.
1960 La Civilization du Val Camonica. *Mondes Anciens*, No. 4. Arthaud, Paris.
Cadzow, D. A.
1934 Petroglyphs (Rock Carvings) in the Susquehanna River Near Safe Harbor, Pennsylvania. *Publs. of the Pennsylvania Historical Commission*, Vol. 3. Harrisburg, Pa.
Fenenga, F.
1949 Methods of Recording and Present Status of Knowledge Concerning Petroglyphs in California. *Univ. of California Archaeological Survey Report*, No. 3. Berkeley.
Frasetto, M. F.
1960 A Preliminary Report on Petroglyphs in Puerto Rico. *American Antiquity*, 25:381-391.
Gebhard, D.
1960 Prehistoric Paintings of the Diablo Region of Western Texas. *Roswell Museum and Art Center Publs. in Art and Science*, No. 3. Roswell, N. M.
Goodwin, A. J. H.
1953 Method in Prehistory. *South African Archaeological Society Handbook Series*, No. 1. Capetown.
Gorsline, E. P.
1959 Artist to the Rescue. *Desert Magazine*, 22:23-24.
Hedden, M.
1958 "Surface Printing" as a Means of Recording Petroglyphs. *American Antiquity*, 23:435-439.
Lhote, H.
1957 Peintures préhistoriques du Sahara; mission H. Lhote au Tassili, Musée des Arts Decoratifs, Paris.
Renaud, E. B.
1938 Petroglyphs of North Central New Mexico. *Archaeological Survey Series*, Eleventh Report. Dept. of Anthropology, University of Denver.
Ruppert, K., and J. H. Denison, Jr.
1943 Archaeological Reconnaissance in Campeche, Quintana Roo, and Peten. *Carnegie Institution of Washington Publ.*, No. 543.
Strong, E.
1960 Stone Age on the Columbia River. Binfords and Mort, Portland, Ore.

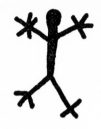

APPENDIX B

Interpretation
of
Petroglyphs

At the outset we state our opinion that the petroglyphs of Nevada are not a form of communicative writing, nor are they maps.[1] These statements are based upon conclusions arrived at by earlier workers (Steward, 1929, p. 226; Heizer, 1958; Kroeber, 1958). The designs themselves evade "translation"; that is, whatever meaning they may have had is no longer ascertainable, and there is no reason to believe that they are "texts" or "messages." The fairly extensive distribution of certain geometric designs, such as concentric circles, grids, ladders, and the like, indicates that the designs themselves have been diffused, so that some generic significance of the symbol to the person who applied it to the rock may be assumed. Whether these designs were symbolic — that is, stood for objects or actions — we cannot say, but the fact that elements had some meaning seems probable. Many suggestions have been made that particular elements symbolize objects or actions, such as water, deer, or battle, but it is our opinion that few if any of these proposals rest upon good evidence. In any event, most designs fall into the category of elements whose meaning is unknown. Recent Indians (that is, of the Caucasian period) disclaim knowledge of who made the petroglyphs and are unable to supply meanings of the designs. If meanings and significance of the designs are ever determined, it will be by the difficult method of deduction and inference rather than direct testimony. A few petroglyph elements are naturalistic representations, but thus far they have not aided in determining the meaning of more abstract (geometric or curvilinear) design elements.

The obviously unplanned or random association of series of petroglyph elements on a single rock face is sufficient evidence per se that the designs are not hieroglyphs ("picture-words") compounded into a message or text.

In 1857, J. W. Gunnison quoted a Mormon-inspired "translation" of a petroglyph in Sam Pete Valley, Utah, in the style which Mallery (1886, p. 251) accurately says "resembles the general type of the Shoshonian system." Gunnison (1857, pp. 62-63) says:

Various coincidences have occurred which strikingly keep alive in the mountain brethren their idea of being chosen of the lord — and confirm them in the belief of the inspiration of the book of Mormon. Among other things are the marks and hieroglyphical characters found engraved on the precipitous cliffs of southern Utah, which are faintly imitated by the present Indians. Those who were associated with Joseph [Smith] as amanuenses pretend to have acquired sufficient knowledge of similar things to be enabled to decipher their signification, and have translated enough to confirm, in the most wonderful manner, the Nephite records.

The following is a specimen taken from the cliff in Sam Pete valley, at the city of Manti.

Translation by one [of] the Regents; "I Mahanti, the 2nd King of the Lamanites, in five valleys in the mountains, make this record in the 12 hundredth year since we came out of Jerusalem — And I have three sons gone to the south country to live by hunting antelope and deer."

While we have no certain representations of astronomical phenomena represented in the Nevada petroglyphs or pictographs, there occur in northern Arizona what seem to be "planetarium panels" and representations of supernovae (Miller, 1955a, 1955b; de Harport, 1951). La Paz (1948) has shown that more recent primitive peoples are aware of meteorites and sometimes make pictographic records of these. An interest in astronomical phenomena (stars, constellations, moon phases, and so on) is very prominent among southern California and Southwestern Indians (cf. Spier, 1955, pp. 16-23), but Great Basin tribes exhibit decidedly less interest in cosmic phenomena. Judging from the relatively slight interest by native tribes of Nevada in astronomical phenomena, we might expect that these would not appear prominently in petroglyph designs.

So far as we can determine, only the western area of Nevada was of interest to modern petroglyph makers. California has a number of modern examples of false petroglyphs made by Caucasians, as described by Elsasser and Contreras (1958). The familiar practice of chiseling, scratching, or painting personal names or initials constitutes one of the most common means of defacing or obscuring older decorations. Petroglyph and pictograph sites in Nevada and California usually bear the scars of these thoughtless self-advertisers in the form of initials and dates. At times, depending upon the place and date, such inscriptions may prove to be highly interesting documents, as in the case of El Morro or Inscription Rock, a huge sandstone outcrop in New Mexico, where Caucasian travelers as early as 1605 scratched their names (Hodge, 1937). Or, we may cite the extraordinarily interesting array of names carved by visitors over the past four thousand years on the blocks of the Great Pyramid of Egypt (Goyon,

1944), of the Greek and Latin inscriptions in the Egyptian royal tombs (Baillet, 1916), and of Napoleonic French names in Upper Egypt (Legrain, 1911).

In discussing types of writing systems, C. and F. Voegelin (1961) establish a type named "Alphabet Excluded Mnemonic Systems" into which they place sign languages of Australia and the American Indians, as well as

systems involving tied knots [quipus] and notched wood, whether or not pictorial representation is included. It is impossible to say whether this type finds expression in petroglyphs — pictures incised or painted on detached stones or on the living stone, as in the paleolithic cave paintings. Though the forms of pictographs are found all over the world, they can be typologized as Alphabet Excluded Mnemonic Systems only when their function is known to be mnemonic.

This passage states clearly the problem which faces the student of prehistoric petroglyphs, namely, the difficulty that we do not know whether they were intended to serve the function of person-to-person communication. If petroglyphs in prehistoric Nevada were intended to convey messages, it is curious that they do not ordinarily occur where people lived or camped. Nevada petroglyphs usually are found at spots where there is no evidence of occupation for the very good reason that such spots are unfavorable for this purpose. This observation has been made elsewhere, but is important here since one may ask why isolated places, where only passing individuals would see them, were used as places to inscribe messages. Thus it seems improbable in the highest degree that Nevada petroglyphs are evidences of a nonalphabetic mnemonic system. Absolute proof cannot be produced for this, but the apparently unplanned aggregates of symbols on one rock surface, which often can be proved to have been applied seriatim, and therefore presumably over many years, also seem to offer support for the argument against these as communication symbols in the strict sense.[2]

The discontinuity of the tradition of making petroglyphs remains our greatest lack in attempting to learn what the symbols were intended to represent. If hunters or shamans were the persons who actually pecked the designs on the rocks, and if (as we suppose) they did so as part of a ritual connected with hunting, then the symbols may be highly individualized, a hunter or shaman applying those particular symbols which seemed to him to offer the greatest opportunity for success in the coming hunt. There remains the fact, however, that certain designs (lizard, mountain sheep, grid, rake, connected circles) occur over a vast geographical area, and some genetic (historical) connection must be presumed to account for this distribution. There seems, therefore, to be a generic petroglyph-making complex which is probably one aspect of an ancient and widespread hunting practice in the Great Basin.

We are now at the point at which it would be possible for some energetic student to classify the petroglyph elements and factor out the petroglyph styles for a large section of western North America, and to then try to see the relative strength of each style within this larger region. We believe that the information now available for the states of Washington, Oregon, Idaho, Nevada,

and Texas would be sufficient. The California data are very numerous and rather scattered, but they exist in several large files of source data and would probably be accessible. A monograph treating seven hundred California sites is being written by the present authors. For the critical states of Utah, Arizona, New Mexico, and Montana, the Donald Scott collection at Peabody Museum, Harvard University, would probably be the best single source, although in each of these states there are quantities of data on file in the archives of universities and archaeological and historical societies which could be consulted.

REFERENCES

Baillet, J.
 1916 Les Inscriptions grecques et latines des tombeaux des Rois ou Syringes. *Mémoires de l'Institut français d'Archéologie orientale.* Cairo.

Elsasser, A. B., and E. Contreras
 1958 Modern Petrography in Central California and Western Nevada. *Univ. of California Archaeological Survey Report,* No. 41, Paper No. 65, pp. 12-18. Berkeley.

Goyon, G.
 1944 Les Inscriptions et Graffiti des Voyageurs sur la Grand Pyramide. *Société Royale de Géographie d'Egypte, Publications Spéciales.* Cairo.

Gunnison, J. W.
 1857 The Mormons, or Latter-Day Saints, in the Valley of the Great Salt Lake. Philadelphia.

de Harport, D. L.
 1951 An Archaeological Survey of Cañon de Chelly: Preliminary Report of the Field Sessions of 1948, 1949 and 1950. *El Palacio,* 58:35-48. Santa Fe.

Heizer, R. F.
 1958 Aboriginal California and Great Basin Cartography. *Univ. of California Archaeological Survey Report,* No. 41, pp. 1-9. Berkeley.

Hodge, F. W.
 1937 History of Hawikuh, New Mexico. *F. W. Hodge Anniv. Publ. Fund,* Vol. 1. Los Angeles.

Kroeber, A. L.
 1958 Sign Language Inquiry. *International Journ. American Linguistics,* 24:1-19.

Laming, A.
 1959 Lascaux Paintings and Engravings. Penguin Books, A419. Harmondsworth, Middlesex, England.

La Paz, L.
 1948 Meteoritical Pictographs. *Contribs. Meteoritical Soc., Popular Astronomy,* 56:322-329.

Legrain, G.
 1911 Les inscriptions françaises de Haute Égypte. *C. R. de l'Acad. des Sciences Morales et Politiques.* Paris.

Mallery, G.
 1886 Pictographs of the North American Indian. 4th Annual Report of the Bureau of American Ethnology.

Miller, W. C.
1955*a* Two Possible Astronomical Pictographs Found in Northern Arizona. *Plateau,* 27:6-13, Mus. of N. Arizona, Flagstaff, Ariz.
1955*b* Two Prehistoric Drawings of Possible Astronomical Significance. *Astronomical Soc. of the Pacific* Leaflet, No. 314, San Francisco.

Schroeder, A. H.
1952 A Brief Survey of the Lower Colorado River from Davis Dam to the International Border. Boulder City, Nev.

Spier, L.
1955 Mohave Culture Items. *Museum of N. Arizona Bull.,* No. 28. Flagstaff, Ariz.

Steward, J. H.
1929 Petroglyphs of California and Adjoining States. *Univ. of California Publs. in American Archaeology and Ethnology,* 24:2:47-238. Berkeley and Los Angeles.

Voegelin, C. F., and F. M. Voegelin
1961 Typological Classification of Systems with Included, Excluded and Self-Sufficient Alphabets. *Anthropological Linguistics,* 3:55-96. Bloomington, Ind.

APPENDIX C

Dating by Patination

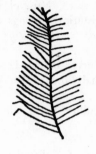

The surface weathering of stone is a process of chemical alteration and is generally referred to as patination. In an area where petroglyphs have been made over a long period of time the older designs will often appear less freshly cut than younger ones.

At the Grimes site (Ch-3) a great many degrees of patination are present, some petroglyphs (for example, conical pits) being indistinguishable from the natural rock surface in color and degree of weathering, and others being sharply contrasting as a result of the penetration of the design through the darker surface into the lighter-colored and unaltered interior body of the rock. These last are clearly much more recent than the heavily patinated examples. Our attempts to determine some rate of patination (through the aid of Professors Howel Williams and Garniss Curtis of the Department of Geology, University of California, Berkeley) have been without success. We can only point out that the least possible age for the youngest petroglyphs at the Grimes site is 150 to 200 years and that they appear as fresh as though they were made yesterday. Because the patination appears to have progressed to its ultimate in the conical pits and grooves at site Ch-3, we are guessing that they may be fifteen or twenty times as old as the obviously recent examples which have a minimum age of 150 to 200 years; that is, the oldest petroglyphs here may be from 2,500 to 3,500 years old.[1] While admittedly speculative, we feel that the oldest Ch-3 petroglyphs may date from the end of the Altithermal temperature age of the Postglacial or the early part of the Medithermal age.[2]

The utility of differential patination of petroglyphs in assigning relative age to styles or elements has long been recognized, and the reader is referred to discussions of this subject by Heizer (1953, p. 20), Goodwin (1960), Wulsin

284

(1941, pp. 113-114), and Flamand (1921, chap. 4). The process of formation of desert varnish has been treated by Laudermilk (1931) and Hunt (1954). Wulsin (*loc. cit.*) has an excellent discussion of this phenomenon in North African petroglyphs, which we quote here:

Patina. A study of the patina of the Libyco-Berber engravings leads to similar conclusions. Some are quite dark, though they are never so dark as the prehistoric engravings. Others show very little patina, a few hardly any. Arab inscriptions near the ancient pictures in southern Oran and a Roman inscription of the time of Marcus Aurelius [Flamand, 1921] found on a block of sandstone at Oued Sebgagne in the northwestern part of the Djebel Amour furnish a rough but convenient scale of dated patinations. Comparisons with this scale suggest that many of the Libyco-Berber engravings are medieval and that others are of approximately the same age as the Roman inscription.

Flamand (1921) investigated patina at great length. He attributes the surface discoloration of rock which goes by this name to the following mechanism. In a dry climate with occasional storms, like that of the region we are considering, rain-water which has soaked into the rock is gradually brought back to the surface by capillary action, and there evaporated. It leaves behind at the surface the chemicals with which it had become charged, including various carbonates, sulphates, silicates, and iron oxides, according to the composition of the rock. Some at least of these chemicals darken the rock surface and tend to harden, consolidate, and preserve it. The action is of course most marked on coarse-grained porous stones. The process requires a certain amount of moisture, neither too much nor too little; if there is too much moisture it leaves the rock in liquid form, taking soluble salts with it, and if too little the salts are not dissolved and so are not brought to the surface. Perret (1935) suggests that patination has been arrested by the second of these causes in parts of the central Sahara. In addition to darkening by the deposition of soluble chemicals at the surface, there seems to be a darkening due directly to the action of sunlight, observed chiefly on limestones and close-grained rocks. The thickness of the layer affected by these agents increases slowly with time. Flamand measured it for many specimens by the method of thin sections, and found that the discoloration under large naturalistic engravings invariably went deeper into the rock than the discoloration under Libyco-Berber cuttings on the same or similar stones, and that the discoloration of exposed rock-surfaces untouched by the hand of man went deeper still. Apparently the darkening of surface color and the thickening of the affected layer proceed together for a considerable time, but the affected layer continues to increase in thickness long after the surface color has caught up with that of the uncut rock and become indistinguishable from it. Thus two engravings of different age may both be as dark as the surrounding rock, and no distinction of color remains to tell us which is the older. Monod (1932) has pointed out this difficulty. It is conceivable that thin sections might still tell the story, but it would be necessary to break off part of the engraving to make them. Flamand's studies confirm and extend the conclusions as to the relative age of the drawings reached by many observers through a comparison of surface color.

It should be added that patina is usually a most unreliable guide to the relative age of engravings, except for absolutely identical rocks and exposures. Fortunately for later investigators the Libyco-Berber engravers often put their works on top of the prehistoric pictures, without any regard for them. This gives a perfect opportunity for comparing the patinas of the two series, for the rock and the exposure are identical and only the age of the cutting varies. Such comparisons invariably show

that the prehistoric pictures are darker and therefore older than the Libyco-Berber. Such superpositions suggest, moreover, that the prehistoric pictures had already turned quite dark when the Libyco-Berber engravings were made. The whole effect of the latter depended on the contrast between freshly exposed light-colored stone and the dark weathered background. Prehistoric pictures cut on the same rocks would have interfered very seriously with this result, unless they had already turned so dark as to be scarcely noticeable.

REFERENCES

Antevs, E.
 1948 Climatic Changes and Pre-White Man in the Great Basin. *Univ. of Utah Bulletin,* Vol. 38, No. 20.
 1955 Geologic-Climatic Dating in the West. *American Antiquity,* 20:317-335.
Bennyhoff, J. A.
 1958 The Desert West: A Trial Correlation of Culture and Chronology. *Univ. of California Archaeological Survey Report,* No. 42:98-112. Berkeley.
Engel, C. G., and R. P. Sharp
 1958 Chemical Data on Desert Varnish. *Bulletin of the Geological Society of America,* 69:487-518.
Flamand, G. B. M.
 1921 Les pierres écrites (Hadjrat-Mektoubat). Gravures et inscriptions rupestres du Nord-africain. Masson et Cie., Editeurs, Paris.
Goodwin, A. J. H.
 1960 Chemical Alteration (Patination of Stone). *In* The Application of Quantitative Methods in Archaeology. *Viking Fund Publs. in Anthropology,* No. 28, pp. 300-324.
Grosscup, G. L.
 1958 Radiocarbon Dates from Nevada of Archaeological Interest. *Univ. of California Archaeological Survey Report,* No. 44, Part I, pp. 17-31. Berkeley.
Heizer, R. F.
 1951a Preliminary Report on the Leonard Rockshelter Site, Pershing County, Nevada. *American Antiquity,* 17:89-98.
 1951b An Assessment of Certain Nevada, California, and Oregon Radiocarbon Dates. *In* Radiocarbon Dating, *Society for American Archaeology Memoir,* No. 8.
 1953 Long Range Dating in Archaeology. *In* Anthropology Today, pp. 3-42, Univ. of Chicago Press.
 1956 Recent Cave Exploration in the Lower Humboldt Valley, Nevada. *Univ. of California Archaeological Survey Report,* No. 33, Paper No. 42, pp. 50-57. Berkeley.
Heizer, R. F., and A. D. Krieger
 1956 The Archaeology of Humboldt Cave, Churchill County, Nevada. *Univ. of California Publs. in American Archaeology and Ethnology,* 47:1:1-190.
Hunt, A.
 1960 Archeology of the Death Valley Salt Pan, California. *Univ. of Utah Anthropological Papers,* No. 47.
Hunt, C. B.
 1954 Desert Varnish. *Science,* 126:183-184.

Laudermilk, J. D.
 1931 On the Origin of Desert Varnish. *American Journ. of Science*, 21:51-66.
Monod, T.
 1932 L'Adrar Ahnet. Contribution à l'étude archéologique d'un district Saharien. *Travaux et Mémoires de l'Institut d'Ethnologie*, Vol. 19.
Perret, R.
 1935 À travers le pay Ajjer — Itineraire de Fort-Flatters à Djanet. *Annales de Géographie*, Vol. 44.
Wulsin, F. R.
 1941 The Prehistoric Archaeology of Northwest Africa. *Peabody Museum Papers*, Vol. 19, No. 1. Harvard University.

APPENDIX D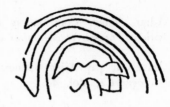

Petroglyph
Site St-1
(Lagomarsino)

This section is adapted from a report we made at the request of the U. S. National Park Service and the Curtiss-Wright Corporation, which was multigraphed for limited distribution in 1958.

There are some minor inconsistencies in classification and incidence of design elements as given in this Appendix and reported in the main text of this work. The reason for these differences lies in a post-1958 reclassification of the St-1 design elements during work involving the analysis of known petroglyphs for the entire state of Nevada. In the interests of saving time and avoiding the statistical recalculation, we have left the St-1 report in its original form.

About ten miles northeast of Virginia City, at an altitude of about 5,000 feet in the Virginia Range of western Nevada, a prominent exposure of fine-grained basalt marks the location of an extensive area of prehistoric petroglyphs. The cliff and talus slope of that part of the basaltic exposure where the markings occur face due south. Downslope from about the center of this section is a small spring, evidently permanent, which serves as one of the sources of a creek called locally Lousetown Creek, but sometimes referred to as Long Valley Creek (fig. D-11).

It might be expected that the great number of markings displayed on the rocks would long ago have attracted the attention of travelers, or at least that the reports of local residents would have encouraged numbers of individuals to visit the site. However, the region is isolated and no well-traveled trails crossed the mountain range at this point, and hence it is assumed that relatively

few persons have visited the site in recent years. The designation "Lagomarsino" is taken from the name of a local rancher who is known to have utilized the area in years past as grazing land for his livestock. In the files of the Department of Anthropology at the University of California, Berkeley, the earliest reference to this site seems to be in a letter from one John A. Reid to Professor J. C. Merriam, dated January 5, 1904. Later, photographs of a small portion of the individual elements and groups of the petroglyphs were sent to Berkeley by Mr. Reid. All his data were subsequently included in Steward's (1929) volume on petroglyphs, where the Lagomarsino site was designated as "208 Pt Virginia City, Nevada." Actually Steward has two sites included under this number. Photographs showing the Lagomarsino site are Steward's plates 66b and c and 67.

Although the site has been formally designated by the state of Nevada as an archaeological site, the petroglyphs there have never been completely recorded. Fortunately, however, they are to this day in an excellent state of preservation, and the almost complete recording in January, 1958, was carried out without any difficulty due to the extreme weathering of the rock surfaces or alterations by vandals. Preservation against the latter is attributable mainly to the relative inaccessibility of the site from population centers, and secondarily, in some small measure, to public ownership of the region. The Nevada State Park Commission has for some years had the site posted with warnings against defacement of the rock markings.

As will be shown below, the petroglyphs are typical of those occurring elsewhere in the Great Basin. There is not one indication in the entire array of markings that the persons who made them had any contact with European-Americans. Such contact would ordinarily be reflected in markings identifiable, for example, as horses bearing riders or men carrying guns. It is therefore difficult or impossible directly to associate the execution of even a portion of the markings with any of the ethnographic groups of the region and thus enable us to provide explanations of their significance in the context of aboriginal cultures which are relatively well-known. Knowledge that the immediate area seems to have been occupied in historic times by the Northern Paiute (Park et. al., 1938, p. 624) does not enlighten us as to the purpose of the markings. No informant among the Northern Paiute or the neighboring Washo, for that matter, has ever given any explanation of the origin of these or any other petroglyphs in Sierran California or in western Nevada.

In spite of the lack of definite knowledge as to the origin and meaning of these petroglyphs, certain clues offered by their physical situation and other circumstances allow us to make some speculations regarding these two aspects. First of all, the very magnitude of the group is suggestive of a fairly long span between the time of cutting or pecking of the earliest and the latest symbols on the rocks. The markings are closely distributed in a 400-yard section of vertical cliff face from 20 to 30 feet high. Below the cliff, on a talus slope which extends in a 30- or 40-degree angle down about 150 yards to the spring,

is a jumble of boulders which obviously have been detached and have rolled down from the original cliff. The larger rocks scattered throughout the jumble have inscriptions on them which appear similar in style and execution to those found on the cliff. Although there was no way of determining whether some of the inscriptions had been lost or obscured by the overturning of the rocks, the general disposition of the markings on many horizontal or easily accessible upright surfaces indicates that any major displacement, presumably from local diastrophic events, must have occurred before the markings were made.

Both the cliff rock and the talus boulders are covered with "desert varnish." This phenomenon is more pronounced on the boulders than on the cliff surfaces, but invariably it is the cutting or pecking action through the superficial "varnishing" which allows the petroglyphs to appear so boldly on the rocks. The color of the rock below the varnished layer is much lighter than the varnish itself, and hence most of the figures are immediately and easily discernible. Even so, many figures were chalked in by us as to allow clearer photography.

In no case did we observe what could be called well-defined revarnishing over already executed figures. This would a priori negate any attribution of great age to the markings, although it should be noted that the knowledge of the formation of desert varnish is not complete, and has only reached a point which allows — and this in a few cases only — extremely rough, relative dating (see Laudermilk, 1931; Hunt, 1954).

The techniques employed in producing the petroglyphs were pecking, scratching, and rubbing, in that order of importance. An experiment conducted by us at the site disclosed that pecking with any of the small stones lying about the present surface of the talus slope would easily break the surface of the desert varnish and in effect duplicate the results of the aboriginal technique for the great majority of the figures. Most of the symbols have been positively executed; in some, however (see figs. D-5m and D-6h) the "negative" method was followed. There is no doubt that rubbing and scratching were of minor importance, since only a few examples of each were observed. Scratch marks are shown in the drawing in figure D-2o. These are known to occur in association with conventional Great Basin-type petroglyphs elsewhere; Schroeder (1952, fig. 14), for example, describes and illustrates a specimen from the Lower Colorado River area which exhibits scratch marks over a previously fashioned petroglyph of the Pecked variety so well represented at the Lagomarsino site. The marks in Schroeder's specimen cannot be identified, however, as a distinct element, such as the "crosshatching" exhibited by some of the scratchings at our site.

Of the approximately 600 separate symbols which occur on the cliff and the talus boulders, 439 have been collected and analyzed. The chief result of the analysis is the recognition of two distinct art styles at the site. We have placed these in an approximate relative chronology which suggests a long period of seasonal occupation of the site.

The close association of the petroglyphs with the favorable environmental features of the surrounding terrain cannot be questioned. If the springs of Louse-

town Creek were running as copiously in aboriginal times as now — and there is no reason to believe that they were not — this in itself would explain the attraction of the spot to mammals such as mountain sheep and deer, and hence to human beings as well. The site is well within the range of the mule deer (*Odocoileus hemionus hemionus*) and the mountain sheep (*Ovis canadensis californiana*) (Hall, 1946, pp. 624, 638). Scattered on the surface of a small occupation or camp site centered about the spring are obsidian chips and an occasional projectile point.

It is inferred that pine nuts (*Pinus monophylla*) were the most important seeds used by the aboriginal inhabitants of this region. The altitude (ca. 5,000 feet) at the site and the general aspect of the terrain correspond to a typical piñon environment: Upper Sonoran zone, Piñon-Juniper belt (see Hall, 1946, p. 36). The fact that we saw no piñon trees in the immediate vicinity of the site may easily be attributed to nineteenth-century denudation for the purpose of supplying the Virginia City silver mines ten miles to the south in the Virginia Range. De Quille (William Wright) refers to the cutting of the piñon in the vicinity of Virginia City as follows (1876, pp. 215, 216):

> In the early days these hills were covered with a sparse growth of nut-pine trees — a sort of stunted pine, in size and form of trunk and branches somewhat resembling an ordinary apple tree — but the demand for fuel for the mines, mills, and domestic uses swept all these away in a very few years, and even the stumps have been dug up and made into firewood by the Chinese. . . . And now all the hills and mountains as far as the eye can reach are brown and treeless.

The reader will observe on the map of the St-1 site (fig. D-11) that a boulder fence (about 4 feet wide and 2 to 3 feet high) runs down the slope toward the spring which rises in the bottom of the canyon just below the petroglyph area. If this boulder fence is contemporary with the period of petroglyph making, it would have served as a diversion fence for game such as deer which were moving past (either driven by beaters or migrating naturally), so that the animals would have been required to pass between the lower end of the fence and the steep, boulder-covered slope on the opposite side where they could be shot. We are not certain that the fence is prehistoric. All we can say is that the situation of the St-1 petroglyph site is sufficiently similar to that observed elsewhere in Nevada that we believe it to have been a game ambush site and the petroglyphs to have been the magical aspect of the hunt carried on at the spot. If this explanation is correct, the camp site around the spring below the petroglyphs must have been unoccupied during the game migration period in the late fall. The camp site may be a winter village where a small group lived, eating stored foods (mainly piñon nuts collected from the vicinity) for part of the year.

It is not difficult to relate certain of the petroglyph elements to natural objects, the increase of which would be advantageous to the Indians' economy. The more obvious examples are the mountain sheep (fig. D-9*f*) and what may be possibly interpreted as the cones of the piñon (figs. D-6*p* and D-7*c*).

While it must be admitted that it is not possible to say with any precision what the purpose of the Indians was in making petroglyphic inscriptions on rocks, one may at the same time make some judgment as to purposes which were *not* envisaged by the makers of these pecked designs. Although a simple type of map making was widely known in the Great Basin in the form of "sand maps" (for details see Heizer, 1958), maps showing topographical features such as watercourses, mountains, valleys, and the like, drawn or inscribed on a plane surface, are not reported for the Great Basin area. There is a conceptual difference between a scale model showing topography and an abstract geographic plane map. The symbols are rather different, and the two types of representation clearly are of different orders. For these reasons, it seems improbable that few if any of the Nevada petroglyphic designs known to date can be proved to be maps (cf. Steward, 1929, p. 226).

A. L. Kroeber (1958) wrote an account of the Indian sign language of the Great Plains and surrounding territory, and discussed the possible relationship of sign language to prehistoric petroglyphs. We quote here his remarks:

. . . *specific* resemblances between sign language and pre-Caucasian American pictography are really very few. The similarities are generic and only two: both methods appeal to sight, and only to sight. The positive conventions which are so strong in sign language are lacking in pictography. I know of no picture writing in which an erect index finger means *man,* or the hooked fingers swept down the side of the head mean *woman,* or other signs of similar conventionalization.

Another obvious difference is that the sign language is actually communicative in intent, whereas native art was primarily decorative. It might also serve ceremonial purpose, in which case it worked out certain symbols. But the meaning or purpose of these was known beforehand — somewhat like the words of petitioning prayers or compelling formulas, or the motions of a dance — so that it was their *enactment* that counted as contrasted with communication. It is quite likely that most communication, except where actual words were used in ritual, is read into ancient pictography by us rather than having been present by intent. If communicative purpose had been present, we ought to be able to understand a large proportion of preserved pictographs instead of being so largely baffled by them.

Another point of difference is that a pictography able to communicate a wide range of information presupposes an ability of realistic representation and discrimination that in general was far beyond native capacities. Such ability generally has to be taught or learned and rests on a developed tradition. On the other hand, the manual and digital skill required to make sign language gestures is in no way special. What there is traditional in it is its conventions: associations of particular gestures with particular meanings. Adequate execution of the gestures would never require more than several trials and might succeed at the first attempt.

Of course, it is also possible for pictography to get along with a moderate degree of skill in lifelike representation, in proportion as it succeeds in developing accepted conventions. This is the path followed by the picture writing of southern Mexico, which grew up in a society calendrically interested and therefore future-oriented — also elaborately ritualized as well as technologically diversified and expert.

If we accept Kroeber's analysis and view the Lagomarsino site petroglyphs in this light, we must admit that, while there are some repetitive designs, these

seem generically rather than specifically similar; that is, many designs are similar but few are identical. Our labeling of a design element as "curvilinear meander" or "gridiron" or "rake" is for convenience and as a classificatory device, and our decision to so lump generally similar designs is not intended to create the impression that they were each believed to represent the same meaning to the individuals who anciently pecked the designs on the rocks. We do not deny that some, though probably not all, similar designs were intended to represent the same meaning, but the wide variability which is displayed is strong presumptive evidence that we are not dealing with evidence construable as a conventionalized system of elements intended to serve as a surrogate for spoken communication. We believe that groups of design elements occurring together on one rock surface and exhibiting as a group the identical degree of weathering and technique of manufacture represent a single suite applied to one rock surface — say in a single day. Now, if these design groups were intended to communicate to another person or social body a message, or to transmit specific information, one would expect that there would be some regularity or repetition of elements on different rock surfaces. But repetition of a precise series of design elements in a sequence arrangement is scarcely to be found, and if we were to argue that these were messages it would have to be further assumed that each message was a quite different one. In view of the known fact of extreme cultural simplicity of the prehistoric peoples of the western Great Basin area, and their uncomplex and practical-oriented activity pattern, it is difficult to believe that there ever existed such a precise mode of written communication or that such a numerous set of situations could have been present which would require communication by this technique. The apparently haphazard and independently assorted occurrence of petroglyphic designs is taken by us to indicate activity by individuals over a period of time. That these individuals had some purpose in mind is undoubtedly true, but we see no evidence that that purpose was to convey a message or information. As Kroeber suggests, it was probably the *enactment,* the act of picking up a pebble and pecking at the exposed rock surface, which lies behind the custom.

ANALYSIS OF ELEMENTS

Petroglyphs on the cliff itself and immediately at the base of the cliff are shown in figures D-1a through D-6e. The figures show all the elements included at the site and are in approximately natural sequence from west to east. Thus, figure D-1a shows the westernmost petroglyph, and figure D-6e the easternmost petroglyph. Figures D-6f through D-10m show the glyphs that are to be found on the boulders scattered on the slope below the cliff. The coverage of the petroglyphs on this talus slope is not complete, but it includes most of the specimens to be found there. No natural ordering or sequence is to be associated with the sequence of figures showing the petroglyphs on the talus slope.

The drawings shown in figures D-1 through D-10 are taken from two series

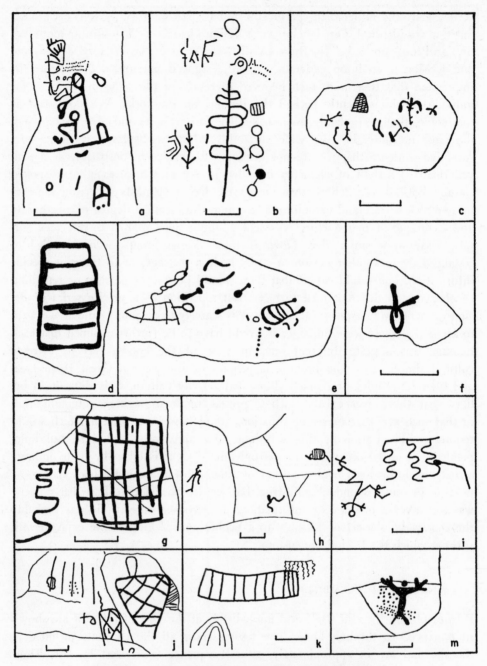

FIG. D-1. Petroglyph elements at St-1, Lagomarsino site.

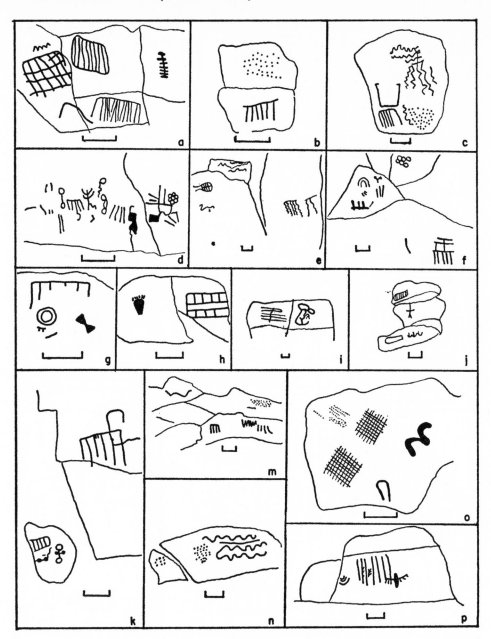

FIG. D-2.

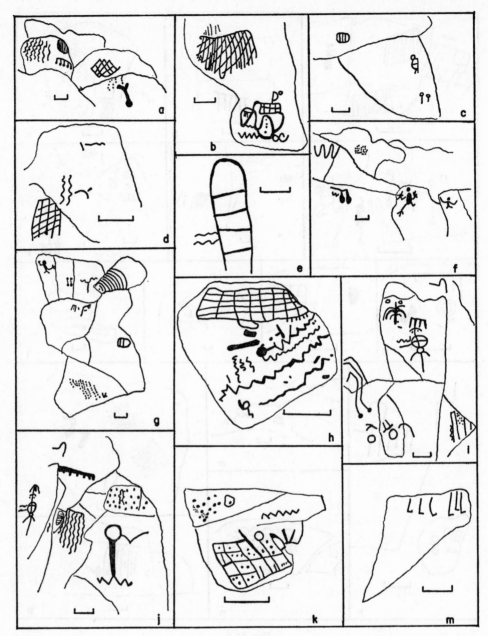

FIG. D-3.

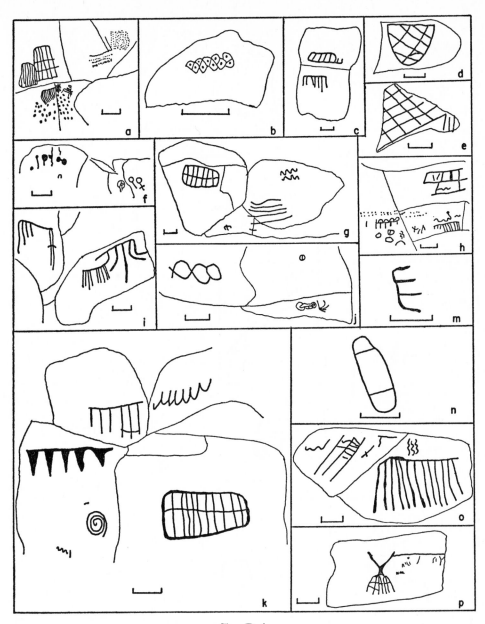

FIG. D-4.

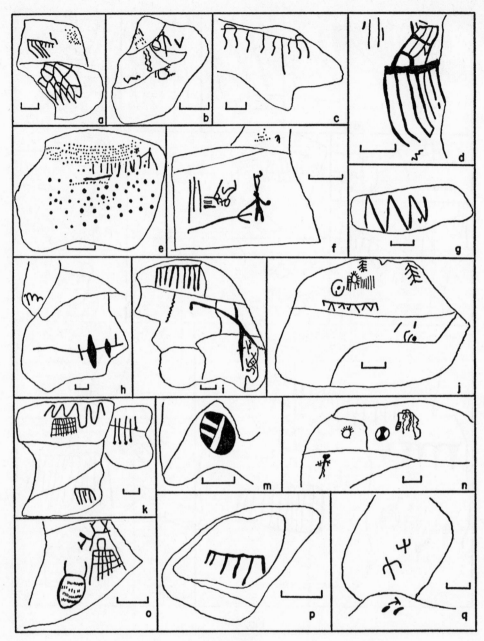

FIG. D-5.

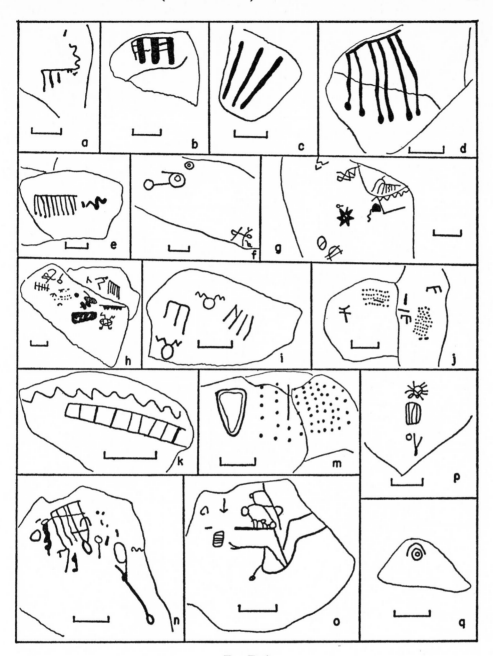

FIG. D-6.

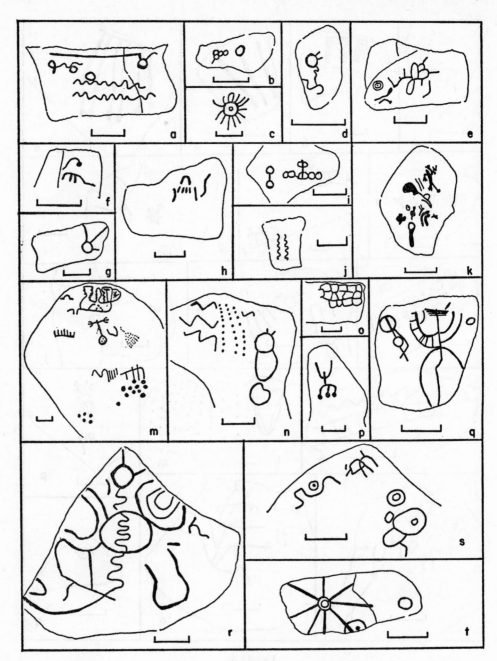

FIG. D-7.

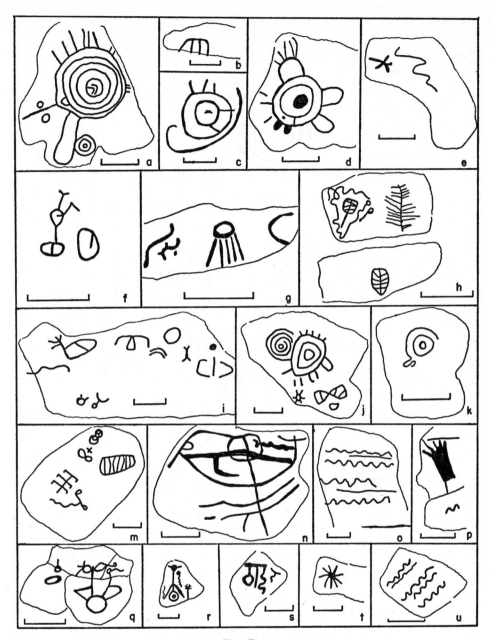

FIG. D-8.

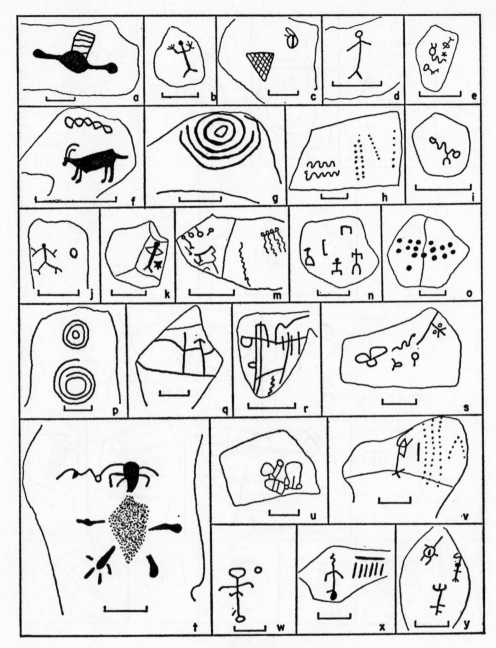

FIG. D-9.

of photographs. One series consists of black-and-white photographs taken
by the University of California Archaeological Survey in January, 1958. The
other series available to us consists of color slides taken in November, 1957,
by Donald E. Martin of Santa Rosa, California, who kindly lent them to us
for this study.

For descriptive purposes each petroglyph at the Lagomarsino site has been

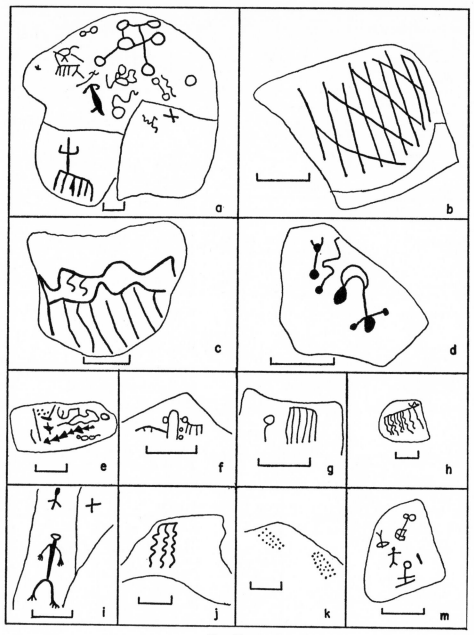

FIG. D-10.

assigned to one of twenty-nine "elements." It is hoped that each of these elements corresponds to an ideal type in the minds of prehistoric artists. No doubt this hope is vain in many cases, but there seems no other way to analyze such a mass of material.

The twenty-nine elements are listed in table D-1, together with references to the figures thus classified.

TABLE D-1
ELEMENTS PRESENT IN ST-1 PETROGLYPHS

Elements	Figures on		Total occur- rences
	Cliff face	Talus boulders	
1. Plant form	D-1*b*, 2*p*, 4*a*, 5*j*	D-8*h*	5
2. Human figure	D-1*c*, 1*i*, 1 *m*, 2*j*, 3*f*(2), 5*f*, 5*n*	D-7*k*, 8*r*, 9*b*, 9*e*(?), 9*j*, 9*k*, 9*n*, 10*e*, 10*m*	17
3. Face	D-1*c*, 3*i*(2)	D-8*a*, 9*s*	5
4. Snake	D-1*e*(2), 1*i*, 3*i*(2)	D-7*e*(2), 7*f*, 8*e*, 8*g*, 9*s*, 10*d*	12
5. Bird	D-1*f*(?), 2*p*, 3*c*(?)		3
6. Feet	D-2*h*	D-7*h*	2
7. Sheep horns	D-2*o*		1
8. Sun figure	D-5*j*, 5*n*	D-6*p*, 7*c*, 7*g*, 7*t*, 8*a*, 8*c*, 8*d*, 8*g*, 8*j*(2), 8*k*, 9*c*, 9*y*	15
9. Hand		D-8*p*	1
10. Mountain sheep		D-9*f*	1
11. Horned toad		D-9*t*	1
12. Bird track	D-1*c*, 1*b*(2), 3*g*, 3*i*, 4*g*, 4*h*, 5*b*, 5*f*, 5*q*(2)	D-6*h*, 7*k*, 7*p*, 10*a*, 10*i*	16
13. Gridiron	D-1*b*, 1*d*, 1*e*(2), 1*h*, 1*k*, 2*a*, 2*e*, 2*j*, 2*k*, 3*a*, 3*c*, 3*g*, 3*j*, 4*a*, 4*c*, 4*h*, 4*n*, 5*n*	D-6*k*, 8*m*, 6*o*, 6*p*, 9*a*	24
14. Rake	D-1*i*, 1*k*, 2*a*-2*f*, 3*a*, 3*f*, 3*g*, 3*i*, 3*j*(2), 4*a*, 4*c*, 4*h*, 4*i*, 4*k*, 4*o*, 5*a*, 5*c*, 5*d*, 5*i*-*k*, 5*n*, 5*p*, 6*a*, 6*b*, 6*d*, 6*e*	D-6*g*-6*j*, 6*n*, 7*f*, 7*m*, 7*p*, 8*b*, 8*s*(2), 9*m*, 10*a*(2), 10*f*-10*h*, 10*j*	50
15. Tailed circle	D-2*d*, 3*c*(2), 4*f*(3), 6*f*	D-6*h*, 6*n*, 7*a*, 7*d*, 7*r*, 8*h* (2), 9*m*, 10*a*(2), 10*f*, 10*g*, 10*h*, 10*j*	21
16. Asterisk or star		D-6*g*, 7*m*, 8*e*, 8*r*, 8*t*, 9*e*, 9*k*	7
17. Spiral	D-4*h*	D-8*j*, 9*p*	3
18. Labyrinth	D-2*i*, 3*k*		2
19. Concentric Circles	D-1*k*, 2*f*, 2*g*, 2*p*, 3*g*, 4*f*	D-6*f*, 6*g*, 7*e*, 7*r*(2)-7*t*, 8*a*, 8*i*, 8*r*, 9*g*, 9*p*	18
20. Dots	D-1*a*, 1*b*, 1*e*, 1*j*, 1*m*(2), 2*b*, 2*c*, 2*m*-2*o*, 3*a*, 3*f*, 3*g*, 3*i*-3*k*, 4*a*(3), 4*h*, 5*a*, 5*b*, 5*e*, 5*f*, 5*h*	D-6*j*, 6*m*, 7*m*, 7*n*, 9*h*, 9*o*, 9*v*, 10*e*, 10*k*(2)	36
21. Circle	D-1*a*, 1*b*(2), 1*j*, 3*b*, 3*i*(2), 3*k*, 4*j*, 5*b*, 5*j*, 5*m*-5*o*	D-6*g*-6*i*(2), 6*p*, 7*a*, 7*b*, 7*q*, 7*t*, 8*f*, 8*i*, 8*m*, 8*q*, 9*j*, 9*r* (2), 9*w*, 10*a*, 10*e*, 10*f*, 10*m*	35
22. Connected circles	D-1*d*, 1*e*, 2*f*, 4*j*	D-6*n*, 7*b*, 7*i*, 7*n*, 9*i*, 9*s*, 10*a*	11
23. Dumbbell	D-1*b*(2), 1*e*(3), 2*d*, 3*g*(2), 3*k*(3), 4*f*	D-6*f*(2), 7*i*, 7*q*, 8*f*, 9*w*, 10*a*(2), 10*d*	21
24. Curvilinear meander	D-1*a*, 2*i*, 3*b*	D-6*o*, 7*e*, 7*m*, 7*r*, 7*s*, 8*n*, 8*q*, 9*m*, 9*u*, 10*a*	13
25. Wavy lines	D-1*g*, 1*j*, 2*a*, 2*c*, 2*e*, 2*j*, 2*m*, 2*n*, 3*a*, 3*d*-*k*, 4*g*, 4*h*, 4*k*, 4*m*, 4*o*, 5*b*, 5*g*-5*i*, 5*k*, 6*a*, 6*e*	D-6*g*, 6*h*, 6*k*, 7*a*, 7*b*, 7*j*, 7*n*, 7*r*, 8*h*, 8*m*-8*p*, 8*u*, 9*h*, 9*m*, 9*r*, 10*a*, 10*c*, 10*e*, 10*f*	51
26. Straight lines	D-1*j*, 2*d*, 2*f*, 2*m*, 2*n*, 2*p*, 3*b*, 3*m*, 4*g*, 4*o*, 5*d*-5*f*, 5*j*, 5*k*, 6*c*	D-6*i*, 6*j*, 6*m*, 7*a*, 7*b*, 7*j*, 7*n*, 7*r*, 8*h*, 8*m*-8*p*, 9*h*, 9*m*, 9*r*, 10*a*, 10*c*, 10*e*, 10*f*	36
27. Crosshatching	D-1*c*, 1*g*, 1*j*(2), 2*a*, 2*h*, 2*o*, 3*a*, 3*b*, 3*d*, 3*h*, 4*a*, 4*d*, 4*e*, 4*g*, 4*k*, 4*p*, 5*a*, 5*k*, 5*o*	D-6*g*, 8*h*(2), 9*c*, 10*b*	25
28. Diamond cluster	D-4*b*	D-9*f*, 10*e*	4
29. Ladder	D-2*a*, 5*h*	D-6*h*, 8*m*	3

A verbal description of the elements follows:

1. *Plant form.* Some of these, at least, seem to be genuine representations of plants. The element shown in figure D-1*b*, for example, may represent the joint pine (*Ephedra viridis*), which occurs abundantly at the site and which

was medicinally important in aboriginal times (Train, Henrichs, and Archer, 1941, pp. 68 ff.).

2. *Human figure.* Examples of these elements are easily identifiable but occur in a variety of forms, from stick figures to full-bodied figures. They may therefore represent different styles.

3. *Face.* Specimens classified under this element consist of a straight or curved horizontal line, a straight vertical line intersecting the horizontal line, and a pair of dots or circles, one on either side of the vertical line and below the horizontal line. These figures seem, indeed, to represent human faces, but even if they do not their resemblance to each other is unmistakable.

4. *Snake.* At least some of the figures so identified surely represent snakes. All such figures consist of a wavy line with an enlarged tip, as if representing a head.

5. *Bird.* Only one of the three figures thus classified is certainly a representation of a bird.

6. *Foot.* Only one of the two figures in this classification corresponds clearly to the "bear or human tracks" of Steward (1929). The other figure may also represent a track, but if so it is in an obviously different style.

7. *Sheep horn.* Since there is only one of these, it is possible that our designation may not be correct.

8. *Sun figure.* Any circle which has rays extending from it has been included in this category. Many of the sun figures on the talus boulders are elaborated with spirals or other circles included within the circle. Many others have lobes as well as rays outside the circle.

9. *Hand.* The single specimen of this element may be fortuitous.

10. *Mountain sheep.* There is only one example of this element, but it is a fine specimen of this kind of figure which occurs so abundantly in southern Nevada.

11. *Horned toad.* Only one example of this element is present, and it does not correspond exactly to Steward's Horned Toad.

12. *Bird track.* This group includes all figures having a curved or angular line intersected by a shorter straight line. These seem to be clearly representative of Steward's "bird track" element, but of course there is no real reason to believe that they were made to represent actual bird tracks.

13. *Gridiron.* This category includes all enclosed areas filled with parallel lines. Many of these figures are quite similar to some of the crosshatched figures (element 27) and undoubtedly represent variations on the same theme.

14. *Rake.* This category includes a wide variety of figures which have in common a straight horizontal line from which other lines descend. The pendant lines may be either straight or wavy. In Steward's classification some of these figures would have been classed under "Rain Figure" and some under "Rake."

15. *Tailed circle.* This element comprises any circle attached to a wavy line.

16. *Asterisk or star.* It is perhaps doubtful that these two kinds of figures should be included together.

17. *Spiral.* These sometimes have circles included in the center.

18. *Labyrinth.* This element corresponds to one of Steward's elements, but it must be noted that the two specimens at Lagomarsino are doubtful representatives.

19. *Concentric circles.* Concentric circles and concentric semicircles are both included here. The semicircles often take this form because they are cut off by the edge of a rock.

20. *Dots.* Dots are to be found in two sizes at Lagomarsino: small ones made by one or two blows of the pecking stone, and large ones sometimes an inch or more in diameter. Dots may be arranged in lines or they may be scattered, simply filling an otherwise blank area.

21. *Circle.* Circles occur at the site in a variety of circumstances (for example, they may be part of a sun figure), but they have only been counted as such when they stand alone.

22. *Connected circles.* These may consist of lines of circles or clusters of circles.

23. *Dumbbell.* These figures are simply two circles connected by a line.

24. *Curvilinear meander.* In this category are included the curving lines seeming to have no real form but covering a considerable area. Figures of this kind show a general similarity, notwithstanding their variety, and seem to have formed a considerable part of one Great Basin petroglyph style. At some sites in Nevada — for example, the Grimes petroglyph site near Fallon — these meanders are found in large numbers and almost always occur alone.

25. *Wavy lines.* Both wavy and zigzag lines are included in this category. Where several wavy lines occur together they are counted as a single element.

26. *Straight lines.* Where several straight lines occur together they are counted as a single element.

27. *Crosshatching.* Included here are enclosed areas with square or diagonal crosshatching, and nonenclosed areas, again with either square or diagonal crosshatching. It seems clear that some examples of enclosed crosshatching are related to certain of the gridirons (element 13), but they have been separated here for purposes of tabulation.

28. *Diamond cluster.* These are ill-defined elements, probably not representative of any artistic or cultural reality.

29. *Ladder.* This category has been included for comparison with Steward, but it is doubtful if the present examples are genuine representatives of the element.

The total occurrences of each element on the cliff face and on the talus boulder is given in table D-2.

It would be of interest to determine whether the distribution of elements between cliff face and talus boulders is merely random or whether certain elements tend to occur oftener one place than another. To test this question statistically the following procedure was adopted.

TABLE D-2
TOTAL OCCURRENCES OF ELEMENTS PRESENT IN ST-1 PETROGLYPHS

	Element									
	1	2	3	4	5	6	7	8	9	10
Cliff face	4	8	3	5	3	1	1	2	—	—
Talus boulders	1	9	2	7	—	1	—	13	1	1
Totals	5	17	5	12	3	2	1	15	1	1

	Element									
	11	12	13	14	15	16	17	18	19	20
Cliff face	—	11	19	32	7	—	1	2	6	26
Talus boulders	1	5	5	18	14	7	2	—	12	10
Totals	1	16	24	50	21	7	3	2	18	36

	Element									
	21	22	23	24	25	26	27	28	29	Totals
Cliff face	14	4	12	3	29	16	20	1	2	232
Talus boulders	21	7	9	10	22	20	5	2	2	207
Totals	35	11	21	13	51	36	25	3	4	439

Let X be the number of occurrences of each element on the talus boulders (for example, $X=1$ for element 1). Then X is a binomial random variable with $p=0.47$ (the percentage of total occurrences on the talus boulders). The following elements are excluded from consideration because they are ill-defined and their identification is therefore tenuous: elements 5, 6, 7, 9, 10, 11, 18, 28, and 29. Now observe the number of occurrences on the talus boulders for each of the elements not excluded. Under the hypothesis (that X is binomial with $p=0.47$) we may associate each observation with a probability, the probability that such a binomial random variable will be as large or larger than the observed value. Each of the observations is now assigned to one of three groups, say G_1, G_2, or G_3, according to the following rule. We say that the observation X falls into

G_1 if the probability that the random variable is as large or larger than the observed value is less than or equal to 0.33

G_2 if the probability that the random variable is as large or larger than the observed value is between 0.33 and 0.67

G_3 if the probability that the random variable is as large or larger than the observed value is equal to or greater than 0.67

Or, symbolically, we say

$$x \epsilon\ G_1 \text{ if } \Pr(X \geq x) \leq 0.33$$
$$x \epsilon\ G_2 \text{ if } .33 < \Pr(X \geq x) < 0.67$$
$$x \epsilon\ G_3 \text{ if } \Pr(X \geq x) \geq 0.67$$

When the observed value of X falls on a boundary value a randomization procedure is adopted assigning the observation to G_1, G_2, or G_3. Consider, for example, element 3. There are five occurrences of this element, of which two are found on the talus boulders. Under the null hypothesis we have

probability that X is greater than or equal to $2 = 0.77$
probability that X is greater than or equal to $3 = 0.44$
probability that X is equal to $2 = 0.33$

In order to make G_2 have the proper size we take the 0.33 probability (probability that $X=2$) and assign 0.23 to G_2 and 0.10 to G_1. Thus $X=2$ falls into G_1 with probability $0.10/0.33=0.30$. Picking a number from a table of random numbers we find that it is 0.31, and therefore the observation is assigned to G_2. The results obtained for all the observations (excepting the ones excluded) are shown in table D-3.

TABLE D-3
OCCURRENCES OF CERTAIN ELEMENTS IN ST-1 PETROGLYPHS

Element	Talus boulders x	Cliff face	Total	$\Pr(X \geq x)$	G
1	1	4	5	0.9211	G_3
2	9	8	17	.4008	G_1
3	2	3	5	.7728	G_3
4	7	5	12	.3089	G_2
8	13	5	15	.0018	G_1
12	5	11	16	.9370	G_3
13	5	19	24	.9980	G_3
14	18	32	50	.9565	G_3
15	14	7	21	.0559	G_1
16	7	—	7	.0051	G_1
17	2	1	3	.4551	G_2
19	12	6	18	.0753	G_1
20	10	26	36	.9943	G_3
21	21	14	35	.0851	G_1
22	7	4	11	.2110	G_1
23	9	12	21	.7239	G_3
24	10	3	13	.0287	G_1
25	22	29	51	.7552	G_3
26	20	16	36	.1944	G_1
27	5	20	25	.9987	G_3

Now consider the random variable
$$Y = \text{number of times } X \text{ falls into } G_2$$
This is a binomial random variable with $p=0.34$. We observe that X falls into G_2 only twice (elements 4 and 17). The probability that the number should be as small or smaller than 2 is 0.019. We may therefore reject the hypothesis at a significance level of 0.02.

Rejecting the hypothesis leads us to the conclusion that the distribution of elements between cliff face and talus boulders is not merely random, that in fact certain of the elements tend to occur oftener on the cliff face and certain others tend to occur oftener on the talus boulders. Picking out the most radical examples of each, we may attempt a preliminary definition of the two different styles.

Cliff Face Style

Included in this are the following elements: plant form (element 1); bird track (element 12); gridiron (element 13); rake (element 14); dots (element 20); and crosshatching (element 27). The most noticeable feature of this style is its tendency to angularity. The crosshatching and gridirons are the most striking elements to the observer, because of both their frequency and size.

Talus Boulder Style

The following elements tend to be most closely associated with this style: sun figure (element 8); tailed circle (element 15); asterisk or star (element 16); concentric circles (element 19); circle (element 21); and curvilinear meander (element 24). It will be noted that the characteristic elements of this style tend to be curvilinear. Among the more notable features are the curvilinear meanders, which occur with high frequency at certain sites in western Nevada.

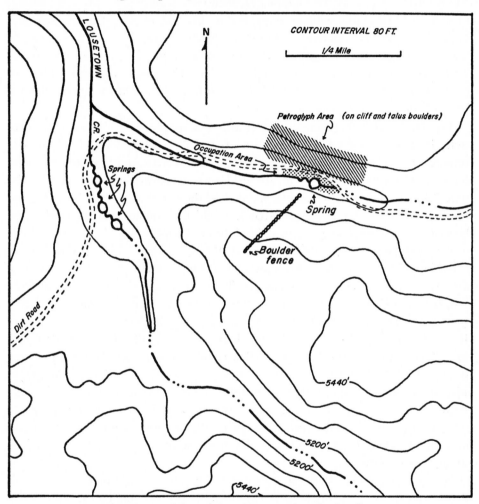

FIG. D-11. Map of St-1, Lagomarsino site locality.

CONCLUSIONS

The petroglyphs found at the Lagomarsino site clearly fall into the Great Basin Geometric style which characterizes Steward's Area A. Steward (1929, p. 220) was able to distinguish two substyles occurring in the Great Basin. The most widespread of these substyles is generally curvilinear and corresponds neatly to the style found predominantly on the talus boulders at the Lagomarsino site.

The circle, in one context or another, is the most common element of this style, but perhaps a more characteristic element is the curvilinear meander. These meanders have a vague sort of composition in that they tend to fill an area defined by the outline of a single boulder. But aside from two restrictions — curving lines without abrupt discontinuities, and spatial restrictions provided by the area of a single boulder face — there seems to be no aesthetic discipline imposed on the style. The lack of discipline is no doubt attributable to the nature of the materials. Petrography is essentially a decorative art — an attempt to embellish an object without reshaping it. But the objects that are decorated — in this case the boulders — are not themselves made by man and therefore they do not possess any degree of uniformity to provide a consistent set of restrictions within which the art might develop. The shapes of the boulders are endlessly and randomly varied so that no uniform set of artistic principles can be applied to their decoration.

The other substyle defined by Steward, within the Great Basin Geometric style, is characterized by an abundance of rectilinear elements and it thus corresponds to the style found on the cliff face at the Lagomarsino site. The most common elements of this style are gridirons, crosshatching, and rakes. This style has only slightly more artistic merit than the curvilinear style. The elements themselves have a bit more consistency, while the composition or relationship between the elements has a comparable lack of discipline.

We find two general styles, then, at the Lagomarsino site — Great Basin Curvilinear and Great Basin Rectilinear. The Curvilinear style is found to occur throughout a wide area of western North America — through the Great Basin proper and extending beyond it at least as far as Utah, Arizona, and Baja California. The distribution of this style is very much the same as that of Jennings' "Desert Culture (1956, fig. 1a), suggesting that Great Basin Curvilinear petrography formed a part of this culture. The Desert Culture, however, is a sort of developmental level, representing a typical, perhaps inevitable, adaptation by a hunting-gathering people to Great Basin environment. Great Basin Curvilinear, on the other hand, is an art style and as such is hardly subject to environmental control except in the negative sense that the rigors of such an environment prevent the development of specialists and thereby restrain artistic virtuosity.

Since Great Basin Curvilinear style is not a necessary result of Desert Culture, there is no reason to attribute to it a comparable age (beginning ca. 6000 B.C.). How old is the Curvilinear style, then? There is really no conclusive answer, but suggestive evidence on the point comes from the Grimes petroglyph site near Fallon (site Ch-3). At that site is found a pure form of the Great Basin Curvilinear style (Steward, 1929, pl. 65b-d), with elements of the style covering boulders over several acres. At the same site, often on the same boulders, are found elements of another style, consisting mostly of long, deeply cut lines, and small, conical pits 1 to 2 inches in diameter. There is no question but that this second style is much older than the elements of Great Basin Curvilinear

style; the surfaces of the pits and lines are completely covered with desert varnish and are indistinguishable from the surface of the boulders, whereas the elements of the Great Basin Curvilinear style, although showing some weathering, still make a marked contrast to the rock surfaces.

Thus we find that there is a third and older style which underlies Great Basin Curvilinear. Great Basin Rectilinear style, on the other hand, is probably more recent than the Curvilinear style. For one thing, the Rectilinear style has a more restricted distribution than the Curvilinear, being concentrated in the western portions of the Great Basin along the edge of the Sierra Nevadas, especially in Owens Valley, California. Further evidence that the Curvilinear style is older comes from Steward's (1929, p. 72) site 37 at Bishop, California. At this site rectilinear elements are found superimposed on curvilinear elements, indicating that here, at least, the Curvilinear style is older.

Our sequence of styles is, then, (1) the Pit-and-Groove style found completely patinated at the Grimes site, followed by (2) the Great Basin Curvilinear style found throughout the Great Basin, and finally (3) the Great Basin Rectilinear style found along the western margins of the Basin. The first style is obviously much older than the second style, suggesting that there was a long interruption between the two periods. A likely time for such an interruption would be the Altithermal or dry period of Post-glacial times. Since this period is dated at approximately 5,000 to 2,000 B.C., we propose that the Pit-and-Groove style was in vogue some time before 7,000 years ago; that Great Basin Curvilinear began since the Altithermal, perhaps 3,000 to 4,000 years ago; and that Great Basin Rectilinear began only about 1,000 years ago.

These proposals are only tentative, of course, and will need testing through observation of the association of the styles with datable cultural materials.

EXPLANATION OF FIGURES

In the drawings of the Lagomarsino site petroglyphs, the thinnest lines shown are edges of rocks or cracks in rocks. The following unusual circumstances are to be noted for certain of the figures:

Figure D-1. In *k* the heavy gridiron overlies the rake.

Figure D-2. In *o* the crosshatching is made by thin line scratching.

Figure D-3. *g* is a continuation of *f*; the human figure in the upper left corner of *g* is the same as that shown on the right in *f*. *j* is a continuation of *i*; it will be seen that two of the elements are repeated.

Figure D-5. In *o* the horned circle at the bottom is made with a series of minute scratches.

Figure D-6. In *m* the thin line inside the heavy triangular figure indicates a chip taken out of the rock.

Figure D-8. In *n* the heavy black lines overlie the thick grayish lines. The heavy black lines were done by pecking, the thick grayish lines by scratching.

REFERENCES

De Quille, Dan [William Wright]
 1876 History of the Big Bonanza. H. L. Bancroft, San Francisco.
Hall, E. R.
 1946 Mammals of Nevada. Univ. of California Press, Berkeley and Los
 Angeles.
Heizer, R. F.
 1958 Aboriginal California and Great Basin Cartography. *Univ. of California
 Archaeological Survey Report, No. 41* Berkeley.
Hunt, C. B.
 1954 Desert Varnish. *Science,* 120:183.
Jennings, Jesse D. (Ed.)
 1956 The American Southwest: A Problem in Cultural Isolation. *Society for
 American Archaeology Memoirs,* 11:59-127.
Kroeber, A. L.
 1958 Sign Language Inquiry. *International Journ. American Linguistics,*
 24:1-19.
Laudermilk, J. D.
 1931 On the Origin of Desert Varnish. *American Journ. of Science,* 5th ser.,
 Vol. 21, No. 121.
Park, W. Z., *et al.*
 1938 Tribal Distribution in the Great Basin. *American Anthropologist,*
 40:622-638.
Schroeder, A. H.
 1952 A Brief Survey of the Lower Colorado River from Davis Dam to the
 International Border. Bureau of Reclamation, Boulder City, Nev.
Steward, Julian H.
 1929 Petroglyphs of California and Adjoining States. *Univ. of California
 Publs. in American Archaeology and Ethnology,* Vol. 24, No. 2. Berkeley
 and Los Angeles.
 1941 Culture Element Distributions: XIII, Nevada Shoshone. *Univ. of Cali-
 fornia Anthropological Records,* 4:209-259. Berkeley and Los Angeles.
Train, Percy, James R. Henrichs, and W. Andrew Archer
 1941 Medicinal Uses of Plants by Indian Tribes of Nevada. *Contribs. Toward
 a Flora of Nevada,* No. 33 (Mimeographed). Division of Plant Ex-
 ploration and Introduction, Bureau of Plant Industry, U. S. Dept. of
 Agriculture.
Voegelin, E. W.
 1938 Tübatulabal Ethnography. *Univ. of California Anthropological Records,*
 Vol. 2, No. 1. Berkeley.

APPENDIX E

Additional
Nevada
Information

Since our original compilation of the Nevada petroglyph materials, we have had occasion to do additional field work. In the course of this work we photographed completely a site which was previously only partially recorded (site Ch-71), and we recorded a site (El-23) which was unknown to us in 1958. Since computations and drawings for our earlier material were by then complete, it would have been difficult to include them in the main body of the work, but since we feel that the data presented should be as full as possible we provide them here.

Ch-71

The geographical situation of this site has been discussed above on p. 00. The additional designs recorded are shown in figures E-1 through E-13, E-14*a-f,* and pls. 23-24. Our usual classification of elements has been applied to them and from that we obtain the following results. Element numbers are those given in chapter iii above. The number in parentheses after the element name is the number of examples found at the site.

1. *Circle* (6): E-1*c,* E-7*g,* E-11*c* (3), E-14*b.* 2. *Concentric circles* (1): E-13*b.* 3. *Bisected circle* (2): E-11*b* (2). 5. *Spoked circle* (3): E-11*c,* E-12*h,* E-13*a.* 7. *Tailed circle* (7): E-2*d,* E-5*c,* E-6*e* (3), E-8*f* (2). 9. *Circle cluster* (3): E-4*h,* E-6*h,* E-14*a.* 10. *Connected circles* (2): E-1*g,* E-12*h.* 11. *Chain of circles* (8): E-2*h,* E-6*h,* E-9*b,* E-9*d,* E-10*b,* E-11*c,* E-12*b,* E-14*f.* 12. *Sun disc* (2): E-8*e,* E-10*e.* 14. *Curvilinear meander* (34): E-1*d,* E-1*h,* E-2*a,* E-2*e,*

E-2*g*, E-3*a*, E-3*d*, E-3*f*, E-4*c*, E-4*f*, E-4*g*, E-4*h*, E-5*e*, E-5*h*, E-6*c*, E-6*d*, E-6*g*, E-7*c*, E-7*d*, E-7*e*, E-7*f*, E-9*a*, E-10*a*, E-10*e*, E-10*f*, E-11*a*, E-11*d*, E-11*h*, E-12*b*, E-12*c*, E-12*f*, E-13*c*, E-14*a*, E-14*b*. 15. *Convoluted rake* (4): E-3*g*, E-4*d*, E-8*a*, E-11*h*. 17. *Dumbbell* (3): E-1*b*, E-4*b*, E-14*d*. 18. *Dots or dot design* (4): E-4*h*, E-8*e*, E-11*e*, E-14*b*. 19. *Wavy lines* (6): E-1*e*, E-1*g*, E-8*c*, E-8*e*, E-12*f*, E-14*b*. 22. *Rectangular grid* (3): E-3*g*, E-5*b*, E-14*e*. 24. *Cross* (1): E-5*h*. 29. *Zigzag lines* (3): E-2*d*, E-13*a*, E-14*b*. 32. *Ladder, two poles* (1): E-11*c*. 33. *Rake* (11): E-3*b*, E-5*f*, E-5*g*, E-6*h*, E-7*h*, E-10*d*, E-10*e*, E-11*f*, E-11*h*, E-12*a*, E-14*a*. 35. *Rectilinear meander* (3): E-9*e*, E-11*g*, E-12*d*. 39. *Plant form* (1): E-7*b*. 43. *Sheep horns* (2): E-7*g* (2). 44. *Quadruped* (1): E-12*e*. 45. *Snake* (15): E-1*a*, E-2*b*, E-2*c* (2), E-2*d*, E-2*f*, E-3*e*, E-5*a*, E-5*c*, E-6*b* (3), E-8*d*, E-11*c*, E-14*b*. 46. *Many-legged insect* (1): E-5*h*. 50. *Horned human* (2): E-12*g*, E-13*e*. 51. *Human stick figure* (8): E-2*c*, E-3*h*, E-5*d*, E-6*a*, E-6*f*, E-8*c*, E-12*c*, E-13*f*.

Summarizing the above we find the diagnostic elements of the three styles of Great Basin petroglyphs in the following numbers: Great Basin Representational, 3; Great Basin Abstract Curvilinear, 59; Great Basin Abstract Rectilinear, 18. According to our style and statistical criteria given on p. 202, both Abstract styles are present but the Representational style is not. This is the same conclusion we reached on previous evidence.

El-23

Until 1959 the petroglyph sites known in northeastern Nevada consisted only of site El-1, which had designs evidently of non-Indian origin. In 1959 and 1960 we did considerable field work and questioned many local informants in that part of the state but were able to discover only a single additional site. This small site was made known to us by William Wright, Jr., of Deeth, Elko County. Mr. Wright has covered a large part of Elko County on foot or horseback, and his statement on the extreme rarity of petroglyphs there must be given considerable weight.

The single known aboriginal petroglyph site in Elko County (El-23) lies in the extreme north, less than a mile south of the Idaho state line. It is thus in the Snake-Columbia drainage and outside the Great Basin. It is at the confluence of Dave Creek and the east fork of the Jarbidge River, the latter a tributary of the Bruneau River. The country there is a basalt plateau at about 6,000 feet elevation, dead flat, but bisected by vertical walled canyons 500 to 1,000 feet deep. The plateau areas between canyons, locally referred to as islands, support only grass and sagebrush, whereas the canyons have a dense growth of conifers and brush. The islands seen are apparently excellent antelope country, and, indeed, numbers of these animals are still present. The canyons undoubtedly supported many deer; these are especially abundant nowadays in the nearby Jarbidge Mountains. Although the islands provided excellent grazing for antelope during much of the year, there is little or no water

present on them so that it would have been necessary for the animals to go down into the canyons to drink. Since the walls are almost vertical, the possible passageways are few in number, and it is at one of these that the Dave Creek petroglyph site is found. On the north side of the mouth of the creek, which flows into the east fork of the Jarbidge from the west, a gentle draw leads to the confluence. This passage must have been used by animals going to drink — antelope and deer tracks were abundant there in July, 1959. Near the bottom the passage narrowed between sheer rock walls. The rocks are flat-topped and stand about 20 feet high, making this a spendid ambush spot. The petroglyphs, shown in figure E-14*g* and *h*, are found just below the ambush spot. These figures are evidently in Great Basin Abstract Curvilinear style, but according to our criteria they are not abundant enough to make positive identification possible.

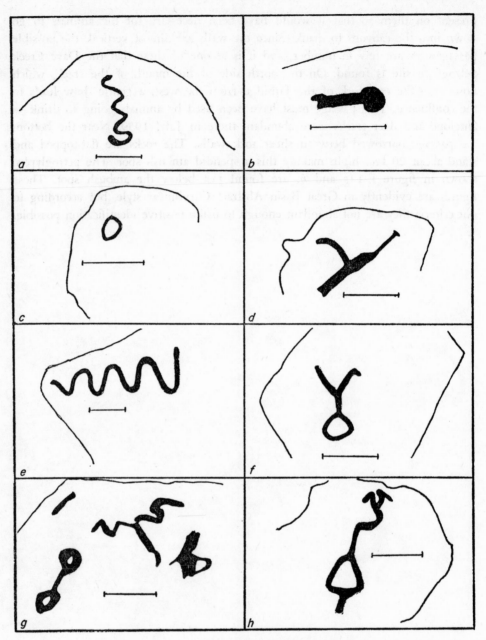

FIG. E-1. Petroglyph symbols at Ch-71.

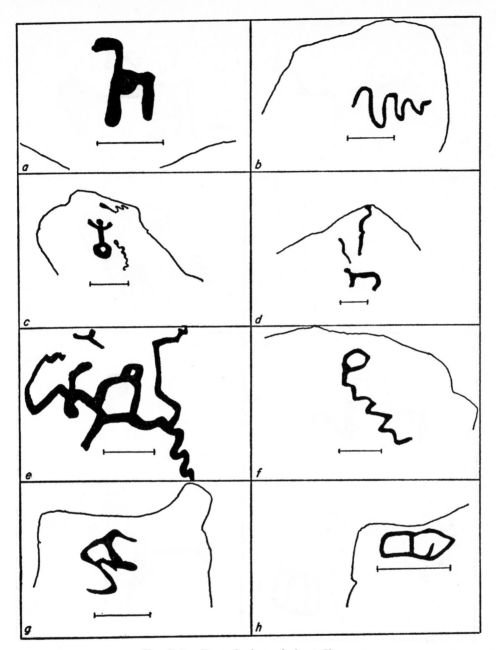

FIG. E-2. Petroglyph symbols at Ch-71.

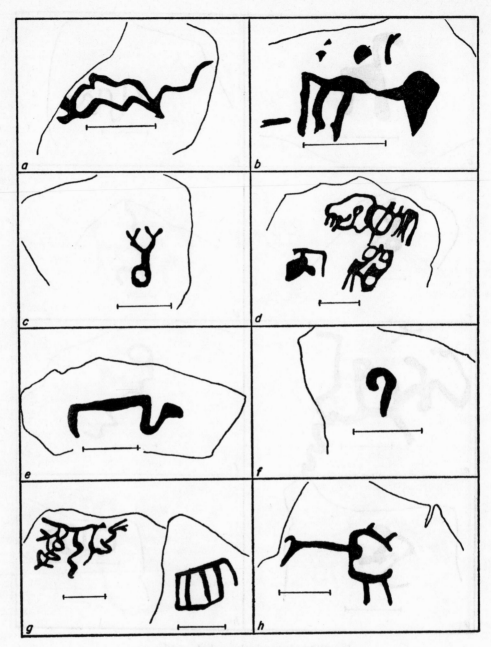

FIG. E-3. Petroglyph symbols at Ch-71.

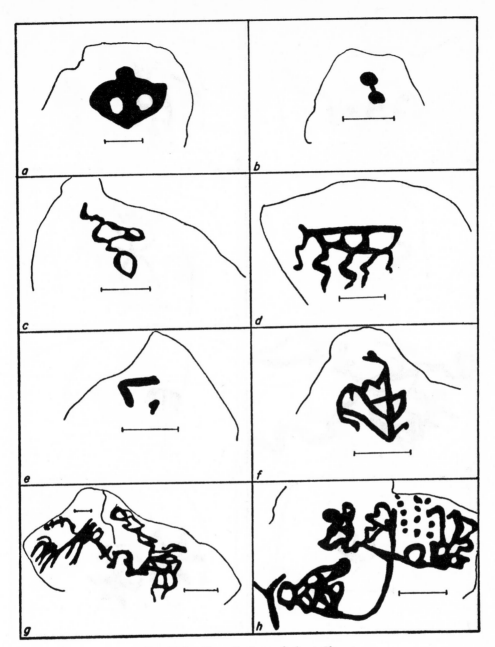

FIG. E-4. Petroglyph symbols at Ch-71.

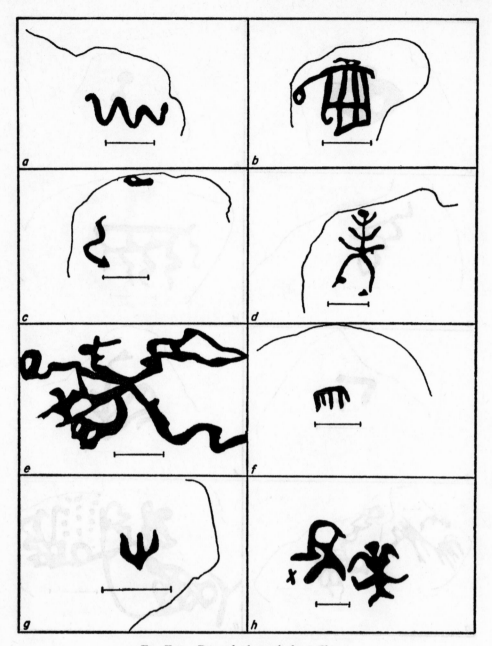

Fig. E-5. Petroglyph symbols at Ch-71.

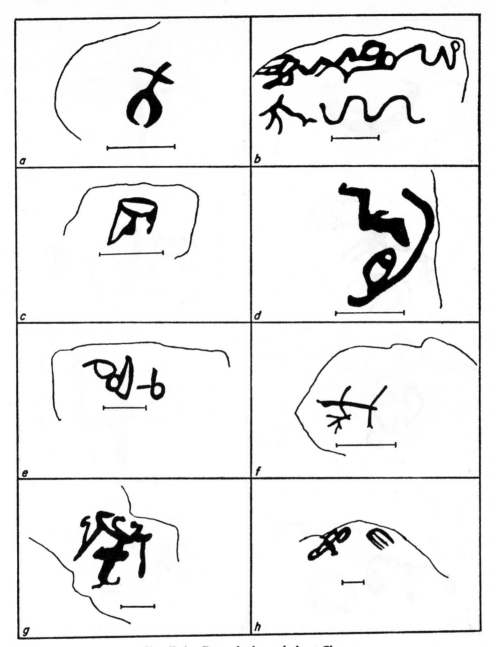

FIG. E-6. Petroglyph symbols at Ch-71.

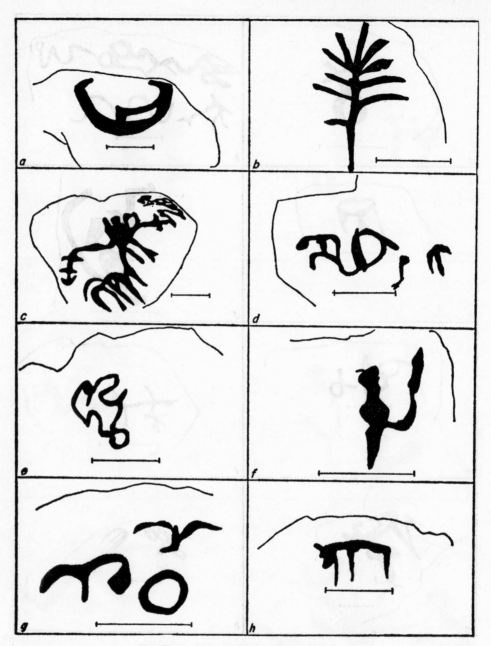

Fig. E-7. Petroglyph symbols at Ch-71.

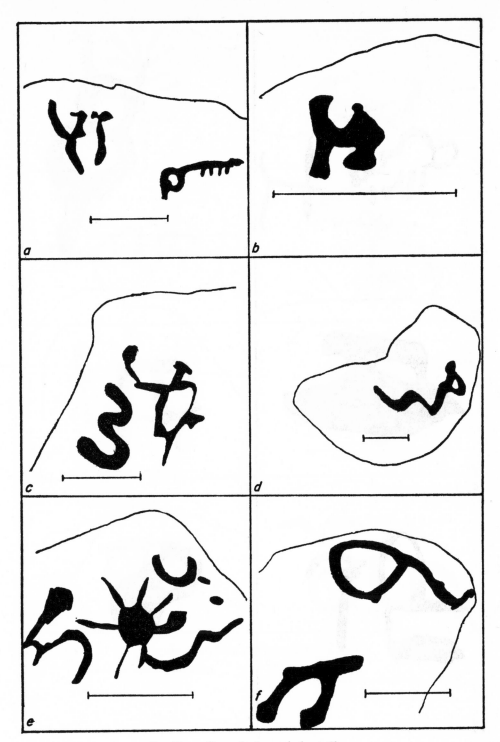

FIG. E-8. Petroglyph symbols at Ch-71.

324

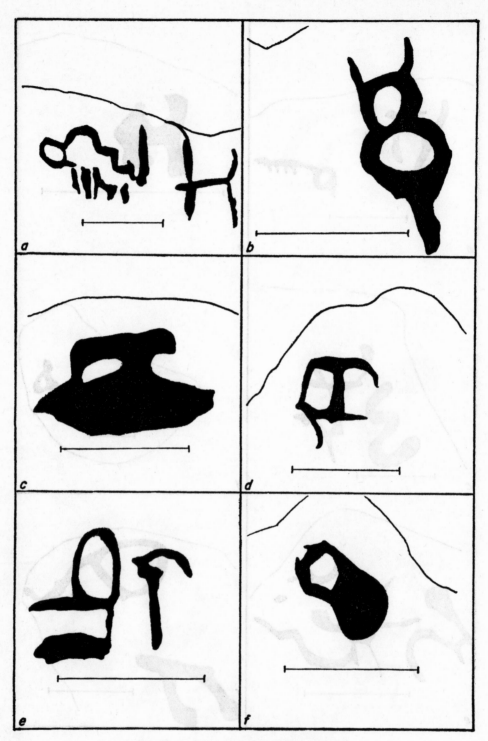

Fig. E-9. Petroglyph symbols at Ch-71.

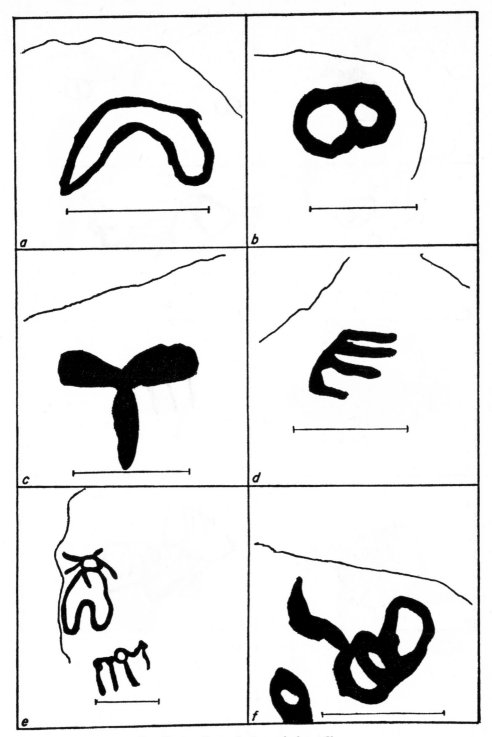

FIG. E-10. Petroglyph symbols at Ch-71.

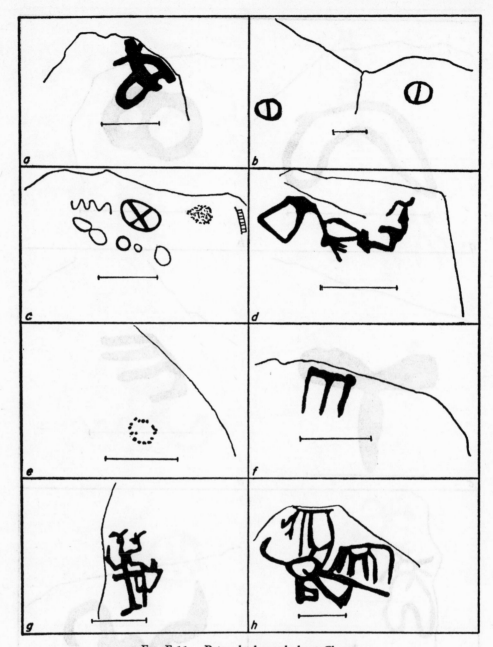

FIG. E-11. Petroglyph symbols at Ch-71.

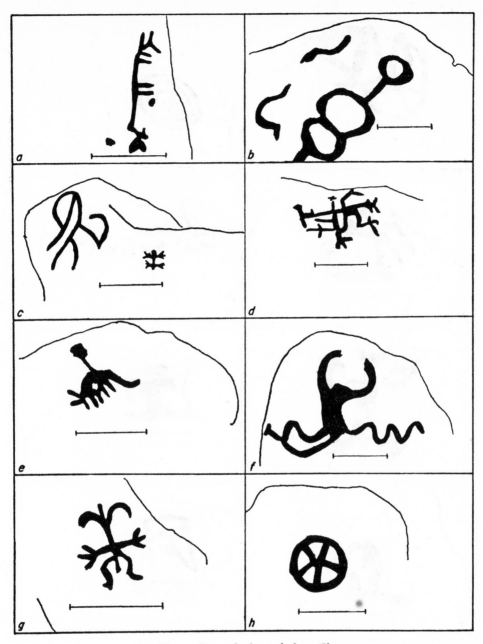

FIG. E-12. Petroglyph symbols at Ch-71.

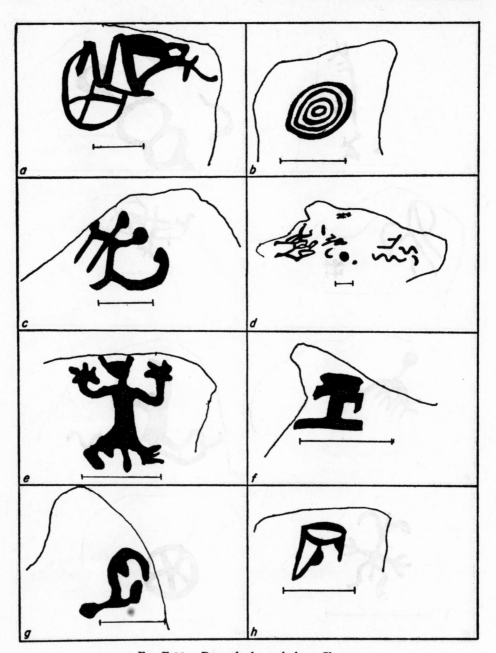

FIG. E-13. Petroglyph symbols at Ch-71.

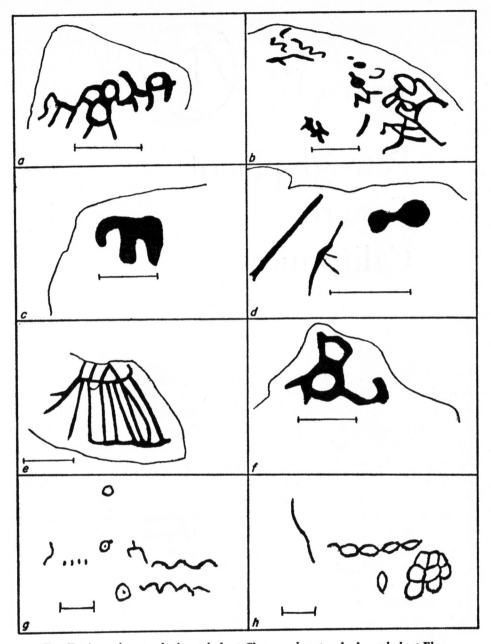

FIG. E-14. *a-f*, petroglyph symbols at Ch-71; *g-h*, petroglyph symbols at El-23.

APPENDIX F

Petroglyphs of Eastern California

Eastern California petroglyphs for the most part are not stylistically separable from those of Nevada; they are, we assume, the result of the same cultural and environmental influences and do not require separate analysis. Because of this we include here the illustrations and tabulation of such eastern California materials as are at hand. Our analysis of the function and meaning of California glyphs cannot be as complete as for Nevada glyphs because we have not done much of the field work personally and have found that persons unaware of our ideas of the function of petroglyphs almost never record the specific information needed.[1] We have therefore performed only a stylistic analysis and leave confirmation or denial of our hunting-magic hypothesis to future workers. We do not include in this section material from the southern California desert (San Bernardino, Riverside, and Imperial counties). We think that cultural relationships in this area may extend into Baja California and across the Colorado River into the Southwest and should be dealt with in those contexts rather than the present one, which centers in the west central Great Basin.

The California counties in the present survey include Inyo, Lassen, Modoc, Mono, Placer, and Plumas. The sites, listed according to county designation and University of California Archaeological Survey number, with Steward's (1929) site number, are shown in table F-1.

The elements of the California petroglyphs have been classified according to the typology used for the Nevada petroglyphs. We present them herewith in

330

TABLE F-1

EASTERN CALIFORNIA PETROGLYPH SITES

Site number	Steward's number	Figure number	Plate number
Inyo County			21*d*
Iny-28		F-1*a-b*	
Iny-198		F-1*c-d*	
Iny-208		F-1*e-g*, F-2–F-9	
Iny-210		F-10, F-12*a-e*	20*a-b*
Iny-259	40	F-11*a-b*	
Iny-265	37	F-11*c*	20*c*
Iny-267	38	F-12*f-i*, F-13*a-j*	22
Iny-268	38	F-13*k-l*	
Iny-269	39	F-13*m*, F-14, F-16*a-e*	
Iny-270	39	F-15*a-c*	
Iny-271	48	F-16*f-n*, F-17, F-18*a*	19, 21*e-f*
Iny-272	41	F-18*b-c*, F-19, F-20, F-21*ab*	20*d*
Iny-274	46	F-19*c-f*, F-22*a*	
Iny-278		F-22*b*	
Iny-279		F-15*d*	
Iny-280		F-22*c*	18
Iny-281		F-22*d-e*, F-23–F27, F-28*a*	
Iny-282		F-28*b*	
Iny-285	54	F-29*a*	
Iny-428		F-29*c, e*	
Iny-429		F-29*b, d, f*, F-30	
Iny-430		F-15*e*	
Lassen County			
Las-1		F-31*a, c*	
Las-32		F-31*b, d*, F-32	
Las-38		F-33*a*	
Las-39		F-33*b*, F-34*a-c*	
Las-49		F-34*d*	
Las-57		F-34*e*, F-35	
Las-61		F-36*a*	
Las-62		F-36*b-e, g*	
Las-63		F-36*f*	
Las-76	18	F-37*a-b*	
Las-77	22	F-37*c*	
Modoc County			
Mod-19	15	F-37*d-g*	
Mod-20	16	F-38*a*	20*e-f*
Mod-21	17	F-38*b-j*	
Mono County			
Mno-6		F-39*a*	
Mno-12		F-39*b*	
Mno-66		F-39*c*	21*g*
Mno-380		F-39*d*, F-40*a-c*	21*a-c*
Placer County			
Pla-26		F-40*d*	
Plumas County			
Plu-2		F-31*a*	

the same form as for the Nevada data. Numbers in parentheses indicate total known occurrence in eastern California (for instance, there are 81 circle elements in our eastern California material) at a site (one example at site Iny-28) or in a given panel (2 examples in fig. 11*a*). The references following colons (F-1*a*, F-5, F-6*b*, etc.) are to Appendix F figures with examples of those elements. The symbol (P) indicates that the example is painted.

1. *Circle* (81)

Iny-28 (1): F-1*a*; *Iny-208* (2): F-5, F-6*b*; *Iny-259* (2): F-11*a* (2); *Iny-269* (7): F-14*a, c, e, i, j* (2), F-16*e*; *Iny-271* (2): F-16*f, h*; *Iny-272* (13):

F-19*a, c, d* (2), *e* (3), F-20*c* (2), *d, e* (3); *Iny-281* (3): F-23*c* (2), F-24*f*; *Iny-285* (1): F-29*a*; *Iny-429* (5): F-29*b* (3), F-30*b, c. Las-32* (8): F-31*b, d* (4), F-32*b, c* (2); *Las-38* (1): F-33*a*; *Las-39* (4): F-33*b* (3), F-34*c*; *Las-57* (5): F-34*e*, F-35*a* (2), *b* (2); *Las-61* (5): F-36*a* (5); *Las-62* (5): F-36*d, e, g* (3); *Las-63* (1): F-36*f*; *Las-72* (4): F-37*a* (4). *Mod-19* (1): F-37*f*; *Mod-21* (9): F-38*d* (2), *f, h* (2), *i, j* (3). *Mno-12* (1): F-39*b*. *Plu-2* (1): F-31*a*.

2. *Concentric circle* (44)

Iny-28 (2): F-1*a* (2); *Iny-208* (1): F-6*b*; *Iny-210* (1): F-12*a*; *Iny-259* (2): F-11*a* (2); *Iny-265* (1): F-11*c*; *Iny-267* (1): F-13*h*; *Iny-268* (2): F-13*l* (2); *Iny-269* (4): F-14*i, l*, F-16*d, e*; *Iny-270* (2): F-15*a* (2); *Iny-271* (4): F-16*h, n* (3); *Iny-272* (2): F-18*b*, F-20*b*; *Iny-279* (1): F-15*d*; *Iny-280* (1): F-22*c*; *Iny-281* (1): F-26*a. Las-32* (1): F-32*b; Las-39* (1): F-33*b*; *Las-57* (1): F-35*b; Las-76* (2): F-37*a* (2). *Mod-19* (1): F-37*d*; *Mod-21* (4): F-38*b, d, f, j. Mno-6* (1): F-39*a*; *Mno-389* (2): F-40*a* (2). *Pla-26* (4): F-40*d* (4). *Plu-2* (2): F-31*a* (2).

3. *Bisected circle* (38)

Iny-210 (1): F-12*e*; *Iny-267* (1): F-12*f*; *Iny-268* (3): F-13*l* (3); *Iny-269* (8): F-14*c* (4), *e, k* (2), F-16*e*; *Iny-271* (3): F-16*k* (3); *Iny-272* (6): F-18*c*, F-19*d*, F-20*b* (2), F-20*d*, F-20*e*; *Iny-274* (2): F-21*c*, F-22*a*; *Iny-281* (2): F-23*b*, F-28*a. Las-32* (2): F-31*d* (2); *Las-39* (2): F-33*b*, F-34*a; Las-57* (1): F-35*a; Las-77* (1): F-37*a. Mod-21* (3): F-38*b* (2), F-38*h. Mno-12* (1): F-39*b. Plu-2* (2): F-31*a* (2).

4. *Sectioned circle* (23)

Iny-267 (1): F-12*h*; *Iny-268* (1): F-13*k*; *Iny-269* (1): F-14*i*; *Iny-271* (1): F-16*g*; *Iny-272* (1): F-20*c*; *Iny-274* (3): F-21*c* (3); *Iny-278* (4): F-22*b* (4); *Iny-281* (3): F-28*a* (3); *Iny-282* (1): F-28*b*; *Iny-428* (1): F-29*c. Las-39* (3): F-33*b* (2), F-34*c; Las-57* (1): F-35*a; Las-77* (2): F-37*c* (2).

5. *Spoked circle* (20)

Iny-208 (1): F-9; *Iny-259* (2): F-11*a* (2); *Iny-267* (2): F-13*a, c*; *Iny-269* (2): F-14*h, e*; *Iny-271* (1): F-17*e* (P); *Iny-429* (1): F-30*b. Las-1* (1): F-31*c*; *Las-32* (4): F-31*d*, F-32*b, d* (2); *Las-38* (1): F-33*a; Las-39* (1): F-33*b*; *Las-57* (2): F-35*b* (2); *Las-76* (1): F-37*a. Mno-6* (1): F-39*a*.

6. *Spoked concentric circle* (5)

Iny-259 (1): F-11*a*; *Iny-281* (1): F-22*e*; *Iny-429* (1): F-30*b. Las-39* (1): F-33*b; Las-77* (1): F-37*c*.

7. *Tailed circle* (39)

Iny-28 (1): F-1*a*; *Iny-208* (2): F-3, F-7*f*; *Iny-210* (1): F-10*f*; *Iny-267* (1): F-12*f*; *Iny-268* (1): F-13*k*; *Iny-269* (4): F-13*m* (2), F-16*e* (2); *Iny-270* (1): F-15*a*; *Iny-271* (1): F-17*e*; *Iny-272* (5): F-19*a* (3), F-20*c, e*; *Iny-281* (1): F-24*f*; *Iny-429* (4): F-29*d* (2), F-30*a, c. Las-38* (1): F-33*a; Las-39* (4):

F-33*b* (4); *Las-57* (3): F-34*e* (3); *Las-61* (1): F-36*a*; *Las-62* (1): F-36*g*; *Las-76* (1): F-37*b*. *Mod-19* (1): F-37*d*; *Mod-21* (1): F-38*c*. *Mno-12* (1): F-39*b*; *Mno-380* (2): F-40*a* (2). *Pla-26* (1): F-40*d*.

8. *Circle and dot* (22)

Iny-208 (1): F-4*d*; *Iny-285* (1): F-29*a*. *Las-32* (2): F-31*d* (2); *Las-38* (1): F-33*a*; *Las-39* (1): F-33*b*; *Las-62* (1): F-36*g*. *Mod-19* (6): F-37*e* (2), *g* (4); *Mod-21* (5): F-38*b* (3), *c*, *j*. *Mno-380* (4): F-39*d*, F-40*c* (3).

9. *Circle cluster* (12)

Iny-28 (1): F-1*a*; *Iny-271* (2): F-16*g*, F-17*b*; *Iny-272* (2): F-20*d* (2); *Iny-274* (1): F-21*d*; *Iny-281* (1): F-24*e*; *Iny-429* (1): F-30*c*. *Las-39* (2): F-33*b* (2); *Las-49* (1): F-34*d*. *Mod-20* (1): F-38*a*.

10. *Connected circles* (55)

Iny-208 (1): F-4*f*; *Iny-259* (3): F-11*a* (3); *Iny-267* (2): F-13*b* (2); *Iny-269* (3): F-14*d*, *j*, F-16*a*; *Iny-272* (6): F-18*c* (2), F-19*e* (3), F-20*e*; *Iny-281* (2): F-22*d* (2). *Las-32* (3): F-31*d* (2), F-32*a*; *Las-38* (3): F-33*a* (3); *Las-39* (3): F-33*b* (3); *Las-57* (10): F-34*e* (2), F-35*a* (7), F-35*b*; *Las-61* (1): F-36*a*; *Las-63* (2): F-36*f* (2); *Las-76* (3): F-37*a* (3); *Las-77* (1): F-37*c*. *Mod-19* (2): F-37*e*, *g*; *Mod-20* (1): F-38*a*; *Mod-21* (4): F-38*b* (2), *d*, *h*. *Mno-66* (3): F-39*c* (3); *Mno-380* (1): F-39*d*. *Plu-2* (1): F-31*a*.

11. *Chain of circles* (52)

Iny-28 (1): F-1*b*; *Iny-208* (2): F-1*e*, F-5; *Iny-259* (1): F-11*b*; *Iny-269* (7): F-14*b*, F-14*j* (4), F-16*e* (2); *Iny-270* (1): F-15*c*; *Iny-271* (4): F-17*a*, *b*, *e*, *k*; *Iny-272* (2): F-18*c*, F-20*c*; *Iny-274* (2): F-21*c* (2); *Iny-281* (3): F-22*e*, F-26*a* (2); *Iny-285* (1): F-29*a*. *Las-32* (2): F-32*a*, *b*; *Las-39* (4): F-33*b* (2), F-34*b*, *c*; *Las-57* (3): F-34*e* (2), F-35*a*; *Las-61* (2): F-36*a* (2); *Las-62* (4): F-36*g* (4); *Las-76* (4): F-37*a* (4). *Mod-20* (2): F-38*a* (2); *Mod-21* (4): F-38*b*, *e*, *f*, *j*. *Mno-380* (2): F-40*a* (2). *Plu-2* (1): F-31*a*.

12. *Sun disc* (20)

Iny-259 (1): F-11*a*; *Iny-267* (1): F-13*g*; *Iny-268* (1): F-13*k*; *Iny-269* (2): F-14*j*, F-16*e*; *Iny-270* (1): F-15*b*; *Iny-271* (1): F-17*a*; *Iny-272* (4): F-19*d*, F-20*c*, *d*, *e*; *Iny-428* (1): F-29*c*; *Iny-429* (2): F-30*a*, *d*. *Las-38* (1): F-33*a*. *Mod-19* (1): F-37*e*. *Mno-380* (1): F-39*d*. *Pla-26* (3): F-40*d* (3).

13. *Spiral* (3)

Iny-281 (1): F-26*a*. *Las-38* (1): F-33*a*. *Mod-21* (1): F-38*d*.

14. *Curvilinear meander* (108)

Iny-208 (8): F-1*e*, F-4*b*, *c* (2), F-5, F-6*a*, *b*, F-7*a*. *Iny-210* (6): F-10*a*, F-11*a* (3), F-12*a*, *d* (P); *Iny-265* (1): F-11*c*; *Iny-267* (2): F-13*e*, *f*; *Iny-269* (17): F-13*m*, F-14*a*, *b*, *c*, *d*, *e*, *i*, *j*, *l*, F-16*b*, *c*, *e* (6); *Iny-270* (5): F-15*a* (2), *b*, *c* (2); *Iny-271* (4): F-16*h*, *k* (2), F-17*f*; *Iny-272* (15): F-18*b*, *c*, F-19*a* (3), *b*, *e*, F-20*a*, *c* (2), *d* (2), F-21*a*, *b* (2); *Iny-274* (1): F-22*a*; *Iny-281* (3): F-23*c*, F-24*f*, F-27*c*; *Iny-429* (8): F-29*b*, F-30*a* (3), *b*, *c*, *d*, *e*.

Las-32 (2): F-31*d*, F-32*h* (P); *Las-38* (1): F-33*a*; *Las-39* (1): F-34*a*; *Las-57* (2): F-35*b* (2); *Las-62* (4): F-36*b*, *g* (3); *Las-76* (8): F-37*a* (7), *b*; *Las-77* (2): F-37*c* (2). *Mod-19* (2): F-37*d*, *g*; *Mod-20* (2): F-38*a* (2); *Mod-21* (6): F-38*c*, *e*, *f*, *g*, *i*, *j*. *Mno-12* (4): F-39*b* (4); *Mno-380* (3): F-39*d*, F-40*b*, *c*. *Pla-26* (1): F-40*d*.

15. *Convoluted rake* (6)

 Iny-198 (1): F-1*d*; *Iny-210* (1): F-10*d*; *Iny-269* (2): F-14, F-16*b*. *Las-32* (1): F-32*a*. *Mno-380* (1): F-40*b*.

16. *Connected dots* (4)

 Iny-210 (1): F-10*e*; *Iny-271* (2): F-16*i*, F-17*m*; *Iny-281* (1): F-26*a*.

17. *Dumbbell* (3)

 Iny-271 (1): F-17*k*. *Las-39* (2): F-33*b* (2).

18. *Dots or dot design* (36)

 Iny-269 (1): F-16*e*; *Iny-271* (3): F-17*j*, *l*, *m*; *Iny-274* (1): F-21*c*; *Iny-278* (2): F-22*b* (2); *Iny-281* (1): F-25*a*; *Iny-282* (1): F-28*b*; *Iny-285* (5): F-29*a* (5). *Las-1* (1): F-31*c*; *Las-32* (3): F-32*a*(P), *e*(P), *h*; *Las-39* (6): F-33*b* (4), F-34*b* (2); *Las-49* (1): F-34*d*; *Las-62* (1): F-36*b*; *Las-76* (1): F-37*a*. *Mod-19* (2): F-37*d*, *e*; *Mod-20* (1): F-38*a*; *Mod-21* (5): F-38*b* (2), *d*, *e*, *i*. *Mno-380* (1): F-40*a*.

19. *Wavy lines* (54)

 Iny-198 (1): F-1*d*; *Iny-208* (2): F-1*e*, F-6*b*; *Iny-210* (2): F-10*c*, F-12*a*; *Iny-259* (3): F-11*a* (2), F-11*b*; *Iny-267* (2): F-13*a*, *b*; *Iny-269* (3): F-13*m*, F-14*b*, *i*; *Iny-271* (2): F-16*f*, F-17*l*; *Iny-272* (13): F-18*c* (2), F-19*a*, *e* (3), F-20*b* (7); *Iny-274* (1): F-21*c*; *Iny-278* (3): F-22*b* (3); *Iny-279* (3): F-15*a* (2), *b*; *Iny-280* (1): F-22*c*; *Iny-282* (1): F-28*b*; *Iny-285* (2): F-29*a* (2); *Iny-429* (2): F-30*a*, *c*. *Las-39* (2): F-33*b*, F-34*c*; *Las-57* (2): F-35*a*, *c*; *Las-61* (1): F-36*a*; *Las-62* (1): F-36*g*; *Las-76* (1): F-37*a*. *Mod-21* (1): F-38*c*. *Mno-6* (1): F-39*a*; *Mno-380* (1): F-40*a*. *Pla-26* (3): F-40*d* (3).

20. *Deer hoof* (0)

21. *Oval grid* (21)

 Iny-208 (1): F-1*g*; *Iny-265* (1): F-11*c*; *Iny-267* (3): F-12*h*, F-13*a*, *d*; *Iny-268* (1): F-13*k*; *Iny-269* (1): F-14*f*; *Iny-271* (1): F-17*e*; *Iny-279* (2): F-15*d* (2); *Iny-281* (2): F-22*d*, F-26*a*. *Las-32* (1): F-31*d*; *Las-39* (1): F-34*c*; *Las-57* (1): F-35*b*; *Las-62* (2): F-36*b*, *d*. *Mno-6* (1): F-39*a*; *Mno-12* (1): F-39*b*; *Mno-380* (1): F-40*a*. *Pla-26* (1): F-40*d*.

22. *Rectangular grid* (21)

 Iny-210 (1): F-10*b*; *Iny-265* (1): F-11*c*; *Iny-267* (1): F-12*i*; *Iny-271* (5): F-16*f* (3), *l*, F-17*j*; *Iny-272* (1): F-20*c*; *Iny-274* (1): F-21*d*; *Iny-279* (1): F-15*d*; *Iny-281* (1): F-28*a*. *Las-32* (4); F-31*b* (2), *d*, F-32*c*; *Las-57* (1): F-34*e*; *Las-62* (1): F-36*c*; *Las-63* (1): F-36*f*; *Las-76* (1): F-37*a*. *Mno-6* (1): F-39*a*.

23. *Blocked oval* (2)
 Iny-268 (1): F-13*k*; *Iny-274* (1): F-22*a*.

24. *Cross* (17)
 Iny-208 (1): F-7*f*; *Iny-210* (2): F-10*d*, F-12*b*; *Iny-268* (1): F-13*k*; *Iny-271* (1): F-16*k*; *Iny-272* (2): F-19*c*, F-20*d*; *Iny-285* (2): F-29*a* (2); *Iny-429* (4): F-29*d* (2), F-30*c* (2). *Las-39* (2): F-34*b, c*. *Mod-19* (1): F-37*f*. *Mno-380* (1): F-40*a*.

25. *Bird tracks* (3)
 Mno-380 (3): F-49*b* (3).

26. *Parallel straight lines* (38)
 Iny-208 (1): F-7*b*; *Iny-267* (1): F-12*f*; *Iny-271* (1): F-17*a*; *Iny-272* (2): F-20*b, d*; *Iny-278* (1): F-22*b*; *Iny-281* (1): F-22*e*; *Iny-429* (1): F-29*f*; *Iny-430* (5): F-15*e* (5) (P). *Las-1* (13): F-31*c* (13); *Las-39* (2): F-34*c* (2); *Las-57* (2): F-35*a* (2); *Las-61* (1): F-36*a*. *Mno-66* (3): F-39*c* (3); *Mno-380* (3): F-39*d*, F-49*b* (2). *Pla-26* (1): F-40*d*.

27. *Triangles* (3)
 Las-63 (1): F-36*f*. *Plu-2* (2): F-31*a* (2).

28. *Lozenge chain* (1)
 Las-61 (1): F-36*a*.

29. *Zigzag lines* (37)
 Iny-259 (5): F-11*a* (2), *b* (3); *Iny-281* (1): F-24*f*. *Las-1* (17): F-31*c* (17); *Las-57* (1): F-34*e*; *Las-62* (1): F-36*g*; *Las-63* (1): F-36*f*. *Mod-19* (4): F-37*e* (3), *f*; *Mod-21* (1): F-38*e*. *Mno-12* (1): F-39*b*; *Mno-66* (4): F-39*c* (4). *Pla-26* (1): F-40*d*.

30. *Star or asterisk* (1)
 Pla-26 (1): F-40*d*.

31. *Ladder, one pole* (7)
 Iny-210 (2): F-12*b, c*; *Iny-271* (1): F-17*c*; *Iny-285* (1): F-30*c*. *Las-39* (1): F-33*b*; *Las-57* (1): F-35*b*. *Mod-21* (1): F-38*e*.

32. *Ladder, two poles* (7)
 Iny-271 (1): F-17*m*; *Iny-272* (2): F-20*c*, F-21*b*; *Iny-285* (1): F-29*a*. *Las-39* (1): F-34*c*; *Las-61* (1): F-36*a*; *Las-76* (1): F-37*b*.

33. *Rake* (31)
 Iny-208 (2): F-4*f* (2); *Iny-210* (3): F-10*b, c* (2); *Iny-265* (1): F-11*c*; *Iny-267* (2): F-12*f*, F-13*a*; *Iny-268* (2): F-13*k, l*; *Iny-269* (2): F-14*e, j*; *Iny-270* (1): F-15*b*; *Iny-272* (3): F-19*a*, F-20*c, e*; *Iny-279* (1): F-15*d*; *Iny-281* (1): F-24*d*; *Iny-429* (1): F-30*a*. *Las-32* (1): F-31*d*; *Las-39* (1): F-33*b*. *Mod-19* (1): F-37*g*; *Mod-21* (2): F-38*c, d*. *Mno-6* (1): F-39*a*; *Mno-380* (4): F-40*b* (2), F-49*a* (2). *Pla-26* (1): F-40*d*. *Plu-2* (1): F-31*a*.

34. *Rain symbol* (7)

Iny-208 (1): F-7*b*; *Iny-210* (5): F-10*b, c* (4); *Iny-281* (1): F-24*c*.

35. *Rectilinear meander* (8)

Iny-208 (1): F-5*a*; *Iny-267* (2): F-13*a, c*; *Iny-269* (1): F-14*g*; *Iny-270* (1): F-15*b*; *Iny-274* (1): F-21*d*. *Las-32* (1): F-32*g*; *Las-57* (1): F-35*b*.

36. *Chevrons* (3)

Mno-66 (1): F-39*c*; *Mno-380* (2): F-40*b* (2).

37. *Radiating dashes* (1)

Las-39 (1): F-34*a*.

38. *Crosshatching* (11)

Iny-208 (1): F-4*e*; *Iny-210* (1): F-12*a*; *Iny-269* (1): F-14*e*; *Iny-271* (2): F-16*j, m*; *Iny-272* (1): F-21*b*; *Iny-281* (1): F-26*a*; *Iny-429* (1): F-30*e*. *Las-32* (1): F-31*b*; *Las-57* (1): F-35*b*. *Pla-26* (1): 40*d*.

39. *Plant form* (9)

Iny-272 (1): F-18*c*; *Iny-278* (1): F-22*b*. *Mod-19* (1): F-37*g*; *Mod-20* (1): F-38*a*; *Mno-12* (3): F-39*b* (3); *Mno-380* (2): F-39*d*, 40*b*.

40. *Bird* (1)

Iny-281 (1): F-27*c*.

41. *Lizard* (7)

Iny-259 (1): F-11*b*; *Iny-274* (2): F-21*c, d*; *Iny-282* (3): F-28*b* (3). *Las-57* (1): F-34*e*.

42. *Mountain sheep* (94)

Iny-198 (1): F-1*c*; *Iny-208* (29): F-1*e*, F-2 (5), F-3 (4), F-7*c* (2), *d* (2), *e* (2), *f*, F-8 (7), F-9 (5); *Iny-210* (1): F-10*b*; *Iny-271* (4): F-16*f, h, k*, F-17*f*; *Iny-272* (5): F-19*a* (2), *c* (2), F-20*e*; *Iny-274* (3): F-21*c, f* (2); *Iny-281* (38): F-23*c* (10), *d* (2), *e*, F-24*a, b, c, d, f*, F-25*d* (3), *e* (7), F-26*a* (2), *b* (6), F-27*b, d*; *Iny-282* (5): F-28*b* (5); *Iny-285* (2): F-29*a* (2); *Iny-429* (4): F-30*a* (3), *b*. *Las-38* (1): F-33*a*. *Pla-26* (1): F-40*d*.

43. *Sheep horns* (16)

Iny-271 (2): F-17*c* (2); *Iny-272* (3): F-18*b*, F-20*d* (2); *Iny-281* (10): F-25*c, f* (8), F-28*a*; *Iny-282* (1): F-28*b*.

44. *Quadruped (not sheep)* (18)

Iny-208 (4): F-1*f* (2), F-4*a*, F-9; *Iny-267* (1): F-13*b*; *Iny-271* (2): F-16*h*, F-17*b*; *Iny-272* (2): F-19*a*, F-20*e*; *Iny-274* (1): F-22*d*; *Iny-281* (6): F-23*f*, F-24*a* (2), *b, d*, F-27*c*; *Iny-285* (1): F-29*a*; *Iny-429* (1): F-30*a*.

45. *Snake* (46)

Iny-208 (3): F-4*c, f*, F-5*a*; *Iny-267* (1): F-13*j*; *Iny-269* (1): F-16*e*; *Iny-272* (5): F-19*a, d*, F-20*d, e* (2); *Iny-274* (1): F-22*a*; *Iny-280* (1): F-22*c*; *Iny-281* (2): F-24*f*, F-27*d*; *Iny-429* (3): F-29*b, d* (2). *Las-32* (4): F-31*d* (2), F-32*b*,

f; Las-39 (4): F-33*b*, F-34*a, b, c; Las-61* (5): F-36*a* (5); *Las-76* (3): F-37*a*
(3); *Las-77* (2): F-37*c* (2). *Mod-19* (3): F-37*f, g* (2); *Mod-20* (1): F-38*a;*
Mod-21 (2): F-38*i* (2). *Mno-380* (1): F-39*d. Pla-26* (1): F-40*d. Plu-2* (3):
F-31*a* (3).

46. *Many-legged insect* (6)
 Iny-280 (2): F-22*c* (2); *Iny-281* (2): F-24*e*, F-28*f; Iny-429* (1): F-30*c.*
Las-77 (1): F-37*c.*

47. *Foot or paw* (11)
 Iny-279 (1): F-15*d; Iny-281* (1): F-28*a. Las-39* (1): F-34*c; Las-49* (1):
F-34*d. Pla-26* (7): F-40*d* (7).

48. *Hand* (1)
 Mod-21 (1): F-38*d.*

49. *Human* (2)
 Iny-271 (2): F-17*e* (2).

50. *Horned human* (7)
 Iny-281 (5): F-23*e*, F-25*c*, F-27*a, d*, F-28*a; Iny-429* (1): F-29*b. Mod-19*
(1): F-37*f.*

51. *Human stick figure* (76)
 Iny-28 (1): F-1*b; Iny-208* (2): F-1*e*, F-9; *Iny-259* (2): F-11*b* (2); *Iny-267*
(1): F-12*f; Iny-269* (3): F-13*m*, F-14*a*, F-16*e; Iny-270* (2): F-15*a* (2);
Iny-271 (7): F-16*h, j, k*, F-17*a, c, d, k; Iny-272* (5): F-19*a* (2), F-20*c, d*
(2); *Iny-274* (1): F-21*f; Iny-281* (41): F-23*b* (30), F-24*b* (6), *f*, F-25*b*,
F-26*c*, F-27*b; Iny-285* (1): F-29*a; Iny-430* (6): F-15*e* (6). *Mod-19* (3): F-37*f,*
g (2); *Mod-21* (1): F-38*h. Pla-26* (1): F-40*d.*

52. *Human, stick limbs* (5)
 Iny-259 (2): F-11*b* (2); *Iny-271* (2): F-16*f, g; Iny-281* (1): F-27*d.*

53. *Katchina figure* (16)
 Iny-271 (1): F-16*h; Iny-281* (12): F-22*d* (3), F-23*a* (3), F-24*c* (2), F-27*a,*
c, F-28*a* (2); *Iny-282* (2): F-28*b* (2). *Mod-20* (1): F-38*a.*

54. *White man* (0)

55. *Atlatl* (0)

56. *Arrow* (1)
 Las-61 (1): F-36*a.*

57. *Deer* (5)
 Iny-265 (1): F-11*c; Iny-267* (1): F-12*g; Iny-281* (3): F-23*e*, F-25*a* (2).

58. *Fish* (0)

If the elements at each site are tabulated by style, using the same style definitions as for the Nevada petroglyphs, we obtain the array shown in table F-2. Figure F-41 shows the location of the sites.

TABLE F-2

ELEMENTS PRESENT AT EASTERN CALIFORNIA PETROGLYPH SITES

Site	Great Basin Representational	Great Basin Curvilinear Abstract	Great Basin Rectilinear Abstract	Total elements
Iny-28	—	4	—	7
Iny-198	25	13	4	69
Iny-208	32	15	2	66
Iny-210	1	3	6	27
Iny-259	—	6		28
Iny-265	—	2	1	6
Iny-267	1	4	—	28
Iny-268	—	3	1	13
Iny-269	—	32	4	70
Iny-270	—	10	1	18
Iny-271	9	14	9	66
Iny-272	6	47	5	98
Iny-274	4	4	1	22
Iny-278	—	—	—	11
Iny-279	1	—	2	6
Iny-280	—	2	—	5
Iny-281	66	14	3	149
Iny-282	7	—	—	14
Iny-285	3	2	—	17
Iny-428	—	—	—	2
Iny-429	6	17	1	42
Iny-430	—	—	—	11
Las-1	—	—	—	32
Las-32	—	20	8	42
Las-38	—	3	—	11
Las-39	1	17	1	51
Las-49	1	—	—	4
Las-57	—	20	2	40
Las-61	—	13	—	19
Las-62	—	13	1	21
Las-63	—	3	1	6
Las-76	—	22	1	30
Las-77	—	5	—	10
Mod-19	1	9	1	30
Mod-20	1	6	—	10
Mod-21	1	25	2	51
Mno-6	—	—	2	6
Mno-12	—	5	—	12
Mno-66	—	3	—	11
Mno-380	—	8	7	36
Pla-26	8	6	2	28
Plu-2	—	5	1	13

The material in table F-2 may now be transformed to show the occurrence of styles at sites. We use the same criteria as we did for the Nevada petroglyphs: in assigning a style, there must be ten recorded elements at a site, and a given style is noted as present if there are ten diagnostic elements of the style present or if more than 20 per cent of all diagnostic elements are in that style. By this method we obtain the data shown in table F-3.

Table F-3 gives us the geographical distribution of the three Great Basin Pecked styles. Great Basin Representational is found commonly as far north as site Iny-429, near Lone Pine. It is not found north of site Iny-429 except at

site Pla-26, near Lake Tahoe. Its presence at a single site far outside the normal range of the style is rather anomalous. There is no question that the style is present at Pla-26 — at least five clear foot or paw elements and an

TABLE F-3
OCCURRENCE OF GREAT BASIN PECKED STYLES IN EASTERN CALIFORNIA

Site	Great Basin Representational	Great Basin Curvilinear Abstract	Great Basin Rectilinear Abstract
Iny-198	+	+	
Iny-208	+	+	
Iny-210		+	+
Iny-259		+	
Iny-267	+	+	
Iny-268		+	+
Iny-269		+	
Iny-270		+	
Iny-271	+	+	+
Iny-272		+	
Iny-274	+	+	
Iny-281	+		
Iny-282	+		
Iny-285	+	+	
Iny-429	+	+	
Las-32		+	+
Las-38		+	
Las-39		+	
Las-57		+	
Las-61		+	
Las-62		+	
Las-76		+	
Las-77		+	
Mod-19		+	
Mod-20		+	
Mod-25		+	
Mno-12		+	
Mno-66		+	
Mno-380		+	
Pla-26	+	+	
Plu-2		+	

unmistakable mountain sheep element are recorded from the site. However, the designs there are extremely stylized, almost schematic as compared with the same elements from sites further south. Site Pla-26 is in the mountains, not the desert, and it is possible that these are more closely related to the petroglyphs of cismontane California than to the desert petroglyphs further south or east. We think we may conclude that normal Great Basin Representational did not spread effectively as far as site Pla-26 and that the designs there are the work of a single artist out of his territory or are part of a similar and related but distinct style area to the west. If we are correct in this hypothesis, Great Basin Representational style in eastern California has a distribution parallel to its Nevada occurrence (see p. 202).

Great Basin Curvilinear is almost ubiquitous in eastern California, as it is at the Nevada petroglyph sites. Its prevalence tends to support our contention that it is somewhat older than the other two Great Basin Pecked styles.

Great Basin Rectilinear style is surprisingly rare in eastern California. It is found at three Inyo County sites, but even here its elements are not numerous nor are they typical examples of similar elements found in Nevada. The same

is true of the occurrence at single sites in Mono and Lassen counties. This situation belies the impression, given by the Nevada material, that the style is crowded up against the east flank of the Sierra. It suggests rather that the style was common in a band north from Clark County in Nevada. This style is found further south into Baja California (cf. Steward, 1929, pl. 92), but tracing its extra-Californian distribution lies outside the scope of the present book.

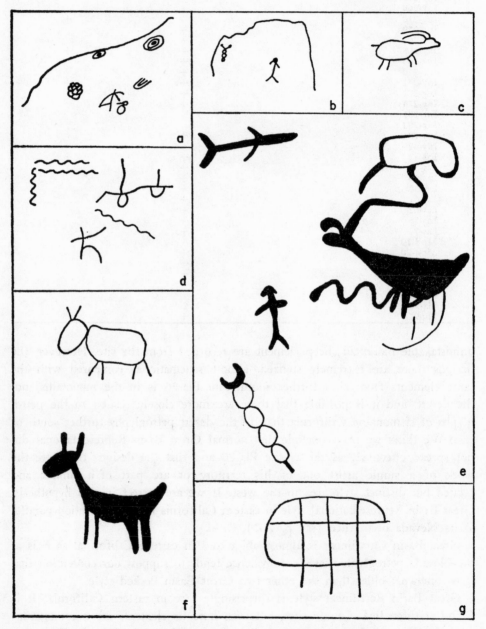

FIG. F-1. a-b, Iny-28; c-d, Iny-198; f-g, Iny-208.

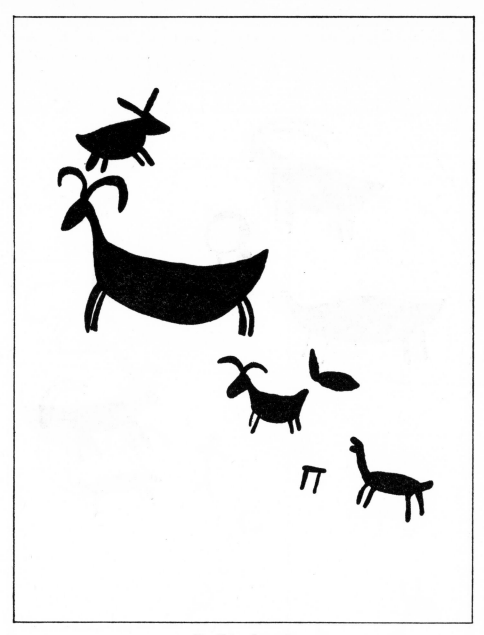

FIG. F-2. Iny-208.

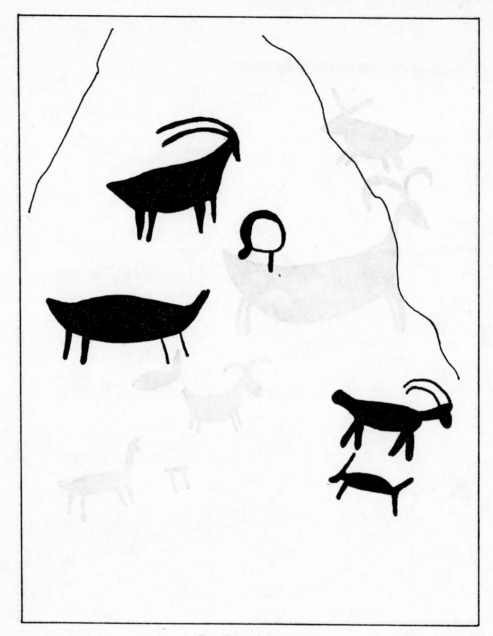

FIG. F-3. Iny-208.

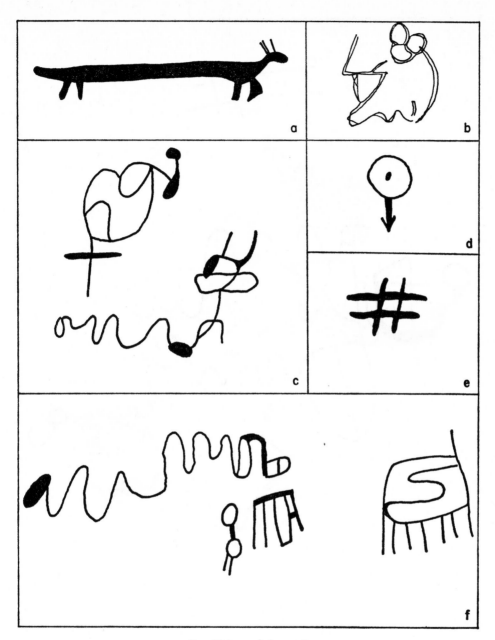

FIG. F-4. *a-f*, Iny-208.

Fig. F-5. Iny-208.

FIG. F-6. *a-b*, Iny-208.

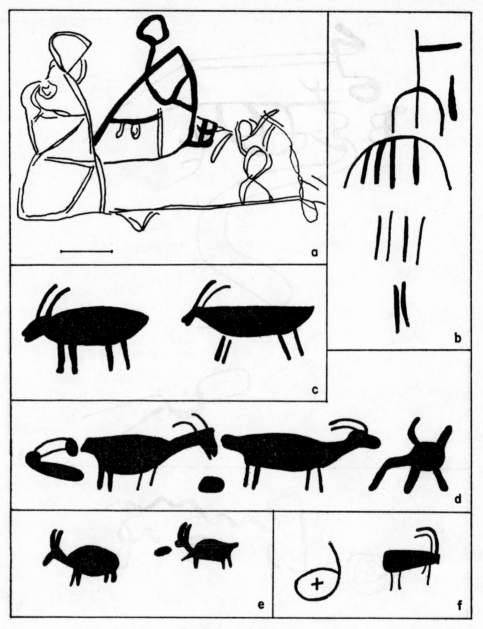

FIG. F-7. *a-f*, Iny-208.

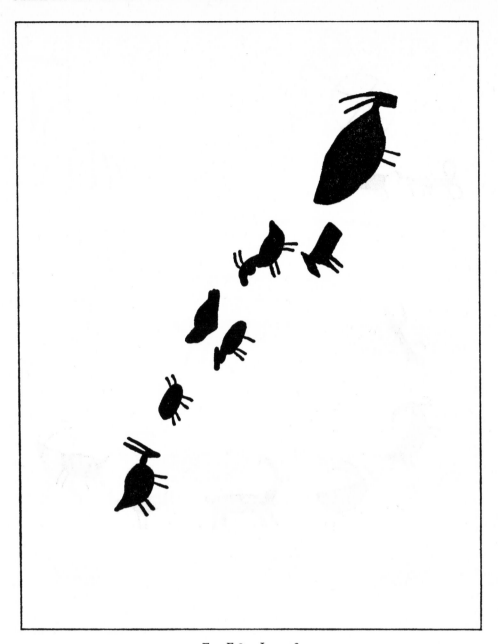

Fig. F-8. Iny-208.

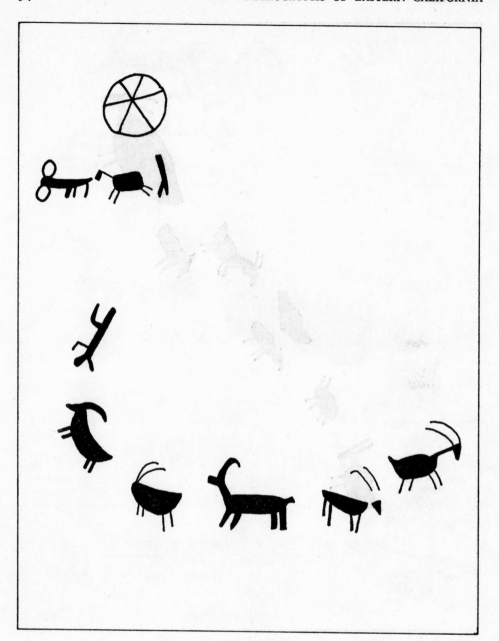

FIG. F-9. Iny-208.

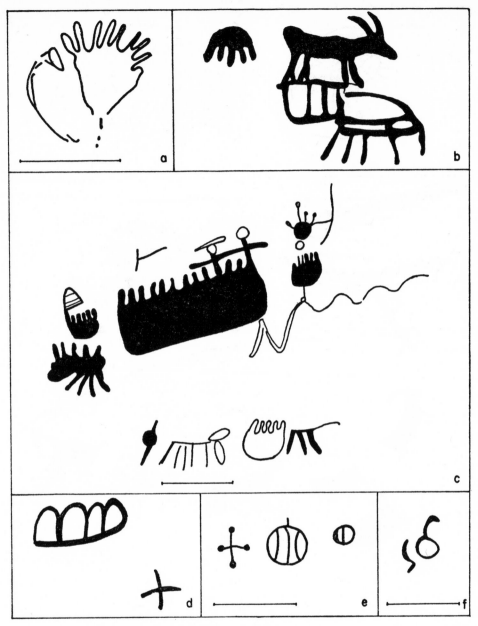

FIG. F-10. *a-f*, Iny-210.

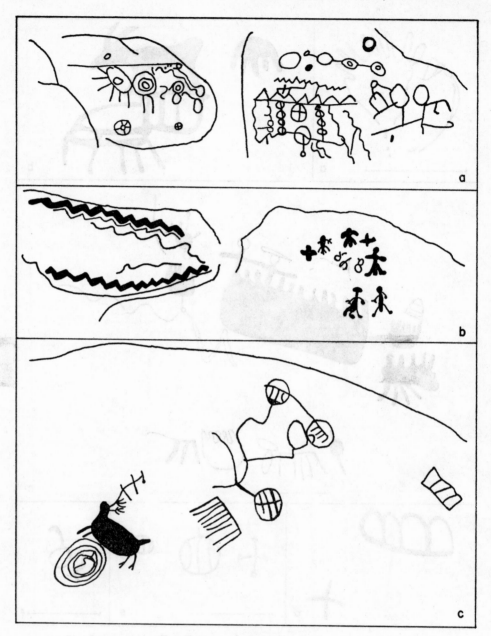

FIG. F-11. *a-b*, Iny-259; *c*, 265.

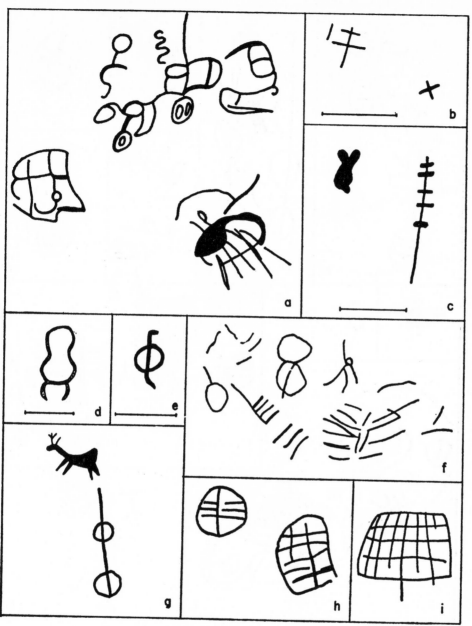

FIG. F-12. *a-e*, Iny-210; *f-i*, Iny-267.

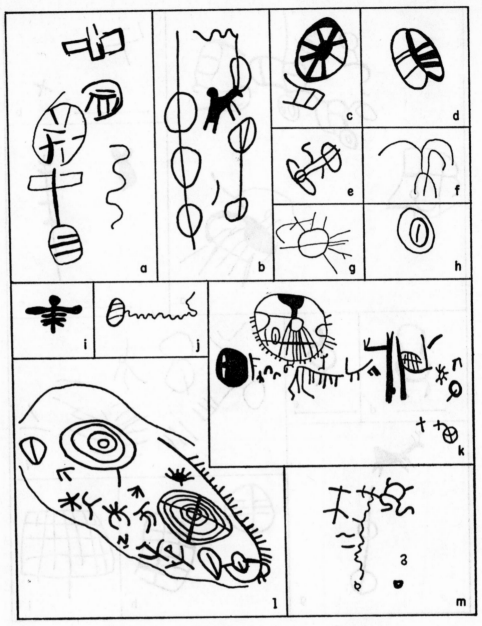

FIG. F-13. *a-j*, Iny-267; *k-l*, Iny-268; *m*, Iny-269.

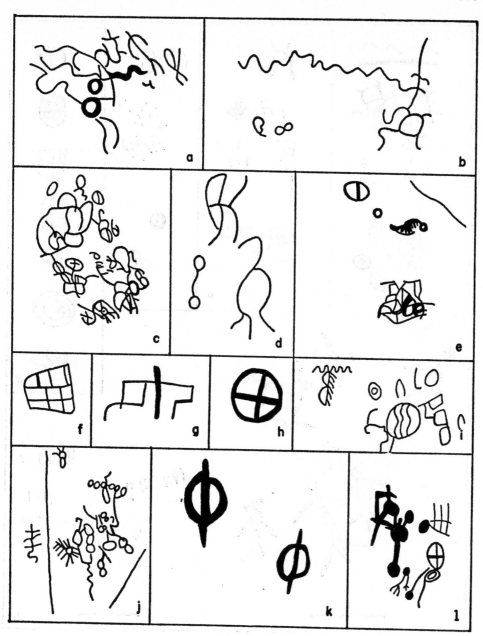

FIG. F-14. *a-l*, Iny-269.

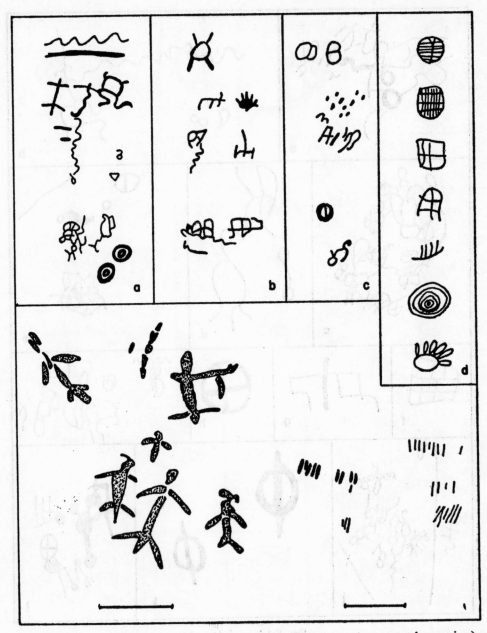

FIG. F-15. *a-c*, Iny-270 (*c* not natural grouping); *d*, Iny-279 (not natural grouping); *e*, Iny-430.

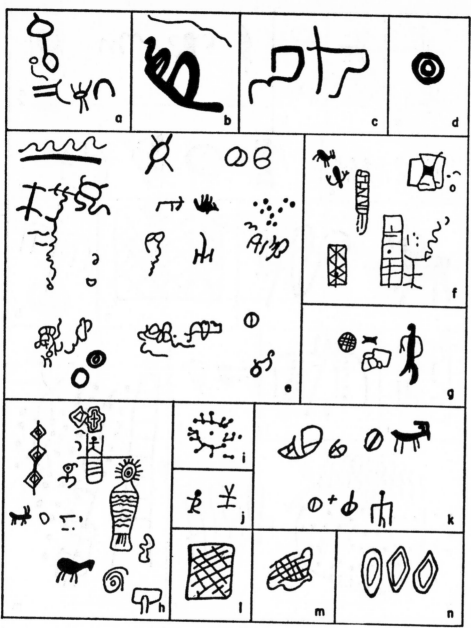

FIG. F-16. *a-e,* Iny-269 (*e* not natural grouping); *f-n,* Iny-271.

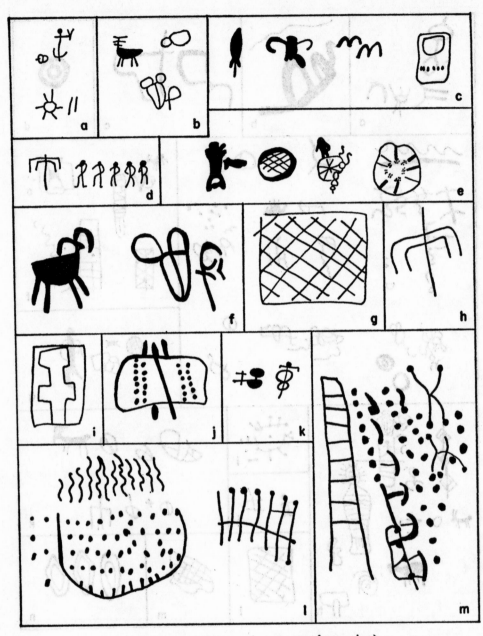

FIG. F-17. *a-m*, Iny-271 (*e* not natural grouping).

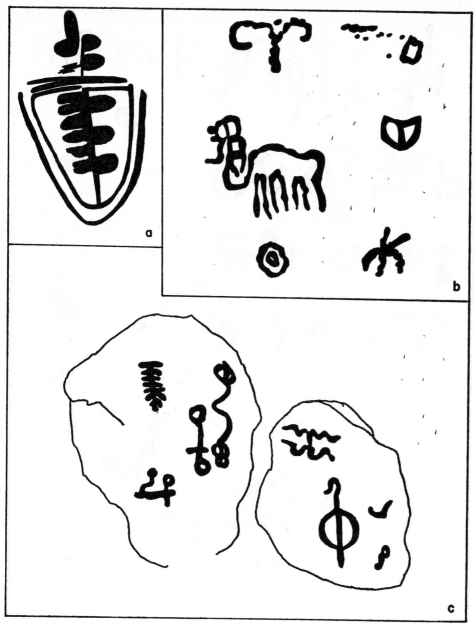

FIG. F-18. *a*, Iny-271; *b-c*, Iny-272.

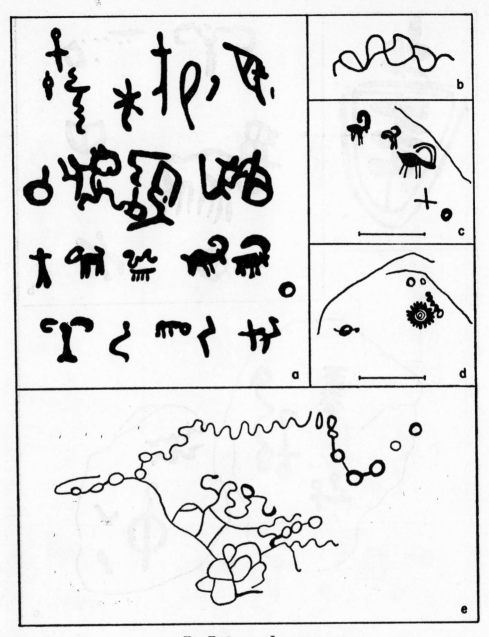

FIG. F-19. *a-e*, Iny-272.

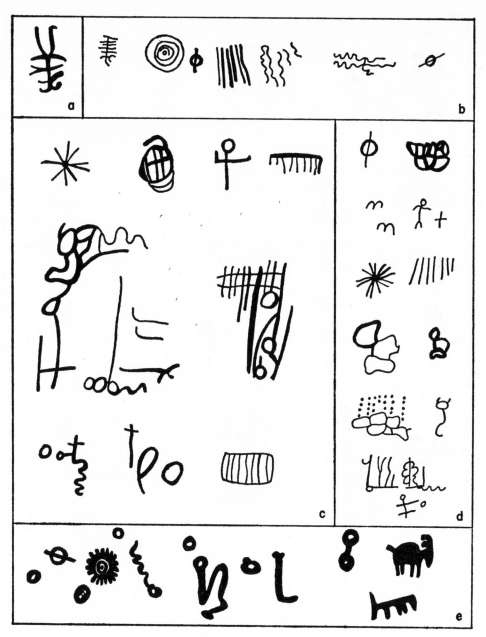

FIG. F-20. *a-e*, Iny-272 (*b-e* not natural grouping).

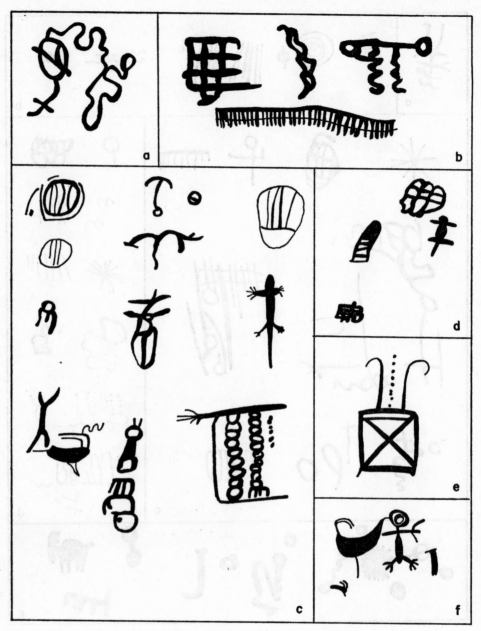

FIG. F-21. *a-b*, Iny-272; *c-f*, Iny-274 (*c* not natural grouping).

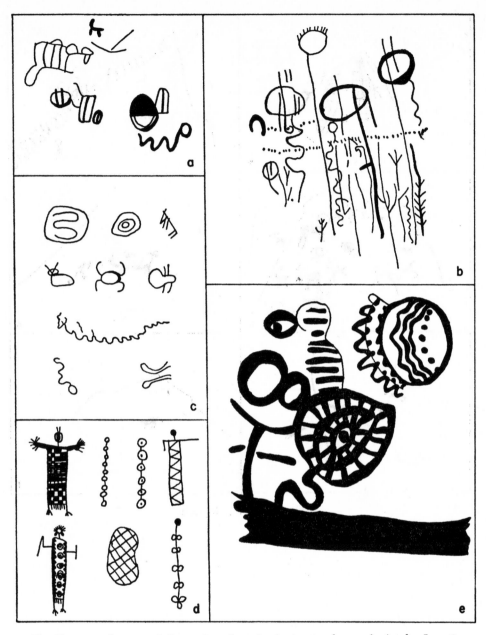

FIG. F-22. *a*, Iny-274; *b*, Iny-278; *c*, Iny-280 (not natural grouping); *d-e*, Iny-281 (*d* not natural grouping).

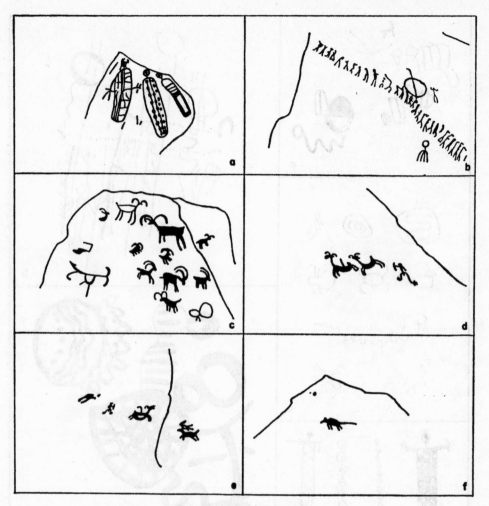

FIG. F-23. *a-f*, Iny-281.

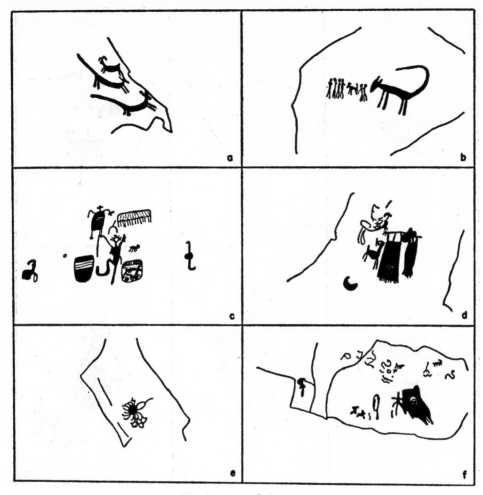

FIG. F-24. *a-f*, Iny-281.

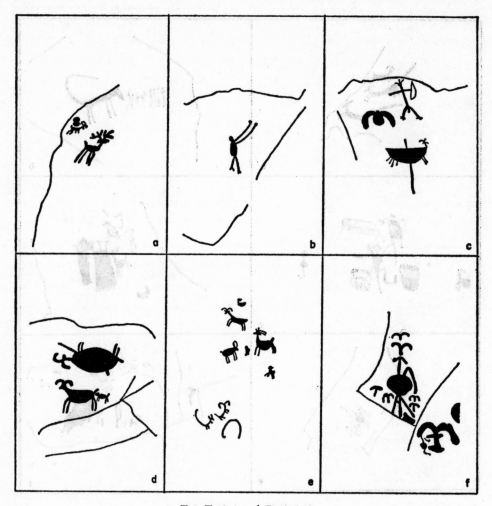

FIG. F-25. *a-f*, Iny-281.

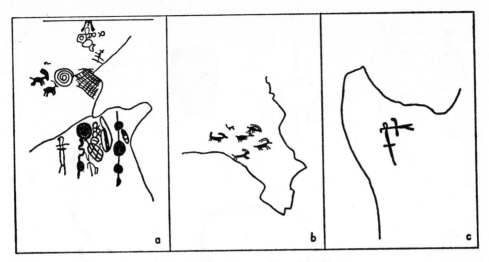

FIG. F-26. *a-c*, Iny-281.

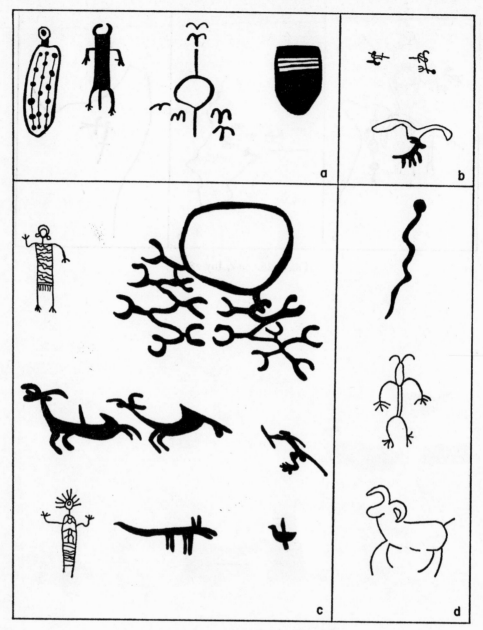

FIG. F-27. *a-d*, Iny-281 (not natural grouping).

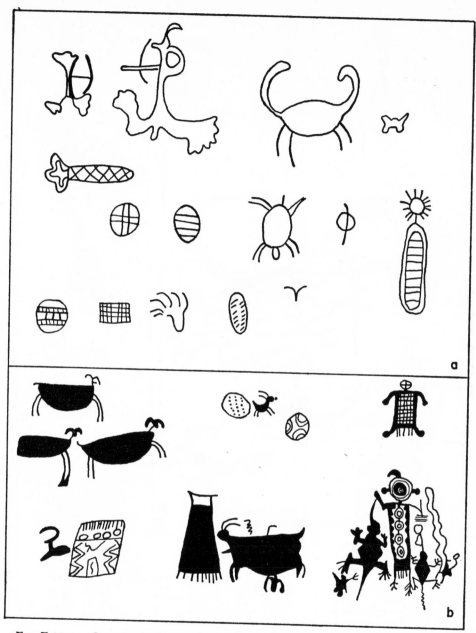

FIG. F-28. *a*, Iny-281 (not natural grouping); *b*, Iny-282 (not natural grouping).

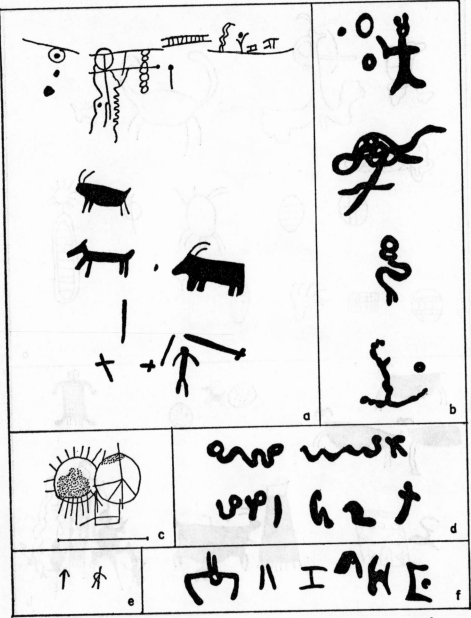

FIG. F-29. *a*, Iny-285 (not natural grouping); *b, d, f*, Iny-429 (*b* not natural group-
ing); *c, e*, Iny-428.

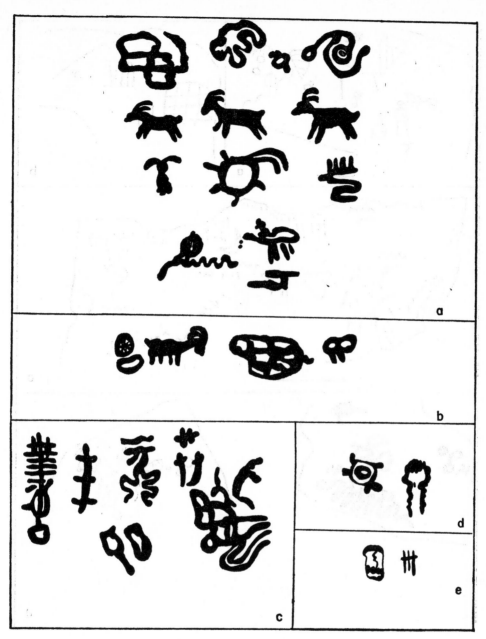

FIG. F-30. *a-e*, Iny-429.

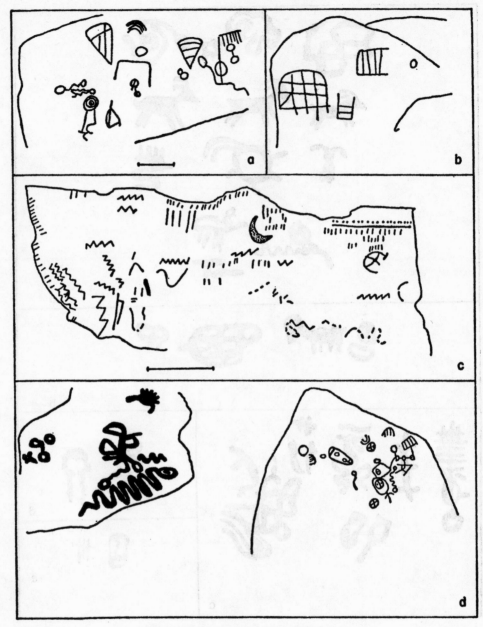

FIG. F-31. *a*, Plu-2; *b*, Las-32; *c*, Las-1; *d*, Las-32.

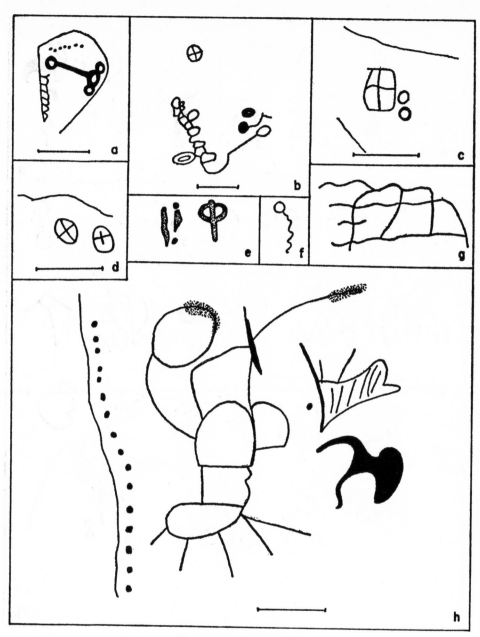

FIG. F-32. *a-h*, Las-32.

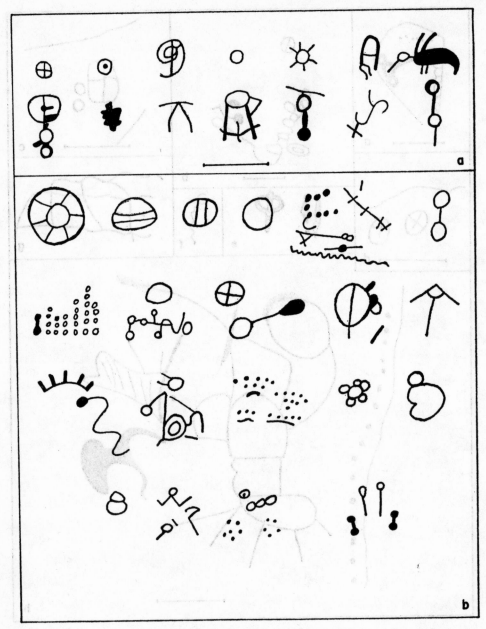

FIG. F-33. *a*, Las-38 (not natural grouping); *b*, Las-39 (not natural grouping).

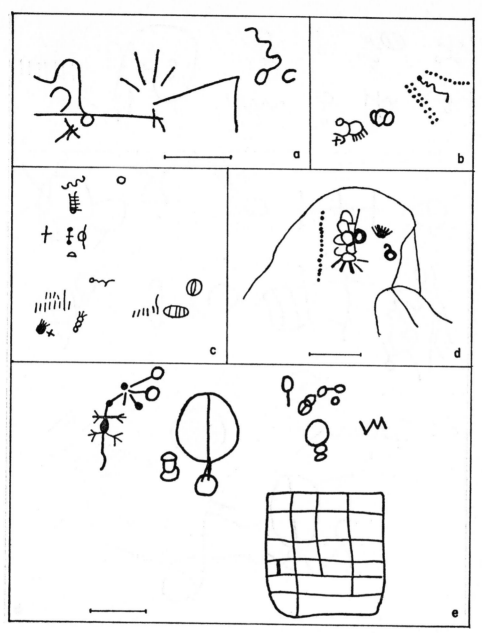

FIG. F-34. *a-c*, Las-39; *d*, Las-49; *e*, Las-57.

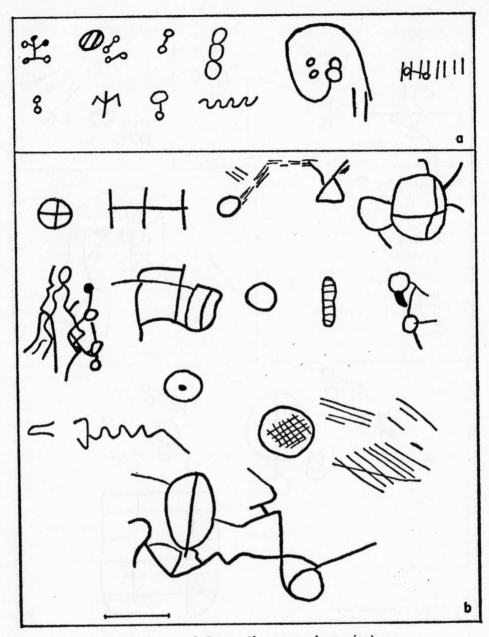

FIG. F-35. *a-b*, Las-57 (*b* not natural grouping).

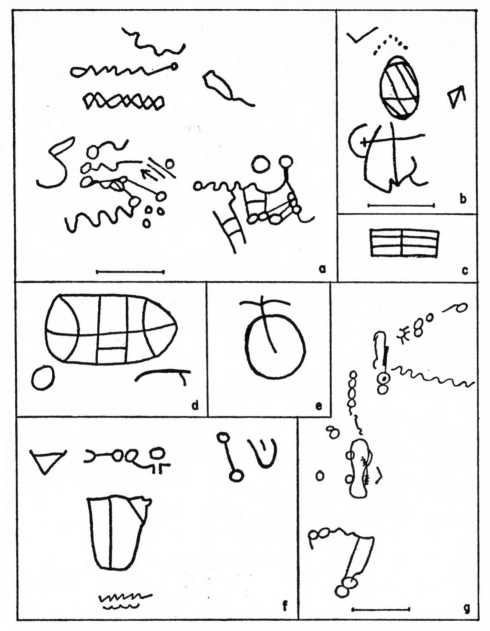

FIG. F-36. *a*, Las-61; *b-e*, *g*, Las-62; *f*, Las-63.

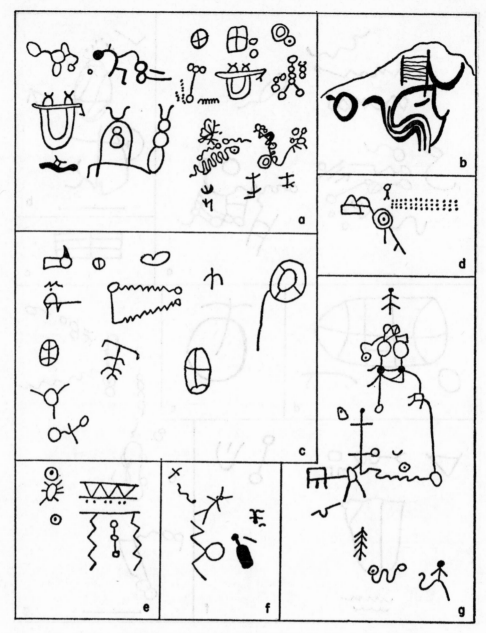

FIG. F-37. *a-b*, Las-76 (*a* not natural grouping); *c*, Las-77; *d-g*, Mod-19.

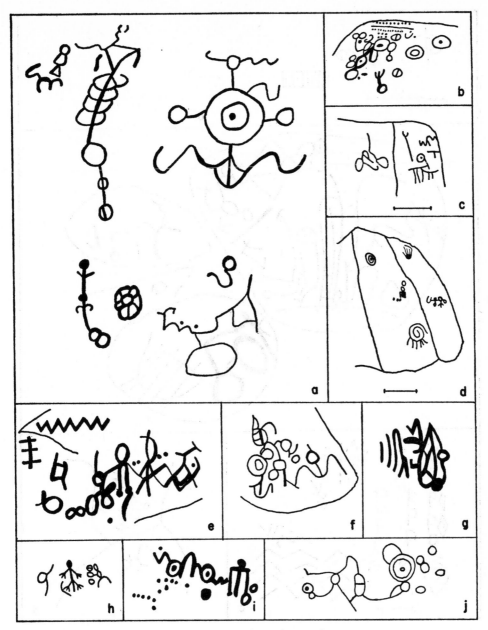

FIG. F-38. *a*, Mod-20; *b-j*, Mod-21.

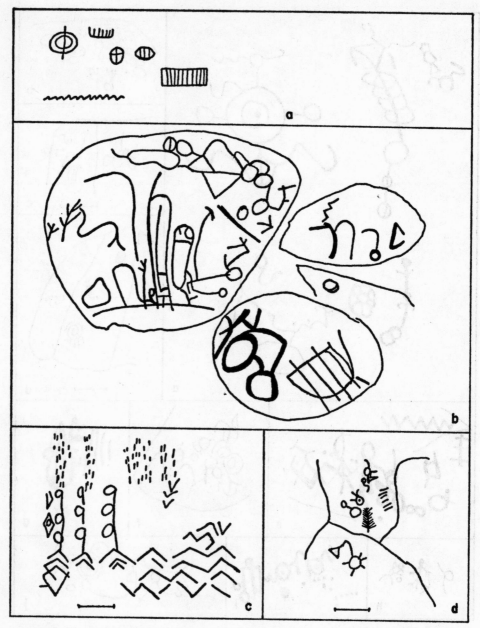

FIG. F-39. *a*, Mno-6 (not natural grouping); *b*, Mno-12; *c*, Mno-66; *d*, Mno-380.

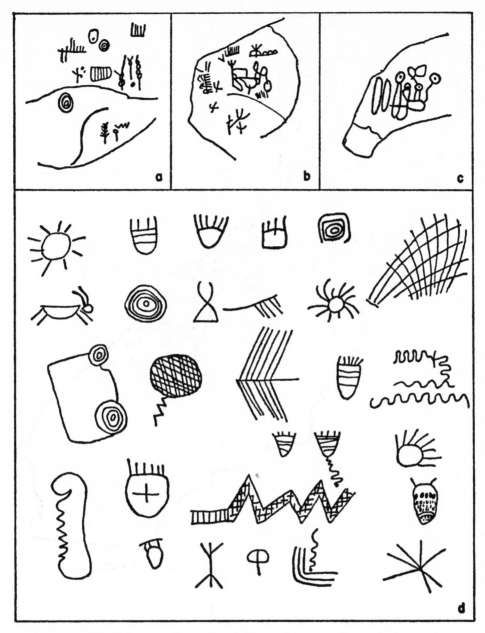

FIG. F-40. *a-c*, Mno-380; *d*, Pla-26 (not natural grouping).

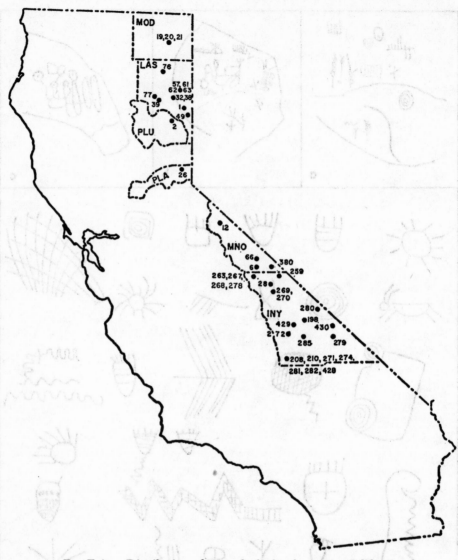

FIG. F-41. Distribution of petroglyph sites in eastern California.

APPENDIX G

Occurrence of Specific Elements at Nevada Petroglyph Sites

The following lists present detailed information on the numerical occurrence of specific elements at particular sites. Figure references are to illustrations in the text (pp. 000-000). In all, 58 elements are treated. Sites where the element occurs are indicated by an italicized county-site number designation. The number of times the element occurs at the site is then listed in parentheses, and this is in turn followed by a list of references to figures in the text where the element is illustrated. The symbol (P) indicates that the example or examples are painted; (S) indicates that the element is done in the scratched style. Figures referred to without special designation are understood to refer to Pecked figures. For the Lagomarsino site (St-1) we give only the total number of occurrences, since the full data for that site are given in Appendix D.

Each of the 58 elements is described in the main text (pp. 72-93).

1. *Circle* (443)
 Ch-3 (8): 33*c, e*; 34*g, h* (2); 35*f*; 40*a, j*. *Ch-55* (1): 41*b* (P). *Ch-57* (2): 41*s, w*. *Ch-71* (3): 43*m*; 44*d, e*. *Cl-1* (51): 46*b* (3); 47*a* (2); 48*a* (4), *b* (2); 49*b* (2), *d* (2), *f*; 50*a* (2), *c*; 51*d, e* (2); 52*a* (3); 54*d*; 55*l*; 56*a* (4); 57*a* (2), *d* (2), *j*; 58*a* (12); 59*c, f, l*. *Cl-2* (2): 100*i*; 101*u*. *Cl-3* (1): 60*j*. *Cl-4* (6): 61*b, d* (2), *e, f*; 62*a*. *Cl-7* (1): 65*a*.

Cl-9 (5): 65*g* (4); 68*a. Cl-123* (1): 66*b. Cl-131* (8): 68*e* (8). *Cl-145* (11): 69*a, c;* 70*a* (2); 71*a* (4); 73*e;* 75*a, d. Cl-146* (3): 77*d* (3). *Es-1* (1): 78*e. La-1* (18): 79*a* (3), *d* (12), *e* (2), *g. La-9* (5): 80*a, b* (4). *Ly-1* (31): 82*a, b, d, f, g;* 83*h;* 84*e* (4), *i, k* (5); 85*c, d, f;* 86*a, c;* 89*c;* 91*d, k;* 92*a, k* (2); 94*a* (2), *b, c. Ly-2* (11): 96*a* (7), *e, f, g, i. Ly-5* (3): 96*l* (3). *Ly-7* (16): 97*b* (2), *c* (2), *e* (6), *g, h, l* (3), *m. Mi-2* (1): 99*a. Mi-3* (2): 99*b* (2) (P). *Mi-4* (26): 99*c, g;* 100*c, d, e, h;* 101*c;* 102*a* (12), *b, c, d, g;* 103*d* (2), *h. Mi-5* (5): 104*b* (P), *d* (P), *f;* 105*c;* 106*a. Mi-13* (33): 107*e* (19) (P), *f* (5) (P), *g* (9) (P). *Mi-14* (2): 107*d* (2). *Ny-3* (18): 106*i* (4); 108*a* (8), *b* (2); 109*a* (2), *b* (2). *Ny-22* (6): 110*a* (6). *Pe-10* (4): 110*g;* 111*b* (2), *c. Pe-14* (1): 111*g. Pe-36* (4): 112*b* (4). *St-1* (35). *Wa-5* (13): 113*e, f* (4); 114*b* (3), *c, i* (2), *j* (2). *Wa-35* (11): 115*a, c, e* (2); 116*f, h;* 117*f, h, i, j, l. Wa-67* (1): 118*c* (P). *Wa-69* (71): 119*c, e* (2), *h, i* (4); 120*b* (4), *d, f, i* (2), *j* (2), *m, n* (2); 121*a* (2), *d* (2), *g* (2); 122*a* (2), *e, h* (3), *i* (2); 123*b, i;* 124*c* (7), *e* (3), *k;* 125*e* (3), *f* (2), *i* (14), *k;* 126*a* (2), *b. Wa-131* (2): 126*d, e. Wa-137* (2): 127*c, k. Wa-139* (8): 128*b* (8). *Wa-142* (7): 128*i;* 129*f* (3), *h* (3). *Wh-12* (2): 130*j* (P); 131*a* (P). *Wh-14* (1): 131*g* (P).

2. Concentric circles (139)

Ch-3 (2): 35*k;* 36*k. Ch-55* (1): 41*b* (P). *Ch-57* (2): 41*s* (2). *Cl-1* (23): 45*a* (2), *b* (5); 47*a;* 48*a* (2), *b* (3); 50*c;* 51*d;* 52*a* (2); 55*c;* 56*a* (2); 59*b, h, l. Cl-4* (1): 62*f. Cl-5* (2): 64*c, l. Cl-7* (1): 65*d. Cl-123* (3): 66*g,* 68*b* (2). *Cl-143* (2): 78*a* (2). *Cl-146* (1): 77*d. Hu-5* (1): 78*f. La-1* (11): 79*b* (P), *c* (2), *d* (2), *f* (5), *g. Ly-1* (6): 86*b;* 88*m, o;* 90*p;* 91*c;* 92*d. Ly-5* (2): 96*l* (2). *Ly-7* (8): 97*b* (3), *e;* 98*c, e, f* (2). *Mi-4* (22): 99*c* (3), *d, f, g;* 100*a* (2), *b, c* (3); 101 (5); 102*e, i* (2), *k;* 103*k. Mi-14* (4): 107*b* (3), *d. Ny-3* (2): 109*b* (2). *Ny-25* (1): 110*c. Pe-10* (3): 110*g;* 111*b, c. St-1* (18). *Wa-5* (7): 113*d, f* (4); 114*a, c. Wa-7* (1): 112*d. Wa-26* (1): 112*f. Wa-35* (2): 115*a, c. Wa-69* (9): 122*a, f, h;* 123*i;* 125*d, i* (3); 126*b. Wa-131* (1): 126*c. Wa-139* (1): 128*a. Wh-14* (2): 131*g* (2) (P).

3. Bisected circle (98)

Ch-3 (5): 35*e, i, n;* 36*n;* 37*d. Ch-55* (1): 41*b* (P). *Cl-1* (25): 45*b* (4); 50*a, c* (2); 51*a, e* (3); 52*g;* 53*c;* 54*a;* 56*a;* 57*f, g, j* (2); 58*a* (3), *c, f* (2); 59*h. Cl-2* (2): 132*l;* 133*a. Cl-4* (5): 61*d* (2), *e;* 62*a* (2). *Cl-5* (2): 64*h* (2). *Cl-7* (1): 65*d. Cl-123* (5): 65*l;* 66*c, d;* 67*d;* 68*b. Cl-145* (5): 69*b;* 73*f;* 74*c;* 75*a, d. La-9* (4): 79*h, i;* 80*c* (2). *Li-1* (1): 81*b. Ly-1* (7): 82*l;* 83*a;* 84*k;* 89*b;* 90*o;* 91*a, l. Ly-2* (3): 96*b, d, i. Ly-7* (1): 98*i. Mi-4* (8): 99*c;* 100*a, d, h, i;* 102*h* (2), *i. Mi-5* (1): 106*a* (P). *Mi-13* (1): 107*e* (P). *Ny-3* (4): 108*a;* 109*b* (3). *Pe-10* (3): 110*h, i* (2). *Pe-14* (2): 11*h* (2). *Wa-35* (4): 115*a;* 116*b,* 117*h, j. Wa-69* (5): 119*h;* 120*f;* 124*b, e;* 125*i. Wa-131* (2): 126*c* (2). *Wa-137* (1): 127*h.*

4. *Sectioned circle* (8)

Mi-4 (4): 100*a;* 102*h, i;* 103*d. Mi-5* (2): 103*r;* 105*c. Wa-69* (2): 120; 125*i.*

5. *Spoked circle* (11)

Li-1 (1): 81*b. Ly-1* (2): 87*l;* 93*j. Ly-7* (1): 97*a. Mi-4* (2): 102*h, i. Wa-68* (1): 118*e. Wa-69* (3): 120*h;* 121*e;* 123*e. Wa-142* (1): 129*f.*

6. *Spoked concentric circles* (17)

Ch-20 (1): 42*h. Cl-1* (8): 45*b* (2); 46*a* (2); 52*a* (4). *La-9* (1): 80*a. Mi-2* (1): 98*l. Mi-4* (3): 100*c, f;* 102*j. Mi-5* (1): 105*b. Wa-29* (1): 112*g. Wa-69* (1): 125*b.*

7. *Tailed circle* (163)

Ch-3 (2): 40*b, d. Ch-16* (4): 42*a* (2), *e* (2). *Ch-49* (1): 41*m* (P). *Cl-1* (1): 59*o. Cl-2* (2): 100*j;* 101*a. Cl-3* (2): 60*j, m. Cl-4* (3): 63*a* (3). *Cl-7* (3): 65*f* (3). *Cl-123* (2): 66*e;* 67*f. Cl-131* (2): 68*e* (2). *Cl-145* (6): 71*a;* 72*b;* 73*f;* 75*a, d;* 76*b. La-1* (1): 79*e* (P). *La-9* (3): 79*h;* 80*b* (2). *Li-1* (1): 81*b. Ly-1* (26): 82*b, f, g;* 84*g;* 85*c* (2); 86*c, d;* 87*k* (3); 89*e;* 90*a* (4), *e, h;* 91*l;* 92*l;* 93*h;* 94*a, g, h, i* (2). *Ly-2* (4): 96*a, b, h, k. Ly-7* (6): 97*a, b* (2), *h;* 98*h* (2). *Mi-2* (2): 99*a* (2). *Mi-4* (9): 99*f, g;* 100*c, d;* 102*a, c, h, i;* 103*h. Ny-3* (3): 106*i;* 108*a, b. Pe-10* (3): 110*h* (3). *Pe-14* (1): 111*g. St-1* (21). *Wa-5* (8): 113*a, e, f* (4); 114*e, i. Wa-26* (4): 102*f* (4). *Wa-35* (5): 105*a, h* (2); 106*f* (2). *Wa-69* (31): 119*c* (4), *i* (2); 120*e, i, j, n;* 121*b, e, f* (2), *g* (4); 122*a* (2); 123*i* (2); 124*i* (4); 125*g, j, k* (3). *Wa-131* (2): 126*c* (2). *Wa-137* (1): 127*i. Wa-139* (1): 128*a. Wa-142* (5): 128*j;* 129*f, g* (2), *h. Wh-14* (1): 131*g* (P).

8. *Circle and dot* (60)

Ch-3 (2): 7*c;* 35*k. Ch-55* (1): 41*j* (P). *Ch-57* (2): 41*w, x. Ch-71* (2): 43*b;* 44*h. Cl-1* (5): 52*a;* 59*l* (2), *o* (2). *Cl-2* (1): 100*e. Cl-4* (2): 62*f;* 63*a. Cl-131* (2): 68*e* (2). *Cl-145* (2): 72*a;* 75*a. La-1* (3): 79*e, f, g. Ly-1* (14): 85*e;* 86*f* (2); 87*j, q;* 88*r;* 89*c* (5); 90*m, p;* 91*r. Ly-2* (1): 96*c. Ly-7* (2): 97*b, i. Mi-2* (1): 99*a. Mi-4* (6): 100*a* (2), *d* (3); 102*a. Ny-22* (3): 110*a* (3). *Wa-5* (1): 114*b. Wa-35* (3): 116*b* (2), *c. Wa-68* (1): 118*e. Wa-69* (5): 122*e, h;* 124*b, g, i. Wa-131* (1): 126*c.*

9. *Circle cluster* (28)

Ch-3 (2): 36*a;* 40*f. Cl-3* (1): 60*o. Cl-4* (1): 61*b. Cl-5* (1): 63*g. Cl-123* (2): 66*b;* 68*b. Cl-145* (4): 72*a;* 75*c* (3). *Ly-1* (5): 82*l;* 85*g;* 86*e, h;* 93*i. Mi-4* (2): 100*b, i. Pe-10* (3): 110*h* (2), *i. Wa-5* (1): 115*d. Wa-29* (2): 118*b* (2). *Wa-69* (4): 111*g;* 122*i;* 123*b, h.*

10. *Connected circles* (130)

Ch-3 (11): 33*d;* 34*e;* 35*e;* 36*m;* 39*e;* 40*a, b, d, h, i, k. Ch-71* (1): 43*d. Cl-1* (18): 45*b* (2); 50*a, c;* 51*c, e, h* (2); 54*d* (9); 58*b. Cl-2* (6): 100*c* (3), *d, i;* 101*a. Cl-4* (2): 62*a* (2). *Cl-5* (2): 64*f* (2). *Cl-7* (2):

65c, f. Cl-9 (1): 68a. Cl-123 (3): 67a, c, f. Cl-145 (8): 71a (2); 72a, b; 73e (2); 74d; 75a. Hu-5 (1): 78f. La-1 (4): 79a, c, d (2). La-9 (1): 80b. Ly-1 (11): 83h, i; 85g; 86c, i; 87d; 88b; 89a; 90f; 91l; 93j. Ly-2 (7): 96a, d (2), g (2), h, k. Ly-7 (3): 97b, g; 98i. Mi-2 (1): 99a. Mi-4 (4): 99h; 100a; 102i; 103m. Mi-13 (1): 107g (P). Ny-2 (3): 106f (3). Pe-10 (1): 110h. Pe-14 (4): 111g (2), h, i. Pe-36 (4): 112b (4). Pe-59 (1): 112c. St-1 (23). Wa-5 (9): 113a, e, f (3); 114i, j (3). Wa-7 (1): 112e. Wa-29 (1): 112g. Wa-69 (11): 120e, n; 121c, g (2); 123d, i (2); 124c (2), g. Wa-131 (3): 126c (2), f. Wa-139 (1): 127a. Wa-142 (4): 128g; 129a (2), d. Wh-11 (1): 130k (P).

11. Chain of circles (122)

Ch-3 (16): 33a, b (2), c; 34a, b, c, e (3); 35m; 36h, i; 37j; 38c; 39d. Ch-16 (1): 42f. Cl-1 (9): 49d; 50c; 51d; 52a; 55e, 57i; 58b; 59k (2). Cl-3 (2): 60p, s. Cl-4 (5): 61d; 62a (4). Cl-123 (3): 65k; 66e (2). Cl-124 (1): 68d. Cl-145 (9): 69b (2); 71b; 72a; 73e; 75a (2), b; 76e. La-1 (3): 79d (2) (P), f (P). La-9 (1): 79i. Ly-1 (15): 82g; 83a (2), d, i; 84j, k; 85c; 86b, c (2); 87b; 88b; 89g; 95c. Ly-2 (3): 96d, f, i. Ly-5 (2): 96l (2). Ly-7 (7): 96m; 97a (2), e, g, l (2). Mi-4 (13): 99c; 100a (2), e, h (2); 101 (6); 103n. Ny-3 (1): 108a. Pe-10 (5): 110h (2); 111c, f (2). St-1 (4). Wa-5 (8): 113f (6); 114a (2). Wa-29 (1): 118a. Wa-35 (1): 115a. Wa-69 (8): 120h; 121f (3); 123c, f, i; 125g. Wa-131 (1): 126c. Wa-137 (2): 127c, d. Wh-14 (1): 131g.

12. Sun disc (100)

Ch-3 (4): 34b; 36b; 39d (2). Ch-55 (2): 41b (P), m (P). Ch-71 (1): 42c. Cl-1 (7): 46b; 47a (2); 52a; 55a, m. Cl-2 (6): 132b (3), j (3). Cl-5 (1): 63h. Cl-123 (1): 66e. Cl-131 (3): 68e (3). Cl-145 (5): 69b, d; 74a; 75a (2). Hu-5 (1): 78f. La-1 (1): 79e. La-9 (1): 80a. Ly-1 (9): 82d; 85c, f; 86b; 88d; 90n; 91f; 92k, l. Ly-7 (2): 97c (2). Mi-3 (1): 99b (P). Mi-4 (17): 99c, e; 100a, f, h (5); 101 (3); 102b (2), c, e; 103f. Mi-5 (3): 103o (S), q (S); 105d (S). St-1 (15). Wa-29 (1): 112g. Wa-35 (4): 115a (2), e; 116b. Wa-68 (1): 118e. Wa-69 (9): 119d, e, h; 120n; 122h (3); 124j; 125e. Wa-142 (3): 129d, h (2). Wh-11 (2): 130k (2) (P). Wh-14 (1): 131g (P).

13. Spiral (41)

Ch-3 (1): 39g. Ch-71 (1): 43c. Cl-1 (3): 49c; 52a; 57j. Cl-5 (3): 64a, d, j. Cl-145 (6): 70a; 74c, d; 75a (2), c. Cl-146 (6): 77d (6). Hu-5 (1): 78f. Li-5 (1): 81h (P). Ly-1 (8): 84c, g, j; 86a, b (2), d; 87h. Ly-5 (4): 96l (4). Ly-7 (1): 97b. Mi-4 (1): 99c. Ny-2 (2): 106i (2). St-1 (3). Wa-5 (1): 133f. Wh-14 (1): 131g (P).

14. Curvilinear meander (443)

Ch-3 (37): 33a (2); 34j, m, n, o; 35d, g (2), m; 36b, c, g (2), i, l, m, o, p; 37a, b, d, e, j (2); 38a (2), b, d; 39d (2), l, m; 40a, c, f, k.

Ch-16 (5): 42*a* (3), *b*, *c*. *Ch-20* (2): 42*g*, *h*. *Ch-57* (1): 42*s*. *Ch-71* (12): 43*h*, *k*, *m*; 44*a*, *c*, *d*, *h*, *j*; 60*a*, *b*, *c*, *d*. *Ch-95* (2): 60*e* (2) (P). *Cl-1* (75): 45*a* (2), *b* (5); 48*a* (7), *b*; 49*c* (3), *d* (4), *e* (4); 50*a*, *b* (6), *c*; 51*a*, *e*, *f* (3), *g* (2), *l* (2); 52*a* (6), *d*, *g*, *h*; 53*a* (3); 54*a*, *b* (3); 55*e*; 57*d* (2), *i*, *j* (2); 58*f*; 59*b*, *e*, *n*, *o*. *Cl-2* (4): 132*b*, *e*, *m*; 133*a*. *Cl-3* (4): 60*g*, *j*, *k*, *t*. *Cl-4* (2): 61*c*, *f*. *Cl-7* (1): 65*e*. *Cl-143* (3): 78*a* (3). *Cl-145* (5): 71*b*; 72*a*; 75*b*; 77*b*. *Es-1* (1): 78*e*. *La-1* (5): 79*a* (4), *d*. *La-9* (3): 79*i*; 80*b*, *f* (S). *Li-3* (2): 81*c* (P), *d* (P). *Ly-1* (82): 82*b*, *e* (2), *f*; 83*b*, *d*, *f*, *g*, *h*, *j*; 84*f*, *g*, *h*, *j*, *k* (4); 85*c*, *d*, *e*; 86*a*, *b*, *c* (2), *d*, *e*; 87*e*, *h*, *i*, *j*; 88*c*, *f*, *g*, *h*, *k*, *l*, *n*, *q*; 89*a* (2), *b*, *d*, *e*, *f*, *g*; 90*d*, *j*, *l*, *m*, *s*, *t*; 91*a*, *b*, *c*, *d*, *g*, *h*, *k*, *l*; 92*a*, *b*, *c*, *f*, *g*, *i*, *j*, *k*, (5); 93*d*, *g*, *i*, *l* (2); 94*c*, *e*, *g*, *i*; 95*f*. *Ly-2* (4): 96*a*, *e*, *g*, *j*. *Ly-7* (10): 96*m* (2); 97*a*, *d*, *e*, *f*, *i*, *m*; 98*a*, *b*. *Mi-2* (2): 98*m*; 99*a*. *Mi-3* (1): 99*b* (P). *Mi-4* (19): 99*c*, *g*; 100*a*, *b*, *d*, *e*, *f*, *g* (2), *h*; 101; 102*a*, *f*, *g*, *h*, *j* (3); 103*l*. *Mi-5* (5): 104*h*; 105*a*, *b*, *c* (2). *Ny-2* (1): 106*f*. *Ny-3* (6): 108*a*, (2); 109*b* (4). *Ny-25* (2): 110*b*, *c*. *Ny-29* (1): 110*d*. *Ny-44* (1): 110*f*. *Pe-10* (9): 110*g*, *i*; 111*a*, *b* (2), *d*, *f* (3). *Pe-14* (1): 111*i*. *Pe-36* (1): 112*b*. *St-1* (13). *Wa-5* (13): 113*d*, *f* (2); 114*a* (2), *b*, *d*, *e*, *i* (4), *j*. *Wa-7* (1): 112*e*. *Wa-29* (1): 112*g*. *Wa-35* (13): 115*a*; 116*a*, *b* (2), *h* (2); 117*b* (2), *c*, *d*, *h*, *j*, *k*. *Wa-68* (2): 118*d*, *e*. *Wa-69* (70): 119*b*, *d*; 120*a*, *d*, *e* (2), *h* (2), *i*, *m* (2), *n* (2); 121*a*, *b* (3), *c*, *d*, *e*, *g*, (3), *i*; 122*a*, *c* (4), *g* (5), *h* (4), *i* (5); 123*a* (2), *c*, *d*, *e*, *f*, *g*, *h*; 124*a*, *c*, *e*, (3), *h*, *k*; 125*b*, *d*, *e* (4), *g*, *h*, *k* (2); 126*a* (2). *Wa-131* (5): 126*d* (2), *e*, *f*, *g*. *Wa-135* (1): 127*b*. *Wa-137* (5): 127*c* (2), *e*, *f*, *h*. *Wa-142* (6): 128*g* (2), *h*; 129*h* (2), *j*. *Wh-3* (1): 130*g* (P). *Wh-11* (1): 130*k* (P). *Wh-12* (1): 131*a* (P). *Wh-14* (1): 131*g* (P).

15. *Convoluted rake* (11)

Ch-3 (7): 36*a*, *e* (2); 37*c*, *g*; 39*h*; 40*b*. *Ch-71* (1): 43*l*. *Mi-5* (1): 106*a* (P). *Wa-142* (1): 129*d*. *Wh-14* (1): 131*g* (P).

16. *Connected dots* (22)

Cl-143 (1): 78*a*. *La-1* (1): 79*f* (P). *Ly-1* (8): 83*h*; 85*c*, *d*; 86*a*, *b*, *h*, *j*; 88*b*. *Mi-4* (1): 100*f*. *Ny-2* (4): 106*f* (4). *Wa-69* (1): 124*g*. *Wa-142* (6): 129*h* (6).

17. *Dumbbell* (6)

Cl-1 (4): 47*c*; 58*a* (3). *Ly-1* (2): 87*d*, 94*j*.

18. *Dots or dot design* (199)

Ch-3 (1): 35*b*. *Ch-55* (2): 41*b* (P), *r* (P). *Ch-71* (1): 43*k*. *Cl-1* (21): 45*b* (2); 49*c* (3); 50*a*; 51*d*, *f* (4); 52*a*, *h*; 53*b* (3); 55*h*, *k*; 56*a*; 57*c*, *i*. *Cl-4* (13): 61*e* (5); 62*a* (3), *f* (4); 63*a*. *Cl-5* (1): 63*i*. *Cl-7* (1): 65*e*. *Cl-123* (1): 65*k*. *Cl-124* (1): 68*c*. *Cl-131* (2): 68*e* (2). *Cl-145* (14): 70*a* (3); 73*e*, *f* (3); 74*a*, *c* (3); 75*b*; 76*b*, *e*. *La-1* (1): 79*b* (P). *Ly-1* (19): 82*a*; 83*c*, *e*; 85*c*, *d*; 86*a*, *b*, *i*, *j*; 87*f*; 89*d* (2); 90*m*; 91*k*, *l*, *m*;

92a, l; 95b (S). Ly-2 (4): 96g (4). Mi-4 (11): 99c; 100h (3); 102a (3), b, c (2), g. St-1 (36). Wa-5 (1): 114d. Wa-35 (2): 116a; 117f. Wa-69 (56): 119a, d, h (2), i (4); 120c (2), e, h, i; 121d, e (2), i (2); 122e (3), f (3); 123a, b, e (6), g (6); 124g, i; 125a, c (2), e (11), f; 126a. Wa-131 (1): 126c. Wa-137 (1): 127h. Wa-139 (2): 127a; 128a. Wa-142 (7): 129a, b (2), c (2), h (2).

19. *Wavy lines* (388)

Ch-3 (14): 33b; 34n; 35e; 36c; 37f, j; 38b; 39n; 40e, g (3), i, j. Ch-26 (1): 42j. Ch-49 (1): 42k. Ch-57 (1): 41v. Ch-71 (4): 43b, d, k; 44i. Cl-1 (56): 45b (8); 47a; 48a; 49b; 50a, c (6); 51a, d, e (3), g (2), m; 52a (9); 53b (3); 54a, d (5); 55c (2), j, k; 56a; 58a (2), b (2); 59h, j, p. Cl-2 (1): 100e. Cl-3 (1): 60r. Cl-4 (7): 61d, e, f; 62a (3), f. Cl-5 (2): 64e, f. Cl-7 (3): 65e (3). Cl-9 (3): 68a. Cl-123 (10): 65j, k; 66e (2), g (2); 67d, e, h; 68b. Cl-124 (1): 68d. Cl-131 (10): 68e (10). Cl-143 (4): 78a (4). Cl-145 (31): 70a (3); 71a (10), b (2); 72b (2); 73e; 74c (4), d (3); 75a (2), b, d (2); 76e (2). Es-1 (2): 78e (2). Hu-5 (2): 78f (2). La-1 (1): 79d. La-9 (12): 79i (2); 80a, e (4) (S), f (3) (S), g (S), i. Li-1 (1): 81b. Li-3 (2): 81f (2). Ly-1 (34): 82a, g; 83a (2), j; 84f (3), k; 85d, e (2); 87h (2), l; 88a (2), b, l; 89c, d; 91a (2), l; 92e (S), l; 93c (2), f, g; 94b (2); 95d, f. Ly-2 (2): 96e, h. Ly-5 (4): 96l (4). Ly-7 (6): 97c (2), m; 98d, e (2). Mi-4 (45): 99c (5), e, f (6), g; 100a (4), d, e, g (2), h (2); 101 (18); 102b, i; 103c (2). Mi-5 (1): 106b. Mi-14 (1): 107b. Ny-2 (3): 106f (2), h. Ny-3 (15): 106i (3); 180a (6), b; 109a (3), b (2). Ny-25 (1): 110c. Ny-29 (2): 110d (2). Pe-10 (3): 110h (2); 111c. Pe-14 (1): 111g. Pe-36 (1): 112b. St-1 (41). Wa-5 (4): 113a (2); 114j (2). Wa-26 (1): 112f. Wa-29 (1): 118a. Wa-35 (3): 115c; 116a, c. Wa-69 (43): 119b, c (2), d, i (9); 120b (3), j, l (8), m (2); 121d (2), h (2); 123c, e, f; 124k; 125f (2), i, k; 126a, b (2). Wa-137 (5): 127j (4), k. Wa-139 (1): 128e. Wh-11 (1): 130k (P).

20. *Deer hoof* (34)

Ch-57 (5): 41x (5). Es-1 (1): 78e. La-1 (1): 79d. La-9 (28): 79h (6); 80b (11), c (2), d (4). Ly-1 (2): 84f; 94d. Mi-4 (2): 100c; 103a.

21. *Oval grid* (65)

Cl-1 (8): 50b, c; 52h; 53i; 55e, i, k; 57i. Cl-3 (1): 60r. Cl-4 (3): 61d, e; 62a. Cl-7 (1): 65c. Cl-123 (4): 65h, i; 66e; 67c. Cl-131 (2): 68e (2). Cl-145 (3): 70b; 71a; 74c. La-1 (1): 79e (P). La-9 (2): 79h; 80d. Ly-1 (7): 82a; 83a (2); 87p; 88a; 92k; 93a. Ly-2 (1): 96g. Ly-7 (1): 97e. Mi-4 (5): 99c, f; 100a; 102c; 103g. Mi-5 (1): 106a (P). Ny-3 (1): 108a. Ny-25 (1): 110c. Pe-14 (1): 111h. St-1 (5). Wa-5 (5): 113d; 114c; 117b, h, k. Wa-7 (1): 112d. Wa-29 (1): 118a. Wa-69 (8): 119h; 120f (2); 121g (2); 122i; 123b; 124k. Wa-131 (1): 126e. Wh-3 (1): 130f (P).

22. *Rectangular grid* (106)

Ch-3 (4): 35e, k, n; 36b. Ch-16 (1): 42a. Ch-57 (4): 41s (3), x. Ch-71 (1): 44k. Cl-1 (10): 45b (2); 46a; 52c, f; 53b; 54d; 58c; 59d, l. Cl-2 (7): 100e, g, h, l (3); 101d. Cl-3 (1): 60u. Cl-4 (3): 61e; 62a (2). Cl-5 (1): 63f. Cl-123 (1): 65i. Cl-131 (6): 68e (6). Cl-145 (3): 71a; 74c (2). La-9 (1): 80a. Ly-1 (10): 85f; 87n; 89c, f; 92k; 93d, j, k; 94j; 95j. Ly-7 (3): 97n (3). Mi-4 (8): 99f; 100e, h (2), i; 101; 102b, j. Mi-13 (2): 107f (2) (P). St-1 (19). Wa-5 (3): 113f (2); 114c. Wa-29 (1): 118a. Wa-35 (4): 115b; 116g; 117j (2). Wa-69 (11): 119i; 120n (2); 121a, i; 122i; 124d (2), g (3). Wh-3 (2): 130a (2) (P).

23. *Blocked oval* (15)

Cl-123 (13): 65h (6), i, j, k (5). St-1 (2).

24. *Cross* (51)

Cl-1 (20): 45a, b (2); 49c, d (2); 50a (3), c; 51g, n; 52h; 54a; 55g, h, k; 56a; 58c; 59p. Cl-2 (1): 100g. Cl-4 (1): 61d. Cl-5 (4): 63f; 65d (3). Cl-131 (4): 68e (4). Cl-145 (3): 69b (2); 70a. La-1 (5): 79b (3), c (2). Ly-1 (3): 84j; 89a, g. Ny-3 (3): 106i; 108b (2). Wa-5 (1): 114b. Wa-69 (5): 119c; 123c; 124k; 125g; 126b. Wa-137 (1): 127i.

25. *Bird tracks* (35)

Ch-3 (8): 33l; 34d (2); 35l; 36d; 37h; 38e; 40c. Ch-55 (1): 41b (P). Cl-1 (6): 48a; 50a; 52h; 53b; 59i, q. Cl-145 (4): 71b; 72a; 75a; 76e. La-9 (3): 80d (3). Ly-1 (3): 87h; 89g; 92l. Ly-7 (2): 97b; 98j. Mi-4 (1): 100c. St-1 (16). Wa-5 (2): 113f (2). Wa-26 (1): 112f. Wa-35 (1): 115c. Wa-69 (3): 125a, d (2).

26. *Parallel straight lines* (117)

Ch-3 (1): 34c. Ch-16 (1): 42a. Ch-71 (1): 44a. Cl-1 (8): 45b; 50c; 51a; 55i; 56a; 57a; 59b, l. Cl-2 (1): 100g. Cl-4 (2): 61d; 62f. Cl-9 (2): 68a (2). Cl-123 (3): 66h (3). Cl-131 (1): 68e. Cl-145 (4): 71a; 73a, c; 76b. Hu-5 (1): 78f. La-1 (10): 79c (2), d (2), e (4), f, g. La-9 (14): 79h, i (2); 80a (7), b, d, e (S); 81a (S). Li-3 (1): 81e (P). Ly-1 (12): 85c; 87e, j, m; 88i, k; 89g; 91b, e, k; 92h; 95j. Ly-2 (1): 96f. Ly-7 (1): 97k. Mi-2 (1): 99a. Mi-3 (1): 99b. Mi-4 (4): 100f; 101; 102a (2). Mi-5 (9): 102o (S); 104a (S), b (P), h (P); 105a (2) (S), d (3) (S). Mi-13 (22): 107e (5) (P), f (13) (P), g (4) (P). Ny-3 (5): 109a, b (4). Pe-14 (1): 111i. St-1 (15). Wa-5 (1): 114j. Wa-35 (2): 115a; 117k. Wa-68 (1): 118e. Wa-69 (21): 119a, i; 120a, i, j; 121b (3), d, f, h; 122a, d, e (2), f; 123a, f (2); 125i, k. Wa-137 (1): 127h. Wh-3 (1): 130a. Wh-11 (1): 130k. Wh-14 (9): 131g (P). Wh-15 (1): 131h (P).

27. *Triangles* (19)

Ch-3 (2): 33h; 35c. Cl-1 (1): 58c. Cl-145 (1): 74d. Ly-1 (8): 93e (3);

i (3); 95*c, i. Mi-4* (2): 100*d, i. St-1* (1). *Wa-35* (2): 117*a, c. Wa-68* (1): 118*e. Wa-69* (1): 125*b.*

28. *Lozenge chain* (5)

 Ch-55 (1): 41*e* (P). *Cl-2* (1): 133*d. Cl-145* (1): 77*c. Ly-1* (2): 83*e*; 84*a.*

29. *Zigzag lines* (53)

 Ch-3 (7): 33*n*; 35*e* (2); 36*h*; 38*e*; 39*j, k. Ch-55* (1): 41*k* (P). *Cl-1* (1): 51*e. Cl-131* (1): 68*e. Cl-145* (1): 75*a. Ly-1* (10): 82*g*; 84*d* (2), *j* (2); 86*g*; 88*b*; 89*c*; 92*l*; 93*i. Mi-2* (2): 99*a* (2). *Mi-3* (2): 99*b* (2) (P). *Mi-4* (1): 99*c. Ny-3* (3): 99*a* (2); 109*b. Pe-14* (1): 111*h. St-1* (8). *Wa-5* (2): 113*d*; 114*d. Wa-7* (1): 112*d. Wa-35* (1): 114*e. Wa-69* (8): 120*d, g* (2), *h*; 125*e* (4). *Wa-137* (1): 127*h. Wa-139* (2): 128*b* (2).

30. *Star or asterisk* (27)

 Ch-3 (2): 35*g*; 36*g. Ch-16* (1): 42*d. Cl-2* (1): 132*b. Cl-4* (1): 62*a. Cl-123* (3): 65*j*; 66*a* (P), *k. Ly-1* (1): 86*a. Ly-2* (1): 96*a. Ly-7* (2): 96*m* (2). *Mi-4* (1): 100*e. Mi-5* (5): 103*o*; 104*a* (S), *b* (P), *g, h* (S). *Ny-22* (1): 110*c. St-1* (7). *Wa-69* (1): 125*g.*

31. *Ladder, one pole* (27)

 Ch-3 (4): 33*i*; 36*f*; 38*f*; 39*i. Ch-57* (1): 41*x. Cl-1* (1): 55*d. Cl-3* (1): 60*i. Cl-131* (1): 68*e. Cl-145* (1): 74*c. La-9* (3): 80*a* (3). *Ly-1* (2): 62*h*; 92*e* (S). *Mi-4* (5): 99*e*; 100*a, b*; 102*d*; 103*j. Mi-5* (1): 104*a* (S). *Ny-3* (1): 109*b. Pe-14* (1): 112*h. St-1* (4). *Wa-69* (1): 119*e.*

32. *Ladder, two pole* (27)

 Ch-3 (1): 33*k. Cl-1* (2): 45*b*; 54*d. Cl-131* (2): 68*e* (2). *La-9* (7): 79*h*; 80*a* (2), *c* (2); 81*a* (2) (S). *Ly-1* (7): 82*g*; 83*b*; 87*b*; 90*m*; 91*e*; 92*b, e* (S). *Mi-4* (1): 99*f. Ny-25* (1): 110*c. Wa-7* (1): 112*d. Wa-69* (4): 120*e*; 121*a*; 122*c*; 124*j. Wa-131* (1): 126*d.*

33. *Rake* (306)

 Ch-3 (21): 33*d, o*; 34*g, h* (3); 35*a, b, c, h*; 36*e*; 37*f*; 39*d, f* (2); 40*b* (2), *e, l. Ch-49* (1): 42*l* (P). *Ch-57* (1): 41*x. Ch-71* (4): 43*l*; 44*b, c, l. Cl-1* (36): 45*b* (8); 48*a*; 49*a, b, c* (2); 50*a* (5), *c* (4); 51*c, e, k*; 52*a*; 55*b, h*; 56*e*; 57*c, j*; 58*a, b* (2), *c*; 59*l. Cl-2* (5): 100*h, i, l*; 101*a, c. Cl-4* (2): 61*d* (2). *Cl-5* (4): 63*e, f*; 64*e, j. Cl-123* (9): 65*h, k* (3); 66*f, g, h*; 67*a, d. Cl-124* (1): 68*d. Cl-131* (4): 68*e* (4). *Cl-145* (30): 69*d*; 70*a* (4); 71*a* (5); 72*a, c*; 73*c, e* (2); 74*c* (3); 75*a* (6), *b, d* (2); 76*e*; 77*b* (2). *Cl-146* (1): 77*d. Es-1* (2): 78*e* (2). *Hu-5* (1): 78*f. La-1* (4): 79*e* (3), *f. La-9* (10): 79*b* (2); 80*a, b* (2), *c, d* (2) (S), *f* (2) (S). *Li-3* (1): 81*c.* (P). *Ly-1* (12): 82*d*; 83*k*; 85*f* (2); 88*m*; 89*c*; 90*q, r*; 92*b, e* (3) (S). *Ly-2* (1): 96*k. Ly-7* (2): 97*b*; 98*i. Mi-4* (22): 99*c* (2), *f* (3); 100*a* (3), *c, d, h* (3), *i*; 101 (5); 102*a, f, j*; 103*d. Mi-5* (4): 104*c* (P); 105*a* (S), *d* (S). *Mi-13* (1): 107*g. Ny-2* (1): 106*d. Ny-3* (3): 108*a* (2); 109*a. Ny-44* (4): 110*f* (4). *Pe-14* (4): 111*g, i* (3). *St-1*

(50). *Wa-5* (12): 113*d* (3), *f* (7); 114*d*, *j*. *Wa-7* (1): 112*d*. *Wa-35* (5): 115*d*; 116*c*; 117*b* (2), *c*. *Wa-68* (1): 118*e*. *Wa-69* (33): 119*b*, *c*, *e*; 120*c*, *e* (2), *g*, *i*, *j*, *k*; 121*c*, *e*, *f* (2), *g* (2), *h* (2), *i* (2); 122*c*, *g*; 123*a*, *g*; 124*a*, *b*, *f*, *i*; 125*d*, *e* (2), *j*, *k*. *Wa-137* (1): 127*h*. *Wa-142* (4): 128*j* (2); 129*f*, *g*. *Wh-11* (4): 130*k* (4) (P). *Wh-12* (2): 131*b* (2) (P). *Wh-14* (1): 131*g*.

34. *Rain symbol* (2)
Cl-1: 56*a*. *Cl-123* (1): 65*h*.

35. *Rectilinear meander* (20)
Ch-3 (4): 35*j*; 36*g*; 37*i*; 39*b*. *Cl-1* (1): 55*g*. *Cl-2* (9): 132*e*, *h*, *j*; 133*b*, *c* (2), *d* (2), *e*. *Ly-1* (1): 85*c*. *Pe-27* (1): 112*a* (P). *St-1* (2). *Wa-69* (2): 121*b*; 126*b*.

36. *Chevrons* (4)
Cl-1 (1): 53*b*. *Cl-5* (1): 64*e*. *La-1* (1): 79*e*. *Pe-10* (1): 110*g*.

37. *Radiating dashes* (9)
La-1 (1): 79*e* (P). *La-9* (2): 80*c*, *d*. *Li-3* (1): 81*f* (S). *Mi-5* (1): 105*b* (S). *Wa-69* (4): 121*c* (2); 125*e* (2).

38. *Crosshatching* (113)
Ch-3 (1): 40*m*. *Ch-49* (1): 42*o* (P). *Cl-1* (2): 49*c*; 59*o*. *Cl-2* (2): 132*c*, *k*. *Cl-4* (4): 62*a* (4). *Cl-5* (1): 64*g*. *Cl-123* (16): 65*h* (6), *i* (3), *j*, *k*, *l*; 66*c* (2), *d* (2). *Cl-145* (2): 70*a*; 72*a*. *La-1* (1): 79*e*. *La-9* (7): 80*b* (2), *c*, *d* (P), *e* (S), *g* (S), *h* (S). *Ly-1* (14): 82*i* (S); 87*b*, *c*; 90*a*, *b*, *c*, *e*; 91*n*; 92*b*, *e* (S), *h*; 94*d*; 95*i*, *j*. *Ly-2* (1): 96*e*. *Ly-5* (1): 96*l*. *Mi-4* (3): 99*c*, *f*; 103*e*. *Mi-5* (20): 103*p* (S), *q* (S); 104*a*, *e*, *f*, *h* (4); 105*a* (4) (S), *b* (5) (S), *c* (S); 106*c*. *Ny-3* (1): 108*a*. *Pe-10* (1): 110*i*. *St-1* (25). *Wa-5* (1): 113*f*. *Wa-35* (1): 116*e*. *Wa-69* (8): 119*a*, *i* (2); 120*a*; 121*d*, *e*; 123*c*, *d* (S).

39. *Plant form* (50)
Ch-3 (2): 33*f*; 34*k*. *Ch-71* (2): 43*b*; 44*g*. *Cl-1* (13): 45*b* (4); 50*c* (2); 52*a*; 54*c*, *d*; 59*a*, *b* (2), *f*. *Cl-4* (3): 61*d*; 62*c* (2). *Cl-9* (1): 65*g*. *Cl-131* (1): 68*e*. *Cl-145* (2): 69*b*; 71*b*. *La-1* (1): 79*a*. *Li-1* (1): 81*b*. *Ly-1* (4): 88*l*; 90*k*; 91*e*; 95*b*. *Ly-2* (1): 96*b*. *Ly-7* (1): 97*i*. *Mi-4* (2): 100*a*, *c*. *Mi-5* (2): 104*e* (2). *St-1* (5). *Wa-29* (2): 112*g*; 118*b*. *Wa-35* (1): 116*b*. *Wa-69* (5): 119*f* (2); 125*a* (2); 126*b*. *Wh-11* (1): 130*k* (P).

40. *Bird* (3)
Cl-145 (2): 75*d* (2). *St-1* (1).

41. *Lizard* (11)
Ch-3 (3): 34*f*; 36*k*, *n*. *Ch-55* (1): 41*i* (P). *Cl-1* (3): 53*c* (2); 59*g*. *Cl-3* (1): 60*h*. *Cl-123* (1): 65*k*. *Ly-1* (1): 88*k*. *St-1* (1).

42. *Mountain sheep* (259)

Ch-71 (1): 43*j*. *Cl-1* (110): 45*b* (8); 46*b* (4); 47*a*, *b* (2); 49*a*, *c* (3), *d* (2), *f*; 50*a*, *c* (2); 51*e* (3), *f*, *i*, *j*, *k* (2); 52*a* (3), *b*; 53*e*, *g* (4); 54*d*; 55*e* (5), *l*, *m*, *p* (11); 56*a* (29), *d*, *e* (7); 57*a* (2), *d*, *e*, *j* (2); 58*c*, *d*; 59*i*, *l* (2), *p*. *Cl-2* (14): 132*a* (3), *b*, *d* (4), *e*, *f* (5). *Cl-3* (1): 60*k*. *Cl-4* (42): 61*b* (9), *d* (24); 62*a* (2); 63*a* (7). *Cl-5* (6): 63*b*; 64*a*, *e* (2), *f*, *i*. *Cl-123* (13): 65*h*; 66*c* (2), *e*; 67*f* (7), *g*, *h*. *Cl-131* (1): 68*e*. *Cl-143* (8): 78*a* (8). *Cl-145* (46): 69*a*, *b* (4), *d* (3), *e* (3); 70*a* (6); 71*b*; 72*b* (2); 73*f* (8); 74*b*, *d* (5); 75*a* (2), *c*, *d* (2); 76*d*, *e* (6). *Li-1* (8): 81*b* (8). *Ly-1* (3): 83*j*, *k*; 84*k*. *Mi-14* (1): 107*d*. *Ny-44* (2): 110*e* (2). *St-1* (1). *Wa-5* (1): 114*f*. *Wa-35* (1): 116*a*.

43. *Sheep horns* (20)

Ch-71 (4): 43*e*, *f*; 51*e*; 53*f*. *Cl-1* (1): 59*c*. *Cl-3* (2): 60*p* (2). *Cl-4* (1): 61*d*. *Cl-5* (2): 64*a*, *l*. *La-1* (2): 79*a* (2). *Ly-1* (5): 84*f*; 85*c* (2); 87*b*; 88*p*. *Ly-7* (1): 98*f*. *St-1* (1). *Wa-5* (1): 114*c*.

44. *Quadruped* (*not sheep*) (78)

Ch-71 (1): 43*i*. *Cl-1* (29): 48*a*; 49*b* (2), *c* (3); 51*m*; 52*a* (5); 53*g* (3); 54*d*; 55*e* (2); 56*a* (2), *e* (2); 57*a*, *d*, *h*; 58*a* (2). *Cl-4* (13): 61*b* (7), *d* (3), *e*; 62*a* (2). *Cl-5* (6): 63*b*, *e*, *f*; 64*a*, *i*, *l*. *Cl-123* (2): 67*e*, *g*. *Cl-124* (1): 68*c*. *Cl-145* (18): 69*e*; 70*b* (4), *c* (2); 72*a*; 73*d* (2), *f* (2); 74*c* (2); 75*d* (4). *Ly-1* (5): 88*g* (2); 91*e*; 93*h*. *St-1* (1). *Wa-69* (3): 121*e* (2); 124*j*. *Wh-3* (1): 130*i* (P). *Wh-13* (1): 131*c* (P). *Wh-14* (1): 131*g* (P).

45. *Snake* (244)

Ch-3 (27): 33*b* (3), *d*, *e*, *g*, *j*, *m* (2); 34*c*, *f*, *n*; 35*n*; 36*b*, *d* (2), *k* (2); 37*k*; 38*e*; 39*c*; 40*e*, *g*, *j* (4). *Ch-16* (2): 42*d*, *f*. *Ch-20* (1): 42*i*. *Ch-55* (2): 41*a* (P), *c* (P). *Ch-71* (1): 60*a*. *Cl-1* (17): 45*b* (3); 47*a*; 49*d*; 51*h*; 52*a*; 54*d*, *e*; 55*a*; 56*a*; 57*b*, *f*; 58*c*, 59*c* (2), *o*. *Cl-4* (1): 61*d*. *Cl-7* (4): 65*c* (3), *e*. *Cl-131* (2): 68*e* (2). *Cl-143* (2): 78*a* (2). *Cl-145* (19): 69*b*; 71*a* (4); 72*a* (2); 73*b*, *e*; 74*c*; 75*a* (4); 76*a* (4); 77*b*. *Cl-146* (1): 77*d*. *Hu-5* (1): 78*f*. *La-9* (2): 79*h*; 80*i*. *Li-3* (1): 81*g* (P). *Ly-1* (51): 82*d*, *l*; 83*e*, *h* (5), *i*, *j*; 84*b*, *f* (2), *j*; 85*a*, *b*, *c* (3), *d* (3); 86*a*, *c* (2), *h*; 87*a*, *d*, *i* (3), *o*; 88*b*, *e*, *k* (2); 89*a*; 91*k*, *q*; 92*a*, *l*; 93*h* (2), *i* (2), *l*; 94*a*, *b* (2), *f*, *i*, *l*. *Ly-2* (2): 96*a*, *k*. *Ly-5* (1): 96*l*. *Ly-7* (8): 96*m* (2); 97*b* (2), *c*, *h*; 98*e*, *h*. *Mi-2* (3): 99*a* (3). *Mi-4* (21): 99*c*, *e*, *f* (2), *g*, *h*; 100*a* (2), *d*; 101 (3); 102*a*, *i*, *k*; 103*a*, *d*, *h*, *m*, *n* (2). *Mi-5* (1): 104*b*. *Mi-14* (2): 107*b* (2). *Ny-2* (5): 106*d* (3), *e*, *h*. *Ny-3* (10): 106*i*; 108*a* (5); 109*b* (4). *Ny-25* (1): 110*b*. *Pe-10* (3): 110*g*, *h*; 111*a*. *St-1* (12). *Wa-5* (8): 113*d* (2); 114*a* (3), *d*, *e*, *j*. *Wa-26* (1): 112*f*. *Wa-29* (1): 112*g*. *Wa-35* (6): 115*a*, *d*; 116*c*, *d*; 117*a*, *e*. *Wa-68* (1): 118*e*. *Wa-69* (20): 119*i*; 120*n*; 121*e*; 122*c*, *g* (2), *h*; 123*f*, *h*, *i*; 124*c* (2); 125*e* (2), *i*, *k* (3); 126*a*, *b*. *Wa-131* (4): 126*c*, *e* (2), *f*.

46. *Many-legged insect* (28)

Ch-26 (1): 42*j* (P). *Cl-1* (4): 45*b*; 51*e*; 52*a*; 59*l*. *Cl-2* (1): 132*m*.
Cl-5 (4): 63*c* (2), *f* (2). *Cl-145* (3): 71*a*; 72*b* (2). *Hu-5* (1): 78*f*.
Ly-1 (2): 89*c*; 91*j*. *Mi-4* (3): 99*f*; 100*h*; 102*j*. *Wa-69* (2): 124*g*, *j*.
Wa-139 (1): 128*a*. *Wa-142* (2): 128*j*; 129*i*. *Wh-11* (3): 130*k* (3) (P).
Wh-14 (1): 131*g*.

47. *Foot or paw* (92)

Ch-55 (1): 41*f* (P). *Cl-1* (46): 45*a*, *b* (6); 49*d*, *f* (2); 50*c* (9); 51*a*
(2), *e* (5), *h*; 52*a* (11); 53*b*, *e*; 56*a* (2); 58*d*; 59*h* (2), *n*. *Cl-5* (6):
64*a*, *b* (2), *e*, *k* (2). *Cl-7* (2): 65*c* (2). *Cl-123* (1): 67*c*. *Cl-131* (2):
68*e*. *Cl-145* (21): 69*e*; 72*a* (11); 74*d*; 75*a* (2), *b* (2), *c* (2); 76*e* (2).
La-1 (1): 79*g*. *Ly-1* (3): 86*j*; 92*l*. *Ly-7* (1): 97*j*. *Mi-4* (1): 100*a*. *St-1*
(2). *Wa-35* (2): 117*g*, *j*. *Wa-69* (3): 122*i*; 123*g*; 125*d*.

48. *Hand* (44)

Cl-1 (9): 52*a* (7); 53*b*. *Cl-2* (1): 132*l*. *Cl-3* (3): 60*f* (3). *Cl-4* (2):
62*a* (2). *Cl-5* (3): 64*b*, *e* (2). *Cl-7* (1): 65*f*. *Cl-131* (2): 68*e* (2).
Cl-145 (10): 71*a* (3); 74*d*; 75*a* (2), *b* (3); 76*a*. *La-1* (1): 79*e*. *La-9* (1):
79*i*. *Ly-1* (2): 87*e*; 92*l*. *Ly-7* (1): 97*i*. *Mi-14* (2): 107*c* (2). *St-1* (1).
Wa-35 (3): 117*g*, *j* (2). *Wa-69* (2): 122*h*, 123*g*.

49. *Human* (91)

Ch-55 (1): 41*d* (P). *Ch-71* (1): 60*a*. *Cl-1* (9): 51*i*; 53*d*; 59*h*, *m* (4),
n, *q*. *Cl-4* (1): 61*e*. *Cl-5* (5): 63*e*, *f*, *j*; 64*c*, *e*. *Cl-7* (1): 65*a*. *Cl-9* (2):
65*g* (2). *Cl-123* (3): 66*i*; 67*h* (2). *Cl-124* (1): 68*c*. *Cl-145* (37): 69*c*
(2), *d* (4), *e* (3); 70*a* (9), *b*; 72*a* (2); 75*a* (3), *b*, *d* (2); 76*a* (4), *c*,
e (4). *Cl-146* (2): 77*d* (2). *Ly-1* (4): 85*d*; 86*a*, 87*g*; 92*g*. *Ly-7* (2): 98*f*
(2). *Mi-4* (2): 101; 103*b*. *St-1* (7). *Wa-5* (1): 113*f*. *Wa-35* (1): 117*j*.
Wa-67 (1): 118*c*. *Wa-69* (8): 119*g* (5); 122*i*; 124*e*, *j*. *Wh-14* (2): 131*g* (2).

50. *Horned human* (33)

Ch-71 (1): 43*g*. *Cl-1* (3): 55*p*; 56*a*; 58*e*. *Cl-5* (6): 63*f* (3); 64*e* (2),
l. *Cl-7* (2): 65*a* (2). *Cl-123* (1): 67*g*. *Cl-124* (1): 68*c*. *Cl-143* (1): 78*a*.
Cl-145 (6): 69*c*; 71*a*; 72*a*; 75*a*, *b* (2). *Ly-1* (12): 82*k* (S); 83*b*; 84*e*, *i*, *j*
(2); 86*a*, *b*; 89*a*; 92*l*; 93*e*. *Mi-17* (1): 107*a*. *Pe-10* (1): 111*e*.

51. *Human stick figure* (258)

Ch-3 (4): 34*a*; 35*f*, *k*; 39*e*. *Ch-16* (4): 42*b*, *d* (3). *Ch-55* (1): 41*o*
(P). *Ch-57* (4): 41*t*, *u* (2), *v*. *Ch-71* (2): 43*a*; 60*c*. *Cl-1* (48): 45*a*
(2), *b*; 46*b* (3); 47*a*; 48*a*, *b*; 49*a*, *d*; 50*c* (6); 51*e*, *g*; 52*a* (3), *b*; 53*e*
(2), *h*; 54*a*, *e*; 55*a* (2), *b*, *f*, *k*; 56*a* (2), *b*, *c*, *e* (3); 57*j* (2); 58*a* (2),
d, *e*; 59*h* (2). *Cl-2* (1): 133*b*. *Cl-4* (9): 61*d* (3), *e*, *f* (3); 62*a* (2).
Cl-5 (6): 63*e*, *f*; 64*a*, *e* (3). *Cl-9* (1): 65*g*. *Cl-123* (7): 66*a* (P), *f*;
67*a*, *b*, *e*, *f*, *g*. *Cl-131* (3): 68*e* (3). *Cl-143* (7): 78*a* (7). *Cl-145* (20):
69*a*, *b* (7); 70*a* (2); 72*b*; 73*e*, *f* (2); 74*a*, *d*; 75*a* (2), *b* (2). *La-1* (1):

79a (P). Ly-1 (45): 82c (2), e, g (2); 83d, g, h, i; 84a, j (2); 85a (3), b, c, d, e, f, g; 86a (2), b (2), i, j; 89g; 90i, m, q; 91o, q, r; 92j, k (2), l; 94a (2), b; 95d. Ly-7 (12): 96m; 97e, i, m; 98a, b (2), c, e, f, g, h. Mi-2 (2): 98k; 99a. Mi-4 (15): 99c (2), d, e, f (3); 100a (3), d, e (2); 102h; 103d. Mi-5 (3): 105b, c, d. Mi-14 (1): 107b. St-1 (11). Wa-5 (6): 113a, c, f; 114f, h (2). Wa-26 (2): 112f (2). Wa-35 (2): 116f, 117d. Wa-69 (24): 119c, d, e (2); 120n; 121b (2), e (2), g; 122c, d (2), f; 124c (2), e, g, i (2), j (2); 125d, f. Wa-131 (3): 126e, f. Wa-135 (3): 127b (3). Wa-137 (1): 127g. Wa-139 (7): 128a (2), d (2), e (2), f. Wh-11 (2): 130k (2) (P). Wh-14 (1): 131g.

52. *Human, stick limbs* (34)

Ch-3 (1): 36j. Cl-4 (2): 61d, e. Cl-143 (2): 78a (2). Cl-145 (13): 69b; 71a (2); 73d; 75a, b (6), c, d. Ly-1 (4): 85d; 86i; 91g; 94a. Ly-7 (1): 95m. Mi-4 (1): 100a. Wa-5 (2): 113d (2). Wa-69 (7): 119d, e; 122b (3); 124e (2). Wa-137 (1): 127i.

53. *Katchina figure* (60)

Cl-1 (4): 51a; 54e (2); 58c. Cl-2 (1): 133c. Cl-4 (13): 62b (5), c (2), d (5), e. Cl-7 (6): 65a (2), b (4). Cl-145 (4): 73e; 75a (2), b. Li-5 (2): 81h (2) (P). Ly-1 (1): 82k. Wh-3 (11): 130a (5) (P), b (P), c (2) (P), d (P), e (P), h (P). Wh-12 (2): 130l (2) (P). Wh-13 (4): 131c (P), d (P), e (P), f (P). Wh-14 (1): 131g (P). Wh-15 (11): 131h (11) (P).

54. *White man* (10)

Cl-4 (10): 61b (5); 62g (5).

55. *Atlatl* (4)

Cl-1 (4): 45a, b (2), 55a.

56. *Arrow* (1)

Cl-1 (1): 59i.

57. *Deer* (2)

Cl-5 (1): 63e. Cl-145 (1): 73f.

58. *Fish* (3)

Mi-3 (1): 99b (P). Wa-69 (2): 120b, f.

Notes

ACKNOWLEDGMENTS

1. Grant Numbers 3917 and 7013.

INTRODUCTION

1. Goodwin (1953, p. 128) says, "Our African petroglyphs seem to have started immensely long ago; they are perhaps the oldest surviving art in the world." For a theory of the origin of such art, see Schellhas (1930).

CHAPTER I

1. The terms petroglyph, pictograph, and petrograph were at one time used loosely to designate various kinds of rock art. In the past thirty years or so the meanings of the terms have become standardized until now it is customary to use the word *petroglyph* for any figure or symbol which is pecked, scratched, carved, or otherwise engraved into the surface of a rock or boulder, while the word *pictograph* indicates a design painted on a rock. We will follow these usages in the present work.

2. We are supported in this view by Kroeber (1958).

3. Sites are often named (e.g., Lagomarsino) and are always designated by a county-number symbol. For county site designations in the state of Nevada, see Grosscup (1957, pp. 2-3) and the list here in Table 1.

4. Kelley (1950, p. 73) suggests that some Texas pictographs may be taken as evidence of a "well organized ceremonial hunting cult." We do not see any such suggestions in the Nevada petroglyphs.

5. Pictographs are reported to have been made by some recent tribes; details are given later in this report.

6. Death Valley, however, is a most unlikely germinating hearth for any culture group or cultural pursuit.

CHAPTER II

1. Figure and plate numbers refer to the present book. The scale in all figures of petroglyphs and pictographs represents one foot.

2. Buechner (1960, p. 56) says the site is "located 15 miles up Meadow Valley Wash from Moapa..."

3. El-23, another petroglyph site recently discovered, is reported in Appendix E.

CHAPTER V

1. Terminology is that of Hall (1946).

2. The southern Nevada situation seems to prevail as well in Death Valley if we correctly interpret the information provided by Hunt (1960). Hunt (*op. cit.,* fig. 37) shows the intimate association of hunting blinds and petroglyphs in the mouth of a wash between sites 37-59C and 62-57. Death Valley site 41-57 (*ibid.,* fig. 84) is apparently a petroglyph area immediately associated with water (Chuckwalla Spring). Hunt's report is regrettably deficient in providing information about the association of petroglyphs with springs, hunting blinds, and game trails. All we are told is that hunting blinds are associated with game trails (*ibid.,* p. 190). Spears (1892, p. 73) mentions that archers in Death Valley occupied stone hunting blinds while men drove mountain sheep along trails toward them. Still further south, on the peninsula of Lower California, petroglyphs are said to be always associated with water (Diguet, 1894, p. 161).

3. Werlhof (1960, p. 578) writes, "The Department of Fish and Game for the State of California has shown from its researches that there have been times when some game animals all but disappeared from Owens Valley for periods upwards of a century. During such blanks in the activities of hunting

larger game the natives doubtlessly forgot the use of such devices as petroglyphy. The art was lost, and even became a mystery to later Indians who lived amongst the rocks on which the designs had been placed." While Werlhof's idea is ingenious, we do not believe that this explanation can account for abandonment of the practice of making petroglyphs throughout most of western North America.

4. Colton (1946) investigated the petroglyph site at Willow Springs in northern Arizona. He cites ethnographic testimony that the Hopi made petroglyph inscriptions of clan symbols at this site when they were on a salt expedition. The particular petroglyph-covered rock which he refers to is rather different from the usual Arizona site, and the practice of pecking clan symbols in this way may be a specific recent practice, though it would appear to be generically related to the earlier (i.e., prehistoric) petroglyph complex. On this site see also Watson (1961).

APPENDIX B

1. Perhaps we should not make this denial too categorically. A. Schroeder, a particularly able archaeologist, while discussing petroglyphs along the Lower Colorado River, writes, "A few of the linear drawings observed appear to be maps, one being a perfect representation of the bends of the [Colorado] river from Topock south to Mohave Rock at [site] L:7:3" (Schroeder, 1952, p. 44). Since the Colorado River tribes are known to have made excellent "sand maps" (Heizer, 1958), it is possible that they also inscribed more permanent maps on rock surfaces. Sand maps are an illustrative device in person-to-person communication about topography and routes, but an incised map in the form of a laboriously pecked petroglyph would seem to belong to a quite different context, since there is implied the ability of other persons to "read"

it without assistance. However, even if it should ultimately be decided that petroglyphs are maps, their total number would be very small and they would comprise a minute proportion of the total of petroglyph designs.

2. While we can scarcely compare our Nevada petroglyphs with the painted cave art of Lascaux, it may be of interest to note that Laming (1959, chaps. 4 and 5) has made a most interesting analysis of the arrangement of animals in the Lascaux caves. While such analysis implies an attempt to discover a pattern of composition, the method might also be applied to unit rock faces bearing petroglyph designs in order to try to determine whether some patterning exists.

APPENDIX C

1. Hunt (1960, p. 292) says, "The archaeological evidence, not only in Death Valley but in the West generally, strongly supports the view that only insignificant amounts of desert varnish have formed during the past 200 years." On the chemistry and formation of desert varnish, see also Engel and Sharp (1958).

2. For the Postglacial climatic sequence see Antevs (1948, 1955). That man was surely present in this area of Nevada 4000 years ago is proved by archaeological materials (see Heizer, 1951a, 1951b, 1956; Heizer and Kreiger, 1956; Bennyhoff, 1958; Grosscup, 1958).

APPENDIX F

1. Since this was written, J. von Werlhof has published (1960) a preliminary account of his observations on petroglyph sites in Owens Valley (Inyo County). He concludes that most of the petroglyphs in this region are definitely associated with game migration routes or game watering places.

General
Bibliography

Adams, Lowell
 1959 Big Game Habitat Management. *Pacific and Southwest Forest and Range experiment Station Technical Paper*, No. 42.

Allen, Joseph C.
 1939 Ecology and Management of Nelson's Bighorn on the Nevada Mountain Ranges. *Trans. of the Fourth North American Wildlife Conference*, pp. 253-256.

Almgren, O.
 1934 Nordische Felszeichnungen als religiose Urkunden. Frankfurt am Main.

Althin, C. A.
 1945 Studien zu den Bronzezeitlichen Felszeichnungen von Skane. 2 vols. Copenhagen.

Anati, E.
 1960*a* Prehistoric Art in the Alps. *Scientific American,* 202:52-59.
 1960*b* La Civilisation du Val Camonica. *Mondes Anciens,* No. 4. Arthaud, Paris.

Antevs, E.
 1948 The Great Basin: Part III, Climatic Changes and Pre-White Man. *Univ. of Utah Bulletin,* Vol. 38, No. 20, pp. 168-191.
 1953 On Division of the Last 20,000 Years. *Univ. of California Archaeological Survey Report,* No. 22, pp. 5-8. Berkeley.

Aschmann, H.
 1959 The Central Desert of Baja California: Demography and Ecology. *Ibero-Americana,* No. 42. Berkeley and Los Angeles.

Baillie-Grohman, W. A.
 1882 Camps in the Rockies. C. Scribners, New York.

Bandi, H. G., and J. Maringer
 1952 Kunst der Eiszeit. Holbein Verlag, Basel.

Battiss, W.
 1948 The Artists of the Rocks. Pretoria, S. Africa.

Baumhoff, M. A.
 1957 Introduction to Yana Archaeology. *Univ. of California Archaeological Survey Report,* No. 40. Berkeley.

Baumhoff, M. A., and J. S. Byrne
 1959 Desert Side-Notched Points as a Time Marker in California. *Univ. of California Archaeological Survey Report,* No. 72, pp. 32-65. Berkeley.

Baumhoff, M. A., and R. F. Heizer
 1958 Outland Coiled Basketry from the Caves of West Central Nevada. *Univ. of California Archaeological Survey Report,* No. 42, pp. 49-59. Berkeley.

Baumhoff, M. A., R. F. Heizer, and A. B. Elsasser
 1958 Lagomarsino Petroglyph Site, Storey County, Nevada. *Univ. of California Archaeological Survey Report,* No. 43. Berkeley.

Bégouen, H.
 1929 The Magic Origin of Prehistoric Art. *Antiquity,* Vol. 3, No. 9, pp. 5-19.

Bennyhoff, James A.
 1958 The Desert West. *University of California Archaeological Survey Report,* No. 42, pp. 98-112. Berkeley.

Bosch-Gimpera, P.
 1950 The Chronology of Rock-Paintings in Spain and in North Africa. *Art Bulletin,* Vol. 32, pp. 71-76.

Brainerd, G. W.
 1951 The Place of Chronological Ordering in Archaeological Analysis. *American Antiquity,* 16:301-313.

Breuil, H.
 1952 Four Hundred Centuries of Cave Art. Centre d'Études et de Documentation Préhistoriques, Montignac, Dordogne.

Breuil, H., M. C. Burkitt, and M. Pollock
 1929 Rock Paintings of Southern Andalusia. Oxford.

Breuil, H., and H. Obermaier
 1935 The Cave of Altamira. Madrid.

Brøgger, A. W.
 1931 Die Arktischen Felsenzeichnungen und Malereien in Norwegen. *Ipek* [Vol. 7], pp. 11-24.

Buechner, Helmut K.
 1960 The Bighorn Sheep in the United States, Its Past, Present, and Future. *Wildlife Monographs,* No. 4.

Burkitt, M. C.
 1928 South Africa's Past in Stone and Paint. Cambridge, England.

Cain, H. T.
 1950 Petroglyphs of Central Washington. Univ. of Washington Press, Seattle.

Chasseloup-Laubat, F. de
 1938 Art rupestre au Hoggar. Plon, Paris.

Clark, G.
 1937 Scandinavian Rock Engravings. *Antiquity,* 11:56-69.

Clark, J. Desmond, *et al.*
 1959 The Prehistoric Rock Art of Central Africa. Salisbury, S. Rhodesia.

Colton, H. S.
 1946 Fools Names Like Fools Faces. *Plateau,* 19:1-8. Museum of Northern Arizona, Flagstaff, Ariz.

Colton, M. R. F., and H. S. Colton
 1931 Petroglyphs, the Record of a Great Adventure. *American Anthropologist,* 33:32-37.

Cooke, C. K.
 n.d. A comparison Between the Weapons in Rock Art in Southern Rhodesia and Weapons Known to Have Been Used by Bushmen and Later People. *National Museum of Southern Rhodesia Occasional Papers,* Vol. 3, No. 22A.

Craig, B. J.
 1947 Rock Paintings and Petroglyphs of South and Central Africa. Jagger Library, Univ. of Cape Town, S. Africa.

Cressman, L. S.
 1937 Petroglyphs of Oregon. *Univ. of Oregon Monographs, Studies in Anthropology,* No. 2. Eugene.

Cruxent, J. M.
 1946-47 Pinturas rupestres de el Carmen, en el río Parguaza, Estado Bolivar, Venezuela. *Acta Venezolana,* 2:83-90.

Dahlgren, B., and J. Romero
 1951 La prehistória bajacaliforniana; redescubrimiento de pinturas rupestres. *Guadernos Americanos,* 58:153-178.

Davidson, D. S.
 1936 Aboriginal Australian and Tasmanian Rock Carvings and Paintings. *Memoirs of the American Philosophical Society,* Vol. 9.

Diguet, L.
 1894 Note sur la pictographie de la Basse-Californie. *L'Anthropologie,* 6:160-175.

Dixon, Joseph S.
 1939 A Survey of the Desert Bighorn in Death Valley National Monument, Summer, 1938. *California Fish and Game,* 25:72-95.

Dixon, Roland B.
 1905 The Northern Maidu. *American Museum of Natural History Bulletin,* 17:119-346.

Driver, Harold E.
 1937 Culture Element Distributions: VI, Southern Sierra Nevada. *Univ. of California Anthropological Records,* Vol. 1, No. 2. Berkeley and Los Angeles.
 1941 Culture Element Distributions: XVI, Girls' Puberty Rites in Western North America. *Univ. of California Anthropological Records,* Vol. 6, No. 2. Berkeley and Los Angeles.

Driver, Harold E., and William C. Massey
 1957 Comparative Studies of North American Indians. *Trans. of the American Philosophical Society,* Vol. 47, Part 2.

Drucker, Philip
 1941 Culture Element Distributions: XVII, Yuman-Piman. *Univ. of California Anthropological Records,* Vol. 6, No. 3. Berkeley and Los Angeles.

Du Bois, Constance Goddard
 1908 The Religion of the Luiseño Indians of Southern California. *Univ. of California Publs. in American Archaeology and Ethnology,* Vol. 8, No. 3. Berkeley and Los Angeles.

Einarsen, Arthur S.
 1948 The Pronghorn Antelope and Its Management. Wildlife Management Institute, Washington, D. C.

Elkin, A. P.
 1949 The Origin and Interpretation of Petroglyphs in Southeast Australia. *Oceania,* 20:119-157.

Elsasser, Albert B.
 1960 The Archaeology of the Sierra Nevada in California and Nevada. *Univ. of California Archaeological Survey Report,* No. 51. Berkeley.

Elsasser, Albert B., and Eduardo Contreras
 1958 Modern Petrography in Central California and Western Nevada. *Univ. of California Archaeological Survey Report,* No. 41, Paper No. 65, pp. 12-18. Berkeley.
Emmons, G. T.
 1908 Petroglyphs of Southeastern Alaska. *American Anthropologist,* 10:221-230.
Engerrand, J.
 1912 Nuevos Pétroglifos de la Baja California. *Boletín del Museo Nacional de Arqueología, Historia e Etnología,* No. 10, pp. 1-8. Mexico City.
Erwin, R. P.
 1930 Rock Writing in Idaho. *Idaho Historical Society, Biennial Report,* No. 12, 1929-1930. Boise.
Fewkes, J. W.
 1903 Prehistoric Porto Rican Pictographs. *American Anthropologist,* 5:441-467.
Flamand, G.-B.-M.
 1921 Les Pierres Écrites (Hadjeat-Mektoubat); Gravures et Inscriptions Rupestres du Nord-Africain. Missions du Ministère de l'instruction publique et du gouvernement général de l'Algérie (Service Géologique). Masson et Cie., Paris.
Fontana, B. L., J. C. Greenleaf, and D. D. Cassidy
 1959 A Fortified Arizona Mountain. *Kiva,* 25:41-52.
Frasetto, M. F.
 1960 A Preliminary Report on Petroglyphs in Puerto Rico. *American Antiquity,* 25:381-391.
Frobenius, L.
 1937 Ekada Ektab, die Felsbilder Fezzan. Leipzig.
Frobenius, L., and D. C. Fox
 1937 Prehistoric Rock Pictures in Africa and Europe. Museum of Modern Art, New York.
Frobenius, L., and H. Obermaier
 1925 Hadschra Maktouba, Urzeitliche Felsbilder Kleinafrikas. Forschungsinstitut für Kultur-morphologie, Munich.
Gayton, A. H.
 1948 Yokuts and Western Mono Ethnography. *Univ. of California Anthropological Records,* Vol. 10. Berkeley and Los Angeles.
Gebhard, D.
 1951 The Petroglyphs of Wyoming: A Preliminary Paper. *El Palacio,* 58:67-81. Santa Fe, N. M.
Gifford, E. W.
 1936 Northeastern and Western Yavapai. *Univ. of California Publs. in American Archaeology and Ethnology,* Vol. 34, No. 4. Berkeley and Los Angeles.
 1940 Culture Element Distributions: XII, Apache-Pueblo. *Univ. of California Anthropological Records,* Vol. 4, No. 1. Berkeley and Los Angeles.
Gjessing, G.
 1952 Petroglyphs and Pictographs in British Columbia. *In* Indian Tribes of Aboriginal America. *Selected Papers of the XXIX International Congress of Americanists,* pp. 66-79.
 1958 Petroglyphs and Pictographs in the Coast Salishan Area of Canada. *In Miscellanea Paul Rivet,* Publicaciones del Instituto de Historia, Primera Serie, No. 50, pp. 257-275. Mexico City.

Goodwin, A. J. H.
 1953 Method in Prehistory. *South African Archaeological Society, Handbook Series,* No. 1. Capetown.
Graziozi, P.
 1942 Arte rupestre della Libya. Naples.
Grosscup, Gordon L.
 1956 The Archaeology of the Carson Sink Area. *Univ. of California Archaeological Survey Report,* No. 33, pp. 58-64. Berkeley.
 1957 A Bibliography of Nevada Archaeology. *Univ. of California Archaeological Survey Report,* No. 36. Berkeley.
 1958 Radiocarbon Dates from Nevada of Archaeological Interest. *Univ. of California Archaeological Survey Report,* No. 44, Part I, pp. 17-31. Berkeley.
 1960 The Culture History of Lovelock Cave, Nevada. *Univ. of California Archaeological Survey Report,* No. 52. Berkeley.
Hafen, LeRoy R., and Ann W. Hafen
 1954 Journals of Forty-Niners, Salt Lake to Los Angeles. Arthur H. Clark, Glendale, Calif.
Hall, E. Raymond
 1946 Mammals of Nevada. Univ. of California Press, Berkeley and Los Angeles.
Hallström, G.
 1938 Monumental Art of Northern Europe from the Stone Age: The Norwegian Localities. 2 vols. Almqvist and Wiksell, Stockholm.
 1960 Monumental Art in Northern Sweden from the Stone Age: Namforsen and Other Localities. 2 vols. Almqvist and Wiksell, Stockholm.
Harrington, E. P.
 1933 More Kachina Pictographs in Nevada. *Southwest Museum Masterkey,* 7:48-50.
Harrington, John P.
 1942 Culture Element Distributions: XIX, Central California Coast. *Univ. of California Anthropological Records,* Vol. 7, No. 1. Berkeley and Los Angeles.
Harrington, M. R.
 1925 The "Lost City" of Nevada. *Scientific American,* 133:14-16.
 1928 Tracing the Pueblo Boundary in Nevada. *Museum of the American Indian, Heye Foundation, Indian Notes,* 5:235-240.
 1932 The Kachina Rockshelter in Nevada. *Southwest Museum Masterkey,* 6:148-151.
 1934 American Horses and Ancient Men in Nevada. *Southwest Museum Masterkey,* 8:164-169.
 1944 Prehistoric Dots and Dashes. *Southwest Museum Masterkey,* 18:196.
Haury, Emil W.
 1945 Painted Cave, Northeastern Arizona. *Amerind Foundation Paper,* No. 3.
 1950 The Stratigraphy and Archaeology of Ventana Cave, Arizona. Univ. of Arizona Press and the Univ. of New Mexico Press, Albuquerque.
Heizer, R. F.
 1947 Petroglyphs from Southwestern Kodiak Island, Alaska. *Proc. of the American Philosophical Society,* 9:284-293.
 1951 Preliminary Report on the Leonard Rockshelter Site, Pershing County, Nevada. *American Antiquity,* 17:89-98.

1953 Sacred Rain Rocks of Northern California. *Univ. of California Archaeo-
 logical Survey Report*, No. 20, pp. 33-38. Berkeley.

1958 Aboriginal California and Great Basin Cartography. *Univ. of California
 Archaeological Survey Report*, No. 41, pp. 1-9. Berkeley.

Heizer, R. F., and M. A. Baumhoff

1959 Great Basin Petroglyphs and Prehistoric Game Trails. *Science*, Vol. 129,
 No. 3353, pp. 904-905.

1961 The Archaeology of Two Sites at Eastgate, Churchill County, Nevada.
 Univ. of California Anthropological Records, Vol. 20: 119-150. Berkeley
 and Los Angeles.

n.d. Archaeology of South Fork Rockshelter, Elko County, Nevada. *Univ. of
 California Anthropological Records, to be published*. Berkeley and Los
 Angeles.

Heizer, R. F., and A. B. Elsasser

1953 Some Archaeological Sites and Cultures of the Central Sierra Nevada.
 Univ. of California Archaeological Survey Report No. 21. Berkeley.

Heizer, R. F., and A. L. Krieger

1956 The Archaeology of Humboldt Cave, Churchill County, Nevada. *Univ.
 of California Publs. in American Archaeology and Ethnology*, Vol. 47,
 No. 1. Berkeley and Los Angeles.

Henley, Ruth W.

1929 Catching Archaeology Alive. *Southwest Museum Masterkey*, 2:23-27.

Hissink, K.

1955 Felsbilder und Salz der Chimanen-Indianer. *Paideuma*, Vol. 6, pp. 60-68.

Hubbs, Carl L., and Robert R. Miller

1948 The Zoological Evidence. *In* The Great Basin. *Univ. of Utah Bulletin*,
 Vol. 36, No. 20, pp. 18-166.

Huckerby, T.

1914 Petroglyphs of Saint Vincent, British West Indies. *American Anthro-
 pologist*, 16:238-244.

1921 Petroglyphs of Grenada and a Recently Discovered Petroglyph in St.
 Vincent. *Museum of the American Indian, Heye Foundation, Indian
 Notes*, Vol. 1, No. 3.

Hunt, A. B.

1960 Archaeology of the Death Valley Salt Pan, California. *Univ. of Utah,
 Anthropological Papers*, No. 47. Salt Lake City.

Jackson, A. T.

1938 Picture-Writing of Texas Indians. *Univ. of Texas Publs.*, No. 3809;
 Anthropological Papers, No. 2. Austin.

James, George W.

1921 The Lake of the Sky. Radiant Life Press, Pasadena, Calif.

Jennings, Jesse D.

1957 Danger Cave. *Memoirs of the Society for American Archaeology*, No.
 14. Univ. of Utah Press, Salt Lake City.

Jennings, Jesse D., and Edward Norbeck

1955 Great Basin Prehistory: A Review. *American Antiquity*, 21:1-11.

Keithahn, E. L.

1940 The Petroglyphs of Southeastern Alaska. *American Antiquity*, 6:123-132.

Kelley, J. C.

1950 Atlatls, Bows and Arrows, Pictographs and the Pecos River Focus.
 American Antiquity, 16:71-74.

Kelly, Isabel T.
1932 Ethnography of the Surprise Valley Paiute. *Univ. of California Publs. in American Archaeology and Ethnology*, Vol. 31, No. 3. Berkeley and Los Angeles.

Kirkland, F.
1937*a* A Study of Indian Pictures in Texas. *Texas Archaeological and Paleontological Society Bulletin*, 9:89-119. Abilene.
1937*b* A Comparison of Texas Indian Pictographs with Paleolithic Paintings in Europe. *Central Texas Archaeologist*, 3:9-26. Waco.
1938 A Description of Texas Pictographs. *Texas Archaeological and Paleontological Society Bulletin*, 10:11-40. Abilene.
1939 Indian Pictures in the Dry Shelters of Val Verde County, Texas. *Texas Archaeological and Paleontological Society Bulletin*, 11:47-76. Abilene.

Koch-Grünberg, T.
1907 Sudamerikanische Felszeichnungen. Berlin.

Kroeber, A. L.
1908 Notes on the Luiseños. In Du Bois, C. G., The Religion of the Luiseño Indians of Southern California. *Univ. of California Publs. in American Archaeology and Ethnology*, Vol. 8, No. 3. Berkeley and Los Angeles.
1925 Handbook of the Indians of California. *Bureau of American Ethnology Bulletin*, No. 78.
1958 Sign Language Inquiry. *International Journ. American Linguistics*, 24:1-19.
1959 Ethnographic Interpretations, 7-11. *Univ. of California Publs. in American Archaeology and Ethnology*, Vol. 47, No. 3. Berkeley and Los Angeles.

Kühn, H.
1927 Die Nordafrikanische und Ägyptische Felsbilden der Eiszeit. Versammlung der Deutschen Anthropologischen Gesellschaft in Köln.
1952 Die Felsbilder Europas. Stuttgart.
1955 On the Track of Prehistoric Man. Hutchinson, London.

Lamb, Sidney M.
1958 Linguistic Prehistory in the Great Basin. *International Journ. American Linguistics*, 24:95-100.

Lange, Arthur L.
1952 The Baker Creek Caves. *Monthly Report of the Stanford Grotto, National Speleological Society*, 2:105-108. Palo Alto, Calif.

Laufer, B.
1899 Petroglyphs on the Amoor. *American Anthropologist*, n.s., 1:746-750.

Lavachery, H.
1939 Les Pétroglyphes de l'Île de Paques. 2 vols. De Sikkel, Antwerp.

Leach, Howard R.
1956 Food Habits of the Great Basin Deer Herds of California. *California Fish and Game*, 42:243-308.

Leighly, John
1956 Weather and Climate. *In* Clifford M. Zierer, ed., California and the Southwest, John Wiley, New York.

Lhote, H.
1952 Gravures, peintures et inscriptions rupestres du Kaouar, d'Aïr et de l'Adrar des Iforas. *Bulletin Institute Français Afrique Noire*, Vol. 14, pp. 1268-1340.

1953*a* Peintures rupestres de l'oued Takécherouet (Ahaggar). *Bulletin Institut Français Afrique Noire,* Vol. 15, pp. 283-291.

1953*b* Le Cheval et le Chameau dans les peintures et les gravures rupestres du Sahara. *Bulletin Institut Français Afrique Noire,* Vol. 15, pp. 1138-1228.

1957 Peintures préhistoriques du Sahara; mission H. Lhote au Tassili. Musée des Arts Decoratifs, Paris.

Linsdale, Jean M.
1938 Environmental Responses of Vertebrates in the Great Basin. *American Midland Naturalist,* 19:1-206.

Linton, R.
1925 Archaeology of the Marquesas Islands. *Bernice P. Bishop Museum Bulletin,* No. 23. Honolulu.

Loud, L. L., and M. R. Harrington
1929 Lovelock Cave. *Univ. of California Publs. in American Archaeology and Ethnology,* Vol. 25, No. 1. Berkeley and Los Angeles.

MacCurdy, G. G.
1924 Human Origins. Vol. 1. Appleton, New York.

McLean, Donald D.
1944 The Prong-Horned Antelope in California. *California Fish and Game,* 30:221-241.

Maenchen-Helfen, Otto
1951 Manichaeans in Siberia. *Univ. of California Publs. in Semitic Philology,* 11:311-326. Berkeley and Los Angeles.

Mallery, Garrick
1886 Pictographs of the North American Indian. 4th Annual Report of the Bureau of American Ethnology. Washington, D. C.

1893 Picture-Writing of the American Indians. 10th Annual Report of the Bureau of American Ethnology. Washington, D. C.

Malouf, Carling
1946 The Deep Creek Region, the Northwestern Frontier of the Pueblo Culture. *American Antiquity,* 12:117-121.

Maringer, J.
1960 The Gods of Prehistoric Man. Knopf, New York.

Meighan, C. W.
1955 Notes on the Archaeology of Mono County, California. *Univ. of California Archaeological Survey Report,* No. 28, pp. 6-26. Berkeley.

Métraux, A.
1940 Ethnology of Easter Island. *Bernice P. Bishop Museum Bulletin,* No. 160. Honolulu.

Movius, H. L., Jr., and S. Judson
1956 The Rock-Shelter of La Colombiere. *American School of Prehistoric Research Bulletin,* No. 19. Peabody Museum, Harvard University.

Muir, John
1922 The Mountains of California. Century Co., New York.

Nelson, Edward W.
1925 Status of the Pronghorned Antelope, 1922-1924. *U. S. Dept. of Agriculture, Department Bulletin,* No. 1346. Washington, D. C.

Nelson, N. C.
1937 South African Rock Pictures. *Natural History,* 40:653-662. American Museum of Natural History, New York.

Newcombe, C. F.
 1907 Petroglyphs in British Columbia. *Victoria Daily Times,* Sept. 7. (Re-
 printed as a separate pamphlet.)
Obermaier, H.
 1931 L'Âge de l'Art Rupestre Nord-Africain. *L'Anthropologie,* 41:5-74.
O'Conner, Jack
 1939 Game in the Desert. Derrydale Press, New York.
Orellana, T. R.
 1953 Petroglífos y pinturas rupestres de Sonora. *Yan,* No. 1, pp. 29-33.
 Mexico City.
Osborn, H. F.
 1916 Men of the Old Stone Age. Scribners, New York.
Park, W. Z.
 1958 Shamanism in Western North America. *Northwestern Univ. Studies in
 Social Sciences,* No. 2. Evanston, Ill.
Pompa y Pompa, A.
 1956 La Escritura Petroglífica Rupestre y su Expresión en el Noroeste Mexi-
 cano. *Anales, Instituto Nacional de Antropológia e Historia,* Época 6a,
 8:213-225.
Quirogà, A.
 1931 Petrografías y pictografías de Calchaqui. Universidad Nacional de
 Tucumán, Argentina.
Reagan, Albert B.
 1929 Geology of the Deep Creek Reservation, Utah. *Trans. of the Kansas
 Academy of Sciences,* 32:105-116.
 1934 The Gosiute or Shoshoni-Goship Indians of the Deep Creek Region in
 Western Utah. *Proc. of the Utah Academy of Sciences, Arts, and Letters,*
 11:43-54.
Renaud, E. B.
 1931 Archaeological Survey of Eastern Colorado. Dept. of Anthropology,
 University of Denver.
 1932 Archaeological Survey of Eastern Wyoming. Dept. of Anthropology,
 University of Denver.
 1933 Archaeological Survey of Eastern Colorado. Dept. of Anthropology,
 University of Denver.
 1936 Pictographs and Petroglyphs of the High Western Plains. *Archaeological
 Survey of the High Western Plains,* 8th Report. Dept. of Anthropology,
 University of Denver.
 1938 Petroglyphs of North Central New Mexico. *Archaeological Survey Series,*
 11th Report. Dept. of Anthropology, University of Denver.
Reygasse, M.
 1935 Gravures et peintures rupestres du Tassili des Ajjers. *L'Anthropologie,*
 45:533-571.
Rhotert, H.
 1952 Libysche Felsbilder. Darmstadt.
Riddell, H. S.
 1951 The Archaeology of a Paiute Village Site in Owens Valley. *Univ. of
 California Archaeological Survey Report,* No. 12, pp. 14-28. Berkeley.
Robinson, W. S.
 1951 A Method for Chronologically Ordering Archaeological Deposits. *Ameri-
 can Antiquity,* 16:293-301.

Rogers, David Banks
 1929 Prehistoric Man of the Santa Barbara Coast. Museum of Natural History, Santa Barbara, Calif.

Rosenthal, E., and A. J. H. Goodwin
 1953 Cave Artists of South Africa. Capetown, S. Africa.

Rouse, I.
 1949 Petroglyphs. *In* Handbook of South American Indians, Bull. 143. *Bureau of American Ethnology* Vol. 5:493-502. Washington, D. C.

Rudy, Jack R.
 1953 Archaeological Survey of Western Utah. *Univ. of Utah Anthropological Papers,* No. 12. Salt Lake City.

Russell, Carl Parcher
 1932 Seasonal Migration of Mule Deer. *Ecological Monographs,* 2:1-46.

Russell, Frank
 1908 The Pima Indians. 26th Annual Report of the Bureau of American Ethnology. Washington, D. C.

Russell, I. C.
 1895 Geological History of Lake Lahontan, a Quaternary Lake of Northwestern Nevada. *U. S. Geological Survey Monographs,* Vol. 11. Washington, D. C.

Sauter, Marc-R.
 1954 Propos sur l'art des Chausseurs préhistoriques. *Club des Arts,* No. 18-19. Geneva.

Schellhas, P.
 1930 The Origin of the Graphic Art of the Ancient Cave Dwellers. *American Anthropologist,* Vol. 32, pp. 571-572.

Schroeder, H. H.
 1952 A Brief Survey of the Lower Colorado River from Davis Dam to the International Border. U. S. Bureau of Reclamation Reproduction Unit, Region 3, Boulder City, Nev.

Schuster, C.
 1955 Human Figures in South American Petroglyphs and Pictographs as Excerpts from Repeating Patterns. *Anales del Museo de Historia Natural Montevideo,* 2nd ser., Vol. 6, No. 6.

Secrist, K. G.
 1960 Pictographs in Central Montana. *Anthropology and Sociology Papers,* No. 20. Dept. of Sociology. Anthropology, and Social Welfare, Montana State University, Missoula.

Shapiro, Meyer
 1953 Style. *In* Anthropology Today, A. L. Kroeber [Ed.]. Univ. of Chicago Press.

Siegel, Sidney
 1956 Nonparametric Statistics for the Behavioral Sciences. McGraw-Hill, New York.

Simpson, Capt. J. H.
 1876 Report of Explorations Across the Great Basin of the Territory of Utah for a Direct Wagon-Route from Camp Floyd to Genoa, in Carson Valley, in 1859. U. S. Army, Engineer Dept., Washington, D. C.

Smith, H. I.
 1927 List of Petroglyphs of British Columbia. *American Anthropologist,* 29:605-610.

Smith, M. W.
 1946 Petroglyph Complexes in the History of the Columbia-Fraser Region. *Southwestern Journ. of Anthropology,* 2:306-322.

Spears, J. R.
 1892 Illustrated Sketches of Death Valley. Rand, McNally and Co., Chicago and New York.

Spier, Leslie
 1930 Klamath Ethnography. *Univ. of California Publs. in American Archaeology and Ethnology,* Vol. 30. Berkeley and Los Angeles.

Steward, J. H.
 1929 Petroglyphs of California and Adjoining States. *Univ. of California Publs. in American Archaeology and Ethnology,* Vol. 24, No. 2. Berkeley and Los Angeles.
 1933 Ethnography of the Owens Valley Paiute. *Univ. of California Publs. in American Archaeology and Ethnology,* Vol. 33, No. 3.
 1937 Petroglyphs of the United States. Smithsonian Institution Annual Report for 1936, pp. 405-425.
 1938 Basin-Plateau Aboriginal Sociopolitical Groups. *Bureau of American Ethnology Bulletin,* No. 120. Washington.
 1941 Culture Element Distributions: XIII, Nevada Shoshoni. *Univ. of California Anthropological Records,* Vol. 4, No. 2. Berkeley and Los Angeles.
 1943 Culture Element Distributions: XXIII, Northern and Gosiute Shoshoni. *Univ. of California Anthropological Records,* Vol. 8, No. 3. Berkeley and Los Angeles.

Stewart, Omer C.
 1939 The Northern Paiute Bands. *Univ. of California Anthropological Records,* Vol. 2, No. 3. Berkeley and Los Angeles.
 1941 Culture Element Distributions: XIV, Northern Paiute. *Univ. of California Anthropological Records,* Vol. 4, No. 3. Berkeley and Los Angeles.
 1942 Culture Element Distributions: XVIII, Ute-Southern Paiute. *Univ. of California Anthropological Records,* Vol. 6, No. 4. Berkeley and Los Angeles.

Stow, G. W., and D. F. Bleek
 1930 Rock Paintings of South Africa. London.

Strong, W. Duncan, W. Egbert Schenck, and Julian H. Steward
 1930 Archaeology of the Dallas-Deschutes Region. *Univ. of California Publs. in American Archaeology and Ethnology,* Vol. 29, No. 1. Berkeley and Los Angeles.

Süss, E.
 1954 Rock Carvings in the Valcamonica. Edizioni del milione, Milan, Italy.

Tallgren, A. M.
 1933 Inner Asiatic and Siberian Rock Pictures. *Eurasia Septentrionalis Antiqua,* 8:175.

Tanner, C. L., and F. Connolly.
 1958 Petroglyphs in the Southwest. *Kiva,* Vol. 3, pp. 13-16.

Tatum, R. M.
 1946 Distribution and Bibliography of the Petroglyphs of the United States. *American Antiquity,* 12:122-125.

Tavera-Acosta, B.
 1956 Los Pétroglifos de Venezuela. Instituto de Antropológia e Historia, Universidad Central de Venezuela. Caracas.

Teit, J. A.
1896 A Rock Painting of the Thompson River Indians, British Columbia. *American Museum of Natural History Bulletin,* 8:227-230.
1930 The Salishan Tribes of the Western Plateaus. Franz Boas [Ed.]. 45th Annual Report of the Bureau of American Ethnology, pp. 23-396.

Train, P., J. Henrichs, and W. Archer
1941 Medicinal Uses of Plants by Indian Tribes of Nevada. *Contribs. Toward a Flora of Nevada,* No. 33 (Mimeographed). Division of Plant Exploration and Introduction, Bureau of Plant Industry, U. S. Department of Agriculture.

Treganza, Adan E.
1952 Archaeological Investigations in the Farmington Reservoir Area. *Univ. of California Archaeological Survey Report,* No. 14. Berkeley.

Treganza, A. E., and R. F. Heizer
1953 Additional Data on the Farmington Complex, a Stone Implement Assemblage of Probable Early Postglacial Date from Central California. *Univ. of California Archaeological Survey Report,* No. 22, pp. 28-38. Berkeley.

Van der Riet, J., and D. F. Bleek
1940 More Rock Paintings in South Africa. London.

Van Riet Lowe, C.
1956 The Distribution of Prehistoric Rock Engravings and Paintings in South Africa. *Archaeological Survey, Archaeological Series,* Vol. 7, Capetown.

Vaufrey, R.
1939 L'Art rupestre nord-africain. *Archives Institut Paleontologie Humaine, Mémoire,* No. 20. Paris.

Voegelin, Erminie W.
1938 Tübatulabal Ethnography. *Univ. of California Anthropological Records,* Vol. 2, No. 1. Berkeley and Los Angeles.

Vogel, Beatrice R.
1952 Baker Creek Pictograph Cave. *Monthly Report of the Stanford Grotto, National Speleological Society,* 2:107-108. Palo Alto, Calif.

Watson, E. L.
1961 Self Illustrated Archaeology. *Science of Man,* 1:76-80.

Wedel, Waldo R.
1959 An Introduction to Kansas Archaeology. *Bureau of American Ethnology bulletin,* No. 174. Washington, D. C.

Werlhof, J. C. von
1960 Petroglyph and Pictograph Sites in Western [Eastern] California and Southern Nevada. *American Philosophical Society Yearbook, 1960,* pp. 575-579.

Wheeler, S. M.
1935 A Dry Cave in Southern Nevada. *Southwest Museum Masterkey,* 9:5-12.
1936 A Pueblo II Site in the Great Basin Area of Nevada. *Southwest Museum Masterkey,* 10:207-211.
1937 An Archaeological Expedition to Nevada. *Southwest Museum Masterkey,* 11:194-197.
1939 The Jean L'Empereur Expedition in Nevada. *Southwest Museum Masterkey,* 13:216-220.
1942 Archaeology of Etna Cave, Lincoln County, Nevada. Nevada State Park Commission, Carson City.

Wheeler, S. M., and Georgia N. Wheeler
1944 Cave Burials Near Fallon, Churchill County, Nevada. Nevada State Park Commission, Carson City.

Wilman, M.
1933 Rock-Engravings in Griqualand West. Cambridge, England.

Windels, F.
1949 The Lascaux Cave Paintings. Faber and Faber, London.

Wormington, H. M.
1955 A Reappraisal of the Fremont Culture. *Proc. of the Denver Museum of Natural History,* No. 1.

Wulsin, F. R.
1941 The Prehistoric Archaeology of Northwest Africa. *Peabody Museum Papers,* Vol. 19, No. 1. Harvard University.

Zervos, C.
1959 L'Art de l'Époque du Renne en France. Editions Cahiers d'Art, Paris.

Index

239-240
 by hunt shamans?, 13, 242
 by hunting groups?, 13, 242
 affected by migrations, 13, 203-205
methods of determining, 197-202
 statistical, 199, 307

Teit, J. A., 228, 229
Tribes
 Anasazi, 208, 234
 Apache, 228, 229
 Athapascans, 230
 Battle Mountain Shoshone, 218, 225
 Cupeño, 228
 Gosiute, 71, 214, 218, 228
 Hohokam, 229
 Humboldt River Shoshone, 218
 Hupa, 237
 Karok, 237
 Kawaiisu-Ute, 227
 Klamath, 229
 Lillooet, 228
 Luiseño, 226, 228
 Modoc, 48
 Mohave, 32
 Monachi-Paviotso, 227
 Mountain Cahuilla, 228
 Navajo, 208, 229, 233
 Nevada Shoshone, 215, 218
 Northern Paiute, 13, 14, 65, 203-204,
 206-207, 212, 213, 215, 218,
 227, 231-232, 233, 243
 Northern Shoshone, 218
 Okanagan, 228
 Owens Valley Paiute, 218, 227, 233

Panamint-Shoshone, 227
Papago, 228, 229, 230
Pima, 229, 230
Pomo, 43, 237
Puebloan, 203, 208, 230, 234
Shasta, 43
Shoshone, 206-207, 212, 213, 216
Shushwap, 228
Southern Paiute, 14, 212, 213, 215,
 218, 227
Thompson, 228
Tolowa, 237
Tübatalabal, 226-227
Ute, 215, 218, 227, 229, 230
Walker Lake Paiute, 55
Walker River Paiute, 48
Walpi, 229, 230
Washo, 65
Western Mono, 218, 226, 227
Western Shoshone, 12-13, 14
Yavapai, 228
Yokuts, 218, 226
Yuman-Piman, 216, 218
Zuñi, 229, 230

Voeglin, C. F., 281
Voeglin, F. M., 281
von Werlhof, J., 28, 35

Wheat, Mrs. M., 62, 63, 65
Wheeler, S. M., 58, 203, 206
Williams, H., 284
Wright, W., *see* De Quille, D.
Wright, William, Jr., 314
Wulsin, F. R., 285